PAPERS ON
THE AMASIS PAINTER
AND HIS WORLD

PAPERS ON
THE
AMASIS PAINTER
AND HIS WORLD

Colloquium Sponsored by
the Getty Center for the
History of Art and the Humanities
and Symposium Sponsored by
the J. Paul Getty Museum

The J. Paul Getty Museum
Malibu, California 1987

Head of Publications	CHRISTOPHER HUDSON
Editor-in-Chief	ANDREA P.A. BELLOLI
Manuscript Editor	BENEDICTE GILMAN
Design	DANA LEVY, Perpetua Press, Los Angeles
Design Manager	PATRICK DOOLEY
Production Manager	KAREN SCHMIDT
Photograph Coordinator	ELIZABETH BURKE
Typography	Andresen's Tucson Typographic Service, Tucson
Printing	Dai Nippon Printing Co., Tokyo

Unless otherwise specified, photographs reproduced in this book have been provided by the institutions that own the objects.

Information about other Getty Museum publications may be obtained by writing the Bookstore, The J. Paul Getty Museum, P.O. Box 2112, Santa Monica, California 90406.

The cover illustration is a detail of side B of a panel-amphora (type B) by the Amasis Painter in the collection of the Staatliche Antikensammlung und Glyptothek, Munich (inv. 8763). Photo C. H. Krüger-Moessner, Munich.

Library of Congress Cataloging-in-Publication Data

Papers on the Amasis painter and his world.

 Includes index.
 1. Amasis, 6th cent. B.C.—Criticism and interpre-
tation. 2. Vases, Black-figured—Greece—Athens—
Themes, motives. 3. Vase-Painting, Greek—Greece—
Athens—Themes, motives. I. J. Paul Getty Center for
the History of Art and the Humanities. II. J. Paul
Getty Museum.
ND115.A55P37 1987 738'.092'4 87-16902
ISBN 0-89236-093-3

Contents

Director's Foreword

These papers were read at a three-day meeting at the Getty Museum in spring 1986 held to coincide with the Los Angeles opening of an exhibition of vases by the Amasis Painter. This publication is intended as a companion volume to the catalogue published for that exhibition, *The Amasis Painter and His World*. The essays speak for themselves; as for the event, practically everything about it was remarkable, both for the Getty and for classical scholarship.

A loan exhibition of Greek vases is a rarity, but a "one-man show" of such vases had never been held. The last exhibition of Attic vases was *Art, Myth, and Culture: Greek Vases from Southern Collections* (New Orleans Museum of Art and Tulane University, New Orleans, 1981–1982); more recently, South Italian material has been shown in *The Art of South Italy: Vases from Magna Graecia* (Virginia Museum of Fine Arts, Richmond, and other institutions, 1982–1983). In 1986 the idea of the Amasis Painter show was carried further with another exhibition of vases by a single painter, *Le Peintre de Darius et son milieu* (Musée d'Art et d'Histoire, Geneva, 1986).

The Amasis Painter exhibition was largely the creation of Dietrich von Bothmer, Chairman of the Department of Greek and Roman Art at the Metropolitan Museum, who proposed it as a commemoration of the centenary of Sir John Beazley's birth in 1885, and who wrote the catalogue. The show was organized by Kurt Luckner and the Toledo Museum of Art, and its tour included Toledo as well as the Metropolitan Museum of Art, New York, and the Los Angeles County Museum of Art. The role of the Getty Museum was to produce the catalogue, share the expenses of the project, and organize an international meeting in connection with the exhibition. To do the latter, we worked together with our colleagues at the Getty Center for the History of Art and

the Humanities, our sister institution, to put together complementary programs. The Center's contribution was the colloquium to which Andrew F. Stewart and Walter Burkert contributed the papers included in this book.

Major symposia on Greek vases, like exhibitions, are becoming more frequent. There was a session in Tübingen in 1978, another in Amsterdam in 1984, and a third in Copenhagen this year. The enthusiasm of the participants at the Getty program told us that there is much room for meetings of this kind, so we expect to sponsor similar events on classical subjects in the future.

To Marion True, appointed curator of antiquities not long after the symposium, we owe thanks for instigating the event, for bringing it off, and for helping the participants to ready their papers for the press.

JOHN WALSH
Director
The J. Paul Getty Museum

PREFACE

When Kurt Luckner and Dietrich von Bothmer extended the invitation to the Getty Museum, in spring 1984, to participate in the first exhibition ever devoted to the works of a single ancient vase-painter, the Department of Antiquities felt the painful constraints of its growing collection. It was obvious that no special exhibition of the dimensions proposed could be accommodated in the overfilled galleries of the Museum. Fortunately, however, the original concept of the exhibition appealed equally strongly to our colleagues at the Los Angeles County Museum of Art, and in collaboration with Constantina Oldknow, Associate Curator of Ancient Art, Myrna Smoot, former Associate Director for Museum Programs, and Earl A. Powell III, Director, all of LACMA, we were able to bring the exhibition to the West Coast.

Although the Getty Museum could not offer display space, the contribution we could make was the sponsorship of an international scholarly convention to celebrate the opening of *The Amasis Painter and His World* in Los Angeles. With the cooperation of the Getty Center for the History of Art and the Humanities, a colloquium and a symposium were developed to focus on issues raised by this unique exhibition.

Because the intention was to create a unified and provocative series of lectures, the invited speakers were asked to address rather specific topics. Participation in the audience was by invitation, in the hope that this large group of informed listeners drawn from all over the United States and western Europe would respond in specific terms to the speakers' observations.

The official opening of the exhibition at the Los Angeles County Museum of Art on Thursday evening, February 27, 1986, was followed by Martin Robertson's lecture, "The State of Attic Vase-Painting in the Mid-Sixth Century B.C.," delivered at the Getty Museum. Friday morn-

ing was taken up by visits to the exhibition, followed in the afternoon by the Getty Center's colloquium focusing on literary interests: Andrew F. Stewart's presentation on narrative and genre, and Walter Burkert's paper on the making of Homer. Serving as both moderator and respondent, John Boardman offered cogent observations on the two papers as well as some thoughts of his own on these topics.

The Getty Museum's symposium commenced early Saturday morning and continued through noon on Sunday. Papers intended to complement one another were presented in sequence, followed by discussion periods. John Griffiths Pedley served throughout as moderator. He also delivered the first paper, a discussion of the possible reflections of architecture in black-figure vase-painting, which was followed by Brunilde S. Ridgway's consideration of the corresponding influences of sculpture. Then, stressing the importance of vase-painting as a source of information, Albert Henrichs brought the worship of Dionysos in sixth-century Athens to life. John Boardman, Alan W. Johnston, and Brian Shefton weighed the evidence for foreign influences on the Amasis Painter and Attic vase-painting of the sixth century; Boardman tackled the difficult question of Amasis' possible Egyptian connections, while Johnston looked at the Etruscan graffiti on the vases of the Amasis Painter, and Shefton attempted to sort out some of the reflections of East Greek influence.

On Sunday morning, Joan R. Mertens expanded on the analysis of the style of the Amasis Painter, presenting the view that potter and painter may well have been the same man, while Mary B. Moore compared the painter's style and iconography with those of his most important contemporary, Exekias. Dietrich von Bothmer concluded with a survey of the connoisseurship of vase-painting, a history of the scholarly recognition of the Amasis Painter, and an appropriate tribute to Sir John Beazley.

The success of these programs was due to the consistently high quality of the speakers' presentations. Thus, the texts have been changed as little as possible in order to preserve the flavor of the original lectures. Extensive documentation has been added by the authors in the form of footnotes, however. Just as the exhibition *The Amasis Painter and His World* was originally conceived to commemorate the centenary of Beazley's birth, it is our hope that the symposium and colloquium papers collected in this volume may serve as fitting acknowledgment of his continuing inspiration.

MARION TRUE
Curator of Antiquities
The J. Paul Getty Museum

ABBREVIATIONS

AthMitt	*Mitteilungen des Deutschen Archäologischen Instituts, Athenische Abteilung*
Beazley Addenda	L. Burn and R. Glynn, comps., *Beazley Addenda* (Oxford 1982)
BSA	*Annual of the British School at Athens*
La Cité des images	C. Bérard et al., *La Cité des images* (Lausanne 1984)
CVA	*Corpus Vasorum Antiquorum*
Development	J.D. Beazley, *The Development of Attic Black-figure* (Berkeley 1951)
Development, rev. ed.	J.D. Beazley, *The Development of Attic Black-figure,* rev. ed., D. von Bothmer and M.B. Moore, eds. (Berkeley 1986)
Greek Vases 1 (1983)	*Greek Vases in The J. Paul Getty Museum* 1. Occasional Papers on Antiquities, 1 (Malibu 1983)
Greek Vases 2 (1985)	*Greek Vases in The J. Paul Getty Museum* 2. Occasional Papers on Antiquities, 3 (Malibu 1985)
HSCP	*Harvard Studies in Classical Philology*
Imagery	T.H. Carpenter, *Dionysian Imagery in Archaic Greek Art: Its Development in Black-Figure Vase Painting* (Oxford 1986)
JbMainz	*Jahrbuch der Akademie der Wissenschaften und der Literatur, Mainz*
JdI	*Jahrbuch des Deutschen Archäologischen Instituts*
JHS	*Journal of Hellenic Studies*
Karouzou, *Amasis*	S. Karouzou, *The Amasis Painter* (Oxford 1956)
LIMC 1	*Lexikon Iconographicum Mythologiae Classicae* 1 (Zurich and Munich 1981)
LIMC 2	*Lexikon Iconographicum Mythologiae Classicae* 2 (Zurich and Munich 1984)
LIMC 3	*Lexikon Iconographicum Mythologiae Classicae* 3 (Zurich and Munich 1986)
OJA	*Oxford Journal of Archaeology*
Paralipomena	J.D. Beazley, *Paralipomena: Additions to Attic Black-figure Vase-painters and to Attic Red-figure Vase-painters,* 2nd ed. (Oxford 1971)
RA	*Revue archéologique*
RE	A.F. von Pauly, *Real Encyclopädie der klassischen Altertumswissenschaft,* rev. ed. by G. Wissowa (Stuttgart 1894–1972)
Sagenbilder	K. Schefold, *Frühgriechische Sagenbilder* (Munich 1964)
Simon and Hirmer	E. Simon, M. Hirmer, and A. Hirmer, *Die griechischen Vasen,* 2nd ed. (Munich 1981)
Trademarks	Alan Johnston, *Trademarks on Greek Vases* (Warminster 1979)
ZPE	*Zeitschrift für Papyrologie und Epigraphik*

Martin Robertson

THE STATE OF ATTIC VASE-PAINTING IN THE MID-SIXTH CENTURY

I am flattered and happy to have been asked to give the opening talk in this symposium and colloquium, but also a little apprehensive. I am no expert on the Amasis Painter—though I did once write a small article on a small detail from one of his smaller vases[1]—nor on black-figure in general, having always been (so far as Attic vase-painting is concerned) a red-figure man; and I face an audience with a formidable array of scholars who *are* experts in this field. Moreover, at the time of preparing this talk I had not seen the exhibition. I have of course studied the magnificent catalogue, and I can at least begin, safely and truthfully, by expressing (not, I'm sure, on my own behalf alone) gratitude and admiration for the splendid way in which this great concept has been carried through: to Kurt Luckner who did so much for the exhibition; to Dietrich von Bothmer, its "onlie begetter" and author of the catalogue with its impeccable entries and beautiful essay on the painter;[2] to the other contributors to exhibition and catalogue; to the anonymous friend who made it possible for the catalogue to be not only an essential tool of scholarship but also such a richly illustrated and beautiful production; and to the authorities and staffs of the J. Paul Getty Museum and the Getty Center, who have invited us to partake in this symposium and colloquium and have organized them so admirably. We may conjecture that a symposium would have appealed more to the Amasis Painter himself than a colloquium, but we ourselves can safely look forward to enjoying both.

To come back to my own situation, I take some comfort from the fact that I am not billed to talk about the painter but about an aspect of the other half of the exhibition's title: his world. I have called my talk "The State of Attic Vase-Painting in the Mid-Sixth Century" because that is a title which points away from details and toward generalities, and I find it a growing vice of age that I become more interested in wider

questions. Of course they demand less hard labor, less of the nitty-gritty, than particularities, but I think—I hope—that it is not solely for that that I feel drawn to them. I am no better able than I ever was to provide *answers*, but I do like mulling the questions over; and that, I'm afraid, is what you're in for this evening: a wander around questions that suggest themselves to my mind as background to an exhibition devoted to a single vase-painter and his world.

One question which, it seems to me, immediately arises from my title is: what do we mean in this context by the mid-sixth century? My friends will know—indeed, it is a frequent subject of vexation to them—that I do not like dates. By this I mean that it worries me to say that a given work of art can be dated, on grounds of its style, to a given point in historical time. It's not that I don't know the rules of the game and can't play it if I choose. Indeed, I often do find myself playing it, because it has become part of the way we think about the subject to say, for instance, that such and such a vase by Exekias is to be dated in the decade 540–530; but I retain a mental reservation that this is a metaphor rather than a factual truth; and I sometimes feel the need to remind myself, and others, aloud that this is how I view it.

Thus, to take first an area where I have done more detailed and original work of my own: I find myself assigning a very early work by the Berlin Painter to about 500 or just before, accepting that his early style runs through the decades 500–480, his middle and later periods 480–460; but I still do not believe that this is quite how things actually happened. I do believe that the Berlin Painter is a real, artistic person-ality, and that works certainly attributable to this one hand show varia-tions in style which can be broadly associated with a chronological de-velopment. I further believe that the same is true of the Achilles Painter; that works which appear to show an early phase of the Achilles Painter's style are very closely related to others which seem to show a late phase of the Berlin Painter's; and that the mature style of the Achilles Painter is so singularly like that of the sculptures of the Parthenon, which are docu-mented by inscriptions and other evidence to the 40s and 30s of the fifth century, that it seems safe to suppose that the Achilles Painter's prime is to be set there, too. This makes it reasonable to infer that the Achilles Painter was learning his craft from the old Berlin Painter in, say, the 60s or 50s.

The story of Boreas and Oreithyia is illustrated on a vase in the late style of the Berlin Painter but never in his earlier work, and the drawing on that vase shows the same general phase of development as that on other vases which illustrate the myth and seem among the earliest to do so. The sudden popularity of this story has been convincingly associated with the gratitude felt by the Athenians to the god, the north wind, for his timely aid in scattering the Persian fleet at Artemision. This suggests that the Berlin Painter's later work should be placed after 480, his earlier perhaps before. The phases of his and his followers' styles can be correlated in a loose way with those of many other vase-painters in whose works similar associations with dated works of art or with pos-sible historical circumstances can likewise sometimes be traced. That is, we can see a large body of vase-painting as the work of a number of

definable artists whose careers can reasonably be seen as falling in the first half of the fifth century, some in the earlier, some in the later part. This construct *may* receive confirmation from what is found in traces of the Persian sack of Athens in 480; but it is so very hard to be certain that any one deposit does actually represent that sack that it is safer to leave that evidence aside. However, we surely do have the Themistoklean wall, thrown up in haste in 479; and the relief bases from that are so close in style to the red-figure vase-painting of the so-called Pioneers, Euphronios, Euthymides, and their companions, as to show that those painters must have been active before the sack. Their work, too, can be shown to precede stylistically, and lead directly on to, early works of the Berlin Painter, the Kleophrades Painter, Onesimos, and other painters of pots and cups who appear contemporary with these. I must confess, however, that the date of 500, which we all accept for the end of the Pioneers and the beginning of the next generation, appears to me absolutely artificial and arbitrary.

Nor do I think that *Leagros kalos* is much help here. Kalos names in general and, since so many painters in different techniques use it, Leagros in particular, are valuable in confirming the approximate contemporaneity of different painters and groups; but even if we can correctly identify the person named, as perhaps we can Leagros, we know so little about his precise dates, about how long and between what ages he might reasonably be called *kalos*, or indeed about what the real meaning of *ho deina kalos* was (and it may not have been consistent) that as a means of establishing a link between vase-painters' activity and historical chronology this evidence is, I think, virtually useless.[3]

Iconography is no doubt related to history: subjects must sometimes have been chosen under the influence of historical events or dynastic claims of political leaders; but the story of Boreas and Oreithyia seems to me one of the very few cases in which one can with any confidence argue from it to establish a date. It is far more often possible to defend several incompatible explanations. One may for instance feel that the great Iliuperseis of the Brygos and Kleophrades painters ought to echo the trauma of the sack of Athens in 480, but that can be mere hindsight. We have it on record that the sack of Miletos in 494 had a profound emotional effect on the citizens of Athens, and they must have been even harder hit by that of Eretria in 490 when the Persian army set foot in Attica. One might even make a case for the popularity of the subject being a boastful reflection of the burning, about 498, of Sardis by Ionians, Eretrians, and Athenians, which makes in some ways a better parallel to the Greek sack of Troy than the others. As a general rule, it is only when one already knows the date of a work of art by other means that one can safely associate its legendary subject matter with a historical event.

Even when one has established a few fixed points of contact between certain works of art and certain historical dates, there are limits to how far one can argue from these to other works. One artist, let alone one generation of artists, does not stop when another begins. There are overlaps of styles—old-fashioned alongside advanced—and of careers,

sometimes long overlaps, between master and pupil; and one can never say for certain even that every work that appears to be in a painter's early manner was actually painted before every work that seems to show greater development. In the almost total absence of documentation for our field of study we are forced to use these rigid constructs, but we ought often to remind ourselves how artificial they are even while we accept that they do have some general correspondence to what actually occurred.

This general correspondence is something I do accept. I think our overall chronological scheme has a sufficiently convincing coherence, and just enough more or less documented contacts with history, to allow us to believe that in its main lines, it is more or less correct, and that to attempt to overthrow it totally, as David Francis and Michael Vickers do, is wrongheaded and creates more and worse problems than it solves.[4] Not useless, though, since it reminds us to look at our assumptions critically and to remember how very tenuous and few our actual links with history are. And Francis and Vickers could be right on some points. For instance, I can just imagine the possibility that the temple sculptures from Eretria really were carved after the Persian wars. I find a degree of mannerism in these splendid pieces which makes it not inconceivable to me that they are the work of a brilliant artist carrying on the Archaic mode when most of his colleagues are into the Classical revolution. Possibilities of this kind are surely something we ought to keep in mind.

In order to construct our scheme, we have to assume that art develops steadily. For Greek art this seems in a general way true. It is, quite evidently, a restless, changing, developing art in a way that Egyptian, for instance, or Byzantine are not; but it is extremely improbable that all artists, even all good artists, were always on the bandwagon of change. Between the two sculptors of the Siphnian friezes I see no qualitative difference whatever. Both are superb artists; but the carver of north and east is far more forward-looking than the carver of west and south. I would not, however, conclude that there is any difference in date, or even that the more old-fashioned artist was necessarily the older man. In this case, however, Francis' and Vickers' view that the decoration of the building should be brought down after 480 seems to me wholly inconceivable. I believe that the interpretation of Herodotos, which places it shortly before 525, is correct. I also believe that stylistic re-semblances in some of the sculptures to some of the earliest-looking Attic red-figure can be taken as showing that the invention of that tech-nique took place about the same time; and one can trace a development of red-figure from this point which is compatible with the picture we've arrived at from the other end, of the successors of the Pioneers already at work before the Persian invasion. The dating of the overlapping careers of pre-Pioneers, Pioneers, and post-Pioneers within the decades between about 530 and about 480 remains to my mind pretty vague, but I accept as clear the general development within this bracket and also the develop-ment alongside it of black-figure, produced in some cases by hands iden-tifiable as the same which produced some of the red-figure.

The state of development of black-figure at the time red-figure was devised is indicated by the bilingual vases, whether—as in the

amphorae of Psiax and the early eye-cups of Oltos and Epiktetos—the same master worked in both techniques or—as with the Andokides Painter and the Lysippides Painter—the red-figure and black-figure pictures are perhaps by different hands. These painters in black-figure can be clearly seen as followers of several great figures who must therefore have been active in the Kerameikos in or around the third quarter of the sixth century: Exekias, Lydos, and the Amasis Painter.

Here we come to another possible point of contact with a historical date. Throughout the period we have been considering and for centuries after runs the series of black-figure amphorae inscribed as prizes at the games in Athens, vases often attributable to hands that produced other work in black-figure and red-figure, and for a short period in the fourth century datable to a year by the addition of an archon's name. Among the stylistically early but not earliest-looking in the series are pieces that can be attributed to Lydos and Exekias; the very earliest look like work of a generation before. A story that Peisistratos reorganized the Panathenaic festival in 566 B.C. is not well documented. The only source for the date is a poor one, and what he is supposed to have done is not very clear. It is not something one would like to make into a foundation stone. Nevertheless, the sudden appearance of a new type of vessel officially inscribed as relating to games at Athens in the repertoire of vase-painters whom we have seen reason, on other grounds, for supposing to have been active around the middle of the century does seem to allow us to put more faith both in our construction of the development of Attic vase-painting and in the tradition about Peisistratos and the festival than either would warrant without the other.

So, we have a kind of idea of what may have been happening in the Kerameikos in the mid-sixth century. You may complain that I've spent a lot of time building up a vague picture of something you knew perfectly well and much more precisely already; but that really is my point. I do think we need to look back often at our accepted system of dating, and remember how flimsy the construction is, to avoid the trap of building on conjecture, however plausible, as though it were fact. I find myself in sympathy with the cautious, undogmatic dating of Bothmer's entries in the catalogue of the Amasis exhibition. A slightly greater precision slips into the chronological table at the end with its Early Period 560–550, Middle Period 550–530, Late Period 530–515, and with this last date I begin to feel a little uncomfortable. While we were in round decades or double decades we could easily remember that we are dealing with approximations, not absolutes; 515 sounds a little too much like a real date. The reason for its choice is evident and logical. The neck-amphora in Boston, number 25 in the catalogue, is unquestionably the latest-looking work of the painter we possess. Beazley in *Development* wrote of it that "the drawing of the muscular bodies would point to a date not earlier than the twenties or teens of the sixth century, contemporary with the Leagros Group and the red-figured work of Euphronios and his fellows."[5] Bothmer quotes this sentence both in the catalogue entry and in his essay, and in the essay goes on to make a specific and telling comparison between figures in the two pictures on the Amasis

Painter's vase and others in Euphronios' great rendering of Sarpedon lifted by Sleep and Death on the krater in New York. That vase he has elsewhere dated about 515 B.C., and so 515 comes in as a date for the end of the Amasis Painter's career. I would myself rather call Euphronios' vase circa 520–510, or even circa 520–500, and the late phase of the Amasis Painter's activity circa 530–510 (or 500), and put in a *circa* likewise before the round dates of his early and middle periods.

But we should get back to the decades around the middle of the century. We have seen that the great artists Lydos, the Amasis Painter, and Exekias must have been forming their styles then, and there is a mass of less careful work, some closely related to theirs, some not, some of which must be earlier than theirs, some more probably continuing alongside it in an old-fashioned manner. When in 1934 Beazley published his article "Groups of Mid-sixth-century Black-figure," he illustrated a neck-amphora in Boulogne which he ascribed to the Swinger.[6] On one side a satyr carries on his shoulder a calyx-krater. That seemed odd, since the earliest calyx-kraters then known are Antimenean, that is, their black-figure pictures show a stage of development contemporary with the earliest red-figure and appear far more advanced than the Swinger's figures. A little later a fragmentary calyx-krater was found which was attributable to Exekias, and another complete one very close to him in character, both in a style that seems to belong late in his career. The style certainly looks earlier than the Antimenean but still later than that of the Swinger's vase. That painter, however, was evidently no innovator, and Elke Böhr in her comprehensive and admirable study sees his career as overlapping Exekias' considerably.[7] She does, however, conclude that the vase featuring a calyx-krater must be earlier than Exekias' fragmentary piece from the Agora, and so the latter cannot be the first vase of the shape made. This of course may well be true, but the Agora vase has primitive characteristics compared with any other surviving example of the shape, which suggests that, if not the first made, it still belongs to an experimental phase and is unlikely to have had predecessors of much earlier date. I do not believe that the evidence we have even for relative dating is of a nature to allow us to say categorically that the Swinger's Boulogne neck-amphora must have been made before Exekias' Agora calyx-krater.

The further back one goes the more schematic absolute dating becomes, but I think I've said enough (indeed almost certainly too much) about the problem of dates. We do seem able to say that the great vase-painters of the generation before red-figure was introduced, among whom the Amasis Painter holds a leading place, must have got their training somewhere around mid-century. We can see work that looks earlier in style and seems to lead on to theirs, but we need not be bothered in this context about the absolute dating of the material from the first half or so of the century. We do need, however, to consider that material from other points of view. One question I feel is of particular interest is that of the phenomenon of vase-painting as a fine art—which flowers so astonishingly in the work of these and a few earlier vase-painters and continues on for many generations—and the relation of this

phenomenon to the common run of pottery decoration, an everyday craft with few pretensions and often of very poor quality, mass-produced insofar as an unmechanized society can mass-produce—for this is, I think, a fair characterization of most black-figure and, later, of most red-figure pottery. The fine art element was always only a small proportion of the production of the Kerameikos, and the few artists who produced it also produced common craft-work like their less ambitious fellows. A few of the earliest pieces by the Amasis Painter in this exhibition, for instance, do not seem to me to qualify as works of art: the lekythos in Philadelphia, for example, catalogue number 40, or the chous with warriors in New York, number 33.

I raised this question in a lecture I gave at Oxford last June,[8] at the meeting held to honor Beazley in his centenary year, and I should like to consider it further in the light of this exhibition, which was itself opened in New York on Beazley's hundredth birthday as part of the same celebration. Beazley would certainly have appreciated the exhibition. I feel much more doubtful whether he would have seen any necessity for raising a question as to when and how far vase-painting can be regarded as a fine art. To him, I think, the fact that the best of it can self-evidently be regarded so was enough, but times change, and I do not think we do his memory any service by declining to raise a question because he would not have thought it needed raising. Nevertheless, I do feel a difficulty in raising it. I said at the beginning that I do not offer answers, but here I am in the worse case of not being at all sure how to formulate the question. However, I do have the uncomfortable feeling that there is a problem here, in how we look at the art of Attic vase-painting, and I will see what I can do about giving it expression.

There are perhaps two related problems which, as students of vase-painting, we ought to consider. The first is that, while the methods Beazley used to establish the artistic personalities of vase-painters, their development, the influence of one on another, and the interaction of their individual styles were borrowed from those of Morelli, Berenson, and others in the field of late and post-medieval painting, and were applied by him as though Attic vase-painting were another field of exactly the same kind, there is in fact, it seems to me, a basic difference that might influence how we study it, ought at least to be taken notice of. There is plenty of hackwork, certainly, in late and post-medieval painting, and—fine or less fine—it was never or seldom undertaken as pure painting but to serve some ulterior purpose, generally religious. Nevertheless, whatever purpose it served and of whatever quality it was, it served its purpose simply by being painting: it exists in its own right as painting. The same thing must have applied to Greek painting on panel or wall, as it does to Greek sculpture throughout its existence, but it does not apply, or at least not without important reservations, to vase-painting. A statue or a picture exists as itself. A vessel exists to serve some practical purpose for the living or the dead: to be drunk or poured from; to have liquids or solids mixed or stored in it. It need not be decorated at all, or its decoration may be a conventionally repeated design of a more or less simple kind, or it may be altogether more elaborate. The decoration of vessels with finely

drawn figures in narrative groups is an unusual phenomenon, and if all the figure-drawing on Attic pots were of a kind to suggest that it aspires, as it were, to the status of fine art, there would be no problem in treating the field as an art like painting on wall or panel, like sculpture; but it is not so. Many Attic vase-painters, from early black-figure to late red-figure, from the Polos Painter to the Fat Boy Group, evidently used figure-work as a quick, simple, conventional way of decorating a pot, daubing it on without originality or care, and those painters who clearly were artists in some sense did not show themselves so all the time, but were sometimes content with conventional decoration.

My second problem has already become apparent: what do we mean by "art?" Neither Greek nor Latin makes a verbal distinction between craft and art, craftsman and artist. Indeed, in Europe at least, that distinction in words seems not to have been made before the high Renaissance, around 1500, first perhaps by Dürer; but the painters of the fourteenth and fifteenth centuries were nonetheless artists in the way we use the term now, and the same certainly goes for the painters and sculptors of Classical Greece. How far this is true of sculptors and painters in earlier cultures is, I think, very hard to say. Their productions appeal to us as works of art, and surely these works were appreciated aesthetically in some way by those who made and those who commissioned them; but it is only with Greek art that individual artistic personality becomes a marked and evidently conscious phenomenon. This is part of the Greek attitude to life in general, as we see clearly in their literature. Already in the seventh and early sixth centuries the poets Archilochos, Sappho, and Alkaios were writing poems in a highly personal idiom, which reflected (in however transmuted a form) actual events of their own private lives and expressed their strong personalities as well as their strong feelings. There is nothing personal in this way in the visual arts of the time, but the frequency with which Archaic artists in all media put their names to their works justifies us in interpreting the marked differences in style as reflections of individual personalities. The *egrapsen*-signatures on vases show that vase-painters shared in this development, and at the end of the Archaic period Euthymides' marginal note, *hos oudepote Euphronios*, "Euphronios never did anything like this," shows them as self-conscious artists rivaling each other's achievements. It may be that the *epoiesen*-inscriptions show the potters, too, as conscious artists, but dispute over the meaning of these remains unsettled. That *egrapsen* in this context means "drew" does not admit of doubt, nor that it refers to the work of the vase-painter, unless one accepts Vickers' idea that Athenian pots were copied closely, inscriptions and all, from designs made for vessels in gold and silver, and this I find wholly implausible.[9]

So, the best Attic vase-painters were artists and proud of it, but at the same time they were part of a commercial business producing pottery for a market, a business in which most of the people employed were simply making and decorating pots in a traditional way, seldom or never aspiring to draw finely. Even the best painters show a great range between carefully considered works of art and more or less mechanical pot-decoration. How this odd situation arose is something that, in this

virtually undocumented area, we can only guess at. "Odd" of course expresses how it looks from our viewpoint, not theirs. No doubt to them it was a natural enough development. The situation was surely more easily accepted because, though a distinction between common craft and fine art was beginning to have substance, it had as yet no name, and so was not recognized, or not clearly recognized. A painter of maiolica in the early sixteenth century would, I imagine, have felt that what he did was not only different from and cheaper than what Raphael or Michelangelo was doing, but also of a lower aesthetic standing—a concept which would not have had meaning for the Attic vase-painter, who could therefore move between common craft and craft as fine art without a sense of crossing a barrier. But this, though it helps to explain *how* the flowering of this art in the craft of vase-decoration may have occurred, does not provide a *reason* for it to happen.

Thirty-five years ago I suggested that it all goes back to the primacy of painted pottery as an art form in Geometric Athens, where huge pots acting as grave markers are the first reappearance of monumental art after the dark ages ensuing on the collapse of Bronze Age civilization.[10] During that time the production of art had virtually ceased, but utilitarian crafts had survived, including painted pottery, which had flourished particularly in Athens in the improving conditions of the Protogeometric and early Geometric periods. When, a little after that, a need again began to be felt for a monumental art, this flourishing craft supplied the means; and so painted pottery found itself established as a leading art form. This is not quite how I put it in that essay, which suffers among other things from a too ready acceptance of the belief that Athenian vase-painting *is* a fine art, or at least from a failure to consider, as I am trying to consider now, the true relation of the fine art element in it to the overriding continuance of the common craft. I think nevertheless that the basic idea may be right, though there are problems of continuity.

That the Geometric grave markers are not only painted pots but also examples of monumental art seems to me undeniable; this tradition of monumental painted pots in a funeral context was carried on in Athens down to the earliest black-figure, the work of the Chimaira-Nettos Painter and his companions, who seem to have been active somewhere in the later seventh century. Alongside this monumental tradition, of course, from the beginning, ran a steady and much larger production of everyday pottery on a normal scale with more or less stereotyped decoration, which was no doubt applied by, among others, the same people who painted the monumental pieces. This everyday tradition continued unbroken into sixth-century black-figure, but the link between the grand style of the monumental pots and the fine "artists' black-figure," which developed at some time in the first half of the sixth century, is less continuously clear. Certainly, the painted pot as grave marker went out of fashion. The largest vessels decorated by craftsmen who seem to have been followers of the Nettos Painter are dinoi on stands, smaller than the grave vases, with much-smaller-scale figures, and usually destined for a different context, the symposium (though they might end up in graves). Painted pottery on a small scale continued to be

produced for funeral purposes. There is also a series of large plaques designed for tomb facades, and though this fashion reached its apogee later, in the work of Lydos and Exekias, it did begin in the time we are considering (with rather weak pieces by Sophilos) and kept up the connection between large-scale vase-painters' work and the graveyard. Even the best work of the best painters of this generation, however (the KX Painter, the Gorgon Painter, Sophilos), lacks the finesse as well as the force of the great work of the generation before.

The new fine style begins in what seems the next generation again, with Kleitias, Nearchos, and the Painter of Akropolis 606. Conventionally, we stop the Nettos Painter before 600 and begin the new fine style around 570, but these dates are exceedingly schematic, and it is possible that some of the new fine painters had in their youth seen the old Nettos Painter at work. The time scale is in any case such that I find no difficulty in seeing a tradition of vase-painting outside the common run surviving as a potentiality across a brief lapse in its actual production, bearing in mind always that there is no question of two distinct traditions. The "fine art" is a special function of the common craft.

The everyday, smaller pots of the Nettos Painter are mainly, so far as the surviving evidence goes, lekanides and other not large vessels to put in tombs. Their successors carried on this tradition, sometimes on lekythoi and other grave vessels, but very often on cups and jugs, the accompaniment of the dinos at the symposium, and it seems rather in this than in the funeral context that the new fine style was developed.

The historical background to these changes is perhaps to be sought in the troubles that led up to Solon's reforms and in those reforms themselves. One has also to consider the perhaps related question of the interplay of Attic with Corinthian vase-painting and the apparent trade rivalry between the pottery industries of the two cities. Earlier in the seventh century Corinthian potters had developed a marvelously fine style on small vessels that were widely exported, but later they seem to have found that mass production paid better. Vessels painted by the Gorgon Painter and others of that generation are the first Attic ware to be found extensively in the west, and their rather humdrum character compared to the masterpieces of the generation before may reflect the same attempt to win markets by quantity rather than quality. As utilitarian pottery their quality is generally excellent. In 1932 Beazley wrote, "Sophilos was by no means a dolt: but it was not such men as he who beat the Corinthians forever from the field. It was men like Ergotimos and Klitias",[11] but this is not quite how I see what happened. I should rather suppose that the battle, if such there was, between Corinthian and Attic potteries for the western markets was fought largely at mass-production level, and that the fine style of Kleitias and the others created or exploited a *new* demand by the Etruscans, which the Corinthians also tried to meet in their Middle and Late Corinthian kraters and related vases.

Anyhow, apparently sometime in the second quarter of the sixth century, drawing in Attic black-figure was developed by a few painters into a fine art, and it was in the generation after this that Lydos, the Amasis Painter, and Exekias emerged. For the relation between these two

generations of potters and painters we have for once some actual documentation in inscribed names. The name of Nearchos is followed by both *egrapsen* and *epoiesen,* and on some vases signed *Kleitias egrapsen,* a further inscription, *Ergotimos epoiesen,* appears. Some of these are Little-Master cups of a particular form, Gordion cups. On some Little Masters of one of the two canonical forms, the lip-cup, certain names occur with a patronymic and the verb *epoiesen*: Eucheiros, son of Ergotimos; Tleson and Ergoteles, sons of Nearchos. Other lip-cups are inscribed *Exekias epoiesen,* though their painted decoration cannot be from the hand of Exekias; and Little Masters of the second canonical form, the band-cup, are ascribed to Lydos and to the Amasis Painter. On one of these last, which is fragmentary (number 55 in the exhibition catalogue; numbers 56 and 57 are others), the name Amasis is found under one handle; under the other, which is missing, was surely written *epoiesen*.

It does look as though the Little-Master cup was created by Ergotimos and Kleitias in the form of the Gordion cup, which has features in common not only with both lip-cup and band-cup, but with the Siana cup, which was certainly developed before; and as though the canonical forms of Little-Master, lip- and band-cup were created in the generation of their sons, which was also the generation of Lydos, the Amasis Painter, the potter Amasis, and Exekias. A son of Eucheiros inscribes himself as such on a fragmentary lip-cup without apparently putting in either his own name or a verb, while the name of Kleophrades, son of Amasis, appears with *epoiesen* on red-figure cups that we date to the early fifth century.[12] These facts suggest that the potter Amasis may have been one of the younger members of the generation, and the potter Eucheiros, son of Ergotimos, one of the older. The second suggestion fits with the observation that the style of drawing of Kleitias, colleague of Eucheiros' father, has a distinctively more archaic look than those of his rivals, the Painter of Akropolis 606 and Nearchos, Tleson's father. The first goes well with the fact, noted by Bothmer, that the name Amasis is not found on the earlier work of the Amasis Painter. I slightly regret that the evidence points this way, since I do feel a similar spirit in the very distinctive potting of Amasis and the style of the Amasis Painter, and could happily see them as one, but a perfect partnership, like that of Kleitias and Ergotimos, is of course just as likely. The appearance of the word *Amasis epoiesen* on a vase decorated by another painter (catalogue, appendix 1; puzzlingly placed under the foot) does not affect the question: Exekias puts his name before both *egrapsen* and *epoiesen,* but as noticed already, not all vases with the *epoiesen* inscription were painted by him.

Among the painters of this second phase of "fine art black-figure" nothing has been attributed to Exekias which looks as early as the earlier-looking work of the Amasis Painter, and that painter's earliest-seeming work in turn looks perhaps more developed than the most primitive pieces assigned to Lydos; so that one would judge Exekias to have been the youngest of this trio, Lydos perhaps the oldest. Obviously, the artists in the two phases must have overlapped considerably, but these doubtful subtleties apart, they do seem to fall distinctly into two generations:

Kleitias, the Painter of Akropolis 606, and Nearchos in the first; in the second, Lydos, the Amasis Painter, and Exekias.

It is easy to see reflections of the earlier group's styles in works of the later, much harder to point to a clear relation of master and pupil between any of them; and it is perhaps unnecessary to expect to find such a link as that. The fine style is not something that stands on its own, but is a special part of the broad tradition of Attic vase-painting, a side of Attic pottery production. There was evidently a demand for it (the fine style), and there were always painters ready to meet that demand and capable of doing so, but one fine artist was not necessarily pupil of another. All were trained and rooted in the common craft. Looking at pictures by Exekias of heroes with their horses, and at the masterpiece signed by Nearchos on the fragmentary kantharos from the Akropolis— Achilles harnessing his chariot—one cannot but feel more than an affinity. The younger painter had surely seen and been inspired by this or similar work by the older. At one time I was inclined to take this perception as equivalent to saying that Exekias was a pupil of Nearchos, and this would really imply that the fine style ran parallel to the common style and to some degree independent of it. Group E would then hardly be, as Beazley put it so beautifully, "the soil from which the art of Exekias springs, the tradition which, on his way from fine craftsman to true artist, he absorbs and transcends,"[13] but rather the work of lesser craftsmen influenced by the great painters. I am now sure that mine was a mistaken view and that Beazley was right. The only hesitation I might still have is that Beazley's sentence seems to imply that Exekias, having become a true artist, left behind his role as a regular craftsman, and this I should be inclined to doubt. I would suppose it likely that even the finest artists among Attic vase-painters spent much of their time producing slighter work for the lower levels of the market, though it may not always have been detected. Even in Exekias' case, though the level of work attributed to him is consistently high, some pieces are much slighter and less careful than others. The reverse of the amphora in Boulogne, on the front of which is the masterpiece with Ajax preparing his death, is a case in point. Another was noted long ago by Bothmer. The neck-amphora in the British Museum (B 210) with Achilles and Penthesilea and the inscription *Exekias epoiesen* is another masterpiece; the picture of the same scene on a second neck-amphora in the same collection (B 209) is, in Bothmer's words, "less careful and certainly less imaginative," and he points out that the shape and subsidiary decoration of this pot are canonical, while B 210 is highly distinctive in both. B 209 is in fact a workaday piece for the ordinary market, albeit the work of a master craftsman; the other is a work of art.[14]

One might compare Exekias' relation to Group E, on the one hand, and to Nearchos on the other, with Michelangelo, trained as a painter in the rather humdrum studio of Ghirlandaio but showing on the Sistine ceiling an inspired affinity with the work of Signorelli in Orvieto, though he was certainly never Signorelli's pupil. So, I find myself back to the comparison with Renaissance painting. Indeed, I find the comparison irresistible, and believe that up to a point it is valid, but I still feel that the

caveat stands: that being trained in a pottery workshop as a vase-painter is seriously different from being trained as a painter in a painter's studio. And if one does allow oneself the comparison, one must always remember that it is a comparison of small things to great. I believe that the best drawing on Greek vases is superlative art, but it is not only on a small scale: its condition as an aspect of a utilitarian craft, and the limitations imposed by that condition, do set it off from the fine arts proper.

How far, though, need acceptance of this (supposing it is accepted) affect our approach to the study of Attic vase-painting? I began this part of my talk by saying that Beazley had borrowed Morellian methods and applied them in a field that is different in kind from that in which they were forged, and I have tried to show that there is a real difference. Beazley's application of these methods, however, makes it quite clear that the methods themselves are in fact perfectly applicable over the whole of this different field, to black-figure and red-figure vase-painting in its humblest craft form as well as when it appears as an art. The Polos Painter and the Pithos Painter, artless hacks, are no less definable by Morellian methods than masters like Kleitias or Onesimos. So, what is all the fuss about? Has there been any point in trying to define more closely the peculiar dualism of Attic vase-painting? Well, I hope so. I think so. Not, certainly, in criticism of Beazley: his work, so far as I can see, is wholly valuable; but it may possibly help us in the way we use his work. It is always good, I suppose, to try to get a better-focused view of a hazy area, and I think there *is* a patch of haze here; but perhaps there is a more particular point. Vase-painting has assumed a very large place in the history of Greek art, and I do think it important to remind ourselves that it is art of an odd and limited kind with an important other aspect, which takes it outside the study of art proper. Beazley's isolation of lesser and greater vase-painters over the whole field, apart from its fascination as an intellectual exercise—the achievement of a quite exceptional eye and mind quite exceptionally dedicated to their task—is certainly of vast potential use in many regions of classical study, and it gives us the history of the craft in newly living terms; but it has, I think, had one awkward side effect which we need to watch. Before Beazley, historians of Greek art felt it necessary to consider vase-painting only in its finer manifestations. Beazley's work, demonstrating as it does the inseparability at craft level of finer and less fine, has as it were lifted the whole craft to a position in the history of art where it does not as such quite belong. When we write, or encourage others to write, major studies in depth of minor vase-painters, we are in danger, perhaps, of muddying rather than clarifying the history of Greek art. I have only lately and with difficulty arrived at this position, and my preaching is of course primarily directed at myself. The haze of which I have spoken may be in my mind alone. If your minds are clear, you will, I'm afraid, have found this an unnecessary and tedious exercise, and I apologize.

I have in any case wandered a good way from mid-sixth-century Attic vase-painting as a background to the Amasis Painter, and perhaps we had better look back at that before closing. I spoke of the relation of Exekias to Group E on the one hand, Nearchos on the other. Bothmer

has analyzed with care and skill many connections of the Amasis Painter with other artists. He notes his affinity with Kleitias; and of the older generation of fine artists, Kleitias is surely the one to whom he owes most. Bothmer notes, however, that the line-border of the handle-picture on the Amasis Painter's aryballos (catalogue number 52) seems taken from the picture in the same position on the aryballos by Nearchos; and I would add that the satyrs in Nearchos' picture, which Beazley noted as resembling those on a lip-cup with the name of Nearchos' son, Tleson, seem to me to look forward also to the satyrs of the Amasis Painter as well as those of the Oakeshott Painter.[15] This last is not mentioned by Bothmer, perhaps because, with so very few pieces assigned to him, all on a small scale, he can only count as a minor painter. Nevertheless he is a fine artist and one who seems to me to stand exceedingly close to the Amasis Painter, especially the Amasis Painter as he reveals himself on the aryballos and in the small friezes he places above the main pictures on his amphorae in Würzburg and Samos. I find Bothmer's account of the painter's relations with other contemporaries most illuminating; of particular interest is the range and detail of his contacts with Lydos. What remains unclear to me is in what workshop the Amasis Painter got his basic craftsman's training. When Beazley, in the article "Amasea" of 1931, first defined the Heidelberg Painter (then the Heidelberg Group), he offered three alternative possible explanations for the very close relation he saw in these vases to the early work of the Amasis Painter: that they were in fact the earliest pieces by the painter himself; that they were the work of his master; or that they were the work of an old-fashioned companion. Twenty years later, in *Development*, he recognized that the first option was no longer open, but he left the nature of the relation unclarified.[16] He still saw it as close, and the fact that he does not mention it in *ABV* or later lists is surely not because he had ceased to believe it, but because he could not see it as a connection that could be defined in a clear form: master and pupil; or companion. He tends in his lists to confine cross-references to relations of that sort. Bothmer notes the fact of some influence on the Amasis Painter from the Heidelberg Painter, and also from the other principal painter of Siana cups, the C Painter, whom Beazley had noticed (once more in *Development*,[17] but not in the lists) as having a relation to the Heidelberg Painter. Bothmer does not feel these influences very important, and I do not think it would be easy to see the Amasis Painter apprenticed in either of these workshops, especially in view of the fact that we have no Siana cup attributed to him. The positive fact that so much of his earliest work is on lekythoi, as well as much that is a little later and much better, might make one look for a lekythos workshop in which he might have been trained, but he is in fact himself one of the first painters to specialize in the shoulder-lekythos. There are examples that seem earlier than any of his, but there exists no body of them forming a workshop in which he might have been trained. Several shoulder-lekythoi have been given to the C Painter, and another contemporary, the Sandal Painter, decorated both shoulder-lekythoi and Sianas, so one might perhaps envisage the prentice Amasis Painter joining the Heidelberg Painter's workshop and being put on to lekythoi,

while the master stuck to his preferred cups; but I am moving into the realm of pure fantasy and had better stop.

Certainly, we cannot see any body of workaday vases which stands to the Amasis Painter as Group E does to Exekias and as a large group of mostly rather poor work does to Lydos. One would guess that wherever the Amasis Painter was trained, he did not sit there long, but moved out quickly on his own. He gives the impression of being his own man from the beginning, and after a few very early works, though not everything he turns out is a masterpiece, of course, by any means, very little of it sinks below a high standard. All of which makes him an unsatisfactory illustration of the dualism I have been trying to trace in Attic vase-painting. I am glad of this. It serves to emphasize that all these artists are individuals, and that none of the generalizations we make really apply in the same way to all of them. And what a splendid, what an ideal choice these characteristics make the Amasis Painter as the subject of a one-man show.

CAMBRIDGE

NOTES

1. Oinochoe, London B 524: *ABV* 154,47; *Amasis Painter* no. 37; M. Robertson, "A vignette by the Amasis Painter," *AK* 9 (1973) 81–84.

2. *Amasis Painter.*

3. On dating by kalos names, and Leagros in particular: E. Langlotz, *Zur Zeitbestimmung der Strengrotfigurigen Vasenmalerei und der gleichzeitigen Plastik* (Leipzig 1920). A different view: E.D. Francis and M. Vickers, "Leagros kalos," *Proceedings of the Cambridge Philological Society* 207 (1981) 97–136.

4. E.D. Francis and M. Vickers, *"Signa priscae artis:* Eretria and Siphnos," *JHS* 103 (1983) 49–67.

5. *Development* 58.

6. J.D. Beazley, "Groups of Mid-sixth-century Black-figure," *BSA* 32 (1934) pl. 8.

7. Swinger's neck-amphora: Boulogne 59; *ABV* 308,76; E. Böhr, *Der Schaukelmaler*, Kerameus, vol. 4 (Mainz 1982) 96, no. 110, pls. 112, 113a; calyx-krater discussed, ibid. 21. Antimenean calyx-kraters: *ABV* 275,134, 135; 280,56; 281,17–19; 284,10; 289,27. Exekian calyx-kraters: *ABV* 145,19; 148,9.

8. M. Robertson, "Beazley and Attic Vase-painting," in *Beazley and Oxford*, Oxford University Committee for Archaeology Monograph, no. 10 (Oxford 1985) 19–30.

9. M.J. Vickers, "Artful Crafts: The Influence of Metalwork On Athenian Painted Pottery," *JHS* 105 (1985) 108–128. Against: M. Robertson (supra, note 8). In *Rivista di Archeologia* 1 (1977) 19–22, A. Linfert offers a different interpretation of Euthymides' inscription, seeing it as referring to Euphronios' achievement not as a painter but as a participant in revels such as that shown in the picture. I am not sure which interpretation is correct, but if Linfert's is, then the remark does not bear the weight which is generally put upon it; though I feel that such references to one another scattered over their pots by painters of the Pioneer Group are not totally irrelevant in this con-

text. One may also note as evidence of personal pride in their work the *eu* or *kalos* appended to some *epoiesen* inscriptions on black-figure cups (*JHS* 92 [1972] 181 n. 5).

10. M. Robertson, "The Place of Vase-Painting In Greek Art," *BSA* 46 (1951) 151–159.

11. J.D. Beazley and B. Ashmole, *Greek Sculpture and Painting* (Cambridge 1932) 25.

12. Little-Masters: J.D. Beazley, "Little Master cups," *JHS* 52 (1932) 167–204; son of Eucheiros: ibid. 176. Kleophrades, son of Amasis: D. von Bothmer, "Amasis Amasidos," *GettyMusJ* 9 (1981) 1–4.

13. Beazley (supra, note 6) 3–4.

14. London B 210 (*ABV* 144,7) and B 209 (*ABV* 144,8): D. von Bothmer, *Amazons in Greek Art* (Oxford 1957) 70.2–3, pl. 51,1–2, and p. 73.

15. Tleson's satyrs (lip-cup, London B 410, *ABV* 181,3 above) like those on Nearchos' aryballos (New York 26.49, *ABV* 83,4): Beazley (supra, note 12) 196. Oakeshott Painter: *Paralipomena* 78. Three band-cups are there ascribed and perhaps a fragment of a lip-cup. Beazley had appreciated and illustrated no. 1 (New York 17.230.5) in *Development* 56, pls. 24, 25. I attributed a lip-cup with inside decoration only, Boston 69.1052, *ABFV* fig. 119.

16. The Heidelberg Group: J.D. Beazley, in "Amasea," *JHS* 51 (1931) 275–282; relation to Amasis Painter, ibid. 277. Heidelberg Painter (*ABV* 63–67): *Development* 50–52; relation to Amasis Painter: ibid. 50, 57.

17. C Painter (*ABV* 50–58), relation to Heidelberg Painter: *Development* 50.

Andrew F. Stewart

Narrative, Genre, and Realism in the Work of the Amasis Painter

I t is generally acknowledged that the narrative impulse is central to Archaic and Classical Greek art. A subject only rarely addressed between the publication of Carl Robert's *Archäologische Hermeneutik* in 1919 and the classic Chicago symposium of 1955,[1] it is now very much in vogue among classical archaeologists, following the lead of art historians, literary critics, and philosophers, too. It therefore seems particularly appropriate in this, the first celebration ever of a single Greek vase-painter's work, to consider him from this perspective, especially when his relationship to this central tradition is a matter of some debate. Was the Amasis Painter purely an entertainer, more interested in form than in content,[2] or are we somehow missing the point and thereby doing him a signal disservice?

First, some general remarks. In the 1955 symposium, G.M.A. Hanfmann suggested that the major Greek achievement in the field of narrative was to recognize the unity of action, to make the "plot" of a picture *eusynoptos,* as Aristotle would put it.[3] Himmelmann, Hemelrijk, Meyboom, and others have refined this concept somewhat, adopting the terms "synoptic" and "complementary" to describe this basic narrative technique.[4] One's preference for one term or the other depends upon whether one believes that the artist sought to distill the essence of an entire myth into one single scene or simply extracted one fundamental episode from it and then added clarifying elements from earlier and/or later parts of the story.

It has rightly been pointed out, first, that neither of these two terms is fully satisfactory, suggesting as they do a greater degree of temporal and episodic conflation than the picture usually warrants, and second, that to attempt to reconstruct the artist's thought processes in this way and at this distance in time is probably misconceived. Yet even so, the evidence of the art itself is clear. Greek painters and sculptors

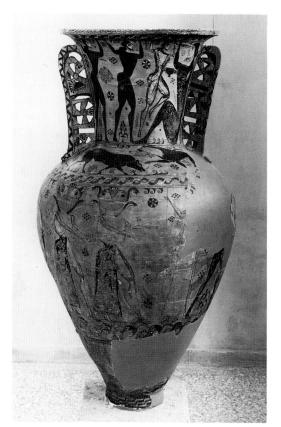

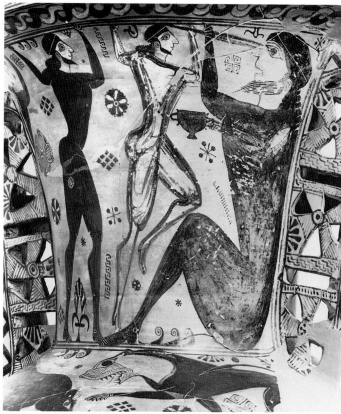

Fig. 1a. Polyphemos amphora. Side A: pursuit of Perseus. Eleusis, Museum, no accession number.

Fig. 1b. Polyphemos amphora. Side A: detail showing the blinding of Polyphemos. Eleusis, Museum, no accession number.

were concerned less with reproducing momentary action than with creating images that communicated a "plot" in a visually coherent way. In practice, this "plot" was not regarded "as a discursive series of happenings in the course of time but as one block-shaped unit," requiring for its realization in visual form "a single closely knit composition."[5] In, for example, the Polyphemos amphora from Eleusis (figs. 1a, b) or Myron's Diskobolos (fig. 2), this kind of "narrative pregnancy" was attained either by including elements borrowed from the past and/or future—such as Polyphemos' wine cup—or by selecting particularly expressive motifs or situations that evoked the passage of time without necessarily representing it in concrete form—such as the Diskobolos' quite fictitious *eremia,* or "momentary stop," between the back- and forward swings, which recalls the past while simultaneously announcing the future.[6]

Narrative time and narrative structure are of course complementary and inseparable, interlocking aspects of a single configurational whole. As Paul Ricoeur has argued in his recent book *Time and Narrative,* "time becomes human time to the extent that it is organized after the manner of a narrative; narrative, in turn, is meaningful to the extent that it portrays the features of temporal existence."[7] Alone among ancient peoples, it was the Archaic Greeks with their resolute anthropocentrism[8] who intuitively understood this fact and who eventually made it the cornerstone of their art. This is why an approach to Greek narrative in

Fig. 2. Myron, Diskobolos. Rome, Museo Nazionale Romano, 126371 (from H. Bulle, *Der Schöne Mensch im Altertum* [Munich 1922] pl. 97).

terms of Ricoeur's work, particularly his analysis of the two prime constituents of the narrational act—the threefold present and "emplotment"—is potentially so fruitful.

The thesis of the threefold present, derived ultimately from Saint Augustine, sees human experience of the transit of time as "distended" between attention to the present, memory of the past, and expectation of the future. Verbal narrative, being temporally linear, may engage these on a basis coextensive with the temporal experience of the listener or reader; pictorial narrative, normally confined to a simultaneously available field,[9] has an instantaneous impact upon the mind, but thereby distends it more sharply. Here, in particular, the very concordance of the intentions of expectation, attention, and memory begets fresh discordance in its turn.[10] The Polyphemos picture, with its helpful but naive and ultimately dislocating inclusion of the cup, illustrates the painter's dilemma to perfection.

It is to this discordance that the poetic or pictorial act of "emplotment" replies. The mimetic function of narrative, Ricoeur argues, involves at least three senses of the Aristotelian term *mimesis*: "a reference back to the familiar pre-understanding we have of the order of action; an entry into the realm of poetic [or here, pictorial] composition; and finally a new configuration by means of this poetic [/pictorial] refiguring of this pre-understood order of action."[11] The movement here is circular, a

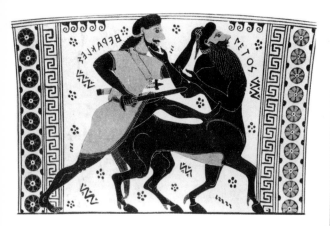

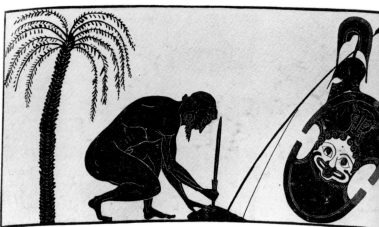

Fig. 3. Amphora by the Nettos Painter. Side A: detail showing Herakles killing Nessos. Athens, National Museum, 1002 (from E. Pfuhl, *Malerei und Zeichnung der Griechen* [Munich 1923] pl. 18.85).

Fig. 4. Amphora by Exekias. Side A, panel: detail showing the suicide of Ajax. Boulogne 558 (from E. Pfuhl, *Malerei und Zeichnung der Griechen* [Munich 1923] pl. 59.234).

"healthy circle" proceeding via the device of "emplotment" from the reader/observer to the narrative and then back to the observer again.

So, to return to the Polyphemos amphora, in the picture on the belly (fig. 1a) the painter introduces a dramatic *peripeteia,* disrupting the foregone conclusion of Perseus' capture and death at the Gorgons' hands by interpolating Athena as *dea ex machina.*[12] The naive conflation of successive stages in the story is gone, for in the goddess both the motivation of the whole affair and its successful outcome now intersect neatly. Just as it was she who prompted the exploit and gave Perseus the means to kill Medusa, so it is she who will soon receive the fruits of victory, the Gorgon's head, that will adorn her aegis with its petrifying stare. A generation later, the Nettos Painter similarly reconfigured the primal sequence of rape and revenge in his picture of Herakles and the ferryman Nessos[13] (fig. 3). Substituting a sword-thrust for an arrow from afar,[14] he created a pictorially compact plot with a definite "sense of an ending," to borrow a phrase from Frank Kermode.[15] For not only is Herakles now shown *about* to kill Nessos for attempting to rape Deianeira (here omitted), but Nessos in turn vainly supplicates *him.* This turns the tables on the avenger and presages the final tragedy to come. For as the viewer is expected to recall, the dying Nessos, his plea rejected, cunningly offered Deianeira his poisoned blood as a love philter, should she ever need one. Many years later, goaded by Herakles' adulterous passion for Iole, she used it, only to see it poison and kill her beloved Herakles in his turn.

In this picture, then, a vignette from the present implies not only a wider physical horizon, including Deianeira and the river, but a wider temporal one, too, involving both the immediate past and the far-distant future. In this way the particulars of the picture now both evoke and combine with this pre-understood narrative envelope, as one might call it, to form a single, indivisible unit, the pictorial equivalent of the term

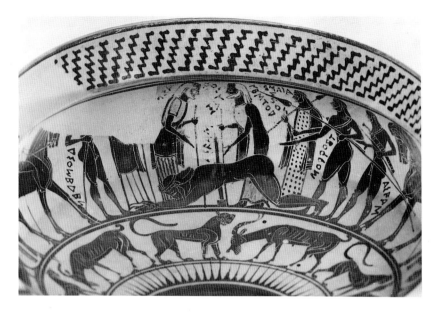

Fig. 5. Corinthian cup. Side A: detail showing the suicide of Ajax. Basel, Antikenmuseum.

syntagma as used by literary critics like Roland Barthes and Jonathan Culler.[16] Here, the syntagmatic structure of the reconfigured narrative is "grasped together" by the painter and in turn structures the observer's judgment and understanding.[17] Meanwhile, in all cases, as Ernst Gombrich has shown,[18] the painter pursues an ever more powerful and evocative naturalism in order to seduce the viewer with the illusion of reality, and so to enhance the truth-value of his image.

In black-figure painting it is Exekias who is the acknowledged master of this kind of narration, anticipating the Classic by two full generations. His supercharged scene of Ajax about to commit suicide not only invokes causes and consequences with a power and economy unattained by his predecessors[19] but incisively locates the epicenter of the action in the *ethos,* or character, of the hero himself,[20] as he grimly fixes his sword in the ground prior to impaling himself (fig. 4).

In contrast to earlier treatments of the theme, which show Ajax already spitted and dead (fig. 5), the narrative is now suspended about him. His own armor, no substitute for the armor of Achilles denied him by the chicanery of Odysseus, leans against the picture's edge. Meanwhile, as Jeffrey Hurwit has recognized, the wilting palm tree behind "droops low as if in mourning for the hero about to die"—a dramatic debut in art of the so-called pathetic fallacy so beloved by later Greek poetry.[21] Meanwhile, Ajax himself, his brow and cheek furrowed in doleful chagrin at his defeat, stares transfixedly at the blade that shortly will transfix him in its turn. His unflinching adherence to the heroic *ethos,* and the terrible price it will soon exact from him, now achieve a crystal clarity as he makes the inevitable choice between an honorable death and an ignoble life. For as Aristotle was later to remark, "*ethos* is that which reveals choice, shows what sort of thing a man chooses or avoids in circumstances where the choice is not obvious."[22] By this act of

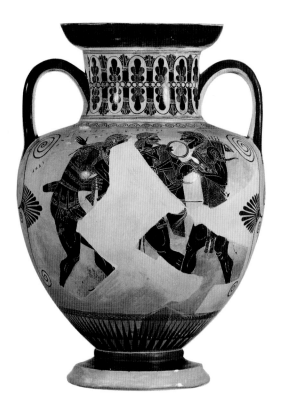

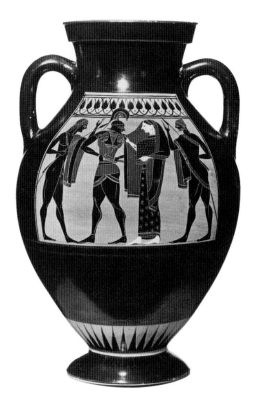

Fig. 6. Neck-amphora by the Amasis Painter. Side A: struggle for the tripod. Boston, Museum of Fine Arts, 01.8027, H.L. Pierce Fund.

Fig. 7. Panel-amphora by the Amasis Painter. Side A: recovery of Helen. Great Britain, private collection (once in Riehen, Dr. Heinz Hoek collection).

pictorial suspension, then, the observer is immediately engaged in puzzling out the interactions of character and situation as they address him via Ajax himself, in determining causes and projecting consequences. As the observer enters the world of the image, "emplotment" becomes as much his to make as the painter's; the circle of *mimesis* is closed, his emotions are fully engaged, and *katharsis* is under way.[23]

The Amasis Painter is often believed to stand somewhat apart from this central narrative tradition of the Archaic. There is, to be sure, some truth in this belief. Yet, although only twelve percent of his one hundred sixty-five multifigured scenes are mythological narratives proper, there is nothing incompetent or lackadaisical about them. He enjoys giving events an unexpected turn, as when Poseidon receives Herakles onto Olympos, or Hermes intervenes in the struggle for the tripod (fig. 6). He revels in presenting unusual scenes with extraordinary mimetic skill and panache, as in the Norbert Schimmel cup depicting (I take it) Poseidon's visit to the Greek camp in book 13 of the *Iliad*. He is attentive to the subtlest implications of an unfolding narrative, as in the two amphorae with the recovery of Helen: on the ex-Riehen vase, Menelaos has yet to draw his sword, and the bystanders (Greeks who have no doubt suffered long at Troy) emphatically urge him on (fig. 7); while on the Munich vase the weapon is drawn, and the chorus has fallen silent and now only points accusingly at the late-repenting adulteress (fig. 8).

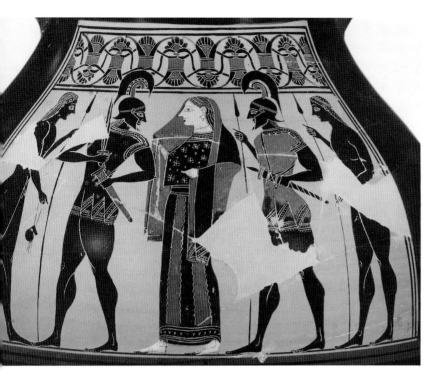

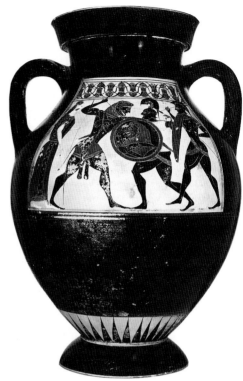

Finally, he can be acutely aware of the distention of narrative time: on an amphora in Paris a massive Herakles strides resolutely into battle as Kyknos runs up; Ares steps off to join them, raising his spear; and Athena, taken unawares, has not yet had time to respond (fig. 9). As the conflict escalates before his eyes, the observer is led to envision the eventual outcome, here implied with an incisive economy of means worthy of Exekias.[24]

Yet these mythological narratives, as I remarked earlier, constitute only a small minority of Amasean figure scenes. The remainder divide almost equally into two main classes: non-narrative or genre scenes that involve the gods, and those that do not. Being non-narrative and so essentially timeless, these exist in an eternal, undifferentiated present that, in contrast to the highly differentiated, humanized, indeed anthropocentric time of the mythological narratives, takes them (and us) "out of time" into an exemplary, emblematic world of ideal transactions and values.

To begin with those scenes involving the gods, sixty-two in all. A few divine assemblies apart, this class includes twenty-one pictures of Dionysos and his thiasos, and thirty-six appearances of gods and daimones (Dionysos included) alongside mortals. Of the Dionysiac scenes, justly the most famous appears on the Würzburg amphora,[25] where explicit reference to the eternal rhythm of the seasons reinforces

Fig. 8. Panel-amphora by the Amasis Painter. Side B, panel: recovery of Helen. Munich, Staatliche Antikensammlungen und Glyptothek, 1383. Photo C.H. Krüger-Moessner.

Fig. 9. Panel-amphora by the Amasis Painter. Side A: Kyknos. Paris, Musée du Louvre, F 36.

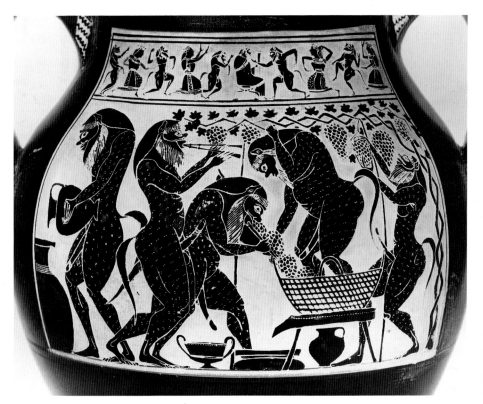

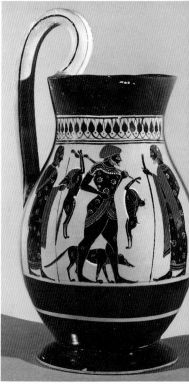

Fig. 10. Panel-amphora by the Amasis Painter. Side A, panel: satyrs vintaging. Würzburg, University, Martin von Wagner Museum, L 265. Photo K. Oehrlein.

Fig. 11. Olpe by the Amasis Painter. Front: hunter's return. London, British Museum, B 52.

the eternal present of the genre (fig. 10). As many commentators have realized, here and in the other three Amasean vases that depict the same theme, the keynote is realism.[26] Precise description of circumstantial detail allies with a step-by-step account of the process to create an extraordinarily compelling scene that is far more particular in its observation than most of the mythological pictures—a distinctly un-Gombrichian development. Like the subject itself, the apparently unprecedented "progressive" rendering of the action may or may not derive from Egypt;[27] what is clear, though, is that the scene has captured the painter's imagination as his mythological pictures rarely seem to have done, and that its temporal specificity and painstaking verisimilitude inaugurated a tradition that later would produce works such as the Foundry Painter's name piece and the Marathon painting—if the literary descriptions of the latter are reliable.[28]

A recent study of realism defines it as "a creative attention to the visible rather than the invisible, an unabating interest in the shapes and relations of the real world, the system that works. It is the view from below."[29] It is this view from below, Northrop Frye's "low mimetic mode,"[30] that occupies the Amasis Painter's attention in over two-thirds of all the pictures that he painted: I refer to those involving, either wholly or in part, ordinary mortals like ourselves.

The large number of pictures, thirty-six in all, showing gods and

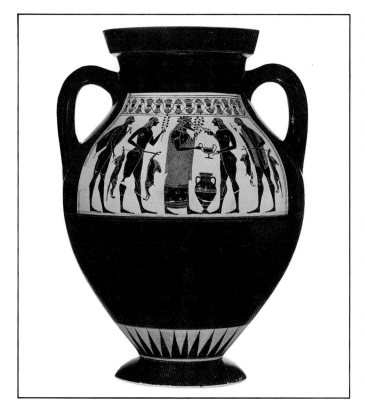

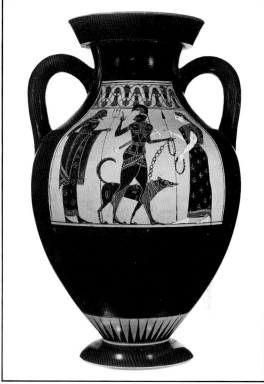

men together have taxed iconographers since the nineteenth century, provoking a variety of explanations, some rather farfetched. Encouraged by some remarks in the exhibition catalogue,[31] I would like to suggest that these are quite simply epiphanies, testimonies to the power of the gods in the world and to their continuing involvement with mortal affairs. These, I would argue, are no haphazard confections of divinities and men, nor are they mythological scenes of abstruse and unique import; rather, in all the vases I have examined, the choices seem carefully calculated, the selections appropriate and apt. Beazley lists two predecessors by the Amasis Painter's probable master, the Heidelberg Painter,[32] but here again the genre as such is essentially the Amasis Painter's creation.

Thus, while one young hunter returns with his kill to a very human reception committee (fig. 11), others are greeted by Dionysos himself (fig. 12), who will inaugurate their victory feast.[33] Sometimes he stays for the komos and encourages it with a gesture, though he remains careful not to compromise his own dignity and Olympian reserve.[34] Elsewhere, Poseidon sees a young hoplite off to war (overseas?) (fig. 13); Herakles introduces another to Hermes, no doubt to enlist him as protector and guide;[35] while on a third vase, a winged daimon whose identity has yet to be explained[36] superintends the departure of another warrior. Such daimones appear frequently in Amasean pictures: on his

Fig. 12. Panel-amphora by the Amasis Painter. Side A: hunters' return and Dionysos. Munich, Staatliche Antikensammlungen und Glyptothek, 8763. Photo C.H. Krüger-Moessner.

Fig. 13. Panel-amphora by the Amasis Painter. Side B: Poseidon, hoplite, and woman. Paris, Musée du Louvre, F 25.

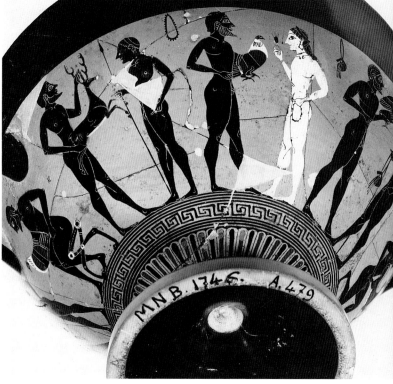

Fig. 14. Lekythos by the Amasis Painter. Front: wool working. New York, Metropolitan Museum of Art, 31.11.10, Fletcher Fund, 1931.

Fig. 15. Cup-skyphos by the Amasis Painter. Side B: love gifts. Paris, Musée du Louvre, A 479.

Madrid cup, for example, the implication is that the horses exercised by the young men are as swift as the daimones at center.[37] One recalls Achilles' horses, Xanthos and Balios, conceived of the harpy Podarge by the west wind, Zephyros, and themselves "swift as the winds in flight" (*Iliad* 16.149–150).

This sensitivity to the perennial and all-pervasive presence of the gods in human life is matched only by the painter's fascination with the particulars of everyday existence itself. Poseidon's stable on the Schimmel cup could be any Athenian riding school were it not for the homunculi that prance over the backs of the two left-hand horses;[38] while on the New York lekythoi the painter has given us the most detailed extant descriptions of a rural wedding, complete with mule-cart, and of the process of weighing, spinning, and weaving wool (fig. 14)—another "progressive" account, this, in the manner of the Würzburg amphora.[39] A cup-skyphos in Paris exhaustively catalogues the permutations of homosexual and heterosexual love gifts (singling out the naked hetairai by skin color and height) (fig. 15), and the earthier side of sex appears on the Boston cup, where two men masturbate as an eye-siren teases two defecating dogs under the handles.[40]

Here, as so often, the Amasis Painter's cheerful "view from below" is very far from the high mimetic, exquisitely timed, massively authoritative manner of Exekias. Yet, though for the most part the two indeed inhabited very different worlds, there is at least one common denominator between them. Both were equally appreciative of the power

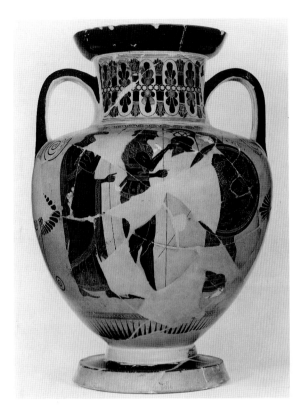

of minute description to render a vivid scene. Only on his two very late amphorae in Boston did the Amasis Painter seriously seek to enter Exekian territory proper, piling on circumstantial detail and clarifying inscriptions in a mannner that, in lesser hands, would certainly have threatened to overwhelm the whole (fig. 16).[41] That this did not occur is a tribute both to his technical control and to his ability to borrow without selling his soul in the process. As Beazley once noted,[42] it is in these vases that the Amasis Painter came closest to Euphronios and the Pioneers, themselves often Exekian in spirit; quite a conversion for one whose career had begun half a century earlier in the shadow of Kleitias, and whose interests had changed very little in the interim.

But perhaps we should not, after all, be too surprised. For a painter so flexible—able not only to make signal contributions to almost every genre in the repertoire but to pioneer a couple of new ones himself—for him such a foray into foreign territory can hardly have posed much of a problem. It is a pity that so much of these pictures is lost, especially that Phoenix's face has not survived, for to judge from its wrinkled forehead and receding hairline it was surely a powerful portrait indeed. Yet, to end on a happier note, so many vases have been added to the Amasean corpus in the last few years that one may be sure that this final phase in his career holds other surprises in store.

UNIVERSITY OF CALIFORNIA
BERKELEY

Fig. 16. Neck-amphora by the Amasis Painter. Side B: arming of Achilles. Boston, Museum of Fine Arts, 01.8027.

1. "Narration in Ancient Art: A Symposium," *AJA* 61 (1957) 43–91.

2. K. Schauenburg, "Neue Amphoren des Amasismalers," *JdI* 79 (1964) 109–141, esp. 119–120.

3. G.M.A. Hanfmann in "Narration in Ancient Art" (supra, note 1) 76, after Aristotle, *Ars Poetica* 7, 1451a4 and 23, 1459a33.

4. N. Himmelmann, *Erzählung und Figur in der archaischen Kunst* (Wiesbaden 1967); review, J.M. Hemelrijk, *Gnomon* 42 (1970) 166–171; P.G.P. Meyboom, "Some Observations on Narration in Greek Art," *Nederlands Institutet te Rome, Mededelingen* 40 (1978) 55–82 (prefers Carl Robert's term "complementary"); useful discussions also by A.M. Snodgrass, *Archaic Greece: The Age of Experiment* (London 1980) 190–191, and J.M. Hurwit, *The Art and Culture of Early Greece 1100–480 B.C.* (Ithaca, N.Y., 1985) index s.v. "narration."

5. Hemelrijk (supra, note 4) 167. Unequivocal examples of "snapshot" pictures are actually very rare in Greek art. A particularly striking one is the volute-krater in Palermo by the Niobid Painter, with its plethora of falling swords, bows, arrows, and quivers; *ARV*² 599,2; best photographs in P.E. Arias and M. Hirmer, *A Thousand Years of Greek Vase Painting*, translated and revised by B. Shefton (New York 1962) pls. 176–181.

6. Cf. M. Robertson, *A History of Greek Art* (Cambridge 1975) 27–28, 340–341, pls. 4b, 114a; best photographs of the vase in Arias and Hirmer (supra, note 5) pls. 12–13; E. Simon and M. Hirmer, *Die griechischen Vasen* (Munich 1976) pls. IV, 15; on *eremiai*, J.J. Pollitt, *Art and Experience in Classical Greece* (Cambridge 1972) 56–60.

7. P. Ricoeur, *Time and Narrative,* vol. 1 (Chicago 1984) 3.

8. See, most recently, R. Renehan, "The Greek Anthropocentric View of Man," *HSCP* 85 (1981) 239–260.

9. For this traditional view of the differences between the two arts, which originates with Lessing's *Laokoon,* see most recently M. Baxandall, *Patterns of Intention* (New Haven and London 1984) 3; important qualifications to the traditional view are proposed by W.J.T. Mitchell, *Iconology: Image, Text, Ideology* (Chicago 1986) esp. 95–115.

10. Cf. Ricoeur (supra, note 7) 21.

11. Ibid. xi.

12. The extant literary versions do not know of her in this role; cf., e.g., Ps.-Hesiod, *Shield of Herakles* 216–237; Apollodoros 2.4.2–3, etc.; *RE* s.v. "Perseus," cols. 984–985.

13. Robertson (supra, note 6) 55, pl. 4c; Arias and Hirmer (supra, note 5) pls. 19–20; Simon and Hirmer (supra, note 6) pls. 44–45; *ABV* 4,1; *Paralipomena* 2,6.

14. Sophokles, *Trachiniae* 555–588; Apollodoros 2.7.6; etc.

15. F. Kermode, *The Sense of an Ending* (New York 1968).

16. See, e.g., J. Culler, *Structuralist Poetics* (Ithaca, N.Y., 1975) 10–16, 32–54, etc. and the present author's essay, "Stesichoros and the François Vase," in W.G. Moon, ed., *Ancient Greek Art and Iconography* (Madison 1983) 53–74, esp. 67–68.

17. I owe this last insight to Joseph Leo Koerner, who introduced me to the "reception theory" of Robert Jauss; see now Ricoeur (supra, note 7) 77, and his *Time and Narrative,* vol. 3 (Chicago, forthcoming).

18. E. Gombrich, *Art and Illusion*, 2nd rev. ed. (New York 1961) 116–145.

19. Simon and Hirmer (supra, note 6) pl. 76; *ABV* 145,18; on the pictorial tradition see *LIMC* 1, pls. 245–250, nos. 104–136; cf. Simon and Hirmer pl. 28 for the new Corinthian cup.

20. On *ethos* and classical narrative see Pollitt (supra, note 6) 43–54 and idem, *The Ancient View of Greek Art* (New Haven and London 1974) 184–189; Robertson (supra, note 6) 263; A.F. Stewart, "Pindaric *dike* and the Temple of Zeus at Olympia," *Classical Antiquity* 2 (1983) 133–144.

21. J.M. Hurwit, "Palm Trees and the Pathetic Fallacy in Archaic Greek Poetry and Art," *Classical Journal* 77 (1981–1982) 193–200; attempted rebuttal and reply, *Classical Journal* 78 (1982–1983) 193–201.

22. *Poetics* 6.23, 1450b 10–12.

23. Ricoeur (supra, note 7) 70–77.

24. *ABV* 150–158,29, 27; *Paralipomena* 67, 65; *ABV* 7, 6; *Amasis Painter* nos. 27, 25, 60, fig. 43a, nos. 14, 5. As will be evident, concerning Poseidon I cannot follow the iconoclasm of P. Bérard, "Iconographie-Iconologie-Iconologique," *Etudes de Lettres. Revue de la Faculté des lettres de l'Université de Lausanne* 4.6 (1983) 5–37, esp. 18–19.

25. *ABV* 151,22; *Paralipomena* 63; Arias and Hirmer (supra, note 5) pl. 55; Simon and Hirmer (supra, note 6) pl. 68; *Amasis Painter* no. 19.

26. So, most recently, B.A. Sparkes, "Treading the Grapes," *Bulletin Antieke Beschaving* 51 (1976) 47–64, esp. 49–50; for the other vases see *Paralipomena* 65 (Basel and Kavalla) with *Amasis Painter* figs. 40, 70, and 71.

27. Cf. Sparkes (supra, note 26) 49 n. 13, and J. Boardman, "The Amasis Painter," *JHS* 78 (1958) 1–3 on the potter/painter's (?) name; contra, *Amasis Painter* 38.

28. Foundry cup, Berlin 2294: *ARV²* 400,1; *Paralipomena* 370,1; Robertson (supra, note 6) 183–184, pl. 59; Simon and Hirmer (supra, note 6) pl. 158; see esp. C.C. Mattusch, "The Berlin Foundry Cup," *AJA* 84 (1980) 435–444. Marathon painting: see esp. E.B. Harrison, "The South Frieze of the Nike Temple and the Marathon Painting in the Painted Stoa," *AJA* 76 (1972) 353–378; cf., e.g., the Caeretan hydria with sacrifices in the Villa Giulia, *La Cité des images* fig. 74.

29. J.P. Stern, *On Realism* (London and Boston 1973) 171.

30. N. Frye, *Anatomy of Criticism* (Princeton 1957) 33–67.

31. *Amasis Painter* 46–47. Martha Hollander draws my attention to a similar problem, similarly solved, in the works of Rembrandt: J. Bialostocki, "Ikonographische Forschungen zu Rembrandts Werk," *Münchener Jahrbuch* 8 (1957) 195–210.

32. *ABV* 63,5–6 (Heidelberg Painter): "Dionysos met by youths and men," "Dionysos seated, with men and women."

33. *ABV* 153,31; *Paralipomena* 65 (Munich); *Amasis Painter* nos. 26 and 4; see esp. A. Schnapp in *La Cité des images* 71–74.

34. E.g., *ABV* 150,6; *Amasis Painter* no. 5; cf. C. Bérard and C. Bron in *La Cité des images* 126–128.

35. *ABV* 150,4, 10; *Paralipomena* 62–63; *Amasis Painter* no. 12; contra, Bérard (supra, note 24) 18.

36. *ABV* 150,5; *Amasis Painter* no. 11.

37. *Amasis Painter* fig. 108.

38. *Paralipomena* 67; Simon and Hirmer (supra, note 6) pls. 70–71; *Amasis Painter* no. 60.

39. *ABV* 154,57; *Paralipomena* 66; *Amasis Painter* nos. 47, 48.

40. *ABV* 156,80, 157,86; *Amasis Painter* nos. 54, 61; on the love gifts, A. Schnapp in *La Cité des images* 75.

41. *ABV* 152,26–27; *Paralipomena* 63; *Amasis Painter* nos. 24, 25.

42. *Development* 58; cf. *Amasis Painter* 52–53.

Walter Burkert

The Making of Homer
in the Sixth Century b.c.:
Rhapsodes versus Stesichoros

The unique position of Homer in Greek civilization is so firmly established that we sometimes forget to wonder about it and to realize that it is in itself a unique phenomenon. Even the role of Shakespeare for the English is not closely analogous. One might be tempted to call Homer the Bible or the Koran of the Greeks, which brings out the basic difference that Homer is not, and never was, a religious revelation demanding submission and worship, but rather literature that invited, and still invites, literary criticism, although he was to form the model and common reference point for the Greek mind. This phenomenon is strange in several respects: there is a strangeness of quality, of age, and of acceptance. I am not going to praise the quality of the *Iliad* and the *Odyssey* here, though I think they are better poems than any considerations of probability would suggest; nor shall I dwell on the fact that these compositions apparently come right at the beginning of Greek literacy and are a monumental achievement, rather than the first and uncertain steps one would expect. Hardly less surprising is the success of Homer among the Greeks, a dashing and lasting success that is not a necessary or natural consequence of either age or quality; age is liable to go out of fashion, and quality is always debatable. Thus it is not enough to state or to postulate that there was one genius, or possibly two, who created these superb pieces of art, the *Iliad* and the *Odyssey*. An equally monumental problem is how the public was made to accept these texts as standard, in combination with a single author's name, *Homeros*, to the exclusion of other, similar texts that fell into neglect and were thus lost to posterity.[1] It is not the question of production but of "reception" that will be the focus here.[2] In other words, I shall not deal with the Homeric question in the traditional sense, i.e., when and through what contributions, alterations, intermediate stages, and manipulations the texts we read came into

existence. (I, for one, imagine the first written *Iliad* as a set of leather scrolls in the first half of the seventh century, emerging from an oral tradition that had been flourishing mainly in the eighth.[3]) The question will rather be: How did it happen that these texts were singled out with the name of *Homeros* attached to them, and were given absolute authority? This evidently was the first making of a classic in Greek literature, and it seems mainly to have been a process of the second half of the sixth century B.C.

To begin by working backward. The special authority of Homer, i.e., basically the *Iliad* and the *Odyssey* bound to this author's name, was well established by the fifth century B.C. "Godly Homer," θεῖος Ὅμηρος, a formula in Homeric meter, resounds from Aristophanes' *Frogs* (1034), where it gives the impression of being familiar to the audience; it also recurs several times in the *Certamen* of Hesiod and Homer.[4] Herodotos has repeated references to Homer, some of which have become famous. He discusses Homer's age and the attribution to him of *Kypria* and *Epigonoi*, which is contested; and he uses Homer's art of storytelling as a model—a striking case is the introduction of a baneful dream that prompts Xerxes to war, as the οὖλος ὄνειρος did Agamemnon.[5] The text of the Derveni papyrus, the author of which I guess might have been Stesimbrotos of Thasos,[6] writing about 420 B.C., shows Homeric philology surprisingly well developed, with a discussion of single forms and meanings and quotations readily assembled. Earlier, possibly toward the middle of the century, Protagoras had made the pun that Homer used the imperative in prayer where he should have used the optative;[7] this has its full effect only if it refers to the very first line of the classical author: μῆνιν ἄειδε θεά. We reach the first half of the fifth century with the inscription on one of the herms of the stoa of herms in Athens, attributed to the epoch of Kimon: it explicitly refers to the praise Homer spent on Menestheus, king of Athens, as being "the best to arrange horses and shield-bearing men" (Plut., *Kimon* 7.6). References to Athenians in the *Iliad* are sparse, to put it mildly; to pick out this line and to commemorate it in public is indicative of a feeling that Athens simply could not do without Homer.[8] Aischylos is credited with the saying that his tragedies were just "slices cut from the great meals of Homer."[9] Anecdotes of this kind cannot be trusted, but the metaphor is original: amid the competition that characterized Greek poetry, it shows deference to the unique classic of the past. For Pindar, too, Homer was a classic suited for ready quotation: "This too is a word of Homer . . .," he says in the *Fourth Pythian* (277),[10] and he alludes to the epithet of θεῖος Ὅμηρος, in the *Fourth Isthmian* (55–57).

We get to the transition from the sixth century to the fifth with Herakleitos and Xenophanes, whose grim criticisms of Homer are an indirect tribute to his special status within the Greek world. Herakleitos also produces the oldest testimony to the Homeric legend, referring to the riddle of the lice that killed Homer at Ios.[11] Somewhat older, because he, too, was criticized by Herakleitos, is Xenophanes,[12] whose moral, theological, and epistemological criticism of the gods of Homer and Hesiod has remained famous; it was not even earnestly contradicted in

antiquity. But if Xenophanes wished to replace the "fictions of the ancients" with more sensible poetry, he was fighting in vain. A famous fragment of his says: "From the beginning following Homer, because they all have learned . . ."; this is an incomplete sentence (B 10) that leaves open exactly what people learned and what they did in consequence; it nevertheless remains the earliest and most comprehensive statement of the authority of Homer as *praeceptor Graeciae*.[13] It bears testimony to a success already established.

Beyond the date of Xenophanes, the picture becomes blurred; only fragments of literature survive, which present their own problems of interpretation. Much depends on whether the fragment of an elegy which quotes the lines about the race of men being like leaves of a tree is to be attributed to Semonides in the seventh century or to Simonides at the end of the sixth century B.C.; the text says these are the most beautiful lines by the man of Chios.[14] I am inclined to side with Martin West against the earlier *communis opinio* and attribute the fragment to Simonides. Simonides also refers to "Homer and Stesichoros," who "sang to the people" about a detail of Meleagros' role at the funeral of Pelias (564 Page), an incident not to be found in our Homer. There remains what seems to be the oldest and most isolated testimony for the name of Homer: in the first half of the seventh century Kallinos attributed the *Thebais* to Homer.[15]

Herodotos has an interesting and much debated story about Kleisthenes, tyrant of Sikyon about 570 B.C. He put an end to the contests of rhapsodes in the city because the epic of Homer was always in praise of Argos and the Argives and, curtailing the cult of Adrastos, he transferred "tragic choruses" to Dionysos.[16] Adrastos would again point to the *Thebaid*. This seems to be the first testimony as to "rhapsodes," if we can be sure that the terminology had not been modernized by Herodotos or some intermediate source. There are, in addition, stories about the authority of Homer having been used in arbitration of political conflicts in the sixth century: Herodotos, in a passage with uncommonly garbled chronological problems, says the Athenians claimed possession of Sigeion at the Hellespont against the Lesbians because of their participation in the Trojan War, as attested by Homer (5.94, cf. Arist., *Rhet.* 1370b30).[17] It is true that the Aeolian and Ionian colonization, and hence Aeolian Lesbians, are conspicuously absent from the *Iliad*, but more could be made of the role of Demophon and Akamas, sons of Theseus, in the *Little Iliad* and the *Iliupersis*. Another case was the quarrel about whether Aias and Salamis belonged to Megara or Athens. In this case, the very passage in the *Iliad* on which the Athenian claim was based, B 558, was impugned by the adversaries as an interpolation by either Peisistratos or Solon. This shows a certain autonomy of the literary feud; it can be traced back to Dieuchidas in the fourth century, but not necessarily beyond that date.[18]

In all these cases we are dealing with later accounts; there always remains the problem of how much remodeling of the tradition has occurred since the sixth century, and what exactly was done, said, or believed then. The name of Homer is presumed to have been around, but it

was not necessarily our *Iliad* that was at the center of interest. The same is true for the epic tradition in various transformations in the poetry of Sappho and Alkaios: there are Hektor and Andromache, the model couple from book 6 of the *Iliad*, or Thetis emerging from the sea to listen to her son, from book 1; but the wedding of Peleus from the *Kypria*, or the *Iliupersis* with Ajax and Kassandra, are hardly less important.[19] Even for Pindar, Achilles' fights with Kyknos and Memnon, from the *Kypria* and the *Aithiopis,* respectively, are on equal footing with the Hektor theme, and for him the tragedy of Ajax is testified to by Homer.[20]

There is another, and in fact much richer, corpus that tells us about the themes of epic poetry in the seventh and sixth centuries: Greek art, which is characterized by the development of epic iconography, or *Sagenbilder,* in this very period. It has been more than fifty years since the book of Friis Johansen on the *Iliad* and early Greek art first appeared; much new evidence has come to light since then, and new controversies have arisen.[21] These cannot be explored in any depth by a philologist, and least of all would I embark on the problem of stylistic affinities between Homer or stages of Homeric poetry and the development of Greek Archaic art, as has notably been done in repeated attempts by Karl Schefold.[22] Fascinating as these studies are, it will be uncommonly difficult to reach agreement in such a field. I shall try to confine myself to some rather simple and obvious remarks.

As soon as Greek art begins to illustrate myth, about 700 B.C., it shows familiarity with Trojan themes, though other themes, such as Herakles and Perseus and the Gorgons, are also important. The earliest incontrovertible Trojan theme seems to be a wheeled Trojan horse on a Boeotian fibula.[23] A climax is attained with the amphora from Mykonos, which has the great tableau of an Iliupersis: the wooden horse with the warriors looking out, the infanticide, and Menelaos threatening Helen. These details, however, are neither in the *Iliad* nor in the *Odyssey.*[24] For compensation we have the famous illustrations of the Kyklops story, as contained in book 9 of the *Odyssey*, which appear in Argive, Attic, and Euboean vase-painting.[25] Yet this episode is, in contrast to, say, Nausikaa or Eumaeus, a special case, a widespread type of folktale which, even if it were ultimately dependent on some *Odyssey*, owed its success to its intrinsic structure and dynamics, and not to special poetical skill. Thus we cannot be at all sure which form of an *Odyssey* was known to the artists in the first half of the seventh century. One early iconographic type depicts two women standing behind two fighting heroes; among epic themes this composition uniquely fits the duel of Achilles and Memnon, assisted by their divine mothers, Thetis and Eos, respectively.[26] An attractive theory of "neoanalysis" postulates that this is an earlier tale and in some respects the model of the *menis* tale that forms the plot of our *Iliad*; the importance of Memnon for Pindar has already been mentioned. Other Trojan subjects prominent in seventh-century art are the Judgment of Paris and the Pursuit of Troilos by Achilles.[27]

All this points to the conclusion that it was not the unique text of the *Iliad* as the one great classic that made its impression on seventh-century art, but a more variegated complex of Trojan themes. This may

be taken together with what is indicated by the literary testimonia but for the fact that Herakles is nearly absent from what we know about literature of the period, and Theban themes are absent from early iconography.[28] The parallelism of art and literature cannot be pressed. As to the special plot of the *Iliad*, there still seems to be just one monument of the seventh century, the Euphorbos plate with its inscriptions that identify a scene from book 17 of the *Iliad*. Euphorbos appears only to serve the narrative needs in the scene of Patroklos' death: he is doubling as himself and Apollo and at the same time he is mirroring Paris' role at the death of Achilles. The painter of the Euphorbos plate presumed his clients to be familiar with this story in considerable detail, though close scrutiny has revealed divergences from the version contained in our *Iliad*.[29] I feel sure the vase-painter had not read about this in a book, but more or less exactly remembered what he had heard.

By about 580/570, however, the whole of the *Iliad* appears to have been widely known, including those parts that are labeled later additions by the analysts: Phoinix, Dolon, *Patroklos Athla* of Sophilos, and the Ransom of Hektor. Even the last book of the *Odyssey* seems to have been around.[30] Athenians showed interest in Menestheus (cf. note 8). This did not encroach on the popularity of the *Kypria*[31] and other *Troika*. Some decades later, among the works of the Amasis Painter, there is the cup from the Norbert Schimmel collection, which has Poseidon urging the two Ajaxes and Teukros to battle, a scene from book 13 of the *Iliad*; this cup is dated to 540/530 by the specialists. It was Friis Johansen's finding that the true efflorescence of *Iliad* scenes in Attic vase-painting was only reached by about 520 B.C.,[32] and this is largely still accepted. He did not know the magnificent Euphronios krater now in the Metropolitan Museum in New York, which takes its inspiration from book 16 of the *Iliad*: Zeus weeping tears of blood at the impending death of Sarpedon and ordering Sleep and Death to take care of the body. With Euphronios we come close to the epoch of Xenophanes. Whether all this was "Homer" to the artists, they chose not to tell us.

It remains to take account of the picture of epic poetry and poets as contained in the Homeric texts themselves.[33] The direct evidence comes mainly from the *Odyssey*: two epic singers, Phemios at Ithaca and blind Demodokos among the Phaeacians, are introduced in this poem and described with an affectionate care that makes one think of a self-portrait of the composer; Phemios is spared, of course, by Odysseus. Both singers have telling names—Phemios Terpsiades, the "narrative tradition that is meant to please," and Demodokos, "accepted by the public." These are singers in the full sense, accompanying their song on a string instrument, the *phorminx*. They normally perform in the hall of the king after meals, as an ornament to the feast, although Demodokos also sings in the agora (*Od.* 8.254ff.) at the public festival given in honor of Odysseus. Phaeacian civilization has several traits more modern than the normal Homeric setting.

The subject of the singer's song in the largest sense is κλέα ἀν-δρῶν, the glorious deeds of men. In practice this means the Trojan cycle, for Phemios as well as for Demodokos: Phemios sings the Return of the

Achaioi, and Demodokos the Quarrel of Odysseus and Achilles and the Wooden Horse. The second Nekyia contrasts, from a vantage point in the beyond, the song of Achilles, the song of Klytaimnestra, and the song of Penelope, i.e., *Achilleis* or *Iliad, Achaion Kathodos,* and the author's own *Odyssey.*[34] The audience is supposed to be familiar with the outlines of the tales, but the singer must find his special way in each case; part of his skill is to choose the point of departure—from where to start the story, ἀμόθεν. Phemios even claims to be αὐτοδίδακτος, "self-taught," for a god has given him various modes of song; this sets him apart not from divine inspiration but from merely reproductive performance of epic song.[35] That such a distinction should have been emerging is of great interest. Normally, the *aoidos* as portrayed by Homer is a creative and a traditional singer at the same time, moving within an accepted frame of traditional themes but generating his text afresh for each performance in the formulaic technique, as was discovered by Milman Parry.[36] The themes are known to singer and audience by catchwords such as "the wooden horse"; but there are no fixed texts, and there is no author's name. The interest of a naive audience would have concentrated on the contents of the tale, a world of fancy believed to be basically "true"; the singer or author is an obstacle to the imagination. In fact the problem of the individual author seems to be nonexistent in pre-Greek or non-Greek literature: there is no author for *Gilgamesh,* for instance. Pre-Greek tradition and the analysis of the Greek formulaic style thus combine to encourage the statement that Homer does not presuppose Homer in the sense of the individual creative author of a fixed and potentially classical text.

Conditions had changed in a remarkable way by the end of the sixth century. At the time of Xenophanes, apparently the challenge was no longer to "sing the Wooden Horse," or even "the Menis of Achilles," but to "recite a passage of Homer." What had happened was that rhapsodes had replaced singers, *aoidoi,* a momentous change indeed. Creative improvisation had given way to the reproduction of a fixed text, learned by heart and available also in book form. The wrong etymology of the word *rhapsodos*—from ῥάβδος, "staff"—which is already used by Pindar (I.4.38), bears witness to their custom, also identifiable in vase-paintings since the beginning of the fifth century: rhapsodes no longer used a *phorminx* for accompaniment, but the same staff as a speaker in the assembly; they did not sing, but recited. This is borne out by the word formation, correctly understood: in contrast to κιθαρῳδός, αὐλῳδός, τραγῳδός, κωμῳδός, who are "singers" in connection with lyre, flute, goat, or revel, ῥαψῳδός is of the τερψίμβροτος type, rephrasing ῥάπτειν ῳδήν, "to sew a song," an external preexisting object. The designation may have been a joke originally, but it hit at some peculiarity.[37] The rhapsode was not a singer in the full sense. For further distinction, rhapsodes are not normally described as performing at the banquets of nobles in a closed hall, but at public festivals in the form of well-organized *agones.* This is presupposed and thus documented by Herakleitos' acid remark that Homer deserved to be thrown out of the *agones* and to be flogged (B 42). This was a most momentous change: rhapsodes did not

claim to produce texts of their own in public performance, but were bound to the name of one author of the past, Homer.

Let us move carefully, since there has been much controversy on "Homer" and the "Homerids." Detailed, if somewhat ironical, pictures of rhapsodes are given by Plato and Xenophon;[38] Ion especially, in Plato's dialogue, is ridiculed for his comprehensive and absurd claims as to the all-round excellence and omniscience of his patron, Homer. It is clear that this name is the trademark on which the rhapsodes were professionally dependent; no wonder they were engaged in Homeric propaganda. We are taken back to the beginning of the fifth century with Pindar: for him the connection between rhapsodes and Homer was already established beyond question. He makes Homer himself a rhapsode, "singing to the staff," and he introduces *Homeridai* as ῥαπτῶν ἐπέων ἀοιδοί, "singers of sewn verses."[39] Herakleitos adds the reference to *agones.*[40]

To sum up the facts: rhapsodes, reciting "Homer," appeared in public contests by the last third of the sixth century—possibly earlier— but they were unknown to Homer. There remains the problem of what exactly the term *Homeridai*, used by Pindar, means. Akusilaos, a contemporary of Pindar, says this was a family from Chios. In spite of Detlef Fehling's criticism, I think it is most economical to combine Pindar and Akusilaos and to conclude that for a while a family from Chios— organized in a form comparable to the Asklepiads from Kos, the family of doctors—was organizing the recitation of Homer as their special craft,[41] referring to the text of the epics as their hereditary possession. The *Kreophyleioi* from Samos, who appear in the Pythagoras tradition, are a parallel from the same period, whose patrimony is the epic about Herakles and Oichalia.[42]

Modern studies of early Greek literature have rightly insisted on the close connection between production and performance in poetry.[43] Still rooted in an oral culture, the poem existed for and through the performance; the literary *genera* in fact reflect different conditions of performance. This is true for the epic singer as portrayed in the *Odyssey*, and it holds for the singers of *Iamboi* and elegies, of monodic lyrics and of choral odes, and even for tragedy and comedy. But it does not apply to rhapsodes; or rather, in terms of performance there was a break between Homeric *aoidoi* and rhapsodes. Here, and here alone, we find a separation of production and performance, by the last third of the sixth century at the latest, which seems curiously deviant in the lively field of Greek poetic productions. In Thukydidean terms, *ktema* has been dissociated from *agonisma.* A frozen classic has appeared in the background, a fixed text, a set of books no doubt, even if it was possible to memorize the whole. This is the making of Homer in the sixth century, possibly due to *Homeridai* of Chios.

This much is certain for simple practical reasons, though it is not always acknowledged: there never could be a question of reciting the complete text of the *Iliad* at a rhapsodic contest.[44] To recite the whole of the *Iliad* alone, not to mention the *Odyssey* and all the other works still attributed to Homer, would take thirty to forty hours, more than the time available for all the tragedies and comedies at the Great Dionysia,

which clearly was the more important literary event in Athens. Homerids could only produce selections from the huge thesaurus that remained in the background. It is here that the well-known testimony of the Platonic *Hipparchos* comes in (228b): Hipparchos, son of Peisistratos, "was the first to bring the Homeric epics into this country [i.e., to Athens] and forced the rhapsodes at the Panathenaia to go through them in due order, one taking the cue from the other, as they still do today." The separation of production and performance is expressly stated here: rhapsodes are "going through" a preexisting text, which has been "brought" and which is used to control what they are doing. The author of the text, of course, is Homer. It is not implied in this "Panathenaic law" that the whole of Homer had to be gone through; the regulation evidently was just meant to ensure that Hektor's Death came after Hektor and Andromache and not vice versa. The festal occasion for the *agon* was the Panathenaia—the Great Panathenaia which the Athenians strove to bring to Panhellenic importance in the sixth century. A parallel text in Diogenes Laertius gives the name of Solon instead of Hipparchos as author of the "law" about the due order of recitation. Probably, the name of the lawgiver has ousted the name of the tyrant.[45] The name of Hipparchos gives a date roughly between 530 and 514, the year of his assassination. Friis Johansen thought the evidence from Athenian vase-painting confirmed the Hipparchean date.

It may appear that with the name of Peisistratos and the Panathenaic recitation we are drawn back into the maelstrom of Homeric controversies. It has been about a hundred years since Wilamowitz' *Homerische Untersuchungen* appeared, and 190 years since Wolf's *Prolegomena*, and we cannot claim to have any new foundations for decisive progress.[46] I shall not discuss these problems. What I shall try to do—and what has not always been done—is to call attention to the interplay of the different *genera* of early Greek literature, especially of epic and choral lyric, keeping in mind that these were competing forms of performance that should be seen in relation to the intended public. It is in this context that we can hail a remarkable discovery that is less than twenty years old: the reappearance of Stesichoros. I vividly recall the surprise when this happened in 1967. There was first the impact of the metrical reconstruction of the *Geryoneis* by W. S. Barrett and D. L. Page; fragments from an *Iliupersis* and a Wooden Horse and from a *Thebais* have followed suit.[47] Part of the surprise was the sheer size of the *Geryoneis* as it emerged from a stichometric sign and Barrett's calculations: more than thirteen hundred lines, i.e., about the length of an Attic tragedy. Equally surprising was the amount of Homerizing style, particularly in a poem dealing with a monster. Geryoneus the "roarer," master of animals, with three heads to be killed three times, turns out to be a hero of human, nay Homeric, dimensions. As he takes the word to speak to his divine mother or to his comrade, the dialogues can be reconstructed from unpromising scraps because they transcribe nearly verbatim well-known passages of the *Iliad*: "If I ever presented you my breast," Kallirhoe says to Geryoneus, as Hekabe says to Hektor. The syllogism of practical heroism is also copied: "If we could be immortal, not even I would go to battle; but since we

have to die anyhow, well, let us see. . . ."[48] Another fragment that had become known earlier, apparently from Stesichoros' *Nostoi* (209 Page), reproduces almost word for word a crucial scene from the *Odyssey*: Telemachos taking leave of Helen and Menelaos at Sparta.[49] In this passage the Telemachy and the main narrative of the *Odyssey* are woven together in such a way that the seams show, but Stesichoros evidently knew exactly the Homeric text that we read. Stesichoros has thus become the clearest *terminus ante quem* for the text of Homer as we know it.

There is not much evidence for securely dating Stesichoros. The testimony of Simonides groups him with Homer as an authority for the mythic-epic tradition; chronographers hence place his death in 556, when Simonides was born, and this cannot be too far off the mark: after Alkman but before Ibykos and well before Simonides. The influence of Stesichoros on figurative art that has been assumed, in particular for the reliefs of Foce del Sele and for some Chalcidian amphorae, would agree well with this.[50]

But it is less the individuality of a poet that matters in our context than the rediscovery of a special *genos* of Archaic Greek poetry—the big mythic-epic narrative in lyrical form. According to what has been said, this means the development of a special form of performance in the first half of the sixth century B.C. It is wrong to censure Stesichoros for lack of originality and slavish dependence on the Homeric epics if his real aim and achievement was to readapt these to new forms of production. Unfortunately, it is precisely the form of performance which has become controversial: Martin West and Bruno Gentili, not negligible experts, have voted for kitharodic performance, one singer accompanying his song on the lyre.[51] Yet the triadic structure routinely used in the Stesichorean poems—*strophe, antistrophos, epodos*—is a strong argument for choral production: we are told, and it makes sense, that this triadic structure had its functional origin in the dance.[52] Kitharody, by contrast, could even do without strophic response. The argument to follow favors choral presentation, but it is not wholly dependent upon this hypothesis.

There is one feature of Stesichorean poetry which contrasts with what we find in Alkman and Ibykos as in Pindar and Bakchylides: there is no overt reference to a specific place, person, or audience, no Hagesichora at Sparta, Polykrates at Samos, or Hieron at Syracuse.[53] This means that these compositions could be performed everywhere in the Greek world without change, and they obviously were designed for this purpose. It is a Panhellenic fantasy world of heroic myth that forms the contents of these poems, mentioning certain landscapes or families—an artistic whole in itself and thus acceptable and interesting in all places. Its counterpart in society must have been traveling professionals who presented these songs in various places.

Stesichoros himself is said to have come from Sicily; his activities are connected with Southern Italy as well as with Sparta, which must have inspired the notorious Helen Palinody; but he did not hold a local appointment, as Alkman had at Sparta. If these were choral performances, we must imagine traveling groups of *technitai* appearing wher-

ever a public festival presented the occasion for a production.[54] It was outdoor singing that fit a chorus, in contrast to the domestic scene for kitharodic *skolia* and other symposiac poetry, and for earlier epic. With the full development of *polis* communities, even music and art moved from the *oikos* of the nobles to the agora. *Mousikoi agones* were organized in the wake of the earlier athletic contests. The reorganization of the Pythian Games in 582 must have been an important event in this respect. This was the epoch of Stesichoros.

We have at least one piece of testimony that professional foreign musicians performed in Athens in the sixth century: the "Old Oligarch"—i.e., Ps.-Xenophon, *Athenaion Politeia*—states that "the *demos* has abolished here [sc. at Athens] those who performed sports and music. They decreed this was not honorable, because (in reality) they knew (but too well) that they could not do this (themselves)." They established choregies and gymnasiarchies instead to make the rich pay for the mob, and thus "the *demos* thinks it proper to get money for singing, running, and dancing."[55] Stripped of its polemical overtones, this remains an interesting account of musical events before the democratic revolutions. In fact we know that the production of dithyrambs was reorganized in 508 to represent all the ten Kleisthenian *phylai* in the performance,[56] and we also know that only Athenian citizens formed the choruses of tragedy. The "Old Oligarch" was looking back at an earlier period when alien professionals showed their expertise—choruses of professionals, I would suppose. This would seem to coincide with the period of Stesichoros' activities; it also raises interesting questions as to the chorus of Thespis.[57]

If this picture of Stesichorean choruses traveling through Greece to perform in their new style at *polis* festivals must remain hypothetical to some extent, this much is clear from the texts: the new *genos*, style, and performance were meant to replace the old epic song. There are the same narratives about Thebes and Troy, Odysseus and Agamemnon; epic style with all its antiquated words and formulae is freely adapted; and even the heroic timber, the stance of facing death with dignity, is taken over. At the same time there is an effervescence of ornamental diction in more variable metrical forms, and a more emotional, even larmoyant appeal; music, and possibly dancing, must have made quite a contrast to the more austere epic singers. As to content, the restrictions of epic realism are discarded as well; there is room for monsters and for miracles, the cup of Helios and the Erinyes pursuing Orestes. All these effects would have combined to make the traditional singer of tales look rather jejune and antiquated. What was most precarious in face of the new rivals was the art of improvisation of the creative-traditional *aoidos*. In the Stesichorean enterprise, especially if these were choruses, premeditation and training were everything; the result was to sweep the lonely singer from the marketplace. Stesichorean production must have been a success, at least for a while. At Sikyon, Kleisthenes abolished epic for the benefit of "tragic choruses."[58] The dependence of Aischylos on Stesichoros is a telling fact, as is the verse of Simonides that puts Stesichoros side by side with Homer (564 Page).

Yet Stesichorean style, or rather Stesichorean performance, was

not to last. If it had tried to outdo the epic singers by pushing forth the elements of music, of emotion, of fantasy, and probably the multiple voices of a chorus, the answer of epic was reduction to the essentials of a narrative text: rhapsodic recitation. This meant abandoning the element of music and the element of improvisation in favor of a fixed text that would stand through the contests. In other words, it is the Stesichorean transposition of mythic-epic narrative to some form of oratorium that explains the gap between the old epic singers and the rhapsodes of the sixth century. It is as a reaction to Stesichorean production that the success of the rhapsodes should be seen. Ousted from the field of music by the new virtuosi at the same time that the setting was changing from the domestic to the public field, epic had to resort to the power of the spoken word to secure its place in the *agones*. This was an opportunity for the rhapsodes, and they made the best of it. They had texts good enough to stand the test: Homerids brought Homer to the foreground, and their success turned out to be more lasting than the Stesichorean fashion had been. We thus comfortably arrive at the epoch of Peisistratos and his sons who "brought Homer" to Athens—that is, Homeric recitation as the reassertion of an older *genos* in new circumstances, in a new form of performance.

The same epoch saw the emergence of another *genos* in Athens which was to dominate the Greek world: the *tragodoi* of Thespis, who first performed about 534 B.C. No texts of Thespis survive, and we cannot be sure about details of his achievement,[59] but this much is clear: tragedy was a combination of choral lyrics and spoken verse, taking up both the tradition of Stesichoros—including the Doric style of the chorals—and of Ionic-Attic *Iambos*. The latter, however, was stripped of its musical accompaniment—the flute that had belonged to it—just as the rhapsode had given up the *phorminx*. The actor, like the rhapsode, recited verse with his individual voice in front of a large public in such a way that the text was clearly understood in all its details. It could be that the special acoustics provided by the natural slope in the precinct of Dionysos south of the Akropolis was decisive for this new form of performance, but the place for the first productions of tragedy is hotly debated,[60] and we do not know anything about the place for rhapsodic contests. Acting and rhapsodic recitation may also be seen as opposites, as they were assigned to the two "great" festivals organized in sixth-century Athens, the Dionysia and the Panathenaia. The actor, wearing a mask, identified with the mythical character he was presenting; the rhapsode, quoting from a text composed ages ago, brought the past to life while maintaining his distance from it. What was still common was the separation of author and performer. It had long been recognized by that time, due to the self-consciousness of many remarkable poets, that every poetic production had an individual author. Even if the success of a tragedy depended very much upon the actors, the chorus, and the appurtenances, one did not forget to ask for the man who "did it," the *poietes*. Improvisations on well-trodden paths of traditional heroic scenery no longer had a chance in an age of competitive professionals. But the making of a classic had.

We probably have one direct document from this situation, a pas-

sage from the Homeric *Hymn to Apollo*. This composition consists of a Delian and a Pythian part, separable in background and style but analogous in structure and thus clearly belonging together. This fact, which has given rise to much debate, is especially puzzling in terms of performance: a situation requiring a composite hymn is almost inconceivable, since no singer or rhapsode could ever be present at Delos and Delphi at the same time. An explanation comes from the fact that once, and only once, Polykrates, tyrant of Samos, organized a festival, *Pythia kai Delia*, at Delos, probably in 522 B.C.: it is here that the composite hymn uniquely fits, and this should establish its date. This suggestion has been made independently by Richard Janko and by myself.[61] Parts of the text may well be older, but the arrangement belongs to the Polykrates festival, including the description of the Delian festival itself contained in the text. At that time, while Asia Minor had fallen to the Persians and Peisistratos had died, Polykrates was claiming the leadership of the Ionians through his patronage of the Delian sanctuary. The so-called hymn is a *prooimion*, as Thukydides calls it, the preface of a rhapsode with reference to the local deities, to be followed by recitation of Homer. In the crucial passage in which the composer turns to praise the *hic et nunc* of the Delian festivities and also to introduce himself, he goes to some length to pay tribute to a chorus performing at Delos, a chorus of girls (156–165). They begin, he says, with a hymn to Apollo, Leto, and Artemis, and then, to the delight of the audience, they sing a song about "ancient men and women, recalling them from memory." This is heroic myth in the form of choral lyrics, in other words, a Stesichorean production—taking "Stesichorean" to refer to *genos* and style, not to authorship. In this production, the girls "know to imitate the voices and chatter of all people: everybody would say he was speaking himself" (162–165). This is enigmatic. Contrary to what both others and I myself have written,[62] I am inclined now to take this as indicating mimetic elements in this very performance of choral lyrics. The Stesichoros texts we have are full of direct speech and dialogues, and we wonder how this came out in performance. It would be tempting to distinguish between voices, to make Geryoneus sound different from his doleful mother and from Herakles (remember that the *tragodoi* of Thespis had made their appearance by this date). I would not suggest that the *Hymn to Apollo* gives a clue to the normal production of Stesichorean lyrics. Rather, it indicates a peculiar experiment made by this one Delian chorus to take up mimetic elements that had proved so successful in the other *genos*. Be that as it may, the composer of the hymn is full of admiration, and he promises to carry the fame of this singular production abroad. In return for this he asks for a similar favor: "You must also remember me in the future," he says, demanding that every stranger arriving at Delos be told about his achievement. In other words, the rhapsode is suggesting to his rivals, the chorus, a joint enterprise of mutual advertisement.

There follows a notorious and enigmatic passage: if anybody asks you, the bard says, "which man comes here as the sweetest of singers for you, and who gives you most pleasure," (169f.) your answer should be: "a blind man, living in rocky Chios; all songs of this man are the best

among posterity" (172f.). For some readers of the text, including Thukydides, the rhapsode was Homer in person, speaking about himself; others have held the hymn to be a fake for the very reason that it introduces legendary Homer. Wilamowitz-Moellendorff pushed the realistic hypothesis that some anonymous rhapsode, accidentally blind, was introducing himself, and even suspected that his name had been secondarily ousted from the text.[63] Yet it is quite an extraordinary claim that is made for the anonym: "all the songs" of this man of Chios "are the best among posterity," *metopisthen*—the same word is used in the no less notorious prophecy in the *Iliad* about the offspring of Aeneas.[64] This is the clearest expression in epic diction of the notion of a classic, an absolute classic, that I can imagine. This is meant to be Homer.

Are we then dealing with mystification, or is it possible to understand the text without the hypothesis of imposture? It is a kind of riddle; it need not be a fake. One observation is important in this respect: the problem is totally different for readers of the text, such as we are and Thukydides was, and for the actual audience at the performance, say at Delos in 522.[65] The bard performing there either was or was not blind, and the public saw and knew which was the case. If he was blind, he made absurd claims about posterity. But suppose he was not—and nothing in the text speaks for a blind composer—then it was clear that he was not referring to himself when he introduced the "blind man of Chios." Since the additional information contained in the situation of performance *hic et nunc* has vanished and only the pure, written text has remained, the modern reader is led astray, as was Thukydides. The text of the hymn is not straightforward and simple, but the reason for this is the very phenomenon that has been in focus here—the separation of performer and author. The joint-enterprise suggestion of the rhapsode would draw attention to his person: I am singing your praise, you sing mine, and if anyone asks which is the best singer, please name— "me," one would expect, but instead there comes the strange word ἀφήμως (171). I understand it to mean: "anonymously," "don't mention a name."[66] It is indeed not the name of the performer which matters, but another, that of the "blind man in Chios." Metrically, *Homeros* would fit. One may still find difficulties with the present tense "he lives," οἰκεῖ (172); it would indeed be no change to read imperfect, οἴκει,[67] but the present tense may rather be timeless; Kleobulos just remains Λίνδου ναιέτας (Simonides 581 Page). Homer's home is Chios; though he was active long ago, he is still present among posterity, he regularly "comes" to the contests—from which he should be thrown out, according to Herakleitos—and he has "come" to Delos as he had been brought to Athens. Earlier in the text, in a list of Aegean place-names, it is Chios alone that gets a line of praise (38): " . . . which as the most brilliant of islands is lying in the sea." The composer is alluding to his own special relations to Chios and to the absolute classic of Chios represented in his performance. We are drawn to the conclusion that in this text, the *Hymn to Apollo*, we hear the voice of a representative of Chian Homerids performing at Delos in 522. He strives to establish the art of rhapsodic recitation of Homer by politely endorsing the rival form of choral,

Stesichorean representation, and yet by also stressing the unique status of the classic of the past. The *Hymn to Apollo* is parallel and contemporary to Hipparchos introducing "Homer" and rhapsodic contests at the Panathenaia. The two testimonies reinforce each other. The revival of epic in the form of rhapsodic recitation takes place in confrontation with choral lyrics of Stesichorean type, and it implies the proclamation of Homer as the absolute classic,

Τοῦ πᾶσαι μετόπισθεν ἀριστεύουσιν ἀοιδαί.

It is tempting to add some general reflections on the situation in which this first making of a classic occurred. This is a period when in other fields of Greek civilization we also find expansion and experiment coming to an end, to be followed by concentration on what has been achieved. This is true for Greek colonization and also for the canon of the Greek temple. At the same time there are thoroughgoing changes in the economy, with the rapidly spreading use of money; in politics, with the Persian onslaught; and in the realm of thought and literature, as we see emerging what was later to be called philosophy, which in fact marked the end of the monopoly that poetry had held on wisdom. I shall not pursue these associations and perspectives, but wish rather to point to the uncertainties still surrounding the Homeric texts we have. I frankly do not know why and under what conditions the *Iliad* was originally written down, nor who originally read and preserved the scrolls, nor when recitation of fixed texts first began to replace the improvising singers of tales. One is still free to imagine Homer himself sitting down to record his poem because it was so great, or his family and friends piously preserving the text and learning it by heart; what is missing in this picture are the complications and coincidences in which real history is so rich. I have tried to call attention to phases of the public's reception, to different forms of production coming to prominence in successive epochs.

Another unsolved problem is the reduction of Homer's oeuvre to the *Iliad* and the *Odyssey*—and, sometimes, the *Margites*[68]—instead of the larger group of epics still acknowledged by Pindar. At any rate, there is reason to insist on a second and no less momentous step in making Homer a classic, after the declaration of rhapsodizing Homerids: the establishment of Homer as a school text. This is another story, an important and a fascinating one, though the early evidence is little more than scanty. A place of pride is occupied by the Douris cup in Berlin, datable to about 490, with its school scene, in which a boy is reading a nonsense epic verse from a scroll.[69] An earlier picture by Phintias depicts a music lesson without scrolls. The establishment of elementary schools, notably in Athens, must have made significant progress with the advent of democracy. The introduction of the institution of *ostrakismos* in 508(?)[70] presupposes that the skill of writing was common among citizens. Nonsense inscriptions disappeared from Attic vase-painting about the same time.

The choice of Homer as a schoolbook is strange: it can hardly be justified on pedagogical grounds. In fact Near Eastern civilizations had been using the traditional epics as schoolbooks, too.[71] Elementary school

texts need to be moderately attractive, and narrative texts are preferable: songs are unsuitable, for the children will learn them by heart rapidly and thus never learn to read. It may simply be that Homer was the most readily available set of books at that time. Tragedies were not yet available as books—hence the eclipse of Thespis—and prose treatises in a jejune or idiosyncratic style, such as Hekataios or Herakleitos, were hardly a choice. It was the rhapsodes who could say: λαβὲ τὸ βιβλίον. At any rate, it is a fact that the *Iliad* was chosen as a schoolbook at an early date,[72] and since nothing is more conservative than school tradition—up to the twentieth century, at least—it has remained a schoolbook. It is not without reason that more modern local tradition of Chios has Homer sitting on a rock teaching schoolboys at Daskalopetra, which in reality had been a Kybele sanctuary.[73] The use of Homer in school must also have been responsible for Ionian orthography finally replacing the old Attic orthography, which was practiced in bureaucracy down to 403 B.C. [74] The Xenophanean phrase ἐξ ἀρχῆς καθ' Ὅμηρον came true. We may still credit the rhapsodes with protecting Homer from total absorption into school dust: live performances by specialists competing for the favor of the public, with the books of the one great classic in the background, were to remain a factor in Greek intellectual life for many generations. It was only toward the end of the fifth century that wealthy and educated people began to acquire private books, and Homer began to reach the third and final stage of a classic: the classic on a shelf.

UNIVERSITY OF ZURICH

NOTES

1. This is not the place to indulge in bibliography on Homeric problems. For such, see D.W. Packard and T. Meyers, *A Bibliography of Homeric Scholarship, 1930–1970* (Malibu 1974); A. Lesky, "Homeros," *RE* Suppl. XI (1967) 687–846 (where part XI, "Nachleben," was planned, but never published); A. Heubeck, *Die Homerische Frage* (Darmstadt 1974); J. Latacz, *Homer, Eine Einführung* (Munich 1985); G.S. Kirk, "The making of the Iliad," in *The Iliad: A Commentary*, vol. 1 (Cambridge 1985) 1–16; A. Heubeck and S. West, eds., "Introduzione generale," in *Omero, "Odissea,"* vol. 1 (Milan 1981) i–lix. On the name *Homeros* and the works attributed to him see U. v. Wilamowitz-Moellendorff, *Homerische Untersuchungen* (Berlin 1884) 328–380; idem, *Die Ilias und Homer* (Berlin 1914) 356–376; F. Jacoby, "Homerisches I: Der Bios und die Person," *Hermes* 68 (1933) 1–50 = *Kleine Philologische Schriften*, vol. 1 (Berlin 1961) 1–53; E. Schwartz, "Der Name Homeros," *Hermes* 75 (1940) 1–9.
2. The term and program of *Rezeptionstheorie* goes back to H.R. Jauss, *Literaturgeschichte als Provokation der Literaturwissenschaft* (Constance 1967); idem, *Toward an Aesthetic of Reception* (Minneapolis 1982); W. Barner, "Neuphilologische Rezeptionsforschung und die Möglichkeiten der Klassischen Philologie," *Poetica* 9 (1977) 499–521; P.L. Schmidt, "Reception Theory and Classical Scholarship: A Plea for Convergence," in W.M. Calder, ed., *Hypatia: Essays in Classics, Comparative Literature, and Philosophy Presented to H.E. Barnes* (Boulder 1985) 67–77. The interrelations among production, performance, and reception are investigated in W. Rösler, *Dichter und Gruppe* (Munich 1980); B. Gentili, *Poesia e pubblico nella grecia antica* (Bari 1984).

3. Cf. W. Burkert, "Das hunderttorige Theben und die Datierung der Ilias," *Wiener Studien* 89 (1976) 5–21; for leather scrolls, see idem, "Die orientalisierende Epoche in der griechischen Religion und Literatur," *Sitzungsberichte der Heidelberger Akademie der Wissenschaften, philosophisch-historische Klasse,* 1984, 1, 33f.; for the problems of Homeric text transmission, see West (supra, note 1) xli-1.

4. *Certamen,* ed. T.W. Allen, *Homeri Opera,* vol. 5 (Oxford 1912) 214, 309, 338.

5. Hdt. 2.53.2; 2.117; 4.32; he quotes the title *Iliad* 2.116.2, *Odyssey* 4.29; on 5.67 see infra, note 16; dream: 7.12–18; cf. *Il.* 2.1-40.

6. Preliminary edition in *ZPE* 47 (1982); cf. W. Burkert, ibid. 62 (1986) 1–5. Parallel is Metrodoros, H. Diels, *Fragmente der Vorsokratiker,* 5th ed. (Berlin 1951/1952) no. 61, even earlier Theagenes, ibid., no. 8.

7. Diels (supra, note 6) 80 A 29.

8. The reference is to *Il.* 2.552–554, as also in Hdt. 7.161.3; Menestheus is named amid Trojan warriors on an Attic black-figure kantharos, Berlin 1737, 575/550 B.C.; *Paralipomena* 72,1; K. Friis Johansen, *The Iliad in Early Greek Art* (Copenhagen 1967) fig. 37. On Menestheus in the *Iliad,* see Kirk (supra, note 1) 179f., 206f.

9. S. Radt, *Tragicorum Graecorum Fragmenta,* vol. 3, *Aeschylus* (Göttingen 1985) T 112.

10. The reference is to *Il.* 15.207. In *Pyth.* 3.81f. he quotes *Il.* 24.527ff., misunderstanding the text; see also infra, notes 20 and 39. The plot of the *Iliad* and characteristic scenes are evoked by Bacchylides 13.105–169.

11. Herakleitos B 56 = 21 Marcovich; cf. B 42 = 30 Marcovich; A 22 = 28 p. 133 Marcovich.

12. Xenophanes, *Silloi,* esp. B 11/12; "fictions of the ancients" B 1.22; criticized by Herakleitos B 40 = 16 Marcovich.

13. (Ὅμηρος) πεπαίδευκε τὴν Ἑλλάδα is an established slogan in Pl., *Resp.* 606e.

14. Semonides fr. 29 Diehl = Simonides fr. 8 West; cf. M.L. West, *Studies in Greek Elegy and Iambus* (Berlin 1974) 179f.; the reference is to *Il.* 6.146 (cf. Mimnermos fr. 2).

15. Kallinos fr. 6 West = Paus. 9.9.5 (the manuscript tradition has ΚΑΛΑΙΝΟΣ); cf. J.A. Davison, *From Archilochus to Pindar* (London 1968) 81f.

16. Hdt. 5.67, a passage heavily discussed in all studies on the beginnings of tragedy; see, among more recent studies, A. Lesky, *Die tragische Dichtung der Hellenen,* 3rd ed. (Göttingen 1972) 42–45; J. Svenbro, *La parole et le marbre* (Lund 1976) 44f., who argues that Kleisthenes' decree presupposes fixed texts, i.e., rhapsodes; E. Cingano, "Clisthene di Sicione, Erodoto e i poemi del Ciclo Tebano," *Quaderni Urbinati di cultura classica* n.s. 20 (1985) 31–40.

17. Cf. W.W. How and J. Wells, *A Commentary on Herodotus,* 2nd ed., vol. 2 (Oxford 1928) 56. Akamas and Demophon and their Trojan adventures appear in Attic vase-painting since Exekias: U. Kron, *Die zehn attischen Phylenheroen* (Berlin 1976) 147–170, esp. pl. 19,2, neck-amphora, Berlin F 1720, *ABV* 143,1.

18. The evidence about this quarrel and the theory of a Peisistratean redaction of Homer is collected and discussed in R. Merkelbach, *Untersuchungen zur Odyssee,* 2nd ed. (Munich 1969) 239–262; Dieuchidas, in F. Jacoby, *Fragmente der griechischen Historiker,* vol. 3B (Leiden 1950) 485 F 6 = Diog. Laert. 1.57. For Menestheus (B 556) see supra, note 8.

19. Hektor and Andromache: Sappho fr. 44; Thetis: Alk. fr. 44; wedding of Peleus: Alk. fr. 42; Locrian Ajax: Alk. fr. 298 Voigt; see D. Meyerhoff, *Traditioneller Stoff und individuelle Gestaltung: Untersuchungen zu Alkaios und Sappho* (Hildesheim 1984).

20. Kyknos, Hektor, Memnon: Pindar, *Ol.* 2.81–83; cf. *Nem.* 3.62; 6.50 (Memnon); Homer honoring Ajax, *Isthm.* 4.35–39, most probably refers to the *Aithiopis,* fr. 2 Allen = Schol. ad loc.

21. Friis Johansen (supra, note 8); *Sagenbilder*; K. Fittschen, *Untersuchungen zum Beginn der Sagendarstellungen bei den Griechen* (Berlin 1969); R. Kannicht, "Poetry and Art: Homer and the Monuments Afresh," *Classical Antiquity* 1 (1982) 70–86.

22. K. Schefold, "Archäologisches zum Stil Homers," *Museum Helveticum* 12 (1955) 132–144; idem, "Das homerische Epos in der antiken Kunst," *Atti del Convegno La Poesia Epica e la sua Formazione.* Accademia Nazionale dei Lincei, quad. 139 (Rome 1970) 91–116, revised in K. Schefold, *Wort und Bild* (Basel 1975) 27–42; cf. B. Andreae and H. Flashar, "Strukturaequivalenzen zwischen den Homerischen Epen und der frühgriechischen Vasenkunst," *Poetica* 9 (1977) 217–264.

23. *Sagenbilder* pl. 6a; Fittschen (supra, note 21) 182.

24. *Sagenbilder* pls. 34, 35; Fittschen (supra, note 21) 182f.; C. Zindel, *Drei vorhomerische Sagenversionen in der griechischen Kunst* (Ph.D. diss., Basel 1974) 87–92.

25. Fittschen (supra, note 21) 192–194; *Sagenbilder* fig. 15, pls. I and 16, pl. 37; on Kyklops and folktale see D. Page, *The Homeric Odyssey* (Oxford 1955) 1–20; W. Burkert, *Structure and History in Greek Mythology and Ritual* (Berkeley 1979) 31–34 (with further bibliography).

26. Fittschen (supra, note 21) 178f.; the type already occurs on the Geometric stand, Munich 8936, mentioned by Fittschen, page 69, for the Molione. H. Pestalozzi, *Die Achilleis als Quelle der Ilias* (Erlenbach 1945); W. Schadewaldt, "Einblick in die Erfindung der Ilias: Ilias und Memnonis," in idem, ed., *Von Homers Welt und Werk,* 2nd ed. (Stuttgart 1951) 155–202; cf. W. Kullmann, "Zur Methode der Neoanalyse in der Homerforschung," *Wiener Studien* 94 (1981) 5–42; idem, "Oral Poetry Theory and Neoanalysis in Homeric Research," *Greek, Roman, and Byzantine Studies* 25 (1984) 307–323.

27. Paris: Chigi Vase, *Sagenbilder* pl. 29b; Troilos: Zindel (supra, note 24) 30–80.

28. I. Krauskopf, *Der Thebanische Sagenkreis und andere griechische Sagen in der etruskischen Kunst* (Mainz 1974) shows that representations of the Theban cycle were more popular in Etruria, but even there they became numerous only toward the end of the sixth century B.C.

29. London A 749; *Sagenbilder* pl. 75; cf. Schefold in *Wort und Bild* (supra, note 22) 33f.; a hypothesis about the name Euphorbos on the basis of the Memnonis theory (supra, note 26) by H. Mühlestein, "Euphorbos und der Tod des Patroklos," *Studi Micenei ed Egeo-Anatolici* 15 (1972) 79–90.

30. Phoinix on a Corinthian cup, circa 580 B.C., Basel, private collection, *LIMC* 1, Aias I 122; Dolon and Phoinix on a Corinthian cup, Brussels, *LIMC* 3, Dolon 1; Friis Johansen (supra, note 8) 71, figs. 15, 16; *Sagenbilder* 83, fig. 36; Ransom of Hektor, Friis Johansen 49f., 127–138 and *Sagenbilder* pl. 76b; Sophilos fragment in Athens, *ABV* 39,16 and *Sagenbilder* pl. VI; amphora as Dionysos' wedding present for Thetis on the François Vase, *Sagenbilder* pl. 48a, cf. E. Simon, *Die griechischen Vasen* (Munich 1976) 70f., in accordance with *Od.* 24.74f. rather than with Stesichoros fr. 234 Page.

31. Ἑλένης ἀπαίτησις on a Corinthian krater in the Vatican in Rome, *Sagenbilder* pl. 72.

32. *Amasis Painter* no. 60 (referring to *Il.* 13.45ff.); Friis Johansen (supra, note 8) 223–241.

33. Cf. W. Schadewaldt, "Die Gestalt des homerischen Sängers," in *Von Homers Welt und Werk* (supra, note 26) 54–86; H. Maehler, *Die Auffassung des Dichterberufs im frühen Griechentum bis zur Zeit Pindars* (Göttingen 1963); Latacz (supra, note 1) 40–42.

34. Cf. A. T. Edwards, *Achilles in the Odyssey* (Meisenheim 1985) 86–93.

35. *Od.* 22.347. The singer's claim to inspiration and to telling the truth preclude the full concept of an author, cf. W. Rösler, "Die Entdeckung der Fiktionalität," *Poetica* 12 (1980) 283–319, esp. 293–298.

36. M. Parry, *The Making of Homeric Verse* (Oxford 1971); A.B. Lord, *The Singer of Tales* (Cambridge, Mass., 1960).

37. See H. Patzer, *"Rhapsodos,"* *Hermes* 80 (1952) 314–324; R. Sealey, "From Phemios to Ion," *Revue des études grecques* 70 (1957) 312–355; G.F. Else, "The Origin of ΤΡΑΓΩΙΔΙΑ," *Hermes* 85 (1957) 17–46, esp. 27–34; G. Tarditi, "Sull' origine e sul significato della parola Rapsodo," *Maia* 20 (1968) 137–145. For word formation, see T. Knecht, *Die Geschichte der griechischen Komposita vom Typ τερψίμβροτος* (Ph.D. diss., Zurich 1946); cf. Hes. fr. 357, Pind., *Nem.* 2.2. The standard picture of a rhapsode with his staff is the neck-amphora, London E 270, *ARV²* 183,15.

38. Plato, *Ion*; cf. H. Flashar, *Der Dialog Ion als Zeugnis platonischer Philosophie* (Berlin 1958) 21–27; Xen., *Symp.* 3.5f.; *Mem.* 4.2.10.

39. Pind., *Isthm.* 4.34; *Nem.* 2.1; the scholium on the latter passage is the *locus classicus* for rhapsodes and Homerids, cf. infra, note 41 and W. Burkert, "Kynaithos, Polycrates, and the Homeric Hymn to Apollo," in G.W. Bowersock, W. Burkert, and N.C.J. Putnam, eds., *Arktouros. Hellenic Studies presented to B.M.W. Knox* (Berlin 1979) 53–62, esp. 54–58.

40. Herakleitos B 42.

41. Akusilaos, in F. Jacoby, *Fragmente der griechischen Historiker,* 2nd ed., vol. 1 (Leiden 1957) 2 F 2; Rzach, "Homeridai," *RE,* vol. 8, 2145–2182; D. Fehling, "Zwei Lehrstücke über Pseudo-Nachrichten (Homeriden, Lelantinischer Krieg)," *Rheinisches Museum für Philologie* 122 (1979) 193–210, esp. 193–199.

42. Cf. W. Burkert, "Die Leistung eines Kreophylos," *Museum Helveticum* 29 (1972) 74–85.

43. Esp. Rösler and Gentili (supra, note 2).

44. This is still often assumed, e.g., *Der Kleine Pauly* s.v. Rhapsoden: "die ganze Il. und Od." The attested length for the Panathenaia is four days, schol. Aristides 196 Dindorf; cf. J.D. Mikalson, *The Sacred and Civil Calendar of the Athenian Year* (Princeton 1975) 34.

45. Diog. Laert. 1.57; Lycurg., *Leoc.* 102: the Athenians "made it a law to rhapsodize every five years at the Panathenaia the verses of Homer alone among all the other poets"; see Friis Johansen (supra, note 8) 223–241.

46. For recent surveys, see supra, note 1; for the Peisistratean redaction, see supra, note 18.

47. The new fragments from *Geryoneis, Iliupersis,* and the Wooden Horse are available in D. Page, *Supplementum Lyricis Graecis* (Oxford 1974) 1–147; cf. M.L. West, "Stesichorus redivivus," *ZPE* 4 (1969) 135–149; D.L. Page, "Stesichorus: The Geryoneis," *JHS* 93 (1973) 138–154; idem, "Stesichorus:

The 'Sack of Troy' and 'The Wooden Horse,' " *Proceedings of the Cambridge Philological Society* 19 (1973) 47–65; the *Thebais* in P.J. Parsons, "The Lille Stesichoros," *ZPE* 26 (1977) 7–36.

48. Stesichoros S 13.5; cf. *Il.* 22.83; Stesichoros S 11.8–24; cf. *Il.* 12.322–328.

49. Stesichoros 209 Page; cf. *Od.* 15.168ff. and 68.

50. Cf. M. Robertson, "Geryoneis: Stesichorus and the Vase-Painters," *Classical Quarterly* 19 (1969) 207–221; P. Brize, *Die Geryoneis des Stesichoros und die frühgriechische Kunst* (Würzburg 1980); a new pre-Stesichorean representation of Geryoneus: P. Brize, "Samos und Stesichoros: Zu einem fr-harchaischen Bronzeblech," *AthMitt* 100 (1985) 53–90.

51. M.L. West, "Stesichorus," *Classical Quarterly* 21 (1971) 302–314, esp. 307–313; Gentili (supra, note 2) 161, following C.O. Pavese, *Tradizioni e generi poetici della Grecia archaica* (Rome 1972) 239f.

52. We only have late sources for this: Syrian., *In Hermog.* I p. 62,1–10; H. Rabe, *schol. rec. Pind.* 11 Boeckh etc.; see W. Mullen, *Choreia: Pindar and Dance* (Princeton 1982) 225–230, who tries to trace the effect of dance, esp. "epodic arrest," in Pindar's texts. The triadic system was proverbially connected with Stesichoros, Zenobius Athous 1.23: M.E. Miller, *Mélanges de littérature grecque* (Paris 1868) 351 (doubts on the interpretation of the proverb have been raised, after O. Crusius, by M. Davies, *JHS* 102 [1982] 206–210, although he shows that the textual basis for Crusius' conclusions was wrong), cf. *Suda* s.v. Stesichoros.

53. M.L. West, "Stesichorus in Sparta," *ZPE* 4 (1969) 142–149 deals with Pap. Ox. 2735, which has references to place and persons; Page however, in his *Supplementum* (supra, note 47) 166 ascribes the text to Ibykos.

54. There is no direct evidence for traveling groups in the sixth century; one might as well imagine a traveling *didaskalos* selecting his chorus for training on the spot, but we know chorus training was a long process. Paus. 5.25.2–4 describes a fifth-century monument of a boys' chorus with *didaskalos* who drowned on a journey from Messina to Rhegion.

55. Ps.-Xen., *Ath. Pol* 1.13; I do not agree with M. Treu, "Eine Art von Choregie in peisistratischer Zeit," *Historia* 7 (1958) 385–391, who, however, has a good discussion of earlier interpretations of this passage.

56. *Marm. Par.* in F. Jacoby, *Fragmente der griechischen Historiker,* vol. 2B (1929; reprint Leiden 1962) 239 A 46; cf. A.W. Pickard-Cambridge, *Dithyramb Tragedy and Comedy,* 2nd ed. (Oxford 1962) 15; G.A. Privitera, *Laso di Erminoe* (Rome 1965) 86–88.

57. U. v. Wilamowitz-Moellendorff takes "einen attischen Bürgerchor" into his definition of tragedy, *Einleitung in die griechische Tragödie* (Berlin 1889) = idem, *Euripides Herakles,* vol. 1 (Darmstadt 1959) 108.

58. See supra, note 16.

59. All the evidence is now collected in *Tragicorum Graecorum Fragmenta,* 2nd ed., vol. 1 (Göttingen 1986) no. 1.

60. See now F. Kolb, *Agora und Theater, Volks- und Festversammlung* (Berlin 1981) 26–58 with the review by R. Seaford in *Classical Review* 33 (1983) 288f.

61. See Burkert (supra, note 39); the same conclusion was independently drawn by R. Janko, *Homer, Hesiod and the Hymns: Diachronic Development in Epic Diction* (Cambridge 1982) 109–114; problematic elaborations by F. De Martino, *Omero agonista in Delo* (Brescia 1982); A.M. Miller, *From Delos to Delphi: A Literary Study of the Homeric Hymn to Apollo* (Leiden 1986) has nothing on the historical setting. A.M. Bowie in his review of Janko, *Classical Review* 35

(1985) 242, finds it a problem that Rheneia (Thuk. 3.104) is not prominent in the hymn. Ps.-Hes. fr. 357 probably is dependent on the hymn, in combination with *Op.* 654f. Peisistratos, too, had installed a sanctuary of Pythian Apollo in Athens, in addition to the old cult of Delian Apollo, *Suda* s.v. Pythion.

62. W. Burkert, *Greek Religion Archaic and Classical* (Oxford 1985) 110, following H.J. Tschiedel, "Ein Pfingstwunder im Apollonhymnos," *Zeitschrift für Religions- und Geistesgeschichte* 27 (1975) 22–39. W. Rösler has drawn my attention to Alkman 39 Page for mimetic elements in choral lyrics.

63. Wilamowitz-Moellendorff 1914 (supra, note 1) 453. The textual evidence for line 171 is discussed in Burkert (supra, note 39) 61.

64. I do not find much discussion of line 173. It is perhaps characteristic that A.L.T. Bergren, without discussion, translates the passage, "All of his songs will be supreme hereafter" ("Sacred Apostrophe: Re-Presentation and Imitation in the Homeric Hymns," *Arethusa* 15 [1982] 83–108, esp. 93). Aeneas: *Il.* 20.308.

65. For a similar argument, see W. Rösler, "Persona reale o persona poetica? L'interpretazione dell' "io" nella lirica greca arcaica," *Quaderni Urbinati di cultura classica* n.s. 19 (1985) 131–144, esp. 140.

66. Burkert (supra, note 39) 61, following a suggestion of Wilamowitz-Moellendorff 1914 (supra, note 1) 454.

67. οἴκει not ᾦκει would be the correct form: P. Chantraine, *Grammaire Homérique,* vol. 1 (Paris 1958) 483.

68. Purportedly attributed to Homer by Archilochos, 303 West, but I share West's skepticism (ad loc.) as to this testimony.

69. Cup, Berlin F 2285, *ARV²* 431,18. Phintias, hydria, Munich 2421, *ARV²* 23,7. Cf. G. Nieddu, "Alfabetismo e diffusione sociale della scrittura nella Grecia arcaica e classica: pregiudizi recenti e realtà documentaria," *Scrittura e Civiltà* 6 (1982) 233–261, esp. 255f.

70. For evidence and problems, see R. Thomsen, *The Origin of Ostracism* (Copenhagen 1972).

71. E. Reiner in W. Röllig, ed., *Altorientalische Literaturen,* vol. 1 of Neues Handbuch der Literaturwissenschaften (Wiesbaden 1978) 157.

72. H.I. Marrou, *Histoire de l'éducation dans l'antiquité,* 6th ed. (1964; reprint Paris 1981) says very little on Homer as a school text; for one detail see vol. 1, 230. E. Pöhlmann, "Die Schriftreform in Athen um 403 und ihre Implikationen," in L. Kriss-Rettenbeck and M. Liedtke, *Erziehungs- und Unterrichtsmethoden im historischen Wandel* (Bad Heilbrunn 1986) 51–60. It is interesting that *Od.* 9.39 appears as a graffito in fifth-century Olbia, *Supplementum epigraphicum Graecum* 30,933. A boy reading the beginning of the eighteenth Homeric hymn from a scroll: red-figure lekythos *ARV²* 452, 677,7; J. Dörig, ed., *Art antique: Collections privées de Suisse Romande* (Geneva 1975) no. 214. Alkibiades reading Homer as a schoolboy: Plut., *Alk.* 7.1.

73. See now F. Graf, *Nordionische Kulte* (Rome 1985) 107–115.

74. Cf. Pöhlmann (supra, note 72) and A. Heubeck, *Schrift,* vol. 3 of Archaeologia Homerica (Göttingen 1979) 161–169.

John Griffiths Pedley

Reflections of Architecture in Sixth-Century Attic Vase-Painting

When I was first asked to give this paper, I found myself in a number of dilemmas. Should I talk about elements of architecture or architectural elements, reflections of architecture or architectural reflections? What is the correct terminology to use? I asked myself whether I should try to correlate architectural elements that appear on sixth-century vase-paintings with actual architectural forms known to us from Athens. Should I attempt to see these architectural images as reflections of real, contemporary architecture, or as echoes of earlier architecture? Should I see later images as copies of earlier representations, with the fountainhouses of the later part of the century, for example, simply echoing Kleitias' famous illustration on the François Vase? Was the representation of this particular form just common practice, a familiar, almost mindless theme, among the painters in the Kerameikos? Or was there a political or social or other meaning behind the image? Should I make claims for architectural views as imaginative creations from private worlds of fantasy, or as excerpts from mythological and literary contexts? Should I attempt to see them as aesthetic devices, controlling the narratives and compositional arrangements? Or as purely decorative, and without other meaning? In the end, this paper touches most of the topics I have mentioned—doubtless in all too peremptory fashion—and while the first part may appear mechanical, the second, I hope, may be if not fanciful at least provocative. In any event, the title might better read *Reflections on* rather than *Reflections of* architecture in sixth-century Athens.

The second quarter of the sixth century B.C. saw the construction on the Akropolis of a great temple to Athena Polias; fragments of capitals, of architrave and cornice blocks, and of metopes show that this building was large in scale and of the Doric order.[1] Associated with this

Fig. 1. Poros Doric capitals from the Old Temple of Athena, circa 520 B.C. (from Travlos, *Pictorial Dictionary of Ancient Athens* 147, fig. 199).

Fig. 2. Theater of Dionysos, restored plans. *Above*: Theater in the second half of the sixth century B.C. *Below*: Theater in the second half of the fifth century B.C. (from Travlos, *Pictorial Dictionary of Ancient Athens* 540, fig. 677).

temple are fragments of pedimental sculpture, likewise huge in scale and stylistically contemporaneous with it.[2] Around these fragmentary architectural members discussion continues to rage: did the temple stand on the site of the later Parthenon, or on Archaic foundations near the Erechtheion? Is it to be linked with the building programs of Peisistratos, or with the institution of the Great Panathenaia? Was it known to its contemporaries as the Hekatompedon? For the purposes of this paper it will suffice to observe that the building was large in scale, eminently visible, probably peripteral in plan, and Doric.[3] Three smaller buildings, which may have resembled treasuries, were constructed at the same time on the Akropolis, but no firm conclusions can be drawn about the details of their elevations.[4]

Around 520 B.C. another temple with architectural details and pedimental sculpture of island marble was built on the Akropolis. Much of the entablature of this building—cornice blocks, metopes, triglyphs, and architrave blocks—was built into the fortification wall of the Akropolis in accordance with the plans of Themistokles. Other blocks may still be seen scattered about the Akropolis (fig. 1). Again, the temple was peripteral in plan, and Doric.[5] At the same time—or rather circa 515 B.C.—the tyranny embarked on its most ambitious architectural project—the temple of Olympian Zeus.[6] Situated in the lower city, the building had a double peripteral plan, was intended to be built of poros—to judge from

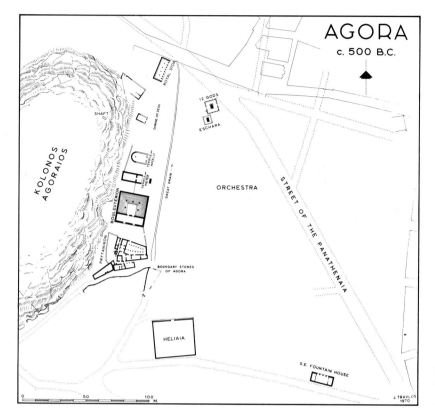

Fig. 3. Agora circa 500 B.C. (from Thompson and Wycherley, *The Agora of Athens*, vol. 14, pl. 4).

unfinished column drums reused in the Themistoklean wall—and was of the Doric order. Gigantic in scale, this temple was evidently intended to rival the enormous temples of Asia Minor and the recently initiated Temple GT at Selinus. Aristotle compares the temple with the building efforts of Polykrates;[7] Vitruvius says that work on the structure stopped with the installation of the democracy.[8] Whatever tyrannical overtones the temple had, for this paper it will suffice to note that it, like Athena's temple (or temples) on the Akropolis, was peripteral and Doric.

A small *distyle in antis* temple, again Doric, was built at the foot of the south slope of the Akropolis in the third quarter of the century to house the cult statue of Dionysos Eleutherios. Close to this structure, and somewhat to the north, a curved wall was constructed, probably intended to shape an *orchestra* and to articulate, along with the slope above (the *auditorium*), Athens' first semiformal theater (fig. 2).[9] On the other side of the Akropolis, in the Agora, postholes for wooden seating for spectators (*ikria*) have been found—though these tend to follow the line of the Panathenaic Way and hardly represent arrangements for a makeshift theater.[10] Accordingly, it is difficult to imagine that any physical structure or contemporary wooden scaffolding would have influenced Sophilos in his impressionistic rendering of a Homeric stadium;[11] and we are a far cry chronologically from the stadium in the Lyceum, described by Xenophon, in which cavalry maneuvered.[12] For Sophilos, the stadium was a

Fig. 4. Early civic buildings at the southwest corner of the Agora (from Thompson and Wycherley, *The Agora of Athens*, vol. 14, 26, fig. 8).

generalization, inspired by myth and song, more significant as a narrative element than as a representation of anything actual.

The sixth century saw the systematic architectural development of what was to be the Agora of Classical Athens (fig. 3). Wells were closed—suggesting the public expropriation of private property—and public buildings erected on the west side.[13] This activity was especially pronounced in the third quarter of the century when the temples of Apollo Patroos and Zeus Phratrios[14] and the colonnaded Stoa Basileios[15] were built. In the southwest corner, on the site of the later Tholos, a complex of buildings arose whose use continues to be a topic of debate; some maintain that these units represent the functional antecedents of the later Bouleuterion and Tholos, while others advance the view that Building F may have been the (or *a*) Palace of Peisistratos (fig. 4).[16] Interesting for our consideration is the fact that the major feature of Building F is an interior colonnaded court. Materials for these buildings were modest, with uneven toichobates of Akropolis limestone and walls of unbaked brick. With reference to the colonnade, of which only the stone bases survive, the excavator writes, "That the shafts were of wood we may infer from their small diameters, from the slightness of their bases, and from the complete absence of fragmentary stone columns. It follows that the superstructure of the porches was also of wood."[17] Even in important public or palatial complexes, then, trabeated architecture was the order of the day.

The last quarter of the century—perhaps circa 520 B.C.—saw the construction at the southeast corner of the Agora of a fountainhouse described by Pausanias as the *Enneakrounos* (fig. 5).[18] This building was provided with a facade of columns facing the Agora and with water basins at either end. There is scattered evidence elsewhere in the city for administrative concern for a copious water supply for public consumption—a pipeline runs south of the Akropolis from sources east of the city

Fig. 5. Southeast fountainhouse. Restored plan and actual state (J. Travlos) (from Thompson and Wycherley, *The Agora of Athens*, vol. 14, 198, fig. 50).

Fig. 6. Houses north of the Areopagos. Inset on right, for comparison with House A, are B, a fourth-century house, and C, a Byzantine house, to show continuity of type (from Wycherley, *The Stones of Athens* 239, fig. 66).

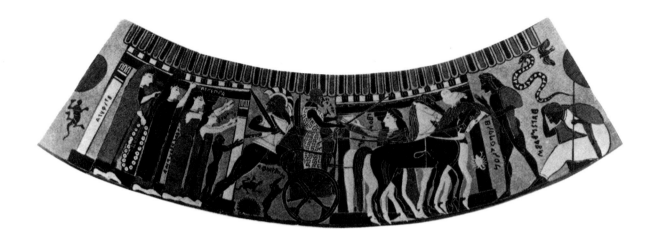

to residential neighborhoods near the Areopagos and another continues northward from the fountainhouse in the Agora.[19] Thukydides refers to another fountain or springhouse near the Ilissos as the Enneakrounos,[20] which may imply—as one commentator has observed[21]—that there were in fact nine outlets to this system, all known by the name Enneakrounos, of which that in the Agora was only one. The installation of such a system, with its blatant suggestion of tyrannical concern for the common good, may well have sparked the contemporaneous and ebullient production of scenes of fountainhouses on pottery.[22]

Thanks to the merciless activities of the Persians, little of the housing of the Archaic city remained unscathed, and little or nothing survives in the archaeological record. In the fifth century, however, houses seem to have accommodated their plans to existing streets—to have, therefore, been irregular in their exterior lines. The interior arrangement, however, seems to have been rather consistent, each unit having a few rooms grouped around a small court; bases for single columns occasionally mark the presence of small porches. Since the type continues in the fourth century, and persists even to the Byzantine period, perhaps we may conjecture from the longevity of the tradition that the sixth-century city was populated with similar structures (fig. 6).[23] This domestic architecture, then, is essentially introverted, whether we think of examples of housing from within the city or from the countryside, such as the country mansions mentioned by Thukydides (2.65) or those explored near the Dema Wall (fifth century) and near Vari (fourth century). Of all examples known to me, only that at Vari signals the entrance with a portico of wooden columns.[24]

Such, in brief, is the archaeological record of the architecture. What then of its appearance on pottery?[25]

We have already seen the stepped platform that Sophilos drew in the early years of the century and on which gesticulating spectators

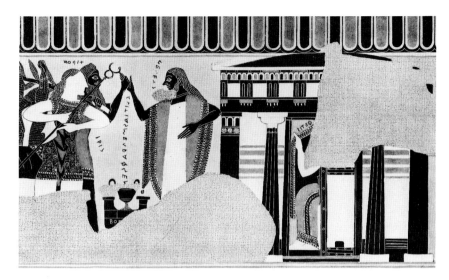

Fig. 8a. The François Vase by Kleitias. Side A: detail showing the house of Peleus (from Reichhold, in A. Furtwängler and K. Reichhold, *Griechische Vasenmalerei*, vol. 1 [Munich 1904] pl. 1 and 2).

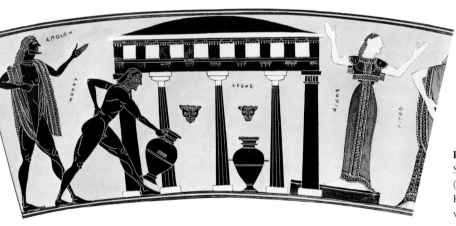

Fig. 8b. The François Vase by Kleitias. Side A: detail showing a fountainhouse (from Reichhold, in A. Furtwängler and K. Reichhold, *Griechische Vasenmalerei*, vol. 1 [Munich 1904] pl. 11 and 12).

Fig. 8c. The François Vase by Kleitias. Side A: detail showing the walls and gate of Troy (from Reichhold, in A. Furtwängler and K. Reichhold, *Griechische Vasenmalerei*, vol. 1 [Munich 1904] pl. 11 and 12).

Fig. 9. Lekythos by the Amasis Painter. Back: house of a bridegroom. New York, Metropolitan Museum of Art, 56.11.1, gift of Walter C. Baker, 1956.

stand[26]—at the same time literary allusion for us, reference to song for him, narrative element, and impressionistic representation. He also, on the dinos in the British Museum,[27] gives us a frontal view of the entrance to the house of Peleus: we see a porch with two columns *in antis,* a doorway behind, and a Doric frieze above. Space is juggled so that the house appears fully frontal while figures are rendered in profile view—the conventional Archaic juxtaposition. Such for the painter was the appearance of the dwelling of an immortal (Thetis) and a mythological hero (Peleus). Although not Attic, a similar treatment is accorded the residence of Amphiaraos on the Corinthian column-krater once in Berlin[28] (fig. 7): a frontal view of a dwelling with two Doric columns *in antis* and a Doric frieze above. Again, a representation of the residence of a mythological figure from the distant past.

Kleitias gives us a frontal view of three buildings on the François Vase,[29] all intended to document mythological tales: the house of Peleus is shown *distyle in antis,* with open door behind, Doric entablature, and gabled roof (fig. 8a); the fountainhouse at which Achilles ambushed Troilos, as a three-columned Doric porch *in antis* with Doric entablature and gable (fig. 8b); and the walls of Troy with gate and battlements (fig. 8c).

A *distyle in antis* arrangement with white-painted, spirally fluted columns is used by the Amasis Painter on the lekythos in the Metropolitan Museum[30] for depicting the house of a bridegroom (fig. 9) whose humbler lineage is shown by the marriage cart in which he and his bride and the best man, the *parochos*, ride, and by the donkeys which provide the locomotion. Nothing here suggests a mythological context, and the painter may be depicting a contemporary marriage in Attica. However, he also uses architecture in mythological scenes and employs the Doric order in his representation of the stables of Poseidon on the cup in the Norbert Schimmel collection,[31] painted in the third quarter of the century: a scene full of activity, surprise, and nervous energy is enacted in an architectural setting that makes use of Doric columns and capitals (or imaginative variations thereof) and a Doric frieze (fig. 10). Other black-figure painters give us abbreviations of buildings, when a column or two and part of an entablature may stand, for example, for the porch of a residence or even for the entrance to the Hall of Hades:[32] often the context is heroic, or divine, or mythological; sometimes it is unclear. Thus, this admittedly selective and cursory review shows that the representation of architecture does not take center stage in the thematic vocabulary of vase-painters in the first three quarters of the century.

In comparison with the scarcity of architectural images on vases in the earlier years of the century, the years following circa 525 B.C. saw the production of scores of vessels, often hydriae, decorated with representations of fountainhouses: some are shown in frontal elevation (fig. 11); others with single column, capital and entablature, and spout, *pars pro toto*; still others with compressed views—frontal elevation and profile wall and spout (fig. 12).[33] There is no mythological context in these representations, but an obvious reference to the installation of the Enneakrounos—however we interpret that term—by the tyrants.

With respect to *individual* architectural members, painters throughout the century evidently emulated—in however approximate a manner—actual forms they saw around them. Sometimes shafts of columns stand on bases, sometimes not. This may be an important distinction, allowing the conjecture that columns depicted with bases are to be thought of as wooden, and those without as stone; yet, in this context, the proportions of columns should perhaps be more significant, with thinness suggesting wood, squatness stone. Spirally fluted columns actually existed in Athens,[34] and the representation of such a column may be seen on the cup by the Heidelberg Painter in Taranto.[35] Most capitals are recognizably Doric, though hardly canonical; some even show the floral neck decoration[36] best known to me in the Greek west, on the capitals of the temples of Hera I and Athena at Poseidonia-Paestum.[37] Such decorated capitals probably—some would say certainly—existed closer to home, and there is little reason anyway to suppose that painters did not travel, or that they did not have knowledge of architecture elsewhere than at Athens (especially given the ethnic character of some names—Lydos, for example). Other capitals apparently mirror Ionic or even Aeolic forms: a hydria in the British Museum shows a fountainhouse equipped with Ionic-looking capitals (fig. 13),[38] while a neck-amphora, also in London, depicts an architectural facade elaborated with what look like Aeolic capitals.[39] Metopes in Doric friezes are sometimes decorated, more often blank, and occasionally open. The cup by the Amasis Painter in the Schimmel collection shows twenty-six such metopes, of which fourteen are decorated and twelve blank (fig. 10).[40] A hydria in the British Museum, on the other hand, shows a Doric entablature with an aryballos suspended from the architrave by a cord that passes through an open metope (fig. 14).[41] Evidently, in this instance, the painting represents a trabeated building; the black rectangles of the frieze stand for the ends of the wooden beams that become the triglyphs, while the blanks between

Fig. 10. Cup (type A) by the Amasis Painter. Side A: Doric columns and capitals in a stable setting. Kings Point, New York, Norbert Schimmel collection. Photo courtesy Metropolitan Museum of Art.

Fig. 11. Hydria by the Priam Painter. Front: front of a fountainhouse. Boston, Museum of Fine Arts, 61.195, William Francis Warden Fund.

Fig. 12. Hydria. Front: detail showing a fountainhouse. London, British Museum, B 330.

evidently represent open spaces not yet—in terms of the history of architecture—blocked up to make metopes.

In comparing the representations of architecture, then, with what we know of actual architecture, it seems *first* that actual architectural members do have pictorial counterparts, but *second* that the buildings represented do not correspond with anything we know from the ground, with the significant exception of the fountainhouses. We must then ask what these images do represent or what function they perform. Two possible answers come to mind: *first,* that they are used by painters as aesthetic devices for controlling space, for compositional clarity, and as narrative and decorative elements; *second,* that they are used by painters to express something more immediate and topical in their own environment. This latter use demonstrates a loosening up, an extension of their thematic vocabularies and an attention to contemporary concerns. It may even be possible to detect in this some elements of jingoism or even political propaganda.

Aesthetic devices first, then. It is evident that architectural elements offer certain three-dimensional spatial opportunities. Martin Robertson has shown how the painter of the Amphiaraos column-krater used representations of the facade of Amphiaraos' palace and the gatehouse opposite to suggest the space where Amphiaraos takes his leave (fig. 7).[42] Though the two buildings shown frontally stand on the groundline of the picture, the figures concentrated in front of the palace

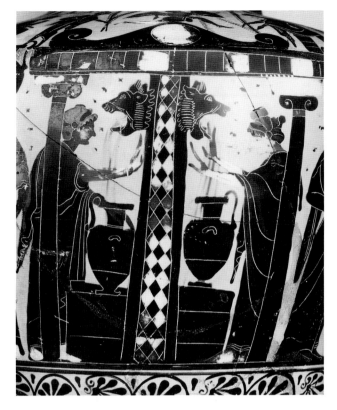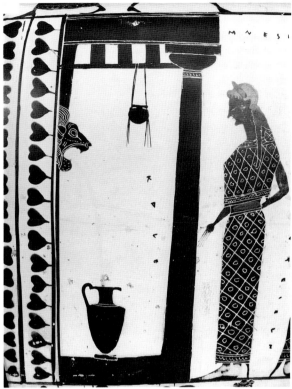

and the gateway, and the relative isolation of Amphiaraos and his charioteer with the open space behind, suggest that the architecture represents two sides of a courtyard and, as Robertson so felicitously puts it, "a unified containing space." On the François Vase, Kleitias presents the fountainhouse (fig. 8b) and the walls of Troy (fig. 8c) as overlapped by figures or as overlapping figures, thereby introducing a suggestion of different planes of activity; at the same time these architectural elements contain, concentrate, and frame the composition: spatial effects, then, but also compositional punctuation marks. Similarly, in the major frieze Thetis is seen within the house of Peleus, within and therefore in a plane further from the viewer (fig. 8a); the scene of the arrival of the guests runs all the way round the shoulder, interrupted only to accommodate the base of one handle,[43] to conclude at—and with—the house of Peleus, the syntactical full stop.[44] The illusion of space is minimal since the architecture is placed parallel to—or revolved into—the plane of the picture, and it is only the overlapping of figures which gives the illusion of space; at the same time this minimal insistence on depth preserves the integrity of the plane of the whole picture. This integrity of the surface is, however, sharply broken later in the century when, in representations of fountainhouses, for example, figures are painted both in front of and behind the columns of the porch (fig. 15) and even placed at an angle as if entering or leaving obliquely (fig. 16).[45] Other painters experimented with other spatial effects; one painter showed both interiors and exteriors

Fig. 13. Hydria. Front: detail showing a fountainhouse with Ionic capitals. London, British Museum, B 334.

Fig. 14. Hydria. Front: detail showing a fountainhouse with a Doric entablature. London, British Museum, B 333.

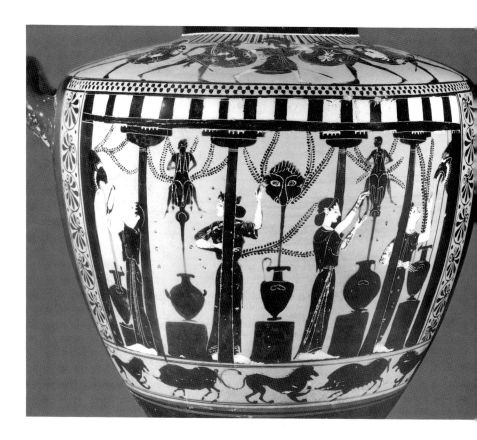

Fig. 15. Hydria. Front: detail showing the porch of a fountainhouse. London, British Museum, B 329.

in the same scene of a potters' workshop, as Alan Boegehold points out in his splendid introductory chapter to the catalogue of the show.[46] Another compressed alternating views, frontal and profile, into a single image.[47] Thus architecture was used for illusionistic space, it afforded three-dimensional effects, and it acted as compositional boundary markers and syntactical periods.

Architecture may also be said to provide essential features of some narratives—the gates of Hell, the battlements of Troy, Troilos' dread fountainhouse;[48] in such instances the architecture is intrinsic to the story. In others it may be extrinsic, and hence perhaps purely ornamental or fantastic; on the other hand, if it is extrinsic, one might be justified in asking whether it represented something actual or something generic. For example, the house depicted on the Amasis Painter's lekythos[49] showing a wedding procession has no counterpart, known to me, in sixth-century domestic architecture; we also see that the same appearance of a facade is accorded to Amphiaraos' palace and to the house of Peleus, whether in Sophilos' or Kleitias' version.[50] What do the human wedding-procession scene and the scenes of myth have in common? The social intricacies of marriage and the reciprocal agreements implied in sixth-century Greece have been illuminatingly studied by, among others, Jean-Pierre Vernant.[51] His work has carefully examined questions of alliances between families, dowry arrangements, degrees of legitimacy of chil-

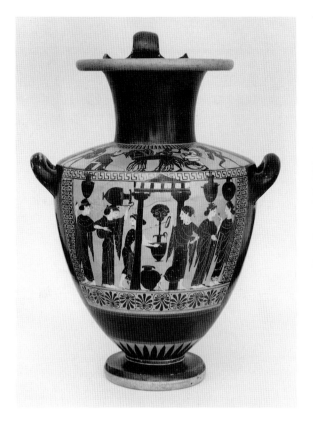
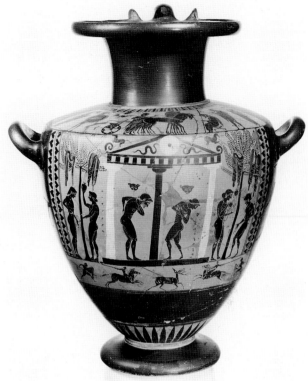

dren, and ownership of property and has underscored the high importance of this event in the lives of contemporaries. Thus wedding scenes, like mythological scenes, incorporate hidden agendas that touch the deepest human concerns about continuity and tend to represent traditional, conservative, and therefore comforting values.

Why then is it that in these scenes, the house, the point of departure and arrival, is shown in the way it is? The elevations of these residences all show two columns *in antis*,[52] an architectural arrangement known to the painters from temple architecture; articulated early in the century in the temple of Hera at Olympia,[53] it was exemplified for them by the Temple of Athena on the Akropolis and perhaps also by smaller buildings there.[54] This is the plan that the painters adopted to set the stage for mythological events as well as for important human events. It was, of course, also the plan of the Late Bronze Age Mycenaean palaces.[55] While it is perhaps beyond belief that the painters would have known, either by autopsy or word of mouth, of the architectural arrangements at Mycenae, Tiryns, or even at Athens, they would have heard the description of the house of Odysseus[56] and engaged, like all of us, in putative reconstructions. It is also possible that representations of these buildings may have existed in other art forms—wall-painting, for example—now lost to us. In any event, they accurately evoke the appearance of the facades of those Bronze Age dwellings. Thus, the first use of architecture

Fig. 16. Hydria by the Priam Painter. Front: porch of a fountainhouse. Toledo Museum of Art, 61.23, gift of Edward Drummond Libbey.

Fig. 17. Hydria. Front: men washing in a fountainhouse. Leiden, Rijksmuseum van Oudheden, xv e 28.

Fig. 18. Southeast corner of the Agora, showing the southeast fountainhouse, the layout of water pipes, and adjacent and subsequent structures (from T.L. Shear, fig. 3, in *Athens Comes of Age*).

on vases—in addition to providing spatial effects, compositional clarity, and narrative elements—is also *retrospective*, and like myth itself provides a link with the heroic events of the past.

The second use of representations of buildings on vases is to reflect actual contemporary structures: these are the fountainhouses, which appear in such profusion in the last quarter of the century. The scenes are full of alacrity and excitement; women drawing water, women queueing up, women gesturing and gossiping, men washing (fig. 17);[57] some fountainhouses are shown frontally, others in profile, and others with mixed views. Why is it that such scenes became so popular so suddenly? Why did painters prefer to draw fountainhouses rather than stoas, or temples, or houses? It is hard to imagine that the answer to this question is not directly connected to the popularity of the installation of the new water supply, the Enneakrounos, by the tyrants.

The southeast fountain in the Athenian Agora, recovered by excavation, is, significantly enough, datable from the archaeological record to the years of the rule of Hippias, son of Peisistratos. It was built around 520 B.C. and was supplied with water by a complex system of terracotta pipes; in plan it runs about eighteen meters east-west, and about seven meters north-south, showing three columns in the middle of the north wall facing the Agora, and water basins at each end (fig. 18).[58] Though it does not seem to be possible to find a precise representation of this building among the images on vases, the scenes on the vases nevertheless represent *real*, not imaginary, buildings.[59] The question for the painter, one suspects, may have been whether to make the fountainhouse recognizable and localize it, or whether to make it generic. That this question

may never have been fully resolved is suggested by the appearance of the name Kallirrhoe attached to some of the representations;[60] this seems to localize the fountain at the spring of that name in the riverbed of the Ilissos, but not all fountainhouses have this name. However that question is resolved, the fact bears repeating that these images are not intended as stone-for-stone replicas, but they do stand for *actual* structures.

The alteration and improvement of the water supply was evidently one of the most dramatic changes in everyday life in Athens and seems to have signaled a political shift in the realm of the government's responsibility for providing public services; it was clearly greeted jubilantly in the Kerameikos by potters, painters, and patrons. Corresponding to this political shift there seems to have been a shift both in what scenes artists chose to paint on vases and in private taste. Mythological scenes continued, but side by side with these, scenes from daily life increased in popularity. Scenes from myth dominated the first half of the century with increased interest in athletic contests coming in the second quarter; from about 550 B.C. onward other themes, other matters, are introduced, and scenes from daily life increase in variety and quantity —the shoemaker, the blacksmith, wine pressing, the olive harvest, weaving.[61] The appearance of the plethora of fountainhouses typifies this trend.

In terms of reflections of architecture, then, there is a shift from representations of buildings with no known functional parallels to images of those whose presence was immediate. The century sees a shift from a retrospective approach to subject matter, an approach that emphasized links with the mythological past, to something that balanced the world of myth with what was more contemporary and immediately recognizable. Is this evident in other aspects of art? Sculpture changes gradually in style, but hardly in subject matter until the big change at the time of the Persian wars;[62] architectural sculpture changes stylistically but maintains its preoccupation with mythological and heroic themes right down to the Aeginetan pediments and the metopes of the Athenian Treasury.[63] We would not, however, expect temples and treasuries—state dedications—to be decorated with anything other than epic and heroic themes. It is in vase-painting, which is the product of private enterprise, that both style and subject matter shift. This may be significant since it is one of the few indications of private taste we have. May we then say that the change of architectural representation on vases from imaginary structures to real buildings reflects a more deep-seated change—a change on the part of both painter and patron from a retrospective, conservative cast of mind to a more radical and liberal *mentalité*? Does this new frame of mind find any response in the political attitudes of the tyrants with their wide-ranging programs of public works, including fountainhouses? Is it an echo, or even a premonition perhaps, of an irresistible social change among the majority of Athenian citizens, which was to sound the death knell for the tyranny and usher in the democracy?

THE UNIVERSITY OF MICHIGAN
ANN ARBOR

NOTES

1. T. Wiegand, *Die archaische Poros-Architektur der Akropolis zu Athen* (Leipzig 1904); J.S. Boersma, *Athenian Building Policy from 561/0 to 405/4 B.C.* (Groningen 1970) 180; J. Travlos, *Pictorial Dictionary of Ancient Athens* (London 1971) 258–260.

2. R. Heberdey, *Altattische Porosskulptur* (Vienna 1919); W.B. Dinsmoor, *AJA* 51 (1947) 145–147; W.-H. Schuchhardt, *AA*, 1963, 811–812; M.S. Brouskari, *The Akropolis Museum: A Descriptive Catalogue* (Athens 1974) 25ff.; cf. I. Beyer, *AA*, 1974, 639–651; B.S. Ridgway, *The Archaic Style in Greek Sculpture* (Princeton 1977) 197–201; J. Boardman, *Greek Sculpture: The Archaic Period* (London 1978) 154.

3. S. Bancroft, "Problems Concerning the Archaic Acropolis at Athens" (Ph.D. diss., Princeton 1979; University Microfilms, Ann Arbor 1983) 26–45.

4. N. Bookidis, "Use and Geographical Distribution of Architectural Sculpture in the Archaic Period" (Ph.D. diss., Bryn Mawr 1967; University Microfilms, Ann Arbor 1979) 29–33.

5. H. Riemann, *Mitteilungen des Deutschen Archäologischen Instituts,* vol. 3 (1950) 7–39; Travlos (supra, note 1) 143–147; Brouskari (supra, note 2) 76–78; H. Payne and G. Mackworth-Young, *Archaic Marble Sculpture from the Akropolis* (London n. d.) 52–54; K. Stahler, "Zur Rekonstruktion und Datierung des Gigantomachiegiebels von der Akropolis," *Festschrift Hans Erich Stier* (Münster 1972) 88–112.

6. G. Welter, *AthMitt* 47 (1922); Travlos (supra, note 1) 402ff.

7. Aristotle, *Politics* V.1313b.

8. Vitruvius, VII *praef.* 15.

9. Travlos (supra, note 1) 540ff.

10. H.A. Thompson and R.E. Wycherley, *The Agora of Athens, the History, Shape and Uses of an Ancient City Center,* vol. 14 of The Athenian Agora (Princeton 1972) 126.

11. Athens, National Museum 15499, from Pharsalos. *ABV* 39,16.

12. Xenophon, *Hipparch.* 3.7.

13. T.L. Shear, "Tyrants and Buildings in Archaic Athens," in W.A.P. Childs, ed., *Athens Comes of Age: From Solon to Salamis,* Papers of a Symposium Sponsored by the Archaeological Institute of America, Princeton University, and the Department of Art and Archaeology, Princeton University (Princeton 1978) 4–5.

14. H.A. Thompson, *Hesperia* 6 (1937) 8ff., 79ff.; Thompson and Wycherley (supra, note 10) 96.

15. T.L. Shear, *Hesperia* 40 (1971) 243–255; ibid., 44 (1975) 365–370; Thompson and Wycherley (supra, note 10) 83ff.

16. H.A. Thompson, "The Tholos and Its Predecessors," *Hesperia* Suppl. 4 (1940) 40–44; Shear (supra, note 13) 6–7, following Boersma (supra, note 1) 16–17.

17. Thompson (supra, note 16) 21.

18. Pausanias I.14.1; H.A. Thompson, *Hesperia* 22 (1953) 29ff.; Thompson and Wycherley (supra, note 10) 197ff.; Travlos (supra, note 1) 204ff.

19. J.McK. Camp, "The Water-Supply of Ancient Athens" (Ph.D. diss., Princeton 1977) 49ff.

20. Thukydides II.15.5.

21. D. Levi, *Annuario della scuola archeologica di Atene* 23–24 (1961–1962) 149ff.

22. Cf. B. Dunkley, "Greek Fountain-Buildings before 300 B.C.," *BSA* 36 (1935–1936) 142–204. The production of vases with these scenes, begun in the last quarter of the century in black-figure, continues on vases in the red-figure style; for one of the last of the traditional fountainhouses see R. Olmos Romera, *Ceramica Griega,* vol. 1 of Guias del Museo Arqueológico Nacional, 2nd ed. (Madrid 1978) 57, fig. 24, a reference I owe to the kindness of Michael Padgett.

23. Most conveniently, R.E. Wycherley, *The Stones of Athens* (Princeton 1978) 237–244.

24. Cf. J.E. Jones, "Town and Country Houses in Attica in Classical Times," *Thorikos and Laurion in Archaic Times,* vol. 1 of Miscellanea Graeca (Ghent 1975) 63–141.

25. On this topic the most detailed general studies remain R. Vallois, "Etudes sur les formes architecturales dans les peintures de vases grecs," *RA*, 1908, 362ff.; and P. Oliver-Smith, "Architectural Elements on Greek Vases Before 400 B.C." (Ph.D. diss., New York University 1969; University Microfilms, Ann Arbor).

26. Supra, note 11.

27. London 1971.11–1.1. A. Birchall, "An Early Attic Bowl with Stand Signed by Sophilos," *British Museum Quarterly* 36 (1971–1972) 107–110.

28. Formerly Berlin 1655 (destroyed).

29. Florence, Museo Archeologico 4209.

30. New York 56.11.1; *Amasis Painter* 183, no. 47.

31. Kings Point, New York, Norbert Schimmel collection; *Amasis Painter* 217, no. 60.

32. E.g., the belly amphora by the Andokides Painter, Paris, Louvre F 204.

33. Hydria in London, B 330.

34. Wiegand (supra, note 1) 155, fig. 171.

35. *ABV* 66,55.

36. E.g., the hydria in Munich, 1693.

37. F. Krauss, *Die Tempel von Paestum* (Berlin 1959) 1 Lieferung, pls. 17–20, 43–44. F. Krauss, *Paestum:Die Griechischen Tempel* (Berlin 1943) pls. 14–17, 36; 3rd ed. (Berlin 1976) with contribution by G. Gruben and D. Mertens, pls. 59, 60, 67.

38. London B 334.

39. London B 49.

40. Supra, note 31.

41. London B 333.

42. M. Robertson, *A History of Greek Art* (Cambridge 1975) 121–123, 126.

43. For a somewhat analogous interruption, cf. the frieze fragments discovered in the foundations of the late Archaic Treasury of the Sikyonians at Delphi. Here metopes depicting the Argo are separated by a triglyph: Ridgway (supra, note 2) 235.

44. On the architecture depicted on the François Vase see *Development* 29.

45. Hydria in London, B 329. Hydria attributed to the Priam Painter, Toledo Museum of Art 61.23.

46. Fragmentary hydria attributed to the Leagros Group: Munich 1717. A. Boegehold, *Amasis Painter* 15–32.

47. Hydria in Munich, 1716.

48. Battlements of Troy: Hydria of the Leagros Group, Munich 1700.

49. Supra, note 30.

50. Florence, Museo Archeologico 4209; for a good illustration, see R. Brilliant, *Arts of the Ancient Greeks* (New York 1974) 60–61.

51. J.-P. Vernant, *Mythe et Société en Grèce Ancienne* (Paris 1982) 57–81.

52. The representation of the facade of a palace on the Corinthian cup in Paris, Louvre CA 2511, is problematical. Described in the *CVA* (Louvre, fasc. 6 [France, fasc. 9] 11–12, pl. 13.1–9 [1–3 showing architecture]) as presenting a "palais figuré à droite avec double portique et porte peinte en noir jauni," it appears to show a *tristyle in antis* facade. See H. Payne, *Necrocorinthia* (reprint College Park, Maryland, 1971) 115, fig. 40. Yet the cup is "much damaged" (Payne), and there is no indication of the walls on either side of the door. It seems that either the painter misunderstood his facade, or the central column is to be thought of as the central jamb of a double door behind a *distyle in antis* facade.

53. H. Berve and G. Gruben, *Greek Temples, Theaters and Shrines* (New York 1962) 317–318.

54. Supra, note 1.

55. C.W. Blegen and M. Rawson, *The Palace of Nestor at Pylos*, vol. 1 (Princeton 1966) 65–71, 420.

56. *Od.* 20 passim.

57. Leiden xv e 28; *ABV* 266, Antimenes Painter No. 1.

58. R.E. Wycherley, *The Stones of Athens* (Princeton 1978) 248; for the discovery and excavation of the southeast fountainhouse, and more detailed discussion, see the references cited supra, note 18.

59. On the question, inter alia, of whether the representations of fountainhouses on Greek vases are images of actual buildings, see most recently A. Malagardis, "Deux temps d'une fête Athenienne sur un skyphos Attique," *AK* 28 (1985) 71–92, a reference that I owe, and gratefully acknowledge, to Gloria Pinney.

60. London B 331.

61. E.g., lekythos by the Amasis Painter with women weaving, New York 31.11.10.

62. When, for example, striding figures step down from pediments to become emblems of political propaganda (Harmodios and Aristogeiton).

63. Bookidis (supra, note 4) M 46.

Brunilde S. Ridgway

Sculptor and Painter
in Archaic Athens

If, in discussing the cross-influences between Archaic sculpture and painting in Athens, I have chosen a title that recalls several famous works—John D. Beazley's *Potter and Painter in Ancient Athens* (London 1946), T.B.L. Webster's *Potter and Patron in Classical Athens* (London 1972), and Bernard Ashmole's *Architect and Sculptor in Classical Greece* (New York 1972)—it is not by chance, nor is it for assonance or mental association. It is because I am trying to convey that there is little originality in what I can contribute, and that I am heavily dependent on the work of others, while treading gingerly in what for me is the mine field of vase-painting. I must stress that I can claim no competence in it, and that only my interest in sculpture has prompted me to explore the given topic.

There has long been a tendency to correlate sculpture and vase-painting, but I shall begin with the influential dissertation by Ernst Langlotz, *Zur Zeitbestimmung der strengrotfigurigen Vasenmalerei und der gleichzeitigen Plastik*. In his work, Langlotz attempted to use dated monuments of sculpture to establish a chronology for early red-figure vase-painting, although eventually he was able to reverse the process to argue that certain pictorial renderings provided clues for the dating of some controversial sculpture. His comparison between the North Frieze of the Siphnian Treasury and the vases by the Andokides Painter has proved the most compelling,[1] although Langlotz himself admitted the possible geographical difference between the two oeuvres and, most significantly, the fact that the peplos continued to appear in the sculptural scenes after it seemed to have disappeared from the vases.[2] But he then compared the double stacks of folds in the Perseus Metope from Temple C at Selinus (fig. 1) with similar renderings on cups by Oltos, thus suggesting a date around 520–510 B.C. for the "provincial" sculptures, since these could not possibly have been the source for such an innovation.[3] An attempt to

Fig. 1. Metope with Athena, Perseus, and Medusa. Selinus, Temple C. Photo courtesy Bryn Mawr Photographic Collection.

reconcile both chronologies by assuming that Perseus' chitoniskos had been modernized by later recutting[4] has not met with general acceptance, and the low dating suggested by Langlotz seems impossible today. Equally difficult may be his correlation between the works of Euphronios and the metopes of the Athenian Treasury at Delphi; although the anatomical renderings seem comparable, the building is now cited with increased frequency as a post-Marathon dedication.[5] Yet if the sculptural framework has proved shaky, Langlotz's chronology for the early red-figure vases has stood the test of time, and only recently have attempts been made to lower the entire system. Of such attempts, those by David Francis and Michael Vickers would have the most noticeable consequences, but they are controversial; more moderate is the corrective curve between circa 550 and 470 B.C. suggested by Renate Tölle-Kastenbein, which allows for the greatest discrepancy around 500, but involves a maximum lowering of only circa ten to fifteen years.[6]

Another notable suggestion would attribute the change from black- to red-figure to sculptural influence. That proposal was made by Homer Thompson in a speech delivered in 1972 and was repeated in a 1984 publication, citing John Boardman's view in support.[7] According to this theory, the transition from highly colored poros statuary against a neutral background to colorless marble reliefs against a painted background, such as would occur on stelai or architectural sculpture, sparked a corresponding shift in vase-painting. The influence from medium to

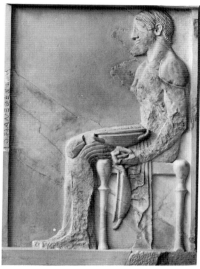

Fig. 2. Herakles and Triton. Pediment of the so-called Hekatompedon. Athens, Akropolis Museum, 35. Photo courtesy Bryn Mawr Photographic Collection.

Fig. 3. Potter's relief. Athens, Akropolis Museum, 1332.

medium, according to Thompson, was made all the more possible by the fact that sculptors and potters worked in close proximity in the Kerameikos, as is suggested by the detailed knowledge of bronze-casting techniques and tools revealed by the Foundry Painter's famous cup in Berlin. To be sure, several wells in the Agora have yielded the unquestionable remains of Archaic potters' dumps and wastes, but only bronze-casting pits and molds of similar date have been found in the area of the Hephaisteion. Marble sculptors' workshops are sporadically attested from the Classical to the Roman period, but, to my knowledge, no evidence for a sixth-century stone-carving establishment has yet been found within the confines of the Athenian marketplace.[8]

Compositional influence from pedimental sculpture has been advocated by Evelyn Harrison to explain the iconographic change in the pictorial rendering of Herakles' struggle with the Nemean lion. The upright position of both hero and animal, producing a pyramidal outline, would have been replaced by the version in which both man and beast lie on the ground in order to fill the awkward corner spaces of a triangular gable. Yet Harrison is properly doubtful that a true correlation between sculpture and vase-painting can be established, and Boardman, who seems to accept the suggestion (and who has published what may be the earliest vase-painting example of the "horizontal" struggle with the lion—by Exekias) has noted that the only extant pedimental composition with the same subject postdates the vase.[9] It could also be pointed out that the pyramidal version is almost better suited to fill a gable than the horizontal rendering, in which the rump of the beast is usually higher than the head, thus breaking the supposed slope from center to corner.

Boardman himself has occasionally correlated sculpture and vase-painting. A casual comment of his about personal names on the lip frieze with Theseus' dance on the François Vase has been construed to suggest that the sculptor Phaidimos was intended,[10] although the suggestion seems unlikely, given the mythologico-geographic context and the specific position of the figure so labeled. Where Boardman has had the greatest impact is in his contention that many epic themes and representations carry political allusions, which would be used by vase-painters and sculptors alike. So, for instance, Herakles struggling with Triton on the Hekatompedon pediment from the Akropolis (fig. 2) would symbolize the amphibious expedition against Megara in 566, in which Peisistratos acquired public acclaim for the first time by trying to secure Salamis for Athens.[11] Conversely, Ajax and Achilles playing dice on the

Fig. 4. Painted and engraved tombstone. Paris, Musée du Louvre, MND 1863.

famous Vatican amphora by Exekias would allude to Peisistratos' return to Athens that caught the Athenians literally napping and playing games, and would thus soothe their sensitivity by providing them with such an illustrious precedent. Exekias is therefore seen by Boardman as the painter of the opposition—if not a partisan of the Alkmeonids, at least an antityrant. Yet he also painted several scenes with Herakles, as has already been mentioned, which may invalidate the Herakles = Peisistratos equation, and Boardman himself points out that the dice-playing scene recurs in more than 150 vases in the 50 years following the Vatican amphora. In Archaic sculpture the scene is rendered with a central Athena, an addition which occurs on several vessels, but the players are kneeling and the resemblance to the pictorial compositions is not striking.[12]

The transition from black-figure to red-figure was discussed again in a 1985 article by Michael Vickers; although he considers metalwork, not sculpture, responsible, his theory must briefly be mentioned here because it seriously undermines our previous conceptions about potters and painters during the Archaic period. Vickers believes that luxury ware in precious metals must have been more extensive than present evidence suggests. He points out that the dark tarnish of silver, far from being objectionable, was probably appreciated, and he therefore sees black-figure as imitating tarnished silver silhouettes applied against a copper background. Conversely, red-figure would reflect the use of gold overlays on a blackened silver vessel.[13] Vase-painters would also have derived their inspiration from such precious wares in a more literal way, through the use of cartoons originally provided for the metalworker. Thus the standard formula *egrapsen* would signify the person who made the drawing, and *epoiesen* would stand for the person who executed it; similar scenes by different hands would then be explained through the use of the same prototype by several painters.[14]

Many more suggestions included in Vickers' lengthy article deserve consideration, but here we can only focus on those that relate to our specific topic. If *epoiesen* refers to painters, potters are virtually eliminated from our picture, becoming thoroughly anonymous and unheralded. Vickers believes that this is as it should be, that the myth of the worthy but humble craftsman was fabricated in our time, because it was congenial to the period of Beazley and his contemporaries. Thus the various dedications on the Akropolis would have been made not by potters but by citizens of the deme Kerameis (since *ho kerameus* is usually restored in the Athenian inscriptions), and even the seated man of the famous votive relief would be a metalworker, not a maker of clay vessels (fig. 3). No poor artisans would therefore be represented by their gifts on the Athenian citadel, and even the basins dedicated by "washerwomen" should be taken as symbols of a prosperous textile industry that could have been far more lucrative than pottery-making.[15]

If this reconstruction of the past is basically correct, we would lose one of the more obvious links between sculptors and vase-makers—the evidence that the latter patronized the former when they wished to dedicate their first fruits or tithes. On the other hand, such widespread use of gold and silver plate as Vickers advocates seems surprising in pre-

Marathon Athens (and I am not sure that his efforts at lowering Archaic chronology are entirely justified), and other offerings on the Akropolis do belong to modest traders, such as the small bronze shield dedicated to Athena by Phrygia, the bread-seller (*artopolis*).[16] It is perhaps surprising that only potters, not vase-painters, could afford expensive votive offerings, and it is also true that not all those listed by Antony Raubitschek may be safely considered potters' dedications.[17] Yet a psykter by Smikros shows Euphronios feasting in aristocratic company, including that famed beauty, Leagros, and the time and context are now plausible for this identification.[18] In addition, it is always dangerous to argue from nonexistent evidence, and although gold and silver plate from Archaic Athens could not reasonably have been expected to survive in great quantities, other media of equally perishable nature might be postulated as prototypes for black-figure/red-figure with at least a fighting chance for correctness: textile patterns, woven against dark or light backgrounds, and ivory inlays on furniture, perhaps of ebony. Finally, I still believe that similar scenes by different painters can be explained through patternbooks, although Boardman does not think they existed. They seem to have existed for Archaic sculptors, and not only within the same workshop, where repetition could be explained through simple imitation, but in places so far removed geographically as to preclude other explanations, according to the many instances assembled by Volker Strocka.[19]

If we can still retain the traditional interpretation of the *epoiesen* and *egrapsen* formulas, further connections can be postulated between sculptors and potters/painters. Not only do we know of artists who could both make and paint their pots (Euphronios, for instance, or Amasis, although this symposium may conclude otherwise) but activities may have been diversified within the same family: Eumares the painter was the father of the sculptor Antenor, and Euthymides' father was the sculptor Pollias. In Classical times, the double activity of Euphranor and Polygnotos, as both sculptors and painters, is amply attested, but the same may be true for Endoios, who on Nelonides' base claimed authorship for both statue and painted design.[20] This is an obvious point of contact and therefore also one of possible influences between sculptors and vase-painters—witness the numerous stelai on which figures are rendered not only with colors but also by engraved contours that strongly recall contemporary renderings on pots (figs. 4, 5). We should also remember that painting and carving seem to have been interchangeable in Archaic Athenian architecture, as in the votive capitals found in the Persian debris, which have merely engraved and painted moldings and volutes, or the functional Ionic columns with painted echinoi.[21]

Given these contacts and this common sphere of action, is it possible to postulate active influence from one form of art to the other and therefore to establish an approximate chronological correlation? The time has come for me to state my own position—and it is one of relative skepticism.

I do not doubt that occasionally such influences occurred. Certainly, the fascination with the human figure in motion, seen in a variety of views and in foreshortened rendering, is common to both relief sculp-

Fig. 5. Stele of Lysias. Athens, National Museum, 30.

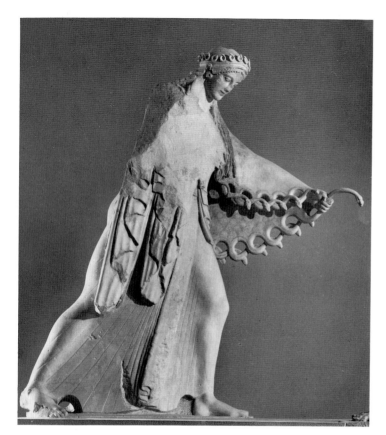

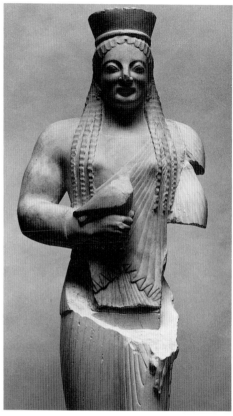

Fig. 6. Athena. Pediment of the so-called Peisistratid Temple. Athens, Akropolis Museum, 631. Photo Telis Anagnostou.

Fig. 7. The so-called Lyons Kore. Athens, Akropolis Museum, 269. Photo courtesy Bryn Mawr Photographic Collection.

ture and vase-painting. It probably originated with the latter (even more plausibly than with wall-painting), for the very high numbers of pots being produced and decorated must have promoted experimentation on a scale virtually unattainable by more monumental forms. Conversely, a successful pose or a new iconographic detail on a public monument may have had considerable impact on the vase-painters, as is shown by the Athena with outstretched aegis as it occurs on the Peisistratid Temple pediment (fig. 6), and then on approximately fifty vases and even in other sculptures.[22] Pictorial touches, such as the quiver and mantle of Herakles hanging from an empty background on the Athenian metopes, must derive from comparable vases, where the illusionistic rendering looks somehow more plausible. But the blobs of dark glaze on the hero's head and in the coiffures of athletes and other painted figures may attempt to imitate the snail curls or beaded beards of sculptural representations.

 Some anatomical patterns appear alike on sculptures and vases toward the end of the Archaic period, and here indeed a monumental painting may have provided inspiration, or even closer observation of real life. Anatomical features that look artificial to us may no longer be typical of our contemporary bodies, which are either bloated by a soft life and rich diet or magnified out of proportion by weight lifting. In the

early fifth century B.C., such detailed anatomical understanding may even have derived from a truer knowledge of the human body in medical terms and for healing purposes.

But the final verdict has to be against correlating sculpture and vase-painting for three major reasons, which can be mentioned here but not discussed in depth because of obvious lack of time.

The first is the fact that during the Archaic period vases and sculptures were basically produced for different purposes, therefore for different circles, and thus illustrated subjects appropriate for different environments. Whatever few themes the two arts may have in common represent such a small proportion of the total production that strict correlation is unwarranted.

The second reason is the true chronological difference we would encounter if we tried to date sculpture on the basis of vases and vice versa. Perhaps this indeed has been a methodological straitjacket with more serious consequences for pictorial than for sculptural renderings, as some of the objections voiced here to Langlotz's theories have suggested.

Finally, the third reason, which is almost a corollary of the previous two, is the very definite difference in the rendering of costume and folds, not only between sculpture and vases but also between black- and red-figure scenes. This point was noted by Langlotz, who tried to date the shift from peplos to chiton/himation, in "real life," between 540 and 530 B.C., on the evidence of vase-painting and a dubious passage in Herodotos about an Athenian quarrel with Aegina. We now surmise the latter anecdote to be legendary, and unless we are grossly mistaken in our dating of Archaic sculpture, we can assume that the two-garment attire had already appeared on the Akropolis by mid-century, both on the basis of Ionic/Cycladic imports and of local imitations such as the Lyons Kore (fig. 7).[23] By contrast, black-figure women, even Exekias' famous Leda on the Vatican amphora, so often compared to the Peplos Kore from the Akropolis, continue to wear a different costume, and even those by the Amasis Painter, supposedly stretching into the red-figure period proper, do not approximate sculptural versions.[24]

I shall end with a few personal comments on the Amasis Painter specifically, and the possible correlations of his work with sculpture, ultimately with a view to establishing his ethnic affiliations. That he was influenced by Ionic art because of the many dogs he painted on his vases cannot be argued on the basis of the definitely Ionic dog-stelai (fig. 8),[25] since other vase-painters of his time introduced the occasional dog into their scenes. Nor can we claim Ionic influence on the strength of the fringed garments he was fond of rendering, for not enough evidence exists on the East Greek side. He seems not to have been well acquainted with Athenian preferences in architectural sculpture, since on the Norbert Schimmel cup he included decorated metopes, which do not occur in Athens until after the Persian War, although the figures on the panels might represent paintings rather than reliefs. In any case, the Amasean building seems more magical than architectural, and carved metopes are as rare in Ionia as in Archaic Athens.[26]

It has been suggested that Amasis' Struggle for the Tripod echoes

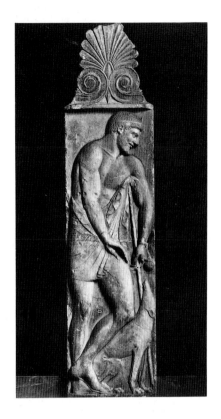

Fig. 8. The so-called Borgia Stele. Naples, Museo Nazionale, 11182. Photo courtesy Bryn Mawr Photographic Collection.

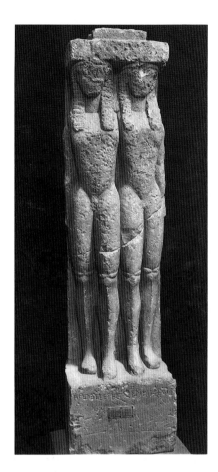

Fig. 9. Dermys and Kittylos. From Boeotia. Athens, National Museum, 56. Photo courtesy Bryn Mawr Photographic Collection.

the Siphnian Treasury pediment at Delphi in its use of a central figure between the two contestants,[27] but the painter used Hermes rather than Zeus, that is, a much less compelling figure with different implications. A vase in Munich shows a four-horse cavalcade led by a beardless youth, and it may be coincidence that on a funerary base from the Kerameikos the same number of men, bearded, is led by a younger rider who wears his hair in the ponytail favored by several Amasean figures.[28] Or perhaps such an arrangement once again reflects real-life practices in which the more youthful horseman would hurry ahead of his sedate companions. It is certainly correct to state that if several men on the Amasis Painter's vases stand in the stance of the stone kouroi, it is not because of direct imitation of statues or stelai but because that is the preferred view and the ideal pose.[29]

More significant may be the fact that the Amasean Potnia Theron often has wings attached to her front, in a rendering that is common in Ionic or Ionic-influenced art—not only in sculpture but also in jewelry, such as the famous series of gold plaques from Kamiros on Rhodes. On one vase the divinity is combined with a scene of two wrestlers who have the plump features so beloved in Ionic territory, where wrestling is still the national sport: but these also appear in other oeuvres and other fabrics, so that no true correlation can be established.[30]

One detail, however, exists that I cannot pass in silence, although all my friends expert in vase-painting refuse to believe my theory. The Amasis Painter seems to have been unusually fond of rendering figures closely linked in an embrace, in a complex posture that presents true difficulties both in painting and in sculpture, as is clearly shown by the Boeotian Dermys and Kittylos (fig. 9), whose disembodied arms seem to descend from the ceiling under the convenient cover of an all-hiding back screen.[31] But what remains in stone a never-repeated provincial manifestation cannot have been the inspiration for the Amasis Painter, and surely the vision of friends and young girls walking arm in arm through the streets of Athens might have provided sufficient stimulus for the painted scenes. Yet in Egypt such unnatural distortion of limbs and artificial embraces were used in sculpture as a virtual hieroglyph for relationship and protection (fig. 10).[32] Could the Amasis Painter, after all, have had an Egyptian connection?

BRYN MAWR COLLEGE

NOTES

1. E. Langlotz, *Zur Zeitbestimmung der strengrotfigurigen Vasenmalerei und der gleichzeitigen Plastik* (Leipzig 1920) 17–31; the comparison has been restated, for instance, by D. von Bothmer, "Andokides the Potter and the Andokides Painter," *Bulletin of the Metropolitan Museum of Art* 24 (1965–1966) 208–212, esp. 210.

2. Langlotz (supra, note 1) 21.

3. Langlotz (supra, note 1) 37.

4. R. Ross Holloway, "The Reworking of the Gorgon Metope of Temple C at Selinus," *AJA* 75 (1971) 435–436. On the Selinus metopes in general see,

most recently, V. Tusa, *La scultura in pietra di Selinunte* (Palermo 1983–1984) 114–117, nos. 7–9, and esp. 116, against Langlotz's chronology.

5. Langlotz (supra, note 1) 69–79. For a later dating see, e.g., *LIMC* 1, Amazones 593, no. 95, and 640. See also H.H. Büsing, "Ein Anthemion in Delphi," in G. Kopcke and M.B. Moore, eds., *Studies in Classical Art and Archaeology* (Locust Valley, N.Y., 1979) 29–36. More circumspect is J. Boardman, "Herakles, Theseus and Amazons," in D. Kurtz and B. Sparkes, eds., *The Eye of Greece* (Cambridge 1982) 1–28, esp. 12–14.

6. L.D. Francis and M. Vickers, "Leagros Kalos," *Proceedings of the Cambridge Philological Society* 207, n.s. 27 (1981) 97–136, and idem, "Signa priscae artis: Eretria and Siphnos," *JHS* 103 (1983) 113–124. Cf. however J. Boardman, "Signa tabulae priscae artis," *JHS* 104 (1984) 161–163.

 R. Tölle-Kastenbein, "Bemerkungen zur absoluten Chronologie spätarchaischer und frühklassischer Denkmäler Athens," *AA*, 1983, 572–584, and chart on page 577.

7. Thompson's speech was delivered on December 28, 1972, at the annual meeting of the Archaeological Institute of America, when he was awarded the Gold Medal for distinguished archaeological achievement; see now "The Athenian Vase-Painters and Their Neighbors," in P.M. Rice, ed., *Pots and Potters,* UCLA Institute of Archaeology, Monograph 24 (1984) 7–19, esp. 14, where he quotes J. Boardman, *Athenian Red Figure Vases: The Archaic Period* (London 1975) 14.

8. See, e.g., H.A. Thompson and R.E. Wycherley, *The Agora of Athens*, vol. 14 of The Athenian Agora (Princeton 1972) 186–189, and the article by Thompson in Rice (supra, note 7).

9. E.B. Harrison, *Archaic and Archaistic Sculpture*, vol. 11 of The Athenian Agora (Princeton 1965) 36–37, no. 96, fragment of pedimental relief, Herakles and Lion (?), circa 530–520 B.C., and comments at the end of the entry; for her skepticism on the correlation of sculpture and vase-painting, see page 16 (end of entry no. 65). J. Boardman, "Exekias," *AJA* 82 (1978) 11–25, esp. 15 n. 19.

10. This is the interpretation given by A. Stewart in W.G. Moon, ed., *Ancient Greek Art and Iconography* (Madison 1983) 70 and n. 79, where he refers to J. Boardman, *Greek Sculpture: The Archaic Period* (New York 1978) 74; there, however, only a comparison with *ABFV* fig. 46,4 is suggested.

11. J. Boardman, "Herakles, Peisistratos and Sons," *RA*, 1972, 57–72, esp. 59–60. Several other articles have followed the same line of thought; see, e.g., his "Herakles, Peisistratos and Eleusis," *JHS* 95 (1975) 1–12, and "Herakles, Delphi and Kleisthenes of Sikyon," *RA*, 1978, 227–234. Others have followed Boardman's lead and have read political meaning in vase-paintings and sculptures; for a different point of view, however, see W.G. Moon, "The Priam Painter: Some Iconographic and Stylistic Considerations," in *Ancient Greek Art* (supra, note 10) 97–118.

12. Boardman, "Exekias," (supra, note 9) esp. 18; for statistics on scenes with Herakles, see the chart on page 25.

 Sculptural group on the Akropolis: M.S. Brouskari, *The Acropolis Museum* (Athens 1974) 102–103 (with bibliography) no. 161, fig. 201.

13. M. Vickers, "Artful Crafts: The Influence of Metalwork on Athenian Painted Pottery," *JHS* 105 (1985) 108–128; see esp. 118: early black-figure "probably reflected the employment by metalworkers of silver figures on bronze, the transition to red-figure reflects metalworking practices introduced when gold began to be used for the backgrounds of black-figure and for the figures of red-."

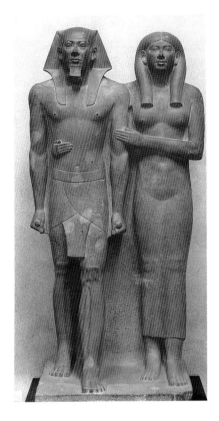

Fig. 10. Group of Mycerinus and his wife. Old Kingdom. Boston, Museum of Fine Arts, 14226. Photo courtesy Bryn Mawr Photographic Collection.

14. Vickers (supra, note 13) 126–127; Andokides "was probably in real life the silversmith who introduced gold-figure to Athens."

15. Vickers (supra, note 13) esp. 124–125 and n. 162 for the restoration of Athenian inscriptions.

 For the dedication of marble basins by women (one specifically describing herself as a *plyntria*) see A.E. Raubitschek, *Dedications from the Athenian Akropolis* (Cambridge, Mass., 1949) nos. 380, 348, and 369.

16. M.L. Lazzarini, "Le formule delle dediche votive nella Grecia arcaica," *Atti Accademia Nazionale Lincei, Memorie*, ser. 8, vol. 19 (1976) 47–354, esp. no. 46, pl. I,2.

17. For a list of votive offerings by presumed potters (besides those listed by Raubitschek [supra, note 15]) see T.B.L. Webster, *Potter and Patron in Classical Athens* (London 1972) 5–6 and, more cautiously, I. Scheibler, "Griechische Künstlervotive der archaischen Zeit," *Münchener Jahrbuch der bildenden Kunst* 30 (1979) 7–30.

18. J. Frel, "Euphronios and His Fellows," in Moon (supra, note 10) 147–158, esp. 147 and fig. 10,6.

19. For Boardman's comments on pattern-books, see his "Exekias," (supra, note 9) 11. For sculptural examples, see V.M. Strocka, "Variante, Wiederholung und Serie in der griechischen Bildhauerei," *JdI* 94 (1979) 143–173.

20. On Nelonides' base see, most recently, B. Schmaltz, *Griechische Grabreliefs* (Darmstadt 1983) 83–85 and fig. 6; also B.S. Ridgway, *The Archaic Style in Greek Sculpture* (Princeton 1977) 294 and n. 15, and cf. 287, with bibliography on page 300, for Eumares, who was possibly both painter and sculptor.

 On Euthymides and Pollias see Boardman (supra, note 7) 33–34.

21. For engraved stelai see, e.g., Schmaltz (supra, note 20) 81–101. Capitals from the Akropolis, in Persian debris: see, e.g., P.P. Betancourt, *The Aeolic Style in Architecture* (Princeton 1977) 100–103 and pls. 53–59.

 Ionic column: Thompson and Wycherley (supra, note 8) 166 and pl. 84b, c.

22. Peisistratid Athena: Brouskari (supra, note 12) 76, no. 631, figs. 144–150. J. Marszal, "The Aigis of the Peisistratid Athena" (M.A. thesis, Bryn Mawr College 1985) concludes that the influence probably derived from the pedimental composition, since of the approximately fifty vases that depict the type, twenty show it in the context of the gigantomachy, as it occurs on the temple.

23. Shift from peplos to chiton/himation: Langlotz (supra, note 1) 31. On Herodotos 5.82–88 and the Athenian quarrel with Aegina see T. Figueira, "Herodotus on the Early Hostilities between Aegina and Athens," *American Journal of Philology* 106 (1985) 49–74. On the early korai on the Athenian Akropolis, including the Lyons Kore, see Ridgway (supra, note 20) 104–106.

24. On the issue of the Peplos Kore and the meaning of the various costumes see B.S. Ridgway, "The Peplos Kore, Akropolis 679," *Essays in Honor of D.K. Hill*, Journal of the Walters Art Gallery 36 (1977) 49–61; idem, "Of Kouroi and Korai, Attic Variety," *Hesperia* suppl. 20 (1982) 118–127; idem, "The Fashion of the Elgin Kore," *GettyMusJ* 12 (1984) 29–58.

25. B.S. Ridgway, "The Man-and-Dog Stelai," *JdI* 86 (1971) 60–79; H. Hiller, *Ionische Grabreliefs der ersten Hälfte des 5. Jahrhunderts v. Chr.*, Mitteilungen des Deutschen Archäologischen Instituts, Istanbul, Beiheft 12 (Tübingen 1975) 129–130, 137–139.

26. Norbert Schimmel cup: *Amasis Painter* no. 60; see page 34 for the term Amasean (Beazley).

On the distribution of carved metopes in Archaic Greece see Ridgway (supra, note 20) 225–238.

27. Amasis' Struggle for the Tripod: neck-amphora, Boston 01.8027; *Amasis Painter* no. 25.

28. Panel-amphora in Munich, 8763; *Amasis Painter* no. 4; cf. pl. on page 62. Base in Athens, Kerameikos Museum P 1001: Boardman (supra, note 10) fig. 240. For Amasean ponytails see, e.g., *Amasis Painter* nos. 9, 11, 21, and passim.

29. *Amasis Painter* 47.

30. Potnia Theron: on panel neck-amphora (special shape), Basel, Antikenmuseum und Sammlung Ludwig, BS 497, *Amasis Painter* no. 21, the scene is combined with two wrestlers (detail on page 121).

 Rhodian plaques: G.M.A. Richter, *Korai* (London 1969) fig. 113. For other examples of this form of wing attachment on Klazomenian sarcophagi see, e.g., R.M. Cook, *Clazomenian Sarcophagi* (Mainz am Rhein 1981) E 8, Berlin 3353, pl. 23, and F 17.

 Relief of wrestlers, from Xanthos: E. Akurgal, *Die Kunst Anatoliens* (Berlin 1961) 135, fig. 86.

31. Dermys and Kittylos: Boardman (supra, note 10) fig. 66. Cf., e.g., *Amasis Painter* no. 19, side B; no. 23, side B.

32. See, e.g., C. Aldred, *Egyptian Art* (New York and Toronto 1980) figs. 35, 36, 61, 64. These compositions belong to the Old Kingdom, but patterns of this nature in Egypt are known to have survived through the millennia.

Albert Henrichs

Myth Visualized:
Dionysos and His Circle
in Sixth-Century Attic
Vase-Painting

I f Dionysos could visit the wine country of northern California or sail the sea, wine-dark or not, that borders this state from one end to the other, he would feel very much at home, I think, and rightly so. Wine is the gift of Dionysos, "a joy for men," as he is called in the *Iliad*. In myth he travels long distances to make his annual epiphany in the spring, to celebrate the Anthesteria in mid-March, and to bring the new wine to the male population of the coastal regions of Greece. He paid separate attention to the female population, and women known as maenads banded together at regular intervals to join the god in ritual activities, which took place on mountaintops outside the cities, and which included ecstatic dances and animal sacrifice.[1]

With their concept of Dionysos, the Greeks realized a physical enjoyment of life that was as much a response to their natural surroundings as it was an expression of some of man's deepest and most enduring feelings and desires. It would be tempting to extend the analogy between the world of Dionysos and the California of today to the equally Dionysiac provinces of ecstatic cults, of sexual liberation, and of a lifestyle that recognizes the importance of the environment and of the social group for the happiness of the individual. But while I resist this temptation, I yield to another by making the point that I cannot think of a place in the western hemisphere more congenial to a Dionysiac topic than the Getty Museum. Something of the spirit of Dionysos passed from the Greeks to the Romans, who embodied it in their triclinia and expressed it in their art. The Getty Museum is a replica of a Roman estate, the Villa dei Papiri in Herculaneum, which to this day lies buried under the debris of Vesuvius, another Dionysiac mountain. Bacchus was the divine patron of Mount Vesuvius, and visitors to the Museo Nazionale in Naples will remember the wall-painting from the Casa del Centenario which shows

the wine god decked out as a gigantic grape cluster and standing next to an image of the volcano itself, whose slopes are covered with vineyards.[2] The original Villa dei Papiri furnished a rich harvest of Dionysiac bronzes. These sileni, fauns, and female dancers are distant but vivid reminders of the earlier companions of Dionysos, who inspired the Amasis Painter and his fellows.[3]

When I was invited to contribute a paper on the cult of Dionysos and its importance for sixth-century vase-painting, my immediate reaction was to reverse this tentative title with its misleading implications and to talk about the importance of Dionysiac scenes on Archaic vases for our understanding of the earliest Greek conception of Dionysos. References to Dionysos and his numerous regional cults are relatively rare in Greek literature from Homer to Pindar and do not add up to a coherent picture. In fact, it would be impossible to give a general account, let alone a detailed description, of a single Dionysiac cult or festival in Athens or elsewhere during the lifetime of the Amasis Painter. If students of Dionysos had to rely on literary evidence alone, their knowledge of the god in the Archaic period would be confined to a few isolated pieces of information such as these: that Dionysos was associated with wine-drinking, phallic processions, and maenadic rites, as well as the origins of drama; that poets like Archilochos and Pindar composed Dionysiac dithyrambs, or songs for male choruses, of which only scarce fragments survive; that a more sinister side of the god comes to the surface in the cult title of "Raw-Eater" (*Omēstēs*), under which he was worshipped on the island of Lesbos and which recalls the gruesome omophagy of maenadic myth; and that at the opposite pole of the Dionysiac experience there is the high life of the symposium, centered on the pleasures of wine-drinking and sexual gratification, which are portrayed in the poetry of Anakreon.[4] Surprisingly, even the mythical record fails us. Homer and Hesiod devote fewer than three lines each to the myth of Semele's seduction by Zeus and Dionysos' premature birth, and important myths such as the Return of Hephaistos or the Battle of the Giants, in which Dionysos plays a major role, have left next to no trace in the extant poetry of the Archaic period.[5] Apart from the Lykurgos myth and the myth of the sailors transformed into dolphins, both of which portray Dionysos as victor over his opponents, the surviving epic literature does not do justice to the prominent place of Dionysos in early Greek religion. But the vase-painters fill some of the gaps, though more in the area of myth than of cult, and most of all through their depiction of the full rhythm of life in the company of Dionysos. Satyrs and maenads, as opposed to nymphs, are not mentioned in the same breath by any extant author before Euripides, and yet their combined presence imparts a distinctly Dionysiac character to scores of black- and especially red-figure vases painted during the second half of the sixth century. Without their help, it would be impossible even to begin to comprehend the powerful grip of Dionysos on the Greek imagination and his place in Greek society.

My remarks will concentrate on three prominent aspects of Dionysos that often overlap: the role of the satyr and the phallus; the ritual

identity of the maenad; and the god's connection with the vintage. I am neither an art historian nor a specialist in Greek vases, and I hope I will not be ostracized by the cognoscenti when I confess that I am more concerned with the narrative and religious content of the vases than with details of style or chronology. Within these parameters, I shall pay particular attention to possible links between art and literature as well as to the tendency, especially evident in the work of the Amasis Painter, to suggest a mythical dimension behind the various Dionysiac realms of the real world.[6]

SATYRS, SILENI, AND THE ROLE OF THE PHALLUS

Dionysos makes one of his earliest appearances in Attic art on the François Vase.[7] Produced circa 570 B.C. in the Attic workshop of Kleitias and Ergotimos, this monumental volute-krater is a unique treasure trove of detailed mythological narrative. Dionysos appears prominently on both sides of the vase. On the main frieze of side A the wine god is shown in the company of other divinities who are on their way to the palace of Peleus to celebrate his marriage with the sea goddess Thetis. The rare frontal view of Dionysos' face, with his piercing eyes and pointed beard, resembles the frontal satyrs on two vases by the Amasis Painter.[8] At the same time he foreshadows the masklike head of the god that characterizes a series of late sixth-century vases associated with the Antimenes Painter, as well as the actual masks that are the center of ritual attention on the so-called Lenaia vases of the fifth century.[9]

About to call upon the newlyweds, Kleitias' Dionysos carries a heavy burden on his shoulder: a large amphora apparently filled with wine, its invisible contents symbolized by the vine branch and grape cluster painted next to it (fig. 1). The sight of a Dionysos who is nimble and fast-moving despite the weight that he carries is so unusual that it calls for an explanation.[10] Normally the god carries a light drinking-vessel in his hand, a drinking horn or a kantharos, while leaving the heavier chores and the larger storage-containers to members of his entourage such as the satyrs, who often busy themselves with amphorae and wineskins on Attic vases. By equipping Dionysos with a wine jar, in striking contrast to subsequent iconographical convention, Kleitias presumably wanted to make a point: the amphora and its contents are not merely an unconventional attribute of the wine god; they are a wedding gift.[11] As an artist who was steeped in epic poetry and who reproduced many of its heroic themes, Kleitias appears to have taken his inspiration from an existing myth. According to epic tradition, still remembered in the *Odyssey* and echoed by Stesichoros, it was an amphora of divine provenance, "the work of Hephaistos" and "the gift of Dionysos" to Thetis, into which the Greeks at Troy gathered the white bones of Achilles after his corpse had been consumed on the funeral pyre.[12] It would be difficult to think of an amphora with a more distinguished pedigree, or a more ominous history. Kleitias and Homer must have had the same mythical amphora in mind, but they followed different epic traditions and looked at different aspects of its role in Greek myth. Depicting the amphora as Dionysos' gift to Thetis, Kleitias illustrates the

occasion for the gift, which Homer fails to mention.[13] Homer, on the other hand, emphasizes its ultimate and tragic utilization as an urn, of which Kleitias may even have been unaware, especially if the vessel he put on Dionysos' shoulders was made, not of gold like its Homeric counterpart, but of clay, as its most recent interpreter believes.[14] The material status of the amphora, however, is less significant than the mythical context by which the vase is characterized. Almost any amphora would suffice to establish the mythical reference, as long as it is unmistakably identified as Dionysos' gift to Thetis. The same amphora, seen from different mythical perspectives, can thus be portrayed as a source of joy or, in the larger Homeric context, a symbol of sorrow.

The fourth frieze on side B depicts the Return of Hephaistos, the most popular Dionysiac myth in Archaic vase-painting.[15] Hephaistos had been thrown from Olympos by his mother, Hera, but Thetis saved him. In revenge he designed a special chair, which trapped Hera and from which she could not extricate herself without his help. When he refused to come to her aid, Dionysos and his crew intervened and made him drunk. Once sedated, he was brought back to Olympos on a mule, surrounded by Dionysos and his entourage. In Kleitias' version, which is the earliest depiction of this myth by an Attic vase-painter, Dionysos leads the mule that carries the lame god. Three horselike creatures form the center of the thiasos. Identified as *silenoi* by an inscription on the vase, they are occupied in different Dionysiac tasks: the first carries a wineskin, the second plays the double-flute, and the third holds a female companion in his arms. Wine, music, and sex remained hallmarks of the Dionysiac experience throughout Greek and Roman antiquity, but the god himself tended to be much less indulgent than his followers. Although damage to the vase's surface destroyed the crucial parts of the embracing couple on the right, the sexual nature of their encounter can be safely deduced from more explicit scenes on several other black-figure vases depicting the Return of Hephaistos. Of particular interest is a hydria in Boston by the so-called Elbows Out Painter, a contemporary of the Amasis Painter.[16] Hephaistos and his Dionysiac escort occupy the body of the vase, while a series of love-making couples frolic about its shoulders. The satyrs who accompany Hephaistos in the principal register do not reappear on the shoulder frieze, which depicts ordinary men and women in the nude. Total nudity is a virtual prerequisite for explicit sexual scenes in Attic vase-painting. On a notorious series of komastic vases from the third quarter of the sixth century, for instance, groups of ordinary men and women engage in various sexual activities.[17] All of the participants are naked, and even though they lack specific Dionysiac attributes, they are occasionally accompanied by satyrs and, more often, surrounded by mixing vessels of enormous size, which create an unmistakably Dionysiac ambience. But whereas satyrs are invariably shown in their natural state, at least before the fifth century, their female companions usually wear clothes, as they do on the François Vase. In fact, a fully dressed woman or nymph appears in the company of two ithyphallic satyrs to the left of Hephaistos and his mule in the lower register of the same Boston hydria that depicts sexual activities on the

Fig. 1. The François Vase by Kleitias. Side A: detail showing Dionysos carrying an amphora as a wedding gift. Florence, Museo Archeologico, 4209 (from Reichhold, in A. Furtwängler and K. Reichhold, *Griechische Vasenmalerei*, vol. 1 [Munich 1904] pl. 1 and 2).

shoulder frieze. The dancing Dionysos to the right of the mule is joined by a satyr and another woman, who is wearing a very short chiton reminiscent of a miniskirt, a type of garment which recurs in other komastic vases by the same painter. Such variations in the portrayal of Dionysiac women on Archaic vases may have amused the painters as well as their customers. But for modern students of Dionysos the alternation of nude and draped female figures in the god's entourage raises important questions about their conceptual status and religious identity that will be taken up in connection with the Amasis Painter.

On a number of black-figure vases, including the François Vase and the Boston hydria, the mule that carries Hephaistos is as ithyphallic as the sileni or satyrs who accompany it. Phallic display on so massive a scale never fails to attract the attention of the curious, who are often unaware of the mythical context and its Dionysiac implications. Conditioned by individual taste and cultural standards, modern reactions to the phallic playfulness of Attic vase-painters have ranged from stern condemnation of the sexual license flaunted by the Greeks to admiring praise of their freedom of expression. Needless to say, the more sympathetic attitude prevails today, but we are still far from an adequate understanding of the role of the phallus in Dionysiac art and of its significance in Dionysiac myth and cult. A recent study of Athenian social history by Eva Keuls bristles with revealing illustrations and provocative comments, which tend to conceal the fact that the book is on the whole more serious than its title might indicate. In her cursory discussion of the phallus in public cult, the author suggests that "the entire Dionysiac religion, and with it both tragedy and comedy, seems to have sprung out of a systematic veneration of the male generative principle."[18] Among the pictorial evidence marshaled in support of this sweeping generalization is a black-figure neck-amphora of the Medea Group (550–535 B.C.) in Madison, Wisconsin, on which the Return of Hephaistos is given a piquant twist: a wine pitcher dangles gracefully from the tip of the donkey's erect phallus.[19] This sportive detail, which recurs on numerous black-figure vases, represents a visual amalgamation of two closely connected provinces of Dionysos, wine and sex, but it was hardly intended as a serious expression of religious beliefs, let alone belief in phallus worship.

The Greeks were evidently fascinated by the male reproductive organ, but they never worshipped it as a cult object, not even in the earliest stages of their culture. If that had been the case, phallic representations from the Archaic period or even the Bronze Age should significantly outnumber those from later periods. But the evidence points overwhelmingly in the opposite direction. Why was the phallus so popular throughout antiquity, and why did its appeal increase over the centuries? Perhaps because it suggested different things to different people, as it does nowadays. The range of possible meanings is still under debate, and each generation of interpreters seems to discover a new facet. No longer considered a mere fertility symbol, which was once the standard opinion, the erect phallus is currently interpreted in at least four different ways. For a long time the phallus was widely regarded as a magical symbol with apotropaic powers. This interpretation is still favored by various

archaeologists and art historians who find it useful when they come across phallic representations in prominent locations such as crossroads, doorways, or floors.[20] Conceptually similar is a more recent functionalist interpretation that is based on the analogy of animal behavior and that sees phallic exhibition as an intentionally obscene provocation designed to mark and protect territory, to keep competitors at a distance, and to establish superiority over a social group.[21] Current feminist interpretation, on the other hand, is more interested in the relationship between the two sexes than in biological function as such and tends to see the phallus in Greek art as the visual manifestation of male dominance and aggression in Greek society.[22] The main support for this view comes, incidentally, from vase-painting, much of it Dionysiac. Still another and more flexible approach has been advocated by Walter Burkert. In connection with ithyphallic herms, for instance, he adopts a strictly functionalist interpretation—the erect phallus functions as a signal that marks a certain perimeter and conveys an intimidating message.[23] But in connection with phallic demonstration in Dionysiac religion, Burkert offers a different perspective and suggests that the Dionysiac phallus is a symbol of unmitigated sexual arousal for its own sake, especially when magnified and projected onto an extraordinary scale, as in those Dionysiac processions in which gigantic phalli were carried through the streets of Classical Athens or other Greek cities.[24]

Any of these interpretations may be more appropriate than the others in a given case. What is more, they are not always mutually exclusive. But Burkert's approach, with its emphasis on sexual stimulation and its visible effects, seems to fit Dionysiac scenes on Archaic vases better than any of the others. Phallic excitement among satyrs is generally a response to two permanent denizens of the world of Dionysos: wine and women. The link between the ithyphallic satyrs and the two Dionysiac powers that stimulate them is therefore primarily physiological. This simple truth is often ignored by modern interpreters, even though it is supported by the expert opinion of a Greek doctor of the imperial period, Aretaios, who interprets the symbolism of the phallus in Dionysiac art along exactly the same lines: "In painting and sculpture, the satyrs of Dionysos are represented as ithyphallic, a symbol of the divine act (σύμβολον τοῦ θείου πρήγματος)."[25] Expressions such as "the divine act" or "the divine thing" (θεῖον χρῆμα) are Greek euphemisms for intercourse.[26] They are as old as the Archaic poet Archilochos, whose poems describe the joys of Aphrodite and Dionysos without the slightest inhibition. If we take our cue from Aretaios, an erect phallus in Dionysiac art means neither more nor less than what its appearance suggests, namely a strong sexual urge. On this interpretation, the ithyphallic satyrs and mules in the Return of Hephaistos may be presumed to feel exactly the way they look. More precisely, their erections are external signs of a physiological and mental condition that the Greeks ascribed to a divine agent and that Plato identifies as one of four types of "divine madness" (θεία μανία).[27] But the main concern of Archaic vase-painters is not the act itself, which would be the province of Aphrodite rather than Dionysos, but the sexual stimulation and elation that lead up to it.[28]

This elation is physiologically comparable to the excitement induced by wine or to the ecstatic fervor generated in orgiastic cults of Dionysos. From an anthropological point of view, sexual release, inebriation, and the sensory stimulation associated with ecstatic cults have much in common.[29] Often combined for heightened effect, they tend to produce an altered state of consciousness and a euphoric mood. In other words, they function as socially sanctioned mechanisms of escape into a different world of raised expectations in which the rules and conventions of ordinary life are kept in abeyance for a limited period of time. The god who presides over the Greek version of such externally induced but inwardly motivated escape mechanisms or fantasy journeys is Dionysos.

Numerous Attic vase-painters convey the various facets of this Dionysiac mood more abundantly and effectively than the written record ever could. Their works serve as constant reminders that the world of Dionysos is largely the product of mythopoeic imagination. While based on ordinary human experience, this mythical world is at the same time far removed from it. Dionysiac art in general has developed a remarkable ability to transcend graphic realism by admitting mythical figures like the satyrs or various kinds of exotic animals as active participants in its grape harvests and cultic scenes. The resulting fusion of real and imaginative elements is a condition Dionysiac art shares with Dionysiac religion through the medium of myth. In Dionysiac myth, whether expressed in pictures or words, men and beasts often act in unison, even to the point where natural distinctions are ignored or obliterated. Dionysiac leopards, for instance, are invariably treated like pets on Greek vases from all periods.[30] While assimilating these predators to more domesticated animals, and thereby de-emphasizing their wildness, the artists also seem to transfer the latent predatory power to the maenads who handle them. In a similar fusion of man and animal, the earliest painters of the Return of Hephaistos synchronized the sexual drives of all the male members of the thiasos by letting the ithyphallic mule share the excitement of the equally ithyphallic satyrs.[31] The satyrs themselves, with their equine features, illustrate the complete ease with which the mythical followers of Dionysos move from one natural realm to the other and appropriate characteristics of both in the process.

Nobody admired the animal-like nature of the satyrs more than Friedrich Nietzsche, who initiated the modern rediscovery of Dionysos as something more than the god of wine, indeed as a central aspect of Greek culture.[32] He regarded the satyrs and sileni as embodiments of the union between man and beast, of that "oneness with nature" in all her manifestations which lies at the heart of Nietzsche's understanding of the Dionysian, both as an art form and as a primal emotional experience. In his *Birth of Tragedy* (1872), Nietzsche characterizes the satyr in euphoric terms as "the archetype (*Urbild*) of man, the embodiment of his highest and most intense emotions, the ecstatic reveler enraptured by the proximity of his god," and again as "the one who proclaims wisdom from the very heart of nature, a symbol of the sexual omnipotence of nature which the Greeks used to contemplate with reverend wonder."[33] In the interest of his aesthetic theory, which connected the origins of Greek tragedy

with the satyr chorus, Nietzsche elevated the satyr to the sublime status of "the true human being," a prominence that no satyr ever enjoyed in antiquity. Nietzsche's conception of the satyr is doubtless exaggerated and flawed, yet the very fact that the Greek "man of the woods" (*Waldmensch*) made such a deep impression on him confirms the powerful influence of ancient art on the modern understanding of Dionysos.

Barely mentioned in pre-Hellenistic poetry outside the satyr-play, the satyrs are the product of myth mediated not by literature but by art.[34] Descriptions of satyrs in Greek and Roman literature which refer to their physical appearance were invariably inspired by artistic representations. It is from such representations that Nietzsche must have derived his particular conception of the satyr, whom he describes as "the bearded satyr who borrowed his name and attributes from the goat."[35] Since goat-footed satyrs are alien to Archaic art and only exceptionally found on some Classical vases, which were too obscure for Nietzsche to have known, he must have been thinking of the goatlike satyrs, or *paniskoi*, of Hellenistic and Roman art. He excluded from consideration the more primitive, horselike creatures of the François Vase and of countless other vases because they did not fit his neo-Aristotelian concept of the origins of tragedy, which required a satyr chorus consisting of men dressed as goats (*tragoi*) rather than horses.[36] By definition, therefore, Nietzsche's satyrs had to be goats. Although he was at the time a professor of classics at Basel, he may not have done his homework on the satyrs, or may have chosen to ignore what he knew, a mistake for which he was severely castigated by his critics.[37] But he was the first scholar in modern times who recognized the full extent of the importance of the satyrs by seeing them as Dionysiac embodiments of man's close ties with the animal kingdom and as visible reminders of shared biological functions. In Nietzsche's formative years, Darwinism had just appeared on the horizon, and man's descent from his primate ancestors was hotly debated. When Nietzsche describes the satyr as a "man of the woods," he immediately adds, "but he was not a mere ape in the eyes of the Greeks."[38] For the Greeks, to be sure, the satyrs were essentially human, but human beings reduced to their most basic, most animalistic needs. Indeed, the history of the satyr in Attic art is one of progressive humanization once he had become domesticated on the Athenian stage through the new artistic medium of the satyr play, in which men disguised as satyrs comically reversed the course of evolution.

NYMPHS, MAENADS, AND MAENADIC DECORUM: THE AMASIS PAINTER

Another feature Nietzsche derived from Classical art and literature is the distinction between many satyrs and a single silenus, whom he regarded as the embodiment of existential wisdom. On the François Vase, however, all three satyrlike companions of Dionysos are called *silenoi*.[39] The inscription that identifies them as such is the earliest occurrence of that name in the Athenian written record. Sileni and satyrs were iconographically identical throughout the sixth century, but for reasons that are still unclear, the Athenians apparently adopted the name "satyr"

only towards the end of the century when the satyr play was named after them.[40]

Whether called satyrs or sileni and whether thought of as horses, like the centaurs, or as goats, the lewdest of animals in the Greek view, these creatures are never far from female companions, whom they tend to treat as mere sex objects, a tendency which is most conspicuous on black-figure and early red-figure vases. In another inscription on the François Vase, the group of three women who round out the Dionysiac thiasos are identified not as maenads but as nymphs (ny(m)phai).[41] The same combination of nymphs and sileni occurs also in the *Homeric Hymn to Aphrodite*, where the mountain nymphs are introduced as future nurses of the divine child and the sileni are described as making love to them in caves.[42] In the Archaic period, all females who had reached the age of sexual maturity, whether mythical figures or not, were called "nymphs." More specifically, the word carried a distinct sexual connotation and described a woman who was the object of male attention, which took the form of either marriage or rape. In Greek art, nymphs, as well as some related deities of the *kourotrophos* type such as the Horai, Charites, and Aglaurids, are often represented in groups of three.[43] This iconographic convention recalls the triadic organization of maenads in both myth and cult. Each of Semele's three sisters leads a separate maenadic thiasos in Euripides' *Bacchae*, a pattern that is also found in actual cult.[44] Nymphs and maenads must be conceptually related. In light of their relationship, the maenads may be defined as ritual nymphs or even ritual mothers, as they were by Jane Harrison, or alternatively, the nymphs of Dionysiac myth may be regarded as proto-maenads who have not yet acquired the ritual identity that constitutes the hallmark of the true maenad in myth as well as in actual cult. But such definitions, which assume not only a conceptual but also a developmental connection between nymphs and maenads, are only of theoretical interest and have limited practical value when applied to Greek art.

Nymphs and maenads are infinitely more frequent on Archaic vases than in early literature. It is hardly surprising that close examination of the Dionysiac vases from the second half of the sixth century has yielded a useful set of iconographical criteria which makes it much easier to differentiate between nymphs and maenads, at least as far as their appearance is concerned. The visual testimony of the vases is indeed so crucial that if asked to define the essence of a maenad, I would be inclined to repeat the answer given by the late Justice Potter Stewart in response to a more delicate question: "I know one when I see one." In a fundamental article on the portrayal of maenads in Archaic vase-painting, published a quarter of a century ago, Mark Edwards defined nymphs as "female figures, clothed or not, accompanying satyrs but not having any Dionysiac attributes such as the *nebris* [fawn skin], *pardalis* [skin of felines], snake, or thyrsos."[45] The distinguishing marks of the maenad, on the other hand, are her ritual dress and paraphernalia. According to this definition, maenads are never nude, whereas nymphs may or may not be.[46] A female companion of Dionysos in proper ritual dress who is brandishing some maenadic implement, such as a thyrsos, is a maenad. If

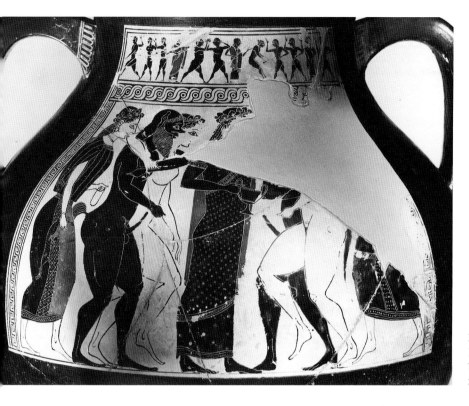

Fig. 2. Panel-amphora by the Amasis Painter. Side B, panel: Dionysos flanked by satyrs and women. Formerly Berlin, Staatliche Museen, 3210 (lost).

she lacks both, she is a nymph. This makes excellent ritual sense. Total nudity of mature women was unknown in Greek cult. The limited extent to which ritual nudity was tolerated is well illustrated by a series of *krateriskoi* (found at Brauron and in other sanctuaries of Artemis throughout Attica) on which young girls run the ritual footrace.[47] On some of the vases, they are wearing short chitons; on the others, they are completely naked. The physical appearance of the naked girls suggests that they are at the threshold of puberty, and a comment in Plato's *Laws* confirms that girls who had reached the age of thirteen could no longer run naked in athletic contests.[48]

It is not the company she keeps that distinguishes the maenad, but her appearance. Maenads, like nymphs, are found in the company of Dionysos, of satyrs, or of both. Unlike nymphs, however, maenads are occasionally shown by themselves. Although their dress and paraphernalia set the maenads apart, students of Greek vases are not always prepared to make a distinction between nymphs and maenads. If, out of convenience, all female followers of Dionysos are called maenads, regardless of their characteristics, then nymphs become maenads by definition and the task of the interpreter is simplified. But outside art, nymphs and maenads have different religious identities which support the distinction. Maenads have prominent *ritual roles* even in myth, whereas nymphs are defined more generally by their social roles as women who serve as objects of male attention or as foster mothers. Students of Greek myth and religion must differentiate between nymphs and maenads, even

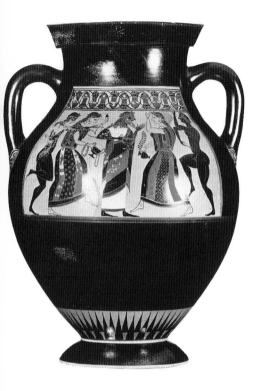

Fig. 3. Panel-amphora by the Amasis Painter. Side B: Dionysos flanked by men and women. Basel, Antikenmuseum und Sammlung Ludwig, Kä 420.

though they recognize that conceptually both are members of the same family.[49]

As we proceed to apply Edwards' definition to the maenads of the Amasis Painter, we run into several problems, which are illustrated by two panel-amphorae, one formerly in Berlin (fig. 2) and the other in Basel (fig. 3).[50] The fastidious, symmetrical arrangement of male and female figures on both vases is characteristic of the Amasis Painter. This symmetry is enhanced by the striking alternation of dressed and undressed bodies, which draws our attention to the women on both vases, who are conventionally described as maenads.[51] According to Edwards' definition, however, two of the four women on side B of the Berlin vase do not qualify as maenads because they are nude.[52] Their nudity mirrors that of the two satyrs with whom they are paired. In contrast to the naked couples who flank Dionysos, the two women on the extreme right and left are fully dressed, and the woman on the left carries a dead hare.[53] It is this combination of attributes, if anything, that inclines one to identify her as a maenad. The exceptional group of Dionysiac figures on the Berlin vase is perhaps best understood as a mannered reinterpretation of the less decorous thiasoi of dancing satyrs and nymphs which are so ubiquitous in black-figure and which the Amasis Painter himself employed to good effect in the subsidiary upper friezes of several of his panel-amphorae, including the frieze on side A of the amphora in Berlin.[54] The juxtaposition of nude and dressed female attendants of Dionysos is not unusual in such scenes. The Boston amphora by the Dayton Painter, from around 520, shows a similar combination of nude and dressed nymphs in the company of satyrs, and not a satyr who "carries a *naked maenad* toward a couch," as one commentator described the scene.[55] The Berlin amphora appears to be unique, however, in that it juxtaposes nymphs and maenads, two groups of Dionysiac women that are normally kept separate in art as well as literature. The Amasis Painter was active during a period in which nymphs were gradually replaced by maenads on Attic vases. Did he try to capture this transition by choosing such an unusual design for the Berlin panel?

As we turn to the Basel amphora, it is immediately clear that we are no longer dealing with a mythical setting. The two naked males are real-life youths, and the two female figures, both wearing peploi, hold drinking vessels, wreaths, an ivy-sprig, and a single flower, all of which are sympotic and erotic rather than maenadic paraphernalia.[56] The two female dancers, both dressed, who flank Dionysos in a thematically related scene on a panel-amphora in the Louvre (fig. 4) gesticulate with empty hands, which makes it all the more hazardous to identify them as maenads.[57] Nor is their dress—elaborate peploi that lack the distinguishing mark, namely the animal skin—particularly maenadic.[58] The Amasis Painter is very fond of richly decorated peploi, which give him an opportunity to display his skill for intricate detail, but he does not confine these garments to female attendants of Dionysos, let alone to maenads. Although it is true that vase-painters occasionally transfer elements from the male world of the wine into distinctly maenadic contexts, I would prefer to regard the revelers on the Basel and Louvre panels as ordinary

HENRICHS

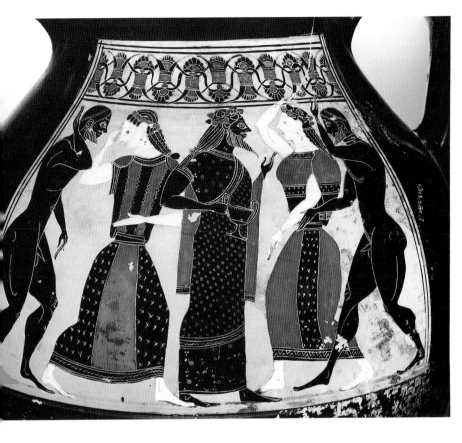

Fig. 4. Panel-amphora by the Amasis Painter. Side B, panel: Dionysos flanked by men and women. Paris, Musée du Louvre, F 36.

komasts without any particular ritual identity.[59] If it should be deemed desirable to invent a special designation for those female companions of Dionysos who are not sufficiently differentiated to be called maenads and yet are perhaps too hieratic merely to be called nymphs or revelers, I would propose to call them quasi-maenads, in order to distinguish them from the full-fledged maenads to whom we shall now turn.

The Amasis Painter was well aware what a full-fledged maenad should look like. At the peak of his long career, circa 540–530 B.C., he painted two indisputable maenads on the reverse of the famous neck-amphora in the Cabinet des Médailles (fig. 5).[60] Fewer than two dozen maenads in Attic black-figure are earlier than this pair, and none are remotely as hieratic.[61] The Paris maenads share with their quasi-maenadic counterparts on other vases by the Amasis Painter the ornate peploi, the ivy wreaths that crown their heads, the rhythm of the dance in which they move, and the close proximity to the god. What differentiates them from the others is the absence of male companions apart from Dionysos himself, and, above all, the animals they carry with them: a hare and a miniature stag, both live, and the spotted skin of a wild cat.[62] Maenads holding small felines, snakes, or other animals begin to appear around the middle of the century, followed shortly thereafter by maenads wearing leopard skins, but hares do not normally form part of the maenadic menagerie.[63] The maenad on the left, who is lifting the hare by

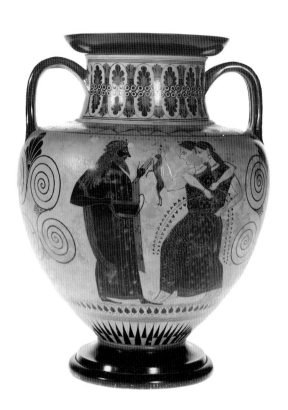

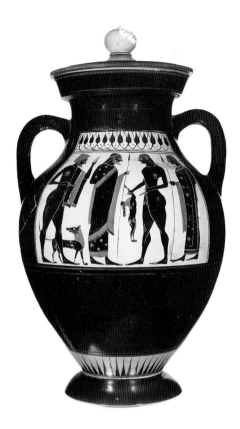

Fig. 5. Neck-amphora by the Amasis Painter. Side B: Dionysos and maenads. Paris, Bibliothèque Nationale, Cabinet des Médailles, 222.

Fig. 6. Panel-amphora by the Amasis Painter. Side B: youth offering a dead hare to an older man. Paris, Musée du Louvre, F 26.

its ears with her right hand to offer it to Dionysos as a gift, adopts a posture that is iconographically comparable to the one adopted on numerous vases, red-figure in particular, by homosexual *erastai* who offer hares or other spoils of the hunt to their *eromenoi*.[64] The Amasis Painter used this erotic motif in a series of amorous encounters on a cup-skyphos in the Louvre, while on one of his panel-amphorae (fig. 6), also in the Louvre, he reverses the roles and shows a naked youth offering a dead hare to an older man.[65] The maenad on the right, however, who is holding the stag with her lowered left hand, is the iconographical descendant of the Mistress of Animals. As portrayed by Kleitias on the François Vase and after him by the Amasis Painter, the goddess Artemis, her arms down, is holding a pair of lions, or in one case a leopard and a stag (figs. 7a, b), much like the maenad on the right.[66] Eschewing complete symmetry, the Amasis Painter chose to vary the gestures of the two maenads. By the simple expedient of the uplifted arm, and by substituting a hare for a feline, he transformed the maenad on the left, potentially another Mistress of Animals, into an adoring and gift-giving follower of Dionysos, an ingenious variation. The god himself reacts favorably, as behooves the Lord of the Maenads (μαινάδων ἄναξ).[67] Here as elsewhere in Greek art and literature, the maenads adopt masculine roles connected with the hunt. The maenads of Greek tragedy are explicitly portrayed as hunters, both of animals and of human prey. The *Bacchae* of Euripides is replete with the language of the hunt, and Aischylos already compares

the killing of Pentheus with the hunting of a hare.[68] By casting the two maenads so conspicuously in different but complementary roles, the Amasis Painter illustrates their domination over the animal kingdom as well as their affinity to Dionysos, himself a hunter.[69]

The ivy branches held by the two maenads recur on several other vases by the Amasis Painter, in the hands both of Dionysos and of various youths who accompany him.[70] These branches are the predecessors of the thyrsos, which first appeared near the end of the sixth century on early red-figure vases.[71] Two or three decades after the Amasis Painter, maenadic scenes without thyrsoi were unusual; the most memorable maenads from that period were invariably provided with them. The Munich kylix by the Brygos Painter, circa 490, shows one of the most fully equipped maenads in all vase-painting: she carries a thyrsos, holds a leopard, wears a *pardalis,* and has her hair bound together with a snake, a detail that recurs on a red-figure bell-krater in the Fogg Art Museum, Cambridge, Massachusetts, and in the parodos of Euripides' *Bacchae.*[72] The Kleophrades Painter provides equally memorable examples of maenads in full regalia.[73] What makes these red-figure maenads so unique is not the thyrsos they carry but the rapturous expression on their faces, which is the first attempt to render through the medium of art the intense emotions released by ecstatic cults, long before Euripides followed suit in his literary portrayal of Dionysiac madness. The Kleophrades Painter, the Brygos Painter, and Euripides have set the standard for maenadic behavior and its portrayal, a standard modern interpreters find difficult to resist. Ever since Nietzsche and his friend Erwin Rohde initiated the psychological interpretation of Dionysiac ritual about a century ago, these mythical maenads and their disturbed state of mind have attracted far more attention than the ritual activities of their real-life counterparts, which we know mainly from inscriptions and prose texts.[74]

The sudden prominence of ritual maenads in full gear on Attic vases from approximately 550 B.C. onwards must reflect a growing interest in maenadic ritual. Unfortunately we lack the cultic evidence to compare the mythical maenads on the vases with their real-life counterparts. The first historical maenad of whom we have any knowledge is the mother of Alexander the Great.[75] Maenadism was a regional practice that existed in some areas of Greece but not in others. It is unlikely that maenadic rites were ever celebrated within the borders of Attica, let alone in Athens. From the Classical period to the time of Pausanias in the second century A.D., the Athenian maenads had to go to Delphi to join the local thiasoi on Parnassos. But regardless of the extent to which the Attic vase-painters preserved authentic details of cultic maenadism, they created once and for all the image of the ideal or archetypal maenad that influenced the Greek and Roman conception of her for centuries to come.

Before moving on to the vintage scenes and other prominent references to wine on sixth-century vases, I should add that the nymphs and maenads of the Amasis Painter's larger panels are more solemn, civilized, and dignified than earlier as well as later artistic convention would lead us to expect. Not only are sexual encounters lacking, with one early exception, but the violence of Dionysiac myth is also ex-

Fig. 7a. The François Vase by Kleitias. Detail of handle A/B: Artemis with a leopard and a stag. Florence, Museo Archeologico, 4209. Photo Archivio Fotografico della Soprintendenza Archeologica della Toscana.

Fig. 7b. The François Vase by Kleitias. Detail of handle B/A: Artemis with lions. Florence, Museo Archeologico, 4209. Photo Archivio Fotografico della Soprintendenza Archeologica della Toscana.

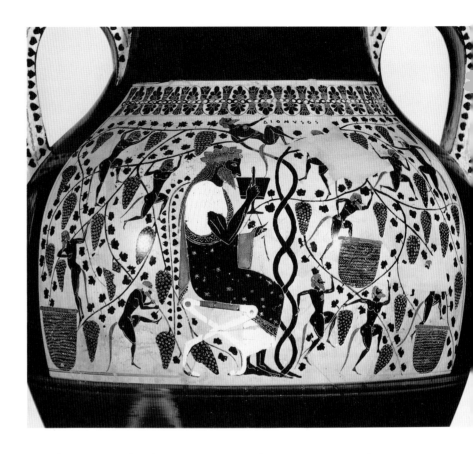

Fig. 8. Panel-amphora. Side B, panel: Dionysos and satyrs in a vineyard. Boston, Museum of Fine Arts, 63.952.

cluded.[76] On vases by the Amasis Painter, the mere presence of Dionysos seems more important than his actions or those of his followers, which are far removed from the blood, frenzy, and sheer agony of the earliest representation of the death of Pentheus by Euphronios on a psykter fragment in Boston, which was presumably painted within a decade after the career of the Amasis Painter had come to an end.[77] The maenad to the left of Pentheus is identified not as Agaue, Pentheus' mother, but as Galēnē, or Calm personified, a name that would describe the maenads of the Amasis Painter incomparably better than the agitated, violent protagonists of the Pentheus myth.

THE MALE WORLD OF THE VINTAGE AND THE WINE

On a magnificent amphora in Boston, from circa 540 B.C., Dionysos appears prominently in the middle of a vineyard surrounded by satyrs preparing to harvest the grapes (fig. 8).[78] Comparison with a contemporary Eastern Greek kylix from Samos (fig. 9) illustrates what an artist had to do if he wanted to convey the god's close connection with the wine and its production.[79] On the Boston vase, Dionysos' identity as the wine god is unambiguously established through his favorite drinking vessel, the kantharos, which he holds in his right hand; through the huge vine laden with grape-clusters that springs up next to him; and through the presence of the satyrs who do the work of the vintage for

Fig. 9. Samian kylix. Tondo: man between trees. Paris, Musée du Louvre, F 68. Photo courtesy Musées Nationaux, Paris.

him. Not one of these elements appears on the Samian kylix. For a long time the man between the two trees was interpreted as a bird-catcher, or the whole design was thought of as a nature scene without any action, until Erika Simon proposed to recognize in the central figure some Dionysiac daemon or even Dionysos himself as "Lord of the Trees," and in the two trees a pair of vines.[80] But the trees lack the characteristics of vines and the male figure has nothing in common with Dionysos. Of the various animals that inhabit the trees—to wit a mother bird and her four nestlings, a stylized snake beneath the nest, a grasshopper on the left below the snake, and another adult bird on the extreme right—only the snake could claim Dionysiac credentials. But it can be shown that the artist assigned a different role to the snake, and that he had a particular myth in mind. When the Greek army was assembled at Aulis for the first time, something ominous happened. The omen is described at great length in the second book of the *Iliad,* but it was also reported in another early epic poem, the *Kypria.*[81] After the Greeks had made a sacrifice on an altar beside a plane-tree in which sparrows had built their nest, a large snake appeared from beneath the altar, darted up the tree, and killed the eight nestlings as well as the mother bird. It is hardly fortuitous that all the principal actors in this animal drama can be found in the same corner of the Samos vase. The snake next to the nest is such an unexpected feature that Erika Simon took it for a vine tendril.

Unless the artist was an experienced bird-watcher who took his lessons from mother nature, the combined presence of the snake and the nest is best explained on the assumption that this dramatic scene was inspired by local epic tradition. On this interpretation, the picture on the kylix retains its special charm as an artistic comment on man's place in the natural world while acquiring an added mythical dimension that expands its literal meaning.

The non-Dionysiac scene on the kylix has sharpened our eye for the true image of the wine god. Like other painters of his period, the Amasis Painter was extremely fond of vintage scenes, which he used repeatedly for his panel-amphorae. Two complete scenes and fragments of three others have survived.[82] The essential elements recur with only slight variations: first the makeshift winepress in the center, consisting of a basket supported by a large trough; then the satyr in the basket who treads the grapes; and finally the busy crew of his wine-making fellows around him, occasionally in the presence of Dionysos and his nymphs, as on the Basel amphora. The vintagers of the Amasis Painter are always satyrs. Conspicuously hairy and ithyphallic, they are far removed from the Attic farmers of the real vintage. The annual grape harvest is thus projected onto a distant mythical plane in an abstraction from reality which amounts to a visual affirmation of the Greek belief that the wine is not a human invention but the gift of Dionysos. The male segment of the population was thought to be the legitimate beneficiary of this gift, especially in Attica and other Ionian cities where every male child was introduced to the wine at a tender age during the annual Anthesteria. Women of citizen status were officially excluded from this male privilege.[83] The vase-painters observed these distinctions by putting drinking vessels in the hands of hetairai, female komasts, or mythical maenads. Women of status, on the other hand, are shown carrying water or, exceptionally, ladling and distributing wine on the ritual occasion of the Anthesteria.[84]

The society of adult men who cultivated the pleasures of the wine is well illustrated on a series of panel-amphorae by the Amasis Painter, which show Dionysos as wine god in the company of naked or lightly dressed youths.[85] These ephebes carry a variety of accoutrements associated with the hunt and with wine-drinking, two predominantly male activities. If they lack individual character, it is because they are ideal representatives of the hunter and the symposiast. Their association with Dionysos seems to suggest that a successful hunt was followed by a drinking party over which the god presided. Athenian women had no access to this male world, and they do not appear in these scenes. Two of the youths attract attention because they pour wine from an oinochoe into the kantharos of Dionysos.[86] An amphora by Exekias provides a close iconographical parallel: a youth holding an oinochoe stands before Dionysos and offers the wine to the god but does not pour it.[87] A vase inscription identifies this youth as Oinopion, a mythical figure whose name means "son of the wine god."[88] The Hesiodic *Catalogue* already mentions him as the son of Dionysos, and from the fourth century on he appears as the first cultivator of the vine in various local mythologies.

But according to a different tradition known in fifth-century Athens, he was the son of Theseus and Ariadne and the founder of Chios, an island famous for its wine. Whatever his genealogy, Oinopion was the mythical model of the winegrower, and on Exekias' amphora it is perhaps in this capacity that he returns to Dionysos the divine gift of the wine in palatable condition.[89] The god is thus seen as the recipient of his own gift, brought to fruition by human care. The same message is conveyed by the wine-pouring youths who appear on the two panels of the Amasis Painter. But whereas Exekias portrayed the relationship between Oinopion and Dionysos in purely mythical terms by excluding any human participants, the Amasis Painter placed the god and his cup-bearer squarely in the real world of the Athenian ephebes. By not naming the youth, the Amasis Painter assimilated him to the other ephebes, who have no connection with myth. Through this shift of emphasis, the wine-drinking god becomes the divine role model for the human would-be symposiasts who surround him.

Dionysos the wine god plays an important part in the world of the Amasis Painter, whose vases define the god's place in Athenian society: his connection with the winegrowers and the vintage, with the komos and the symposium, and, above all, with the daily life of the male citizens who controlled the wine and its consumption. If the Amasis Painter brings Dionysos into sharp and realistic focus, his competitor Exekias prefers more imaginary and mythical settings for his portrayals of the god. The amphora with Oinopion and Dionysos illustrates this tendency well, but the celebrated Munich cup (circa 540–535 B.C.) brings it to perfection (fig. 10).[90]

Half a century ago Walter F. Otto devoted several chapters of his influential book to the timeless and powerful presence of Dionysos.[91] On Exekias' cup, this presence seems to be captured once and for all. I am not concerned with the artistic qualities of this masterpiece but with its mythical content. It is often assumed, by professional scholars as well as by amateurs, that the scene represents a particular myth, the transformation of the sailors into dolphins as told in the *Homeric Hymn to Dionysos*, which was presumably composed sometime in the sixth century.[92] There is common ground, no doubt, but the shared elements are of a general nature and can be found elsewhere in art and literature. They include the concept of Dionysos aboard a ship, the mast or tackle turned into vines, and the dolphins as fellow travelers and as a conventional representation of the sea. More significant than these similarities are the differences. I would not attach much importance to the varying appearance of Dionysos: a Zeus-like adult man versus a beardless youth.[93] Painters and poets often follow different conventions. The whole point of the *Hymn*, however, is the triumph of Dionysos over mortals who fail to recognize his divinity. The story pattern is the same as in the *Bacchae*, a resistance myth. Pentheus is the principal nonbeliever in Euripides' play, but the dramatist allows for two equally prominent believers, Kadmos and Teiresias, who stand by Dionysos. So, also, does the helmsman in the *Hymn*, who sees the god in Dionysos and tries in vain to convert the rest of the crew. They persist in their opposition, and, when they are finally

so perplexed that they jump into the sea, they are turned into dolphins. Only the pious helmsman is saved. If Exekias was trying to render this myth, he certainly missed its point. There is no helmsman, and the dolphins are just that, dolphins, with no trace of their former state. Yet the few certain representations of the myth in Greek art always invest the sailors-turned-dolphins with a vestige of their human form.[94] Because of these discrepancies, informed interpreters of the vase assume that Exekias did not intend a visual version of this myth.[95]

Instead of postulating a specific mythical reference, which is difficult to establish, many scholars recognize an equally specific cultic reference and connect the scene on the cup with Dionysos' springtime arrival by sea, which was ritually commemorated in several Ionian cities, including Athens.[96] The annual opening of the sailing season in March marked a new beginning which coincided with the broaching of the new wine. The connection is tempting, but far from certain. The travels of Dionysos and his arrival by land or sea are such common concepts in Dionysiac myth that their presence on the Exekias cup is not enough to link the vase with any particular festival.

There is an alternative, however, which puts Exekias' cup and its symposiastic Dionysos where they belong, in the context of the symposium. Exekias painted a Dionysos who reclines like a symposiast: the upper part of his body is naked, and he is holding a drinking horn in his

hand. Greek symposiasts often described their condition in nautical metaphors: the symposium is compared to a ship, their drunken behavior to sailing and rowing, and the toll that the wine takes to seasickness. Greek literature, albeit after Exekias, provides overwhelming evidence for this conception of the symposium as a ship of Dionysos.[97] It is easy to appreciate the relevance of the symposium and its atmosphere to the design on the vase. As the fortunate users of the cup gradually emptied its contents—the gift of Dionysos—they would see the god himself as a mirror-image of their own inebriated state, reclining in the characteristic posture of the symposium, drinking, and carried to distant shores as they perhaps were in their own minds.[98] Placed in the world of the symposium, for which he was intended, Exekias' Dionysos epitomizes the experience of his fellow symposiasts. He is, in short, the divine representation of a symposiast's dream, or fantasy, come true.

Students of Greek literature and Greek religion may be reluctant to part with interpretations that have tended to endow Exekias' masterpiece with a concrete literary reference or with a religious dimension in which myth and cult seem to coincide. But if the essence of great art lies in its ability to transcend the concrete occasion or spontaneous impulse that inspired it, nothing is lost. Exekias' Dionysos, motionless and yet propelled by his invisible power, has left the confines of the symposium far behind and established a ubiquitous presence, which is tantamount to a permanent theophany. But no matter how hard artists like Exekias or poets like Euripides tried to convey this presence, and no matter how well they succeeded, there is always something about the Greek Dionysos that seems to escape us. Hölderlin, another poet, had his own vision of Dionysos, but not without being aware of the god's elusive quality: "Nah ist und schwer zu fassen der Gott" —Dionysos is so near and yet so difficult to grasp.[99] The Amasis Painter would not have shared this sentiment: he seems to know exactly where Dionysos belongs. But Exekias reminds us that the god is always on the move, a powerful but fleeting presence.[100]

<div align="right">

HARVARD UNIVERSITY
CAMBRIDGE

</div>

NOTES

1. On the principal aspects of Dionysos in historical perspective see A. Henrichs, "Changing Dionysiac Identities," in B.F. Meyer and E.P. Sanders, eds., *Self-Definition in the Graeco-Roman World,* vol. 3 of Jewish and Christian Self-Definition (London 1982; Philadelphia 1983) 137–160, 213–236 (with bibliography).

2. H. Herter, "Bacchus am Vesuv," *Rheinisches Museum für Philologie* 100 (1957) 101–114 = idem, *Kleine Schriften* (Munich 1975) 626–637 (with plate); W.F. Jashemski, *The Gardens of Pompeii, Herculaneum and the Villas Destroyed by Vesuvius* (New Rochelle, N.Y., 1979) 220–221, figs. 318–319.

3. D. Comparetti and G. de Petra, *La Villa ercolanese dei Pisoni, i suoi monumenti e la sua biblioteca* (1883; reprint Naples 1972) 267–272, with pls. 13–16.

4. G.A. Privitera, *Dioniso in Omero e nella poesia greca archaica* (Rome 1970); A. Henrichs, "Greek and Roman Glimpses of Dionysos," in C. Houser,

Dionysos and His Circle: Ancient through Modern, ex. cat. (Cambridge, Mass., Fogg Art Museum 1979) 1–11.

5. Return of Hephaistos in art: *Imagery* 13–29; in fragments of early Greek poetry: R. Merkelbach, *ZPE* 12 (1973) 212–215. Battle of the Giants: E. Simon, *ZPE* 57 (1984) 1–21, esp. 6–10; *Imagery* 55–75; R. Seaford, *Euripides, "Cyclops"* (Oxford 1984) 94–95; M.B. Moore in *Greek Vases* 2 (1985) 21–40; *LIMC* 3, Dionysos 609–663. Dionysos attends the birth of Athena in the company of other Olympian gods on several Attic black-figure vases (listed by F. Brommer, *JbMainz* 8 [1961] 76 n. 10), including two amphorae of the Tyrrhenian Group (infra, note 17): Prometheus Painter, Paris, Louvre E 852; *ABV* 96,13; *CVA* Louvre 1, III Hd, pls. 5,6, and 7,5; S. Pingiatoglou, *Eileithyia* (Würzburg 1981) pl. 3,1. Kyllenios Painter, Berlin F 1704; *ABV* 96,14; CVA Berlin 5, pls. 12,1 and 16,2; Brommer (supra, this note) pl. 20; K. Schefold, *Götter- und Heldensagen der Griechen in der spätarchaischen Kunst* (Munich 1978) 13, fig. 1; F.T. van Straten, *Lampas* 17 (1984) 169, fig. 9; Pingiatoglou (supra, this note) pl. 2. Dionysos' presence on this occasion is not explicitly recorded in the poetic and mythographical tradition, and not noted by Carpenter, *Imagery* (who discusses some of the iconographical peculiarities of both these Tyrrhenian vases in *OJA* 3 [1984] 46).

6. The original lecture, here reproduced with some revisions, was written without the benefit of Carpenter's fundamental book (*Imagery*), which was not yet available at the time of the Amasis symposium. His study is concerned with the development of Dionysiac iconography in sixth-century Athens, mine with its significance as our earliest extensive record of Dionysos and his religion. Our approaches are different, and while I rarely disagree with his iconographical findings, I am not prepared to adopt his excessive reluctance to interpret the mythical, ritual, or social relevance of the vase-paintings, nor to accept his narrow conception of Dionysos as "a light-hearted symbol of the pleasure of wine" whose "vital forces dissipate" as his imagery becomes "more serious" after the middle of the sixth century (*Imagery* 124–126).

7. Florence 4209; *ABV* 76,1; *Development,* rev. ed. 26–29, pls. 24,2 and 25,4; *Imagery* 1–29 with pls. 1b, 4a; Simon and Hirmer 69–77, pls. 51–57; A. Perissinotto in *Vaso François,* Bolletino d'Arte, ser. spec. 1 (Rome 1981) 136, fig. 82, and 165, fig. 132; *La Cité des images* 158, fig. 225; *LIMC* 3, Dionysos 496, 567. The earliest depiction of Dionysos on a Greek vase is by Sophilos, circa 580 B.C. (London 1971.11–1.1; *Paralipomena* 19,16 bis; *Imagery* xv, 1–12, 89, 124, with pls. 1a, 2).

8. Würzburg 265; *ABV* 151,22; *Development,* rev. ed. pl. 54,2; *Amasis Painter* no. 19; *Imagery* 92, with pl. 19b; *LIMC* 3, Dionysos 415. Cracow 30; *ABV* 156,84; *Amasis Painter* 209, fig. 109a. Other frontal-faced satyrs appear on the following sixth-century vases: Lydos, New York 31.11.11; *ABV* 108,5; *Development,* rev. ed. pl. 36,2; M.A. Tiverios, *O Lydos kai to ergo tou* (Athens 1976) pls. 54a, 55b; K. Schefold (supra, note 5) 31f., figs. 23–24; S. McNally, "The Maenad in Early Greek Art," *Arethusa* 11 (1978) 110, fig. 3; *Imagery* 25–26, 72, 84; *LIMC* 3, Dionysos 563; infra, notes 31, 49, 61. Lydos, Basel 424; Tiverios, *Lydos,* pl. 96. Exekias, Budapest 50.189; D. von Bothmer, *Bulletin du Musée national hongrois des Beaux-Arts* 31 (1968) 17–25, fig. 13a; *Amasis Painter,* fig. 35; *Paralipomena* 61; *Imagery* 72 n. 80. Oakeshott Painter, New York 17.230.5; *Paralipomena* 78,1; *CVA* New York 2, pl. 19; *Development,* rev. ed. pl. 48,1; *Imagery* 22. The Affecter, Boston 01.8053; *ABV* 246,72; *Imagery* pl. 12b; and Orvieto, Museo Civico 1014 (239); *ABV* 244,46; K. Kerényi, *Dionysos: Archetypal Image of Indestructible Life* (Princeton 1976) fig.

39b; H. Mommsen, *Der Affecter* (Mainz 1975) pls. 100–101; *LIMC* 3, Dionysos 815. Lysippides Painter, Paris, Louvre F 130; *ABV* 262,49; *Hommes, dieux et héros de la Grèce*, ex. cat. (Rouen, Musée départemental des Antiquités, 23 octobre 1982–31 janvier 1983) 284, fig. 115a; *La Cité des images* 152, fig. 215. Manner of the Lysippides Painter, Boston 01.8052; *ABV* 259,26; *CVA* Boston 1, pl. 24,3–4; *Imagery* 94, with pl. 23a. Painter of Berlin 1686, Würzburg 249; *ABV* 296,10; E. Langlotz, *Griechische Vasen in Würzburg* (Munich 1932) pl. 80. Phintias, Tarquinia RC 6843; *ARV*² 23,2; *CVA* Tarquinia 1, pl. 1; P.E. Arias and M. Hirmer, *A History of One Thousand Years of Greek Vase Painting*, translated and revised by B. Shefton (London 1962) pl. 95,2.

9. *ABV* 275,1–8 (neck-amphorae with masks), cf. *ABV* 205–207 (cups with frontal Dionysiac masks, Group of Walters 48.42); Simon and Hirmer, pl. XXVIII (Tarquinia RC 1804; *ABV* 275,5; *Paralipomena* 121). On frontal representations of Dionysos in Attic vase-painting see A. Frickenhaus, *Lenäenvasen*, 72. Winckelmannsprogramm (Berlin 1912); W. Wrede, "Der Maskengott," *AthMitt* 53 (1928) 66–95; *Imagery* 11 n. 36, 97; J.-L. Durand and F. Frontisi-Ducroux, *RA* n. s. (1982) 81–108; F. Frontisi-Ducroux and J.-P. Vernant, "Figures du masque en Grèce ancienne," *Journal de Psychologie* 80 (1983) 53–69, reprinted in J.-P. Vernant and P. Vidal-Naquet, *Mythe et tragédie en Grèce ancienne*, vol. 2 (Paris 1986) 25–43; F. Frontisi-Ducroux in *La Cité des images* 147–161; Y. Korshak, *Frontal Faces in Attic Vase Painting of the Archaic Period* (Chicago 1986).

10. Dionysos' pose, at least from the waist down, resembles that of the dancing komasts on a kylix by the KY Painter, circa 580 B.C., Havana, Conde de Lagunillas; Simon and Hirmer, pl. 49 (upper figure); cf. W. Burkert, *Greek Religion* (Oxford 1985) 414 n. 45, who describes this Dionysos as "a masked dancer" (the god is indeed dancing but does *not* wear a mask). Carpenter offers a slightly different interpretation: "Dionysos' pose seems to reflect the archaic running pose—such as the one used for frontal-faced Gorgons— rather than to indicate the weight of the vase" (*Imagery* 11). It is significant that Dionysos' pose is more animated than that of the other gods, whose movements are calm and controlled.

11. The drinking horn as an attribute of Dionysos, established by the time of the Heidelberg Painter (after 570 B.C.), preceded the kantharos; see Carpenter, *OJA* 2 (1983) 281–282; *Imagery* 1 n. 1, 117–118. The amphora is unique.

12. *Od.* 24.71–75, cf. *Il.* 23.92 (a problematic verse). Thetis' amphora in Homer (infra, note 13) and Dionysos' amphora as portrayed by Kleitias (infra, note 14) were first connected by A. Rumpf, *Gnomon* 25 (1953) 469–470, whose most recent followers include Simon and Hirmer, 70f.; A. Stewart, "Stesichoros and the François Vase," in W.G. Moon, ed., *Ancient Greek Art and Iconography* (Madison, Wisc., 1983) 53–74, esp. 55–56; and D. von Bothmer and M.B. Moore in *Development*, rev. ed. 97 n. 3 bis. D. Williams in *Greek Vases* 1 (1983) 33 and Carpenter in *Imagery* 10–11 argue plausibly, against Rumpf, that the amphora on the François Vase should be full rather than empty; both scholars reject any connection between the two amphorae.

13. According to scholiastic tradition, the amphora improbably changed hands after Dionysos escaped Lykurgos by taking refuge in the depth of the sea, where Thetis received him (schol. *Od.* 24.74, with reference to *Il.* 6.135ff.; schol. A and T *Il.* 23.92). The Mythographus Homericus ascribes the same explanation for the gift to Stesichoros (schol. D *Il.* 23.92 = Stesich. fr. 57 [234] Page), but his ascriptions are notoriously unreliable and must be treated with utmost caution in the absence of corroborative evidence. Most

scholars follow the scholia (e.g., W.B. Stanford, *The Odyssey of Homer,* 2nd rev. ed. [London 1965] 415–416; G. Nagy, *The Best of the Achaeans* [Baltimore and London 1979] 209), but the François Vase suggests a much more plausible occasion for Dionysos' gift to Thetis. Although the different scenarios envisaged by Kleitias and, if genuine, Stesichoros are irreconcilable (pace Stewart, supra, note 12), they both go substantially beyond anything found in the Homeric poems, thus pointing to several variants of the myth (cf. Privitera [supra, note 4] 84–87). Kleitias' conception of the mythical amphora thus appears to be independent from either Homer or Stesichoros. The shared mythical datum in all three cases is the link between Dionysos and Thetis via an amphora given by the wine god to Achilles' mother.

14. G. Schaus, "Gold or Clay? Dionysos' Amphora on the François Vase," *Echos du monde classique/Classical Views* n.s. 5 (1986) 119–128. On the neck of the amphora carried by Kleitias' Dionysos appears an SOS design similar to the decorations commonly found on ceramic ware made in large quantities for commercial purposes (*Imagery* 10 n. 33). I doubt (pace Schaus, Carpenter, and Williams, supra, note 12) that the decoration as such and its conventional association with storage vessels are sufficient to dissociate this amphora from its famous epic counterpart.

15. *Imagery* 13–29, esp. 19–20.

16. Boston 95.62; *ABV* 249,9; *CVA* Boston 2, pl. 72.

17. *ABV* 95–105, *Paralipomena* 34–43; A. Greifenhagen, *Eine attische schwarzfigurige Vasengattung und die Darstellung des Komos im VI. Jahrhundert* (diss. Königsberg 1929) 39–40; *ABFV* 210 and fig. 61 (Munich 1432; *ABV* 102,98); K.J. Dover, *Greek Homosexuality* (Oxford 1978) pls. B51 (Munich 1431; *ABV* 102,99) and B53 (Heidelberg 67/4; *ABV* 102,101); G. Arrigoni, *Quaderni urbinati di cultura classica* 44 (1983) 8–9, with pls. 1–2 (Sassari 2402; *ABV* 102,96); T.H. Carpenter, *OJA* 2 (1983) 279–293, and *OJA* 3 (1984) 45–56, who lowered the accepted date for the so-called Tyrrhenian vases by almost two decades to circa 560–530 B.C., the period of the Amasis Painter.

18. E.C. Keuls, *The Reign of the Phallus: Sexual Politics in Ancient Athens* (New York 1985) 65–97, at 78. Compare the same author's "Male-Female Interaction in Fifth-Century Dionysiac Ritual," *ZPE* 55 (1984) 287–296, where the phallic satyrs who sexually assault maenads on Attic vases are implausibly interpreted as masquerading "participants in an actual ritual," and their sexual advances as ritualized "play-acting" carried out to defuse tensions between the two sexes.

19. Madison, Wisc., Elvehjem Museum; W.G. Moon and L. Berge, *Greek Vase-Painting in Mid-Western Collections,* ex. cat. (Art Institute of Chicago 1979) 96–97, no. 56; Keuls (supra, note 18) 81, fig. 70. Other vases with symposiastic paraphernalia such as oinochoai, flute cases, or wreaths hanging from the phalli of ithyphallic donkeys/mules or satyrs are listed in *Imagery* 21, 26, and 27 n. 66 (Paris, Louvre E 876; *ABV* 90,1; *CVA* Louvre 2, III Hd, pl. 23; *La Cité des images* 132, fig. 187b. Paris, Louvre F 3; *ABV* 297,12; *CVA* Louvre 3, III He, pl. 10,3. Munich 1522; *ABV* 283,1; *CVA* Munich 8, pls. 419,3, 422,1; H. Hoffmann in D. Metzler, B. Otto, and C. Müller-Wirth, eds., *Antidoron. Festschrift für Jürgen Thimme* [Karlsruhe 1983] 65, fig. 4. Dresden ZV 1466; F. Brommer, *JdI* 52 [1937] 203, fig. 3. Paris, Louvre F 351; C.E. Haspels, *Attic Black-Figured Lekythoi* [Paris 1936] 214,188. Basel 21.343; *CVA* Basel 1, pl. 52,4). Additional examples: Paris, Louvre AM 1008; *CVA* Louvre 4, III He, pl. 29,6. Athens, National Museum 541; Haspels (supra, this note) 208,49, pl. 23,2; *ABFV* fig. 235,1. Rome, Villa Giulia 3550; *ABV*

375,201; Kerényi (supra, note 8) fig. 54a. Brundage Collection 3/196; *Paralipomena* 149,15 ter; W.G. Moon in *Greek Vases* 2 (1985) 55, fig. 13b. I owe the following references to Mr. Michael Padgett: Yale 127; P.V.C. Baur, *Catalogue of the Rebecca Darlington Stoddard Collection of Greek and Italian Vases in Yale University* (New Haven 1922) 85, with pl. 5 (lantern hanging from phallus of Dionysos' mule). Basel market; *Münzen und Medaillen AG,* Auktion 40 (December 13, 1969) no. 81 (black-figure oinochoe of the Seattle Group; three donkeys amid satyrs, each with dangling oinochoe on phallus). London market; black-figure amphora (satyrs, maenads, and youth on donkey, the latter ithyphallic with aryballos in the shape of a human leg hanging from its phallus).

20. K.M.D. Dunbabin, *The Mosaics of Roman North Africa: Studies in Iconography and Patronage* (Oxford 1978) 162; H. Herter, "Phallos," *RE* 19.2 (1938) 1681–1748; idem, *Kleine Schriften* (Munich 1975) 645–646.

21. D. Fehling, *Ethologische Überlegungen auf dem Gebiet der Altertumskunde* (Munich 1974) 7–38.

22. See the recent book by Keuls (supra, note 18).

23. W. Burkert, *Structure and History in Greek Mythology and Ritual* (Berkeley 1979) 39–41.

24. Burkert (supra, note 10) 166. On phallic processions in Athens see E. Buschor, *AthMitt* 53 (1928) 96–108; A.W. Pickard-Cambridge and T.B.L. Webster, *Dithyramb, Tragedy and Comedy,* 2nd ed. (Oxford 1962) 132–162.

25. Aretaeus, *De causis et signis acutorum morborum* 2.12, vol. 2 of Corpus Medicorum Graecorum (Berlin 1958); Kerényi (supra, note 8) 274 (who misunderstands the phrase θεῖον πρῆγμα).

26. Archilochos, Cologne Epode, line 10 (D. Page, *Supplementum Lyricis Graecis* [Oxford 1974] S 478.15); Hesychios, *Lexicon* π 839 (M. Schmidt, ed. [Halle 1861]).

27. Plato, *Phaedrus* 265C; E.R. Dodds, *The Greeks and the Irrational* (Berkeley 1951) 64f., 218f.

28. Ithyphallic satyrs not engaged in outright sexual activities are considerably more frequent on Attic black-figure vases than masturbating satyrs or satyrs copulating with women or with Hephaistos' mule; cf. *Imagery* 80–83.

29. J.N. Bremmer, "Greek Maenadism Reconsidered," *ZPE* 55 (1984) 267–286; I.M. Lewis, *Ecstatic Religion* (Harmondsworth 1971) 57–64, 89–90.

30. Modern nomenclature for big cats (*Felidae*) other than lions and tigers in ancient art is problematic; cf. W.L. Brown, *The Etruscan Lion* (Oxford 1960) 170–176; C. Vermeule, *Bulletin of the Museum of Fine Arts, Boston* 59, no. 315 (1962) 13–21, and ibid. 62, no. 329 (1964) 102–113; M. Detienne, *Dionysos Slain* (Baltimore 1979) 37; *Imagery* 54 n. 2. Ancient authors refer to large, spotted felines, regardless of their species, variously as *pardalis* (first in the Homeric epic), *panther* (from the late fifth century B.C., e.g., in Herodotos, Xenophon, and Aristotle) or *leopardos* (not attested before the imperial period). I use "leopard" only to avoid confusion with the different cats (pumas and cougars) of the New World, which are also called "panthers" in American usage. Hunting leopards appear as pets in red-figure genre scenes of the first half of the fifth century B.C.; see A. Ashmead, "Greek Cats," *Expedition* 20 (spring 1978) 38–47. But most of the leopards accompanying Dionysos and his maenads on Attic vases do not look like hunting leopards and seem to belong to a wilder species of feline. Unlike hunting leopards, Dionysiac leopards are not to my knowledge shown with collars and leashes, except when they serve as mounts for the god.

31. E.g., on the François Vase (supra, note 7), a dinos in Paris (Louvre E 876; supra, note 19), a band-cup in New York (17.230.5; supra, note 8); *Imagery* 19–22, 26. The Return of Hephaistos by Lydos is a rare exception (New York 31.11.11, circa 550 B.C.; *Imagery* 25–26; supra, note 8); neither the mule nor the satyrs are ithyphallic. On an amphora fragment by the Amasis Painter, an ithyphallic mule joins in the dance of ithyphallic satyrs (Samos; *ABV* 151,18; *Development,* rev. ed. pl. 56,1; Karouzou, *Amasis* pl. 30,2; Kerényi [supra, note 8] fig. 54b).

32. Cf. M.S. Silk and J.P. Stern, *Nietzsche on Tragedy* (Cambridge 1981); A. Henrichs, "Loss of Self, Suffering, Violence: The Modern View of Dionysus from Nietzsche to Girard," *HSCP* 88 (1984) 205–240.

33. F. Nietzsche, *The Birth of Tragedy*, section 8 (translated by W. Kaufmann [New York 1967]). J.D. Beazley, "Attic Black-Figure: A Sketch," *Proceedings of the British Academy* 14 (1928) 240 seems almost to echo the language, if not the sentiment, of both J.J. Rousseau and Nietzsche when he characterizes the ithyphallic satyr in the "enlèvement" scene on the London pelike by the Acheloos Painter as "natural man" whose "rude, impetuous courtship" is contrasted "with the humaner methods of civilization" (i.e., a couple in decent embrace) depicted on the reverse side of the same vase (London W 40; *ABV* 384,20; Keuls [supra, note 18] 376, figs. 319–320, and *ZPE* 55 [1984] pl. 21,17–18).

34. The earliest references to satyrs, apart from the satyr play, are found in the Hesiodic *Catalogue of Women*, fr. 123.2 (= P. Turner 1, fr. 1.18; Hesiod, Appendix fr. 10(a),2 Merkelbach/West) and Euripides, *Bacchae* 130 (Carpenter assumes, mistakenly, that satyrs are not mentioned in the *Bacchae* [*Imagery* 79]).

35. Nietzsche (supra, note 33) section 2. On the distinction between the horse-like satyrs on Archaic and Classical vases and the goatlike satyrs of later art see G.M.A. Hanfmann and J.R.T. Pollard in N.G.L. Hammond and H.H. Scullard, eds., *The Oxford Classical Dictionary*, 2nd ed. (Oxford 1970) 956 (but the capture of Silenos by Oreios and Therytas is found on the Ergotimos Cup [Berlin 3151; *ABV* 79], *not* on the François Vase).

36. Silk and Stern (supra, note 32) 148; W. Burkert, *Greek, Roman and Byzantine Studies* 7 (1966) 87–121, esp. 88–91.

37. W.M. Calder III, "The Wilamowitz-Nietzsche Struggle: New Documents and a Reappraisal," *Nietzsche-Studien* 12 (1983) 214–254. Reprinted in idem, *Studies in the Modern History of Classical Scholarship*, Antiqua 27 (Naples 1984) 183–223.

38. Nietzsche (supra, note 33) section 8.

39. *Imagery* 19 n. 31, 76–78, with pl. 4a; P. Kretschmer, *Die griechischen Vaseninschriften ihrer Sprache nach untersucht* (Gütersloh 1894) 132–133; C. Fränkel, *Satyr- und Bakchennamen auf Vasenbildern* (Halle 1912) 20; M. Cristofani in *Vaso François* (supra, note 7) 178, no. 124, and 194, fig. 243.

40. F. Brommer, *Philologus* 94 (1941) 222–228; A. Lesky, *Die tragische Dichtung der Hellenen*, 3rd ed. (Göttingen 1972) 32–37; Seaford, "*Cyclops*" (supra, note 5) 5–16. The words satyr and silen could be used interchangeably well into the fourth century (Pl. *Symp.* 215a7 versus 216c5, Sokrates as silen/satyr; Hdt. 8.138.3 versus Xen. *An.* 1.2.13, the capture of Silenos/Satyros by Midas).

41. A. Minto, *Il Vaso François* (Florence 1960) pls. 15 and 30; *Vaso François* (supra, note 7) 178, no. 125, and 194, fig. 244; *Imagery* 9, 19, 76–77; Kretschmer (supra, note 39) 162, 200; L. Threatte, *The Grammar of Attic Inscriptions*, vol.

1 (Berlin 1980) 486–488, on the common omission of internal nasals before stops, as in *ny(m)phai*. Sophilos' vase inscriptions identify his nymphs as *nyphai* (London 1971.11-1.1; supra, note 7) as well as *nysai* (Athens, Akr. 587; *ABV* 39,15; *Development*, rev. ed. pl. 15,2; *Imagery*, pl. 3a). Carpenter rejects *nysai* as "a simple case of misspelling" (*Imagery* 9, 82 n. 25). On the basis of Pherekydes, *Fragmente der griechischen Historiker* 3 F 178 (*nysai* = "trees"), however, M.L. West, *Hesiod, Works and Days* (Oxford 1978) 373–374 has made a case for interpreting the Nysai as tree-nymphs.

42. *Hymn. Hom. Ven.* 262–263, presumably composed around the mid-sixth century B.C. (R. Janko, *Homer, Hesiod and the Hymns: Diachronic Development in Epic Diction* [Cambridge 1982] 179–180). Carpenter has shown that the association of satyrs/sileni with nymphs on three Attic vases antedates their association with Dionysos on the François Vase (*Imagery* 21 and 80–82). After 570 B.C., the combination of satyrs, nymphs, and Dionysos is common in art but rare in literature. In P. Oxy. 1038 = Soph. fr. dub. 1130.7 Radt (from a satyr-play), the satyrs of the chorus introduce themselves as "sons of nymphs" (παῖδες νυμφῶν) and "ministers of Bakchos." For nymphs/maenads as nurses see *Il.* 6.132ff.; *Hymn. Hom.* 26.3ff.; Eur. *Bacch.* 699ff.

43. In Kleitias' depiction of the wedding procession for Peleus and Thetis, for instance, three Horai appear next to Dionysos (François Vase, side A; *Imagery*, pl. 1b). In Sophilos' slightly earlier version of the same scene on the London dinos (supra, note 7), the procession includes separate triads of Nymphs, Charites, Muses, and Moirai. On female triads in Greek myth and cult see S. Scheinberg, *HSCP* 83 (1979) 2–7.

44. A. Henrichs, "Greek Maenadism from Olympias to Messalina," *HSCP* 82 (1978) 121–160.

45. M.W. Edwards, "Representations of Maenads on Archaic Red-Figure Vases," *JHS* 80 (1960) 778–787, at 80 n. 11.

46. Edwards (supra, note 45) 80–81; *ABFV* 210 and 232–233 ("always dressed" versus "usually fully dressed"); Burkert (supra, note 10) 166 ("always clothed"). Maenads without their ritual gear have lost their identity. The description "naked maenads" for undressed female figures in Dionysiac art is a common but unfortunate misnomer; see, e.g., J. Heckenbach, *De nuditate sacra sacrisque vinculis*, vol. 9, fasc. 3 of Religionsgeschichtliche Versuche und Vorarbeiten (Giessen 1911) 22, 34; *Development*, rev. ed. 55; Karouzou, *Amasis* 15; McNally (supra, note 8) 113.

47. L. Kahil, *AK* 20 (1977) 86–98; E. Simon, *Festivals of Attica: An Archaeological Commentary* (Madison, Wisc., 1983) 87–88; S.G. Cole, *ZPE* 55 (1984) 238–244; L. Kahil, "Mythological Repertoire of Brauron," in *Ancient Greek Art and Iconography* (supra, note 10) 231–244; H. Rühfel, *Kinderleben im klassischen Athen* (Mainz 1984) 100–107; Keuls (supra, note 18) 310–320; G. Arrigoni, *Le donne in Grecia* (Rome 1985) 101–104, with pls. 17–18, and 21, pl. 2.

48. Plato *Laws* 833 CD; P. Perlman, *Greek, Roman and Byzantine Studies* 24 (1983) 115–130. Plato's comment, however, differs from the vase-paintings in two important respects: he refers to unspecified athletic competitions, whereas the vases depict a ritual footrace; according to him, all girls under thirteen run naked, but girls in this age-group are wearing chitoniskoi on several vases.

49. Beazley never differentiated between nymphs and maenads in his descriptions of the female attendants of Dionysos. Carpenter, who considers Edwards' distinctions (supra, note 45) "too rigid" (*Imagery* 80 n. 17), intro-

duces less plausible distinctions of his own. Both Edwards (80–81, 83) and Carpenter (*Imagery* 67, 83–84) conclude that the leopard skin is more exclusively Dionysiac (Carpenter) or maenadic (Edwards) than the fawn skin, which is also worn by non-Dionysiac figures. Carpenter properly describes the female companion of a satyr on a London hydria (London B 302; *ABV* 261,40) as "a maenad wearing a panther skin" (*Imagery* 114, with pl. 32; Beazley in *Development*, rev. ed. 71 called her a nymph), but he is overcautious when he expressly denies the designation "maenads" to the nine women (including one with a snake wrapped around her waist) who are dressed in fawn skins in Lydos' Return of Hephaistos (New York 31.11.11; *Development*, rev. ed. pls. 36 and 37,1; supra, note 8); in his vocabulary they are "nymphs" (*Imagery* 84; but earlier, on p. 72, he describes the same woman with a snake, perhaps inadvertently, as "a maenad who pursues a satyr"). The scant references to maenads in pre-Classical Greek literature invariably focus on their agitated movement or the mountain setting of their rites, but fail to mention their dress or, with one exception (*Il.* 6.134), their paraphernalia.

50. Berlin 3210 (present whereabouts unknown); *ABV* 151,21; *Development*, rev. ed. pl. 55,1; Karouzou, *Amasis*, pls. 27, 28 (the only reproduction known to me on which the dead hare carried by the woman on the extreme left is sufficiently distinct); *Amasis Painter*, fig. 45b; *Imagery* 85. Basel, Antikenmuseum und Sammlung Ludwig, Kä 420; *Paralipomena* 65; *Amasis Painter*, fig. 40b; *Imagery* 86, with pl. 24b.

51. *Development*, rev. ed. 55; *Paralipomena* 65; Karouzou, *Amasis* 15; *Amasis Painter* 49, 82, 128. Carpenter, in *Imagery* 85–86, is deliberately more cautious and describes the female companions of Dionysos on both vases as "women."

52. Carpenter sums up the dilemma with exceptional clarity: "But of the Berlin vase the questions arise, are the naked women nymphs, or are the clothed women (one of whom carries a hare) nymphs, are they all nymphs, or are some of them mortal maenads?" (*Imagery* 85). Yet Carpenter does not commit himself in this case (cf. supra, notes 49 and 51), nor does he firmly rule out the possibility that the naked women may be maenads.

53. Supra, note 50. Held by its front legs, its head drooping, the animal is hardly "a pet hare" (*Development*, rev. ed. 55). On hares, live or dead, as gifts see infra, notes 64–65, 69.

54. Karouzou, *Amasis*, pl. 26; *Amasis Painter*, fig. 45a, cf. nos. 18 bis, 19.

55. Boston 76.40; *Paralipomena* 144,1; *CVA* Boston 1,29, with pl. 39 (emphasis mine).

56. Two naked women holding similar wreaths and flowers appear in the courting scenes on a cup-skyphos by the Amasis Painter (Paris, Louvre A 479; *ABV* 156,80; *Amasis Painter* no. 54). Cf. G. Koch-Harnack, *Knabenliebe und Tiergeschenke: Ihre Bedeutung im päderastischen Erziehungssystem Athens* (Berlin 1983) 91, fig. 25 (naked woman with flower and wreath in erotic scene). The circular wreaths conform to an established type discussed by M. Blech, *Studien zum Kranz bei den Griechen*, vol. 38 of Religionsgeschichtliche Versuche und Vorarbeiten (Berlin 1982) 41–42, 63–74; they are different from the "dot-fillets" used as decorations for sacrificial animals and the Delphic omphalos, on which see A. Krug, *Binden in der griechischen Kunst. Untersuchungen zur Typologie (6.–1. Jahr. v. Chr.)* (diss. Mainz 1967; Hösel 1968) 37–41, 97–101, 122–126.

57. Paris, Louvre F 36, side B; *ABV* 150,6; *Amasis Painter* no. 5; *Imagery* 86, with pl. 24a; *LIMC* 3, Dionysos 811.

58. Two maenads by the Amasis Painter wear leopard skins: Paris, Cabinet des Médailles 222 (infra, note 60). Athens, Agora Museum P 7223; *ABV* 156,72; E. Vanderpool, *Hesperia* 8 (1939) 265, fig. 20; Karouzou, *Amasis*, pl. 40,10.

59. Cf. *Imagery* 86–88, esp. 86: "The explanation for the naked men in some of these scenes and the naked women in some of the others may be that the Amasis Painter has used imagery from komos scenes in his depictions of Dionysos." Two naked women (nymphs) appear in embrace with two ithyphallic satyrs on an amphora fragment from Samos by the Amasis Painter; *ABV* 151,18; *Development*, rev. ed. pl. 56,2; Karouzou, *Amasis*, pl. 30,3; *Amasis Painter*, fig. 67 (lower half of the fragment missing).

60. Paris, Cabinet des Médailles 222; *ABV* 152,25; *Development*, rev. ed. pl. 50,2; Karouzou, *Amasis*, pls. 31–32; E. Simon, *Die Götter der Griechen*, 2nd ed. (Munich 1980) 285, fig. 277; Simon and Hirmer, pl. XXIII (the best reproduction known to me); *Amasis Painter* no. 23; *Imagery* 66–67, 90, 125, with pl. 17; *LIMC* 3, Dionysos 294; M. Robertson, *A History of Greek Art*, vol. 1 (Oxford 1975) 135 describes the two maenads as "a pair of nymphs." But Carpenter (*Imagery* 90) stresses the singular importance of this scene, both as a turning point in Dionysiac imagery and as one of the earliest explicit records of maenadism:

> This is the first vase on which women appear alone—without satyrs—with Dionysos, and it is the first vase on which a female companion of the god wears a leopard skin. It seems that women here have become central to the meaning of a Dionysiac scene and that whatever confusion may have existed as to the identity of the women with the god has passed. Suddenly the women have attributes that give them an identity, and suddenly they are unambiguously connected with the god who welcomes them.

The changes in the perception of Dionysiac women were perhaps not quite as sudden and dramatic as the surviving vases might suggest. On a "Tyrrhenian" amphora by the Castellani Painter (Paris, Louvre E 831; *ABV* 103,108; *CVA* Louvre 1, III Hd, pl. 2,4; Carpenter, *OJA* 2 [1983] 280–281, with fig. 1; *LIMC* 3, Dionysos 325), which according to Carpenter's own chronology (supra, note 17) is either contemporary with, or slightly earlier than, Paris, Cabinet des Médailles 222, Dionysos is surrounded by six women ("maenads" in my terminology), two of whom carry a small lion, while another carries a snake; there are no satyrs.

61. Included in this approximate count are female companions of Dionysos who are identified as maenads by the animals they carry and/or the animal skins they wear (the thyrsos being a later addition; infra, note 71): Lydos, New York 31.11.11, circa 550 B.C.; supra, notes 8 and 49 (nine maenads wearing fawn skins, including one with a snake and another, exceptionally, with a bunch of grapes). Lydos, Herakleion, Giamalakis 217; *ABV* 684,71 bis; Tiverios (supra, note 8) pls. 14b, 15–16; *Imagery* 23 (describing the four maenads as "nymphs in animal skins"). Exekias, Budapest 50.189, circa 550 B.C.; supra, note 8 (maenad holding a snake, and part of a dancing maenad, both wearing fawn skins). Castellani Painter, Paris, Louvre E 831, circa 550–530 B.C. (supra, note 60).

62. Carpenter describes the hare and the stag as "dead animals" (*Imagery* 66). But the hare clearly has control of its front legs, and the stag of its head; dead hares are iconographically different (supra, note 53; infra, note 65).

63. Edwards (supra, note 45) 80–81; *Imagery* 66–67, 72; supra, note 61. A skittish hare joins several dancing satyrs and a maenad in a Dionysiac scene by

Lydos; London B 148; *ABV* 109,29; *Paralipomena* 44; *Development*, rev. ed. pl. 37,2; Tiverios (supra, note 8) pls. 51a, 52a; *Imagery* 52; *LIMC* 3, Dionysos 299. A subdued hare rests comfortably on the left hand of Tragedy personified (who, maenadlike, is holding a thyrsos with her right hand) on a red-figure bell-krater (circa 440 B.C.); Compiègne 1025; *ARV*² 1055.76, 1680; K. Schefold, *Die Göttersage in der klassischen und hellenistischen Kunst* (Munich 1981) 34, fig. 29.

64. On courting scenes see J.D. Beazley, *Proceedings of the British Academy* 33 (1947) 198–223; on hares as erotic gifts, Koch-Harnack (supra, note 56) 59–128, figs. 3–10, 12–15, 20, 24, 26 (Amasis Painter, Paris, Louvre F 26; following note) 78; A. Schnapp in *La Cité des images* 67–83, figs. 112–113, 116, 119; B. Ginge, *The Erotic Hare: A Hare-Shaped Etruscan Plastic Vase in the Odense University Classical Collection* (Odense 1981) 13–18; on stags instead of hares, see Koch-Harnack (supra, note 56) 119–124. In most instances the exchange takes place between male partners. Hares as gifts in heterosexual courtship are rare; but see the example on a red-figure alabastron in Athens (Kerameikos Museum 2713; *Paralipomena* 331; *La Cité des images*, fig. 112), where a man (*erastes*) offers a hare to a woman (*eromene*).

65. Paris, Louvre A 479 (a dead hare and a live stag as gifts exchanged between male lovers); *ABV* 156,80; *Development*, rev. ed. pl. 58,2; Karouzou, *Amasis*, pls. 13–14; *Amasis Painter* no. 54; *Imagery* 51–52. Paris, Louvre F 26, side B; *ABV* 150,5; *Amasis Painter* no. 11. In an erotic scene on a fragmentary tripod-pyxis from Aegina by the Amasis Painter the gift is again a hare (M. Ohly-Dumm in *Amasis Painter* 236–238, Appendix 4), not "a small stag" (von Bothmer, ibid., 200; only the lower part of the animal is preserved, but its paws make the identification certain).

66. Kleitias, Florence 4209, details of both handles (Artemis with leopard and stag, and with two lions); *ABV* 76,1; *Development*, rev. ed. pl. 28,1–2; Simon and Hirmer, pl. 51; *Amasis Painter* 40, fig. 23a, b. The Amasis Painter depicted the Potnia Theron four times (*Imagery* 43), in all but one case with two lions: Basel, Antikenmuseum und Sammlung Ludwig BS 497 (on both sides); *Paralipomena* 66; *Amasis Painter* no. 21. Paris, Louvre F 71; *ABV* 154,49; *Amasis Painter* no. 41. Orvieto, Faina 40; *ABV* 151,14; *Amasis Painter* 85, fig. 60c (Artemis holding a lion and a fawn).

67. This is one of the titles of Dionysos in an unpublished iambic inscription, of the Hellenistic period, from Thasos; cf. J. Roux, *Euripide, "Les Bacchantes,"* vol. 2 (Paris 1972) 633.

68. Aisch. *Eum.* 24–26; Eur. *Ba.* 135–140, 434–436, 719, 731–732, 866–872, 1020–1023, 1108, 1168–1199, 1237–1242; cf. C. Segal, *Dionysiac Poetics and Euripides' Bacchae* (Princeton 1982) 32–36.

69. Beazley (*Development*, rev. ed. 53) calls the hare and the stag on the amphora Paris, Cabinet des Médailles 222 "pet animals" (supra, note 53). Carpenter (*Imagery* 90 n. 65) objects, rightly, and interprets these animals as "gifts to the god," adding that the two women "are sisters of the hunter-maenads described by Euripides in the *Bacchae* (734–748)." I agree, but would add that nowhere else in Greek art, to my knowledge, or in literature, do maenads offer the spoils of their hunt (which are usually not in one piece) to Dionysos, as ordinary hunters would offer theirs to Artemis. Iconographically as well as conceptually, the portrayal of the two maenads with their animals is a striking experiment peculiar to the Amasis Painter. Is it conceivable that he intended the hare as an *erotic* gift, as if the maenad were courting the god in the same way in which the homosexual *erastes* courts his *eromenos*?

70. See *Amasis Painter* nos. 4, 8, 12, 14–15, 19, 24; *Imagery* 44–53.

71. Edwards (supra, note 45) 84–85; *Imagery* 63, 125; West (supra, note 41) 374–375 (on *bakchoi*, "[sacred] branches," as natural predecessors of the more formal thyrsoi composed of the fennel-rod and ivy); Blech (supra, note 56) 200, 205. The first appearance of the word "thyrsos" itself is not in Euripides' *Bacchae* (so *Imagery* 64; Edwards 84, "absence of the word from literature before the time of Euripides," may well be accurate), but in Soph. *Ichneutai*, fr. 314.226 Radt (date unknown, but considerably earlier than *Bacchae*); Kratinos *Dionysalexandros*, fr. 40 Kassel/Austin (430/429 B.C.); Eur. *Hypsipyle* fr. 752.1 Nauck (411/408 B.C.); Trag. adesp. fr. 406 Kannicht/Snell; cf. Ion of Chios, fr. 26.1 West (θυρσοφόρος, of Dionysos); Eur. *Cyc.* 64 (Βάκχαι τε θυρσοφόροι), Eur. *Phoen.* 792 (θυρσομανής). Several female companions of Dionysos on red-figure vases are explicitly identified as maenads by vase inscriptions (Fränkel, supra, note 39, 90–105); all but one carry a thyrsos (the exception carries a snake; Brygos Painter, Castle Ashby; *ARV²* 371,16).

72. Munich 2645, tondo; *ARV²* 371,15; *Paralipomena* 365; M. Robertson, *Greek Painting* (Geneva 1959) 107; J. Boardman, *Athenian Red Figure Vases: The Archaic Period* (London 1975) fig. 256; Simon and Hirmer, pl. 36. Maenads with snakes in their hair: Curti Painter, Cambridge, Mass., Fogg Art Museum 1960.343, side A; *ARV²* 1042,2; *CVA* Robinson 2, pl. 46; Houser (supra, note 4) 39, fig. 12; *La Cité des images* 24, fig. 27; *LIMC* 3, Dionysos 314. Cf. Eur. *Ba.* 102–104; Horace, *Odes* 2.19,19–20. On a volute-krater in Ferrara, several male and female participants in the rites of Sabazios are handling snakes, and five of them have snakes attached to their headbands, just like the maenad on the bell-krater in the Robinson collection: Ferrara T 128, circle of Polygnotos, circa 435 B.C.; *ARV²* 1052,25; E. Simon, *Opfernde Götter* (Berlin 1953) 79–85; F.T. van Straten, *Lampas* 9 (1976) 63–65, with fig. 12; Kerényi (supra, note 8) fig. 88; *La Cité des images* 18–26, with figs. 21a–f; E. Keuls, *ZPE* 55 (1984) 290, 297, with pl. 17,2 ("maenadic ritual"); *LIMC* 3, Dionysos 869.

73. Munich 2344, circa 500–490 B.C.; *ARV²* 182,6; *Paralipomena* 340; Simon and Hirmer, pls. 120–124, XXXIII–XXXIV; *LIMC* 3, Dionysos 311.

74. Henrichs (supra, note 44).

75. Plut. *Alex.* 2; Duris, *Fragmente der griechischen Historiker* 76 F 2.

76. The one exception is the amphora fragment from Samos (supra, note 59).

77. Boston 10.221; *ARV²* 16,14; L.D. Caskey and J.D. Beazley, *Attic Vase Paintings in the Museum of Fine Arts, Boston*, pt. 2 (Oxford 1954) no. 66, pl. 31; A. Greifenhagen, "Der Tod des Pentheus," *Berliner Museen* 16 (1966) 2–6 with fig. 5; Schefold (supra, note 5) 80, fig. 92; M. Anderson in Houser (supra, note 4) 102.

78. Boston 63.952; *Paralipomena* 62; *CVA* Boston 1, pl. 12,3; M. Anderson in Houser (supra, note 4) 101; *Imagery* 93–94, with pl. 21.

79. Paris, Louvre F 68; Robertson (supra, note 72) 68–69 (superb color plate); Simon and Hirmer, pl. 35.

80. Simon in Simon and Hirmer 57.

81. *Il.* 2.303–320; *Kypria* as summarized by Proklos, *Chrestomathia* (T.W. Allen, *Homeri Opera*, vol. 5 [Oxford 1912] 104,1–3; E. Bethe, *Homer. Dichtung und Sage*, 2nd ed., vol. 2, pt. 2 [Leipzig 1929] 153); Apollod. *Epit.* 3.15; Ov. *Met.* 12.11–23.

82. *Imagery* 91–93. Würzburg L 265, side A; *ABV* 151,22; Karouzou, *Amasis*, pl. 29; Simon (supra, note 60) 286, fig. 278; Simon and Hirmer, pl. 68; *Amasis*

Painter no. 19 (color pl., page 61); *Imagery*, pl. 20a. Basel, Antikenmuseum und Sammlung Ludwig Kä 420, side A; *Paralipomena* 65; *Amasis Painter* 47, fig. 40a; *Imagery*, pl. 20b. For the three fragmentary amphorae see *Amasis Painter* no. 18 bis; 116, fig. 70; 117, fig. 71.

83. Henrichs (supra, note 1) 140–143, 214 n. 13; J.-L. Durand et al. in *La Cité des images* 117–119, 124. Bibulous Athenian housewives indulged their passion for wine in the secrecy of the storeroom: *Greek Vases: Molly and Walter Bareiss Collection*, ex. cat. (Malibu, The J. Paul Getty Museum, 1983) 55, no. 39.

84. On women at the fountainhouse or village pump, see Keuls (supra, note 18) 235–243, with figs. 208–218, and *La Cité des images* 92 and 118, with figs. 130 and 164; on wine-ladling women at the Anthesteria and on the Lenaia vases (supra, note 9), see W. Burkert, *Homo Necans: The Anthropology of Ancient Greek Sacrificial Ritual and Myth* (Berkeley 1983) 235–238.

85. *Imagery* 44–53 (Carpenter routinely treats these youths as "stock figures" adopted by the Amasis Painter from the Heidelberg Painter, while acknowledging that the scenes "in which the youths are specifically associated with Dionysos" could have "some special significance," page 53); *Amasis Painter* nos. 2, both sides (color pl., side A, page 63); 8, side A; 12, side A; 15, side A; 75, fig. 57a. On the social dimension of wine-drinking in the life of Greek ephebes see J. Bremmer, *Arethusa* 13 (1980) 285–286, elaborated in his "Adolescents, Symposium and Pederasty," in O. Murray, ed., *Sympotica* (Oxford, forthcoming).

86. Munich 8763, side A; *Paralipomena* 65; *Amasis Painter* no. 4; *Imagery* 49, with pl. 14b. Munich 1383; *ABV* 150,7; *Amasis Painter* no. 14; *Imagery* 49, with pl. 14a; *LIMC* 3, Dionysos 807.

87. London B 210, side B, circa 530 B.C.; *ABV* 144,7; *CVA* British Museum 4, pl. 49,2b; Simon and Hirmer, pl. 75; *Amasis Painter* 47, fig. 41; *LIMC* 3, Dionysos 785.

88. The name Oinopion must be derived patronymically from *Oinops* (F.G. Welcker, *Die Aeschylische Trilogie Prometheus* [Darmstadt 1824] 549 n. 848), and certainly not from οἶνον πιών ("wine-drinking"), as some ancient and modern interpreters suggest. On the various myths connected with Oinopion see E. Wörner in W.H. Roscher, ed., *Ausführliches Lexikon der griechischen und römischen Mythologie*, vol. 3 (Leipzig 1897–1909) 791–798; K. Keyssner, *RE* 17.2 (1934) 2272–2275; F. Graf, *Nordionische Kulte. Religionsgeschichtliche und epigraphische Untersuchungen zu den Kulten von Chios, Erythrai, Klazomenai und Phokaia*, vol. 21 of Bibliotheca Helvetica Romana (Rome 1985) 125–126.

89. Carpenter (*Imagery* 50) suggests, along similar lines, "that Exekias, and perhaps the Amasis Painter, saw Oinopion as a personification of a function rather than as a literal son of the god." What function? As usual, Carpenter's caution deprives us of an answer.

90. Munich 2044, interior; *ABV* 146,21; *Paralipomena* 60; *Development*, rev. ed. pl. 67,2; Robertson (supra, note 72) 71; *ABFV* fig. 104,3; Simon (supra, note 60) 282–288, with fig. 279; Simon and Hirmer, pl. XXIV; *LIMC* 3, Dionysos 788.

91. W.F. Otto, *Dionysos, Mythos und Kultus* (Frankfurt 1933); translated by R.B. Palmer, *Dionysos: Myth and Cult* (Bloomington and London 1965).

92. *Hymn* 7 in the standard editions of the Homeric Hymns; Janko (supra, note 42) 184 dates it tentatively "within the seventh century" rather than the sixth. The most recent proponents of a close connection between the

Exekias cup and this hymn include T.B.L. Webster, "Homeric Hymns and Society," in J. Bingen et al., *Le Monde grec. Hommages à Claire Préaux* (Brussels 1975) 86–93, at 91, and Schefold (supra, note 5) 70–71.

93. *Imagery* 68 n. 58 (in connection with the Homeric Hymn to Dionysos): "The god is described as a beardless adolescent, but it is not until the last quarter of the fifth century that he is depicted as beardless on vases." The beardless Dionysos from the east pediment of the Parthenon dates from the third quarter of the fifth century (F. Brommer, *Die Parthenon-Skulpturen*, 2nd ed. [Mainz 1982] pl. 133), and the earliest specimens of this type in round works appear to be from the same period, if not later (E. Pochmarski, *Das Bild des Dionysos in der Rundplastik der klassischen Zeit Griechenlands* [diss. Graz; Wien 1974] 66–94).

94. Athens, Monument of Lysikrates, circa 335 B.C. (Dionysos' opponents shown with dolphins' heads); J. Travlos, *Pictorial Dictionary of Ancient Athens* (London 1971) 348–351, with fig. 451; Schefold (supra, note 63) 186, fig. 252; *LIMC* 3, Dionysos 792. Dougga, Tunisia, Roman mosaic, third century A.D. (sailors with fins); Dunbabin (supra, note 20) pl. 8,16. On an East Greek cup, circa 540–530 B.C., in a private collection, normal dolphins alternate with humanoid dolphins whose bodies end in legs; cf. E. Rohde, *AA* 70 (1955) 94–126, no. 2, fig. 6 (who connects them with the transformation myth, but the connection is doubtful).

95. T.W. Allen et al., *The Homeric Hymns*, 2nd ed. (Oxford 1936) 376; most recently Simon (supra, note 60) 284–288; H. Herter, "Die Delphine des Dionysos," *Archaiognosia* 1 (1980) 101–133, at 123.

96. E.g., E. Maass, "Dionysos Pelagios," *Hermes* 23 (1888) 70–80; L. Deubner, *Attische Feste* (Berlin 1932) 110–111; Burkert (supra, note 84) 199–201, and idem (supra, note 10) 166. But according to A. Lesky, "Zum Schiffskarren des Dionysos," in *Gesammelte Schriften* (Bern 1966) 297–309 (first published in 1925), the annual procession of the Dionysiac ship on wheels seen on three Attic skyphoi was an agrarian custom, with many parallels in northern Europe, which he claims is unrelated to the myths of Dionysos' arrival by sea. For the three skyphoi see A. Pickard-Cambridge, *The Dramatic Festivals of Athens*, 2nd ed. (Oxford 1968) figs. 11–13; Kerényi (supra, note 8) figs. 56–57, 59.

97. W.J. Slater, "Symposium at Sea," *HSCP* 80 (1976) 161–170 (on nautical metaphors in connection with the symposium); M.I. Davies, "Sailing, Rowing, and Sporting in One's Cups on the Wine-Dark Sea," in W.A.P. Childs, ed., *Athens Comes of Age: From Solon to Salamis*, Papers of a Symposium Sponsored by the Archaeological Institute of America, Princeton University, and the Department of Art and Archaeology, Princeton University (Princeton 1978) 72–95 (on the literary as well as visual evidence for the association of wine-drinking with seafaring). Nautical metaphors for symposiastic activities are not attested before the second half of the fifth century. But, since three of the four attestations from that period are found in fragments of lyric, elegiac, and epic poetry (Pindar fr. 124ab Snell/Maehler; Dionysius Chalcus fr. 5 West; Choerilus of Samos fr. 9 Kinkel; cf. Eur. *Cyc.* 503–509), it is not unreasonable to assume that such metaphors were common in real life, and were perhaps established earlier than the literary evidence might suggest.

98. Cf. Slater (supra, note 97) 165–166.

99. Friedrich Hölderlin, "Patmos" (1803), first stanza; cf. Henrichs (supra, note 32) 216–218.

100. I owe thanks to Mr. Andrew Clark, Professors David G. Mitten, Warren G. Moon, and Mary B. Moore, as well as Dr. Cornelius Vermeule, for their help in locating slides for the original lecture; to Dr. Jan Bremmer, Mr. Michael Padgett, and Dr. Renate Schlesier for their valuable comments on a draft of the published version, and for numerous references; to Miss Marian Demos and Mr. Scott Scullion for much assistance in the preparation of both the lecture and the final product.

Alan W. Johnston

AMASIS AND THE VASE TRADE

In this paper my primary aim is to push forward by a fraction of a millimeter our knowledge of the particular workings of sixth-century trade, both in vases and other commodities. I will not be tackling directly the conceptual framework of this difficult topic; we had hoped for guidance from Sir Moses Finley in this respect, and my own contribution is tacitly based on his thoughts and on those of a range of other scholars, from Starr to de Ste. Croix, Marx to Mele.[1] While many feel it necessary to apologize for the word "trade," I personally feel that "economy" is potentially more misleading. Naturally, "exchange" is a safer usage, but my impression is that by the sixth century we can with impunity employ "trade" broadly to describe Greek practices; it does not have the burdensome innuendo of bureaucracy which, to me at least, is implied by the dead hand of "economy." One must accept as a base-line the tenet of Finley that trade must not be construed as denoting any form of state-induced activity, though even here there will be a caveat to be entered.

I will treat of Amasis, but also of broader issues, and I would hope to keep apart the questions of total trade and of ceramic trade in their manifold ramifications. Decorated vases are, of course, a prime evidential factor for the former as well as the latter, which makes it exceedingly difficult, for example, to calculate what the ratio of pots to other artifacts or produce may have been in any given cargo, on any given route (to Etruria or elsewhere!). There are endless problems associated with the other type of artifact which survives in any quantity—bronzes—especially as regards provenance; at least with pottery we do not have the added complication of the reuse of the raw material.

A fair amount of broadly statistical work on decorated vases has already been done by Robert Cook, John Boardman, Carlo Tronchetti, and others, using evidence with circumspection but largely confining

themselves to pots included in *ABV* and *ARV²*. Cook attempted to estimate the actual percentage of surviving material from the survival rate of Panathenaic prize amphorae. Apart from questioning the use of the Panathenaic as a typical indicator, I feel unhappy about taking back into the sixth century figures derived, however solidly, from circa 375, in *Inscriptiones Graecae* II² 2311. My own estimate of the total number of amphorae in the list is a little higher than Cook's—about 1,450—but what does this tell us of the later sixth century?[3] So I would spread gloom about our ability to assess survival rates in sixth-century production. One might add that even with the enormous help afforded by die-linkage, numismatists are equally chary about the amount of coins minted during the same period.[4]

Such pessimism can also infiltrate more comparative studies,[5] though there are valid exercises, such as those carried out by Boardman and Tronchetti, comparing like with like (to be brutally laconic), e.g., Cerveteri against Tarquinia or Vulci, Rhodes against Gela. But there are serious difficulties in taking things further; the amount of controlled excavation on Greek and Etruscan town sites is minimal, and of that only a small percentage has been published. We await publication of relevant material from the Agora of Athens, but we will not be able to compare it properly with that from the Akropolis, for example, where the material has been selectively excavated, sorted, and published.[6] My own doubts as regards "easy" statistics started, I recall, on being shown several boxes of feet of Attic kylikes from a sector of the Parthenos sanctuary at Kavalla—hundreds, comparable *perhaps* with the finds from the Artemision on Thasos. Little red-figure of quality is known from Naxos, but we have very fine fragments from Thera. How are we to react? The list could go on, but I merely add one further difficulty which I have encountered—how to reconcile wasters of at least two hundred amphorae of SOS type from Chalkis with a total of three or four such jars known from other sites?[7]

On a related point, I make one comment with regard to Dietrich von Bothmer's fine catalogue. He writes that "for many ancient settlements, especially on the coast of Anatolia, the main burial sites have not yet been discovered" (p. 46), with the implication that our distribution map is skewed because we have not as yet found the riches in painted pottery there, to balance those from Etruria. I would judge that an adequate sample of these cemeteries *has* been tapped, enough to indicate that the Ionians did not furnish their graves in this manner, especially with regard to Attic vases. Ephesos, Samos, Klazomenai, and Pitane come to mind. We might rather cite Hanna Philipp: ". . . dürfte aber deutlich geworden sein, daß man sich allgemein im 6. Jh. mit nur wenigen Beigaben in Attika und im östlichen Ionien begnügte," confirming the much earlier suggestion of Johannes Boehlau.[8] Yet, a little high-quality Attic pottery is known from Samos, some even by the Amasis Painter, and some from Chios—in the latter case probably from graves of the fifth century.[9] We can contrast Dorian habits; Rhodes, Thera, and Gela have yielded burials well stocked with good black- and red-figure, though perhaps not up to the average Etruscan numbers. In sum, it is unlikely to

be the *graves* of Ionia that will increase our percentage of preserved Amasean material.

All the cemeteries I have mentioned, in Etruria and the Dorian settlements, have yielded some, or many, Attic neck-amphorae.[10] This is a shape that is extremely rare in Athens itself; ovoid neck-amphorae, yes; small neck-amphorae, some; but standard neck-amphorae, no.[11] While some aspects of this observation remain unexplained, to me at least, I think that we can conclude that Athenian potters and painters were knowingly producing large numbers of such vases for export, together with the more exotic lines such as Nikosthenic amphorae.[12]

Here I must add a plea to take *all* ceramic products into account when considering workshops and trade. And here matters become even less calculable. One important aspect, however, is the plain or semi-decorated storage jar. Inherently involved with such containers are, of course, the contents—the oil, wine, fish, pitch, etc. The use of containers in large-scale trade seems to have commenced in the late eighth century. Here I merely touch upon one or two aspects of the matter.

We may first look at the few prices we have for commodities in the fifth century and note the very approximate ratio of value between an empty, decorated neck-amphora and a plain jar full of oil or wine.[13] This would be in the region of 1:15—with all due respect for the uncertainty introduced by profit, tare, demand, and availability (e.g., whether to load up more with empty red-figure vases—however stacked?—or full Corinthian jars, if available, if the weight allows, if a suitable loan can be got, etc.). We now have clear signs of the bulk export of goods in amphorae in the seventh century in the shape of Attic and Corinthian jars in the instep of Italy and East Greek amphorae at Kommos on Crete.[14] The more pottery that is retained in an excavation, the greater is the role that plainware plays—at sites such as Histria, Klazomenai, Olympia, Aegina, Policoro, Pithekoussai, Gravisca, Montalto, Huelva, and elsewhere.[15]

We can add at least one "time capsule" in the shape of the Giglio island shipwreck, with its very mixed cargo dating to circa 600 B.C., which includes both decorated and plain pottery from a variety of centers that was being coasted north, it would seem, from a port or strand in southern Etruria.[16] The wreck dates from the intriguing period after the foundation of Naukratis but shortly before the establishment of Greek posts at Gravisca and perhaps other Etruscan harbors. Just the period when Attic exports to the west were on the increase. Or was it? I should not be allowed to forget that Attic oil jars of the SOS type are tolerably common in the west in contexts of the second half of the seventh century, but decline markedly around 575. A simple reason would be that redundant Attic potters then took to producing more figured ware, borrowing heavily from Corinth for iconographic inspiration; simple, but there may be some truth in this.[17] On the demise of Corinthian figured pottery in the next generation, I do not wish to add much. It is to be noted that the Corinthian B amphora first appeared *after* that demise, to become a common export item throughout the Mediterranean world.[18] In a sense, it was only a few *painters* who were the victims at Corinth. I

myself do not see that the products of the red-ground style are in any way inferior to the run of contemporary Attic black-figure, but they form a limited series, and small fluctuations could have caused a full stop. Certainly, one area that does seem to have been closed to Corinthian material from circa 550, apart from a modicum of type B amphorae, is Etruria. I do not, however, feel happy about the argument adduced by John Salmon that, in précis, this was a war of attrition won by Athens. One should always remember the Diolkos, though I confess not to know how it affects the argument.[19]

To return briefly to the Panathenaic amphora, I would first point out its relevance to traditional dating and interpretation of signatures, which have both been challenged of late,[20] but would like also to stress the fact that no prize vase, wherever found, carries a graffito or *dipinto* under the foot that tallies with marks found on other types of vases from the same workshops.[21] This strongly suggests that the commercial career of the Panathenaics, before they reached Etruria or any other destination, was different, and in particular it argues that those other vases were marked in a first phase of life, rather than "second-hand," since it would have been in that phase that any prize amphorae would have been sent west. The marks on other vases therefore pertain to a trader-*potter* relationship.

Pursuing graffiti and *dipinti,* I stress that marks on Attic vases from Etruria of the second half of the sixth century do not recur on pieces found outside that area, save for a small overlap with Campania, as far south as Fratte. Rhodes, Sicily, and Athens have produced no comparable material.[22] A small number of these marks are in black glaze, applied to the vase before firing; here again, the fact that such marks appear on vases found *only* in Etruria suggests a deliberate concentration on that western trade. I have concluded that most marks—whether *dipinto* or graffito—were applied in the workshop, either before or after firing.[23] That is not, however, a watertight rule, since red *dipinti* can be an owner's marks applied in the receiving area, however rare they may be.[24] Further, the red *dipinto* itself is far from waterproof; washed-out remains are common enough, and here too, I fear, one must despair of being able to give anything like accurate figures for the total percentage of Attic vases ever given such marks. With sophisticated techniques one *may* be able to detect such understains, but surely not in every relevant museum. The Tyrrhenian amphorae are one particular group in which there are often sad traces of red *dipinti,* but sometimes not even that much survives.

Such faded, or possibly totally washed-out, *dipinti* also play a part in the study of plain jars, though there they are normally found on the shoulder or neck, rather than under the foot. Fortunately, on the glazed Attic SOS amphora it was clearly preferable to incise rather than paint any message (as we see on a percentage of totally undecorated pieces). Such marks are highly disparate and extraordinarily difficult to interpret; they seem to point to systems in which many individuals were involved, either as producers of the material contained or as potters or shippers, in the broadest sense.[25] Recently, a few links between marks on plain and decorated pots have come to light that are of interest if not enlightening.

The first is a rather indirect link, between two Attic "à la brosse" amphorae of probably the second quarter of the sixth century; on both we find the graffito ΓET. On the strength of its appearance on one fragment from Tell Defenneh, I was tempted to interpret it as an abbreviation of an Egyptian name, but the other piece makes this unlikely, since it comes from that goal of Attic vase-painters, Cerveteri.[26] Despite the similarity in the range of Attic material found in Egypt and the west at this period, and later, this is the first "commercial" epigraphic link of which I am aware between the two areas as far as Attic pottery is concerned. It may be significant that the pieces probably date before 550, since we do have Corinthian vases from west and east (in this case Rhodes) with what I would take to be the mark of the same person, and in Corinthian script.[27] The Graviscan angle must also be considered; Mario Torelli has shown, convincingly for the most part, very close, presumably family connections between Ionians known from dedications at Naukratis and at Gravisca. To convolute the argument even further, I regret, one should note that there seems to be very little connection between these Ionians at Gravisca and the men whose abbreviated names appear as trademarks on Attic vases found at nearby Tarquinia or elsewhere in Etruria.[28] So although there are similarities between the Attic pots found in east and west, the traders involved, or at least their practices, seem curiously different.

Fig. 1a. East Greek amphora. Made on Samos (?) Mid-sixth century(?) London, British Museum, unregistered.

Fig. 1b. Graffito on the shoulder of amphora, fig. 1a.

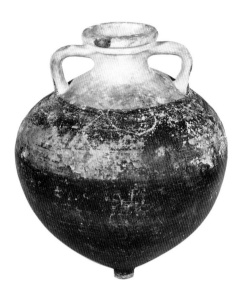

Fig. 2. Laconian amphora with graffiti on shoulder. From Vulci. Late sixth century. London, British Museum, 1848.6-19.10.

Also datable before 550, I judge, is a second link. One graffito is on a small, perhaps Samian amphora in the British Museum, with no known provenance, but perhaps from Tell Defenneh (figs. 1a, b); its "anchor" graffito is relatively frequent on other East Greek decorated vases from Naukratis and Tocra (including Chiot).[29] There does seem to be an East Greek *koine* of marks, to which we can now add one plain(ish) jar.

Another British Museum amphora provides the third link (fig. 2). It is a glazed Laconian jar from Vulci, on the shoulder of which is the graffito **ΣO** in a hand that I am tempted to see also in graffiti cut on the far more cramped undersides of some Attic black-figure feet.[30] Be he Sostratos or not, I would argue strongly for his Aeginetan origin, and ask how a Laconian amphora got involved in the system, when, for example, no Corinthian or Chiot amphora is (as yet) known to bear any mark typical of decorated Attic vases. The evidence again suffers from statistical paralysis; is this the tip of an iceberg or the exception that proves the rule? I note that many Laconian black-glazed kraters have been found at the Aphaea sanctuary on Aegina. Where was the British Museum amphora filled, and with what? And what does the current total of four Laconian amphorae from Etruria signify?[31]

We have visited Egypt in this interlude, the place of origin of Amasis' name. Perhaps I should turn to the man himself. I first assume that his work as we now have it is a fair reflection of his total output, give or take a Panathenaic vase or *kothon*. We should perhaps note also that the harvest from Etruria may overemphasize his amphora production. Here I hesitate between potter and painter; perhaps I should concentrate on the latter. The range of provenances is of course largely fortuitous; it includes no unexcavated site. One might, nonetheless, proceed to the conclusion that the range of provenances as we have it reflects what one would expect if Amasis' work had been distributed by Ionian traders—until one asks what distribution pattern would *not* fit that thesis. The two pieces from Boeotia are a slight irritant, nine from Naukratis a positive proof.

On a more particular level, we have a good knowledge of the record of the painter as regards trademarks on his work, in particular with the larger vases, which are the main repository of such marks. One oinochoe, Florence 3791, has a graffito (fig. 3); it bothers me that the Etruscan aura of the mark is belied by the letter to the right, and I can do no more than place it *sub iudice*.[32] Of the amphorae, thirteen are known to be unmarked (with the proviso of the wholly worn *dipinto*), several have little or no foot preserved, and eleven have marks. Unusually, four of these are in glaze, all different, and none convincingly associable with any other mark, in glaze or any other medium. The proportion of such isolated marks is far higher in the period before 550, and so, in a sense, a pattern is confirmed. It is a pattern that seems to indicate a broad spread of minor transactions.

As we now have a glaze signature of Amasis on the underside of a foot (*Amasis Painter* Appendix 1), we should perhaps be a little cautious before automatically taking abbreviated glaze marks as "commercial," but one should immediately add that many glaze marks of the *next* generation belong to groups that include red *dipinti* and graffiti and they

surely have transactional import.[33] One notes, too, that the few vases with kalos names which also bear marks display no connection between name and underfoot abbreviation, though it is of course no easy matter to be sure whether the abbreviation may or may not be that of an *erastes*, as Webster has argued in certain cases. One can, however, point to the *same* kalos name on vases bearing different marks, some of them in Ionic script.[34]

Fig. 3. Graffito on Florence, Museo Archeologico, 3791. (*ABV* 153,42).

The difficulty of interpreting small sets of marks is highlighted by the graffito accompanying the glaze lambda or gamma on the Embirikos amphora. This EN and the *dipinto* obviously refer to two separate things—an owner and a trader, two traders, a person and a vase name? I have cautiously suggested *en(themata)*.[35] *Non liquet.*

Two other graffiti appear only once on Amasean vases, but can be linked with the work of others. The seemingly Ionic omega-based mark on Munich 1383 recurs on Louvre F 99, related to the BMN Painter, and on Boston 99.522 of circa 530 (*Trademarks* type 29A). The shape of the omega is different on each. There is a second graffito on the Boston vase, IH which is not Ionic if the H be taken as the aspirate. An alternative would be to see it as an Ionic numeral, 18, but the growing body of IH or HI graffiti, all on vases of the third quarter of the sixth century, makes that interpretation less attractive.[36]

Fig. 4. *Dipinti* on the foot proper and on the navel of the foot of a horse-head amphora. 550–540 B.C. Formerly London market.

The other singleton is on Basel L 20: retrograde lambda epsilon, which is either Attic or Etruscan. Here again there is company in the third quarter of the century, including pieces from Lydos and the Exekian stable. We may add a mat black *dipinto*, partly preserved, on the foot of a late horse-head amphora recently on the London market (fig. 4).[37] Such a mark is likely to be Greek, and I would take many of these lambda-epsilon marks as Greek, probably Attic, though Etruscan cannot be ruled out in slightly more isolated cases, as on the Amasis amphora. One may ponder whether the foot, ex-Louvre G 520, may not have a closer link with Amasis than appears. It is also worth noting an oddity in the Lydos graffito, where a "blue" xi (Ξ) and epsilon is added, *lexe*, a concatenation of letter forms not found in any strictly epichoric script (fig. 5). I have failed to discover the whereabouts of a vase with a similar graffito noted by Beazley, where it is in company with a second mark that could be termed *the* Amasean trademark, since it appears four times, in red or graffito, on his vases: ΗΡ .[38] I also assume, on no solid grounds, that the mark is reduced to a simple H on the New York amphora, *Amasis Painter* number 1.

Fig. 5. Graffito on Paris, Musée du Louvre, E 804 (*ABV* 108,13).

This mark also appears on vases by the Painter of Berlin 1686 and on two unpublished feet, probably of type B amphorae, in the Louvre (figs. 6a–c, 7a–c). It is often, but not always, followed by a numeral—three, four, or five strokes. Also, the ligatured letters can be preceded by between two and four dots (fig. 6c); in two cases the dots are of the same number as the strokes, though on the vases by the Painter of Berlin 1686 there are two dots and the graffito is pi.

This is a complex net to untangle. We note first that the mark can be *dipinto,* or graffito, or both. Then it presents an alphabetical puzzle similar to that raised by the contemporary set of ΣΗ *dipinti* on vases of Group E (*Trademarks* type 1E); the latter combine, it seems, Ionic eta with

Fig. 6a. Foot of an amphora. Remains of a red *dipinto* on the navel of the foot. Paris, Musée du Louvre, CA 7311.

Fig. 6b. Profile of the foot, fig. 6a.

Fig. 6c. Graffito on the foot, fig. 6a.

a form of sigma not used with regularity in any script after circa 550 (Naxos and Kos are possible exceptions). HP could well be a purely Ionic abbreviation, but Attic Her.... cannot be ruled out.

The association of a ligature with numerals is also unusual. If we could interpret these numerals, and preferably also the significance of the dots, we would be a long way down the road to explaining the mechanics of the vase-trade at this period. We should not forget that the ligature does often stand without numerals. The mid-sixth century is early as far as attested usage of numeral notations is concerned in the Greek world; it would be poor procedure to draw conclusions from the rarity of ligatures with numerals in later generations.[39] One might hope that the range from three to five strokes might be generally reflected in more or less contemporary graffiti so that a useful conclusion could be drawn, but there must be doubts. Briefly, the problem is bedeviled by the difficulties with pi; it is easy to pick out marks where simple strokes are used to indicate numerals from one to nine; but are we to take pi, and pi iota, as numerals or alphabetic abbreviations (not to confuse the issue with cases where lambda = 5)? It is impossible therefore to quantify the occurrence of five or six in our record of such marks in this relatively early period. In some cases we also seem to have dots or the like indicating fractions of a unit.[40]

One possible line may remain unblocked. A slightly later mark was taken by H. R. W. Smith as an ideogram for a lekythos; it, too, is accompanied by two, three, or normally four strokes.[41] A little later again, Leagran vases more explicitly list batches of vases with their abbreviated names: lekythoi (lambda eta) form the smallest batches, from five to seven.[42] There is perhaps just more than a hint here that the Amasean numerals may refer to relatively small numbers of lekythoi or the like accompanying the marked vase. If HP denotes a non-Athenian person, the vases would have been allotted to him, whatever form of

financial transaction took place, a matter about which I would prefer to say very little. The variety that we have in the numerals certainly does not lend much support to interpretations such as capacity or price, but in isolated cases early numerals could have been so used. As a caution, I note one of the earliest numerical graffiti known to me, on an Attic SOS amphora of circa 600 from the cemetery of Monte San Mauro in Sicily; it has three horizontal strokes on one handle (as on an SOS amphora from Megara Hyblaea); eight verticals, preceded perhaps by a horizontal, on the lip; and ten long verticals on the body. I add no commentary.[43]

What conditioned the size of batches of vases is not clear. It is likely to have been the constraints of some form of packaging, taking the word in its broadest possible sense, although it could also have been the availability of accompanying material that limited the set.[44] There may be a hint here that by the third quarter of the sixth century the Kerameikos was becoming involved in a regular trading pattern and that demand for pottery was high. The glaze *dipinti* certainly point to pre-firing orders of some kind, which on the face of it put the potter in a privileged position, though I am aware that alternative scenarios are possible. We certainly need to assume for such views that the person in charge of the individual pottery worked independently of those who acquired the vases destined for export.

On the subject of prices, I would stress that the earliest good evidence that I know belongs to the early fifth century: it is in a graffito on the calyx-krater by the Troilos Painter, Copenhagen 126. Here a price in quarter-obols is quoted, which is worth noting because of the rather dogmatic view often expressed that in early days coinage was not designed for minor transactions.[45] For the sixth century, however, we do still lack evidence that can throw light on the finances of the vase-trade. I accept in broad terms the dating of early mainland coinage proposed by

Fig. 7a. Foot of an amphora. Paris, Musée du Louvre, CA 7312.

Fig. 7b. Profile of the foot, fig. 7a.

Fig. 7c. Graffito on the foot, fig. 7a.

Fig. 8. Upper half of an anchor stock inscribed with a dedication to Aeginetan Apollo by Sostratos. Late sixth century. From Gravisca, the port of Tarquinia (from F. Coarelli, *Etruscan Cities* [London 1975] 24).

Nancy Waggoner and Martin Price, with Aeginetan issues (with a few fractions) commencing at some time around or after 550.[46] And it is to that island that I would like to turn for some further considerations of Archaic trade, an island that has indeed yielded a particularly exciting new piece by our painter actually in an archaeological context. It leads me to stress that some part of Athenian vase production was always destined for fairly local use—funerary plaques, dedications for the Akropolis, many lekythoi. One can add a few other commissioned (or "bespoke," as they are often called) dedications in glaze, not only from Attica, as well as Exekias' famous dinos destined for a Sikyonian client—if it ever reached him in Sikyon, wherever Sikyon precisely was in 540.[47]

Aeginetans, we know, were involved with Eastern Greeks in the emporion of Naukratis, and we can now add Gravisca as a similar venture. Tom Figueira has recently argued that the Aeginetans would not have been able to sustain their population from available local resources and so were forced, by circa 500 at any rate, to turn to trade for subsistence. While downward adjustments have to be made in his figures, so that they are not as drastic as he originally argued, there remains much validity in his position.[48] In this instance we are not far from having to admit the existence of that dangerous concept "state-directed trade."

Here of course I have slipped from pottery into a broader field. It is pots, though, that give us something of the flavor of the "internationality" of this emporion-based trade, and the hints are intriguing. On the one hand, it is relatively clear that it was in the sixth century in particular that the local epichoric scripts were at their most fossilized; there are few exceptions to the "official" lettering found in sacral laws, dedications, even vase-paintings. On the other hand, there does seem to be evidence, as we have seen, of mixed scripts in trademarks, and we can go a little further. I mentioned Gravisca. The votive anchor of Sostratos is inscribed in Aeginetan lettering (fig. 8); yet the rho is of a peculiar form, with the loop rising *up* from the stem, a form that is otherwise found only in Ionian texts—the nearest from Paros, the majority from Samos (fig. 9), all of late Archaic date.[49] One example is on a statue base from Emporio on Chios. That island is also the home of kantharoi with bespoke dedications, a number of which have been found at the Aphaea temple on Aegina. Dyfri Williams has demonstrated that some of these exhibit the Doric dialect, dedications by Aristophantos and Damonidas. The scripts of Aegina and Ionia are actually very similar (a fact not uninteresting in itself), but we note in these *dipinti* a form of alpha which is very typical of Aegina, being found in some ninety percent of its Archaic texts, while on Chios the only other orthograde text in which I know it to occur is the selfsame base from Emporio.[50]

I note one further Archaic inscription that I would take as Aeginetan—a dedication from Olbia Pontica.[51]

This range of connections has tempted me to look for Aeginetan hands among our trademarks on Attic vases, a task in which speculation is easier than proof. One should also observe that in Etruria the anchor dedicated by Sostratos does rather stand out among the vast majority of graffiti in Ionian script; only one other text is taken by myself and Torelli

as Aeginetan, that of Euarchos inscribed on an Attic black-figure kantharos.[52] We may now add one further link between Etruria and Aegina that has come to light back home in the Aphaea sanctuary, in the shape of a mean little black-glazed bowl, perhaps Laconian, certainly not Etruscan, which bears an Etruscan graffito; it is the first such text that we know assuredly, or virtually so, to have been cut on Greek soil. The interpretation is not simple, but basically it appears to be an owner's inscription, perhaps that of one Plaute, a name now reasonably well attested in Archaic Caere.[53]

To conclude, I would like to return firmly to the pottery with a word or two on the status of Attic potters and vase-painters. De Ste. Croix and others have argued for their very low status or class position, while the dedications on the Akropolis have been placed in the other scale of the balance.[54] It is probably true that Amasis and Nikosthenes must have belonged to an exploited class, even if the identity of the exploiters remains hazy—Ionian traders? Etruscan aristocrats? Peisistratos? The wealth they attained is a matter of dispute. I have not been able to construct any worthwhile model from the direct evidence available (vase prices, etc.), even by extrapolating back from the fifth century with its meager harvest of useful material. Michael Vickers has suggested that we cannot use the evidence of dedications on the Akropolis since the word *kerameus* there should be taken as a demotic, not a trade description. There is in fact much to be said for his argument: the definite article is always omitted, which happens only once in other Akropolis dedications where a professional description is included, on the pedestal of the basin dedicated by the laundress Smikythe.[55] Also, the most grandiose of the pieces brought into consideration, the Nearchos base, cannot be said with any conviction to be that of a potter; the most likely restoration of the lacuna is perhaps [τοῦ δεῖνα *h*υ]ύς.[56] Alan Boegehold adds "Endoios," but here the reading is even more dubious.[57]

There is, however, much to be said on the other side, too. Where *kerameus* is assuredly preserved, on less prestigious bases, two of the three dedicants appear to be known potters, Mnesiades and Euphronios, while Andokides is associated with Mnesiades.[58] It would be a striking coincidence if they were from the deme Kerameis and yet none of them were the potters known to us by name from the relevant period. Also, it is noteworthy that a deme was called Kerameis in the first place and that, on Vickers' argument, people were happy to use a "derogatory" term as their demotic. "The Potters" in England are a football team from Stoke-on-Trent, but I will not develop an irrelevant analogy. Some support for Vickers' case could be seen in an unpublished *ostrakon* of the early period with a deviant form of a demotic, ἐχς Ἀλοπέκο;[59] yet one would surely have expected the form *kerameus,* seemingly in common use in dedications, to have appeared here and there in the reasonable number of *ostraka* against Leagros, of that deme. I cannot see that the case can stand on the evidence available, although it is fair to add that none of the assured examples of *kerameus* from the Akropolis is earlier than a possibly post-Kleisthenic date of circa 505 on conventional dating. We can conclude therefore that some potters did accede to modest wealth, and that is a

Fig. 9. Inscription recording dedications made by Perinthians at the sanctuary of Hera, Samos. Late sixth century. Vathi, Samos, Archaeological Museum, 1196. Photo courtesy DAI, Athens.

measure, however unsatisfactory, of the financial success, if not social status, of the members of the Athenian Kerameikos in the years immediately following the career of our particular artist.

<div align="right">
UNIVERSITY COLLEGE
LONDON
</div>

NOTES

1. I am deeply grateful to the J. Paul Getty Museum for the invitation to take part in the symposium and for the assistance and hospitality of so many of its members during the proceedings. Sadly, I was unable to discuss any of the points contained herein with Sir Moses before his death in June 1986. This is not the place, nor is there any need, to list his contributions in this area. I mention merely a few recent discussions: P.A. Cartledge, "'Trade and Politics' Revisited," in P. Garnsey, K. Hopkins, and C.R. Whittaker, eds., *Trade in the Ancient Economy* (London 1983) 1–15; review of the same volume by C. J. Howgego, *English Historical Review* 101 (1986) 207; more general, J. Riley, "Pottery Analysis and the Reconstruction of Ancient Exchange Systems," in S.E. van der Leeuw and A.C. Pritchard, eds., *The Many Dimensions of Pottery* (Amsterdam 1984) 55–73, with bibliography.

2. R.M. Cook, *JdI* 74 (1959) 114–123; J. Boardman, *Expedition* 21.4 (1979) 33–39; C. Tronchetti, *Dialoghi di Archeologia* 7 (1973) 5–16. Further works are cited by M. Martelli in M. Cristofani, ed., *Civiltà degli Etruschi* (Milan 1985) 175–181. Also, one should not forget the range of material gathered in T.B.L. Webster, *Potter and Patron in Classical Athens* (London 1972). On the use of *ABV* and *ARV* see also *Imagery* 33 n. 9.

3. Cook (supra, note 2) 120 refers to the accepted figure of thirteen hundred amphorae. M. Tiverios, *Archaiologikon Deltion* 29 A (1974) 147 n. 29 makes an assessment at circa twelve hundred, which seems to pay little regard to the requirements of the stone. In most respects I would follow A. Mommsen's reasoning in arriving at circa thirteen hundred (*Feste der Stadt Athen in Altertum* [Leipzig 1898] 65–97 embraces the relevant arguments). His judgment of the events missing on the stone must be more or less correct, but he underestimates the numbers of amphorae awarded in the men's events. See my note in *BSA* 82 (1987) forthcoming.

4. The new "decadrachm" hoard from eastern Lycia, for example, has thrown substantial new light on the production of the mints of Athens and Akanthos in the second quarter of the fifth century outlined in the ninth Oxford Symposium on coinage and monetary history (April 1986) to be published in 1987 in *British Archaeological Reports*.

5. I fortuitously echo Boardman's words (supra, note 2) 33 on the same subject. On the other hand, I feel that Cartledge (supra, note 1) 14 has overemphasized the cautions which I expressed in my book *Trademarks*.

6. The material from the Akropolis has not, of course, been wholly published, and not all of that included in the publication is illustrated. It is not possible to estimate how much material was discarded during and after the excavations.

7. Chalkis: *BSA* 73 (1978) 111–112 (with the date perhaps a shade too high).

8. For bibliography see H. Philipp, *Mitteilungen des Deutschen Archäologischen Instituts, Istanbul* 31 (1981) 160, 164–166. The material from Pitane is largely unpublished, in the museums of Istanbul, Izmir, and Bergama. For

Klazomenai see E. Doğer in *Recherches sur les amphores grecques,* Bulletin de correspondance hellénique, suppl. 13 (Athens and Paris 1986) 461–471. For a particular statement on Attic material from Samos see J. Boehlau, *Aus ionischen und italischen Nekropolen* (Leipzig 1898) 139–140.

9. The material from Chios was largely salvaged during building operations, a state which presumably applies to far too many sites. The material from Thera is largely unpublished and of the later period.

10. See the indices of *ABV* and *ARV,* or, for Gela and Rhodes, peruse the pages of *Monumenti Antichi* 17 and *Clara Rhodos.* There are fewer amphorae from Thera, but publication is not yet complete; the burial of Timosthenes is perhaps exceptional, *Archaiologikon Deltion* 17 B (1961–1962) 270.

11. See my note in H.A.G. Brijder, ed., *Ancient Greek and Related Pottery,* vol. 5 of Allard Pierson Series (Amsterdam 1985) 210 n. 17.

12. For these see T. Rasmussen, "Etruscan Shapes in Attic Pottery," *AK* 28 (1985) 33–39.

13. I work here on the assumption that decorated wares were normally sent empty, a point that cannot be argued here; see *Trademarks* 50; Carpenter (supra, note 2) 35 obliquely contests this view. In any case, my figures can only be *grossly* approximate, drawing on the few prices that we have for wine and oil (most conveniently listed by W. Kendrick Pritchett, "The Attic Stelai. Part II," *Hesperia* 25 [1956] 184, 199–203), compared with a range of vase prices of a generally slightly earlier period (*Trademarks* 33). I would stress that most storage jars are larger than most figured vases and that we do not know whether a greater profit margin could be gained by a shipper on decorated ware than in the perhaps more competitive area of wine exports.

14. L'Incoronata and Policoro have yielded significant amounts of material from the instep of Italy; for the former, see P. Panzeri Pozzetti in *I Greci sul Basento* (Como 1986) 134–143 and D. Ridgway, *Archaeological Reports,* 1981–1982, 76. For Kommos: P. Callaghan, *Hesperia* (forthcoming).

15. For some of these sites see supra, notes 8 and 14. Pithekoussai: D. Ridgway, "The Eighth-Century Pottery at Pithekoussai: An Interim Report" in *La céramique grecque ou de tradition grecque au VIIIᵉ siècle en Italie centrale et meridionale* (Centre Jean Bérard, Naples 1982) esp. 23–24. Histria: most recently, P. Dupont, *Dacia* 27 (1983) 42. Olympia: W. Gauer, *Olympische Forschungen,* vol. 8 (1975) 119–132. The present writer will publish material from the Aphaea temple, Aegina, in *AA.* Huelva: J. Fernandez Jurado, *La presencia griega arcaica en Huelva* (Huelva 1984) 38–40, and see P. Cabrera and R. Olmos, *Mitteilungen des Deutschen Archäologischen Instituts, Madrid* 26 (1985) 61–75. Material from Gravisca, Montalto, and other Etrurian sites will be published in *Le anfore di trasporto e il commercio etrusco arcaico,* vol. 3 of Studi di archeologia pubblicati dalla Soprintendenza archeologica per l'Etruria meridionale. For Gravisca, see also M. Slaska, *La Parola del Passato* 37 (1982) 354–359 and M. Torelli, ibid. 308, with earlier references.

16. For preliminary reports, see M. Bound and R. Vallantine, *International Journal of Nautical Archaeology and Underwater Exploration* 12 (1983) 113–122 and M. Bound, "Una nave mercantile di età arcaica all'Isola del Giglio," in *Il Commercio Etrusco Arcaico,* Atti dell'Incontro di studio 5–7 dicembre 1983 (Rome 1985) 65–70.

17. There is little to support the idea that Attic amphorae of SOS or "à la brosse" type were exported in any significant numbers after circa 575. The question of the SOS shouldered by Dionysos on the François Vase is vexed and agreement seems far away; for recent views see A. Stewart, "Stesichoros and the

François Vase" in W.G. Moon, ed., *Ancient Greek Art and Iconography* (Madison 1983) 53–74, esp. 55–56; *Imagery* 10–11; and G. Schaus, *Echos du Monde Classique* n.s. 5 (1986) 119–128; rather bold, then, the words "needlessly questioned" in the resumé of the talk given at the American Institute of Archaeology by J.C.P. Cotter, *AJA* 90 (1986) 187.

18. For early Corinthian B jars see C. Koehler, "Corinthian Developments in the Study of Trade in the Fifth Century," *Hesperia* 50 (1981) 452.

19. J.B. Salmon, *Wealthy Corinth* (Oxford 1984) esp. 114–118; his argument is more nuanced than that of J.L. Benson in *Greek Vases* 2 (1985) 17–20, who follows the traditional line of declining quality as the root cause of loss of trade.

20. For these challenges see M.J. Vickers, *JHS* 105 (1985) 108–128, with earlier bibliography in nn. 36 and 40 there. It is difficult to believe with Vickers that the signatures of Hypereides, Nikias, and perhaps Echekleides on early Panathenaics can have been copied from metal originals; and what of Pindar, *Nem.* X.35–37? As regards chronology, what indicators we have for the earlier sixth century hold together well, though perhaps we should await the full publication of the Rifriscolaro cemetery at Kamarina (traditionally founded in 599) to assess how well it fits with the generally accepted dating of the early Panathenaics to 566 and after. As with most historical evidence of this period, one can merely assess what may be more reliable (which normally means originating nearer the time in question) and note that in most cases there is a coherence with archaeological evidence, without full circularity of argument being involved.

21. *Trademarks* 223.

22. Ibid. 16–19.

23. Ibid. 48.

24. *BSA* 70 (1975) 153.

25. *BSA* 73 (1978) 128–132; V. Karageorghis, ed., *Excavations at Kition*, vol. 4 (Nicosia 1981) 37 n. 2.

26. *BSA* 73 (1978) 115, pl. 17f. The Cerveteri piece will be published by M. Guarducci in *Le anfore di trasporto* (supra, note 15).

27. *Trademarks* 234–235.

28. M. Torelli, *La Parola del Passato* 37 (1982) 314–322; idem, and A.W. Johnston in *Il Commercio Etrusco Arcaico* (supra, note 16) 255. Some of Torelli's links may be a little overspeculative.

29. British Museum, unregistered. H: 41.3 cm. Diam: 34 cm. Well levigated clay with some mica. Traces of chestnut-red glaze banding on shoulder and upper body, perhaps on lip, too, and down the handles. For the graffiti on East Greek vases see *Trademarks* 236, type 36A. Compare the piece from Migdol, E. Oren, *Bulletin of the American School of Oriental Research* 256 (1984) 19, fig. 22,6.

30. *Il Commercio Etrusco Arcaico* (supra, note 16) 265.

31. For details see *Le anfore di trasporto* (supra, note 15).

32. It is published as *Corpus Inscriptionum Italicarum Antiquioris Aevi* 40e, and my rubbing (fig. 3) confirms the reading. I saw no traces of a crossbar to make the first letter an alpha, which would ease the problem of interpretation substantially. A crossbar *may* have been omitted. Some two dozen Attic vases have the graffito **AI** , but they are an extremely scattered set (and therefore not included as a type in *Trademarks*); the nearest piece to the Florence oinochoe is perhaps Vatican 358 (inv. 17709) by the Towry White Painter,

with the mark in red. Regarding the larger closed vases by the Amasis Painter, I have no knowledge of the presence or not of marks on *ABV* 151,14 and 153,43 (Orvieto).

33. *Trademarks* 4.

34. Webster (supra, note 2) 271. Kalos names: Leagros, vases with marks of type 9E (42, 45, 51—the middle one in glaze), 10E (42) and 18E (6); Charmides, 6D (29) and 10E (106). Rather rarer is the repetition of the same mark on vases with the same kalos name: Leagros (9E) and Antias (15C,1 and 2).

35. *Trademarks* 232.

36. Three black-figure vases with the mark are added to the three in my list, *Trademarks* type 12A, by D. von Bothmer in his review of the book, *AJA* 85 (1981) 353. As there is no lack of Greek personal names starting with Hi..., a trademark so abbreviated is not unexpected.

37. Sotheby's, London, September 12, 1985, lot 155. The mark is in dull black and remains of further, separate letters are poorly preserved. This is the only addendum I am aware of for my type 15E.

38. For the piece noted by Beazley, see *Trademarks* 15E, 10 and page 216. The partly preserved letters on the Sotheby horse-head amphora (above) *could* be construed as a ligature of (h)eta and rho. For addenda to my type 5D (apart from the Louvre feet) see Bothmer (supra, note 36) 354.

39. I discuss examples of ligatures followed by a numeral in *Trademarks* 3. It would perhaps not be unexpected to find the word *herakleion* attested as a vase-name. Such an explanation would ease the problem of having two apparent personal name abbreviations on a single vase-foot, as for example Louvre E 804, but it is less attractive when we come to consider those cases where the ligature of (h)eta-rho is used *without* any numerals.

40. *Trademarks* 40–41.

41. *CVA* San Francisco 26–27; *Trademarks* 207.

42. *Trademarks* type 2F, vii, with page 221.

43. I thank Dr. Paola Pelagatti for allowing me to study this material; the amphora is from tomb 34.

44. See also D. Gill, *OJA* forthcoming.

45. *Trademarks* 227. The role of fractional issues in early silver coinages is currently undergoing something of a reassessment, with more emphasis on its presence than its lack; see for early issues of fractions J. Kroll, *American Numismatic Society, Museum Notes* 26 (1971) 17–18 and D. Berend in A. Houghton et al., eds., *Festschrift für Leo Mildenberg* (Wetteren 1984) 7–30, esp. 11; the role of fractions in early issues of "Croeseids" will be stressed by Ian Carradice in the proceedings of the Oxford symposium (supra, note 4).

46. N. Waggoner and M. Price, *Archaic Greek Silver Coinage: The "Asyut" Hoard* (London 1975) 122.

47. *ABV* 146,20; see Webster (supra, note 2) 45. An intriguing bespoke dedication is published by J.-J. Maffre, *Thasiaca,* Bulletin de correspondance hellénique, suppl. 5 (1979) 65–69.

48. T. Figueira, *Aegina: Society and Politics* (New York 1981) chapter 1. He perhaps overestimates fallow and underestimates polycropping, but his position remains strong, and he tells me *per litteras* that he would stand by it in general terms.

49. I will discuss this point more fully in a forthcoming article.

50. D. Williams, *AA,* 1983, 171–186. The Emporio base, *BSA* 58 (1963) 54. The alpha has the crossbar sloping up to the right.

51. See supra, note 49; *Sovetskaia Arkheologiia* 2 (1971) 232–238. Vinogradov takes the inscription as Rhodian, which seems less likely.

52. M. Torelli, *La Parola del Passato* 37 (1982) 315. See also *Trademarks* 26.

53. To be published by D. Williams and myself in *AA*.

54. G.E.M. de Ste. Croix, *The Class Struggle in the Ancient Greek World* (Ithaca, N.Y., 1981) 274–275 (on "status"); M.J. Vickers, *JHS* 105 (1985) 124–125 with n. 162; B.S. Ridgway in this volume, pages 84–85.

55. A.E. Raubitschek, *Dedications from the Athenian Akropolis* (Cambridge, Mass., 1949) no. 380.

56. Raubitschek (supra, note 55) no. 197. In this respect I should withdraw my remark in *AJA* 89 (1985) 182.

57. *Amasis Painter* 28. Raubitschek (supra, note 55) no. 70.

58. Raubitschek (supra, note 55) nos. 178, 225.

59. From the excavations of the south slope of the Akropolis.

John Boardman

AMASIS: THE IMPLICATIONS
OF HIS NAME

The name Amasis is a hellenized form of the Egyptian name that is generally pronounced A-ahmes (although we cannot be sure of its pronunciation in antiquity). The appearance of a Greek potter with such a name has encouraged speculation about his origins, and virtually every discussion of his work and career has included reflections on this topic. The lectures and catalogue stimulated by the meetings in Malibu and the exhibition in Los Angeles are no exception to the rule, but times and interests have changed, and it is no longer fashionable to attach much importance to the origins of Amasis' name and what it might imply.

Foreignness in Greek painters and potters exercised interest and speculation as soon as Greek decorated vases attracted scholarly attention. The most notorious example concerns our Amasis' contemporary, the great Exekias, and his famous Dionysos cup in Munich (a case called to my attention by Jody Maxmin). Scholars had not been slow to associate the fine Dionysos on his boat in the interior of the cup with the story of the god and the Tyrrhenian pirates whom he turned into dolphins while the mast of their ship sprouted a vine. Yet it was possible for the suggestion to be made in the 1829 publication of the *Museum étrusque* of Lucien Bonaparte that the figure in the boat was none other than Noah, and that the scenes of battle by the handles on the exterior showed the biblical fight between Osiris and Typhon, the sons of Ham.[1] This identification was abetted by the observation of what was taken to be an inscription in characters resembling demotic Egyptian, perhaps Phoenician or Hebrew (fig. 1). The letters are in fact simply the crackle of the paint just below the rim of the cup read with the eye of faith, an organ which has operated with no little success in our studies to the present day. (Within the last few years I have come across parts of the dress of a figure shown on a seal read as Cypriot syllabary letters, and part of the

Fig. 1. Cup by Exekias. "Inscriptions" and signature. Munich, Staatliche Antikensammlungen und Glyptothek, 2044 (from *Museum étrusque* pl. 42).

Fig. 2. Inscription from a statue at Abu Simbel, Egypt (from J. Boardman, *Greeks Overseas*, 2nd ed. [1980] 116, fig. 135).

filling ornament on another read as Aramaic.[2]) On the Munich cup it was natural enough that the name of the master Exekias should accordingly be read as Hezekiah.

We are spared many, but not all, such mistakes today and are subject rather to scholarly fashions. In the days of Panionism in art-historical scholarship it was easy to suppose that Amasis either had Egyptian blood in his veins or had spent some influential period of his life in the Ionian trading town of Naukratis in the Nile delta, or at the very least had enjoyed an Ionian upbringing which might account for the oddity of his name if not some of the idiosyncrasy of his style (for it was not unnaturally assumed that he was painter as well as potter). As long ago as 1831 Carl Otfried Müller suggested that he came from Egypt.[3] The debate continues, with waning support for anything other than a thoroughly Athenian background and training for the artist, and I shall disappoint those who expect a reactionary plea for his Egyptian ancestry; but I have speculated about his Ionian or Egyptian connections,[4] and the subject is not a dead one, nor can it be dismissed in a cavalier manner. This paper is devoted to further exploration of the familiar problems.

King Amasis of Egypt reigned from 570 to 526 B.C. (Egyptologists' dates). The name A-ahmes had already been hellenized as Amasis, since we read it thus in one of the graffiti left on the statues at Abu Simbel by Greek mercenaries in the course of the expedition into Nubia in 591 B.C. (fig. 2).[5] A-ahmes was a fairly common name in Egypt and by that time would have been very familiar to Greeks living in Egypt, but it was likely to have been known in Athens only after the king of that name had ascended the Egyptian throne. Amasis the potter was working by 550 (following Bothmer's chronology), and it would not have been altogether impossible for an Athenian child to have been named Amasis at birth and operational as a potter by 550. If our Amasis is the painter too, starting his career by about 560, the equation becomes impossible, but we are of course not obliged to believe that the name was given at birth, although this is the most likely case if the child was of an Athenian family. Born elsewhere, or a slave, he could have picked up the name or adopted it at any time, although it remains true that he would have been unlikely to pick it up in Athens, whoever he was, until after 570, or indeed some years later, since Amasis the king was no philhellene for the first part of his reign, whatever his record later.

The obvious parallel is with young Kroisos, whom we know

Fig. 3. Ionian aryballos. Oxford, Ashmolean Museum of Art and Archaeology, 1885.566.

from the fine kouros that adorned his grave in Attica.[6] He must have been Attic-born to be honored with such a monument, and from the apparent date of the statue he could have been so called after his namesake, the Lydian king, had ascended the throne in the 560s. And there is the earlier example of a native Greek acquiring the name of a foreign king in the last tyrant of Corinth, called Psammetichos after the Egyptian king.[7]

The phenomenon of these foreign or odd names in the Athenian potters' quarter can bear yet another look. The adoption of the name of a foreign dignitary such as Amasis is altogether exceptional, and the only real parallel in Attica is the young Kroisos, who is also altogether exceptional. Many other names are ethnic. Our catalogue (*Amasis Painter* 30) reminds us of Lydos, Skythes, Mys, Sikelos, Sikanos, Thrax, Syriskos, and Kolchos, but because one or two other ethnic names seem attached to native Greeks, it goes on to conclude that "connection of a name with a barbarian country no longer seems an issue." But it does remain an issue because two of the three names cited for comparison (Skythes, Thessalos, Lakedaimonios) refer to Greek areas, not barbarian ones, and because the number of such names in the potters' quarter far outnumbers such names in any lists of citizens. When we add to them the many other nicknames that appear,[8] we can see that we are dealing with a body of men of quite unusual composition. Moreover, we may remember that the Lydos who heads the list signs himself *ho Lydos*, "the Lydian," which seems a very definite statement of origin (not apparent, I must agree, in his painting), and that later in the century another Lydos painting in Athens declares himself unequivocally a slave, *dolos on.*[9]

One certainty about Amasis is that he was a potter. There seem no good grounds for doubting that this is the explanation of *epoiesen*, though the matter is still much debated. An *epoiesen* signature of Amasis has also appeared on a vase painted by another hand: the lekythos in Malibu by the Taleides Painter.[10] The suggestion that Amasis may have potted two vases for Lydos, the Lydian, has to be substantiated,[11] but we are sorely in need of a proper study of Amasis the potter as detailed as that which has by now several times been accorded to the Amasis Painter.

There is certainly nothing particularly foreign—Ionian, for instance—about his potting, or at least not more Ionian than that of others in the potters' quarter, although he affects a double-edged foot for some neck-amphorae which appears also in the Northampton Group.[12] Oddly enough, it could be argued that there is something Egyptian about him, for his painter decorates the first alabastron of purely Egyptian shape that we know from Athens.[13] (The earlier Corinthian alabastra are irrelevant, since their shape is not Egyptian in origin but, if anything, eastern.) Amasis' alabastron need not, of course, derive from Egypt or Naukratis, since the form had already been adopted by Ionian potters (fig. 3) and was familiar in Anatolia in Lydian metalwork, but the coincidence of name and shape is an odd one even if you dismiss it as accidental.

Of far more potential relevance is Bothmer's suggestion (*Amasis Painter* 128, 132) that Amasis the potter might have made the so-called Botkin Class of neck-amphorae. In shape and decoration, these owe almost everything to Ionia, and they should be early works in the potter's

career. The Ionian characteristics of the Botkin Class in both its potting and decorative schemes have been well explored by D. A. Jackson in his *East Greek Influence on Attic Vases*.[14] If the suggestion could be reinforced by a close study of the vase-profiles, we would immediately be carried to the east and to a milieu in ready and constant touch with Egypt; to one in which, at home or elsewhere, a name such as Amasis might easily have been adopted at almost any time. The association, or at least the possible association, of the Botkin Class with our man seems to throw open the whole question again.

I have spoken of Amasis the potter, but our subject is the Amasis Painter. Are they one and the same? The new orthodoxy states that they are not, or at least need not be, and this view is closely associated with the belief that the painter's work is wholly in the Athenian tradition. I had queried the mainstream Athenian character of the painter's work and ventured the opinion that painter and potter were the same because "the distinctive elements in each craft seem to share a common spirit."[15] I might have added that we are dealing with a period in which one might almost expect a potter to be a painter. Painters, at any rate, are not indifferent to the shapes of the vases they decorate. Nor, surely, were potters indifferent to or incapable of having an influence upon the decoration of the shapes they made. They were, after all, the senior partners in the operation, even when not the same persons.

Amasis the potter always signs *epoiesen,* "made"; but *epoiesen* does not always have to mean "*only* potted." For example, Exekias sometimes tells us that he potted a vase *and* painted it, but on other vases, which we are sure he painted, he signs *epoiesen* only, and who are we to say that he was not also telling us that he painted the vase, or even that the thought was uppermost in his mind, since he uses "made," *epoiesen,* far more often than he uses "painted," *egrapsen,* and he uses it on vases that he potted for others to paint. So let us not be too sanguine about what the inscriptions can and cannot mean. *Epoiesen* implies physical involvement in the creation of a work, and this might embrace more than one aspect of its creation.

My thought that painter and potter were the same was neither original nor revolutionary, and the remark was made in the course of drawing attention to other odd features yet to be mentioned here. The idea had a good pedigree. Are they the same man? Read Beazley in his *Attic Black-figure, A Sketch,*[16] and bear in mind the question of whether our artist is mainstream or not: "With the Amasis Painter, as with Exekias, the question arises, was the painter responsible for the shape of the vase also, or rather for the total vase, compound of shape and decoration? It seems likely, for the harmony is complete." He goes on, "In vase-shapes the main line of development runs through or from Exekias: Amasis is a by-path. And the same is true of Amasian drawing." And in his *Development of Attic Black-figure*[17] we read, "A great part of the pleasure one receives from the vases he decorated . . . is due to the potter-work . . . in fact to Amasis, and the potter Amasis is as clearly defined a personality as the Amasis Painter; he has his own idea of shape, and goes his own way, keeping apart from the majority."

So, what of Amasis the painter, his Atticness? Our cataloguer again: the painter is "thoroughly Athenian," and "neither the vases nor their decoration reveal any traits of foreign birth or upbringing" (*Amasis Painter* 38); and in Professor Boegehold's graceful essay on "The Time of the Amasis Painter": "The existence of an Attic style is clear, and some of those who worked within that style were foreign born and educated" (ibid. 31). I would be inclined to say rather that "some of those who helped to create that style were foreign born and educated." There is a distinctive style in Attic sculpture, but we can readily distinguish in its very clear development the decisive part played by non-Athenian artists, and we do not have to guess about their presence and influence, for we have their names and homes recorded on their works. In vase-painting too, what we call the Attic tradition is compounded of a variety of non-Athenian styles and traditions, starting with the Corinthian, which is overwhelming, and continuing with the Ionian. We cannot isolate any Attic tradition which does not embrace all the works made in Attica; they are our only evidence for it, after all. Here recall also the evidence of names, and we can see that the potters' quarter was not wholly staffed by thoroughbred Athenians, nor was its great tradition one which sprang inevitably and exclusively from Athenian soil.

What, then, might there be which is not mainstream in our painter's work? Intimations of the Ionian and Egyptian in it have been explored elsewhere in this volume by Brunilde S. Ridgway (pp. 81–91), and the reader is referred to her paper. What may we conclude about our artist or artists? I confess that I find it difficult to answer and am profoundly suspicious of those who find it easy. I have a strong feeling that potter and painter are the same man, and I am in good company in this. I think it very likely that he was not Athenian by birth and that he acquired his name in Ionia or in an Ionian milieu, although I would not rule out the possibility that it was adopted only after he was in Athens, but even then not without some reference to his origins. I think he probably came to Athens and worked as a potter, whether or not he had been one previously; that he took up painting, probably at the elbow of the Heidelberg Painter. In other words, that he was a successful immigrant, or the son of a successful immigrant, who had his own kiln and business, which he was able to hand on to his distinguished potter-son, Kleophrades.[18] (Whether this Kleophrades ever painted or not is another matter; we can be reasonably sure, I think, that he was not the Kleophrades Painter, but the Athenian potters' quarter was by then a very different place from what it had been in Amasis' day, and far more devoted to specialization.)

For his early painting Amasis picked up some of the more mechanical tricks of the Heidelberg Painter, but with his eyes open to the work of others, including the Lydian, another successful foreigner (or at least a non-Athenian). In the early days his work was inevitably "rude, untutored," as Bothmer describes it (*Amasis Painter* 43). In his drawing there was nothing to mark out his style from that of others working in Athens; nothing distinctly un-Athenian. His readiness to draw in outline was no great novelty for Athens, but that does not mean that he was not

aware of an even stronger tradition of line drawing elsewhere in the Greek world, one that was going to be more influential than the Corinthianizing black-figure of Athens. What I find decidedly not mainstream in his work is his attitude, so far as we can detect it—but this is a very subjective matter—and his choice of subject matter, where we are less likely to be accused of subjectivity. Whenever he treats a standard mythological theme, which is comparatively rarely, he does so in the traditional Attic manner and has nothing really of importance to add. What he does add is a taste for genre which is unfamiliar, but I am more impressed with the difficulty scholars have had with his other, apparently more innocuous themes. I refer to the difficulty of deciding "what men or gods are these?"—just who these young men are who consort with gods, or who these winged demons are that consort with mortals, or what occasion it is that brings these gods or heroes or mortals together. The excessive ingenuity that often has to be summoned to make sense of many of these is, I suspect, misapplied. It was not that Amasis was stupid or did not care, but he was less interested than, say, Exekias or the main artist of Group E, in plain storytelling; he creates an atmosphere of the intermingled divine, heroic, and mortal that defies description yet is not in any sense absurd.[19] What he achieves with flair, others managed more ineptly. I think especially of the Affecter and of Elbows Out, both of whom are very closely connected with Amasis, potter or painter, as many have seen. Mainstream in style and art but decidedly not mainstream in mood, would be my judgment of them, and I doubt not that many would agree. Their interest seems to be in form rather than content, and in this respect they are certainly proceeding on a course somewhat deviating from the mainstream, which we can effortlessly trace from Kleitias through Lydos, Group E, and Exekias. I sometimes feel that they are treating the traditional subject matter of Attic vase-painting in much the same manner as—in earlier generations—Greek artists treated the subject matter of Near Eastern art.

Of Egypt itself or of Egyptian influences we have really had nothing to say beyond observation of the generally Ionian character of most Greek dealings with Egypt. There is, of course, something of a story here, even if it apparently has little enough to do with Amasis. In Athens itself we have to explain the appearance of the purely Egyptian motif of Herakles striding along the chariot pole in gigantomachies, as though he were a Pharaoh, a feat impossible in any Greek chariot, real or imagined.[20] This seems a motif which had not been picked up in Ionia. In Ionia itself, of course, there is much more: a flood of Egyptian objects at sites such as the Samos Heraion, and from an early date;[21] and what now seems more than circumstantial evidence for Greek potting and painting in Egypt, notably the remarkable fragmentary vase in Dr. Herbert Cahn's collection with the Greek subject matter and the Egyptian cartouches (figs. 4a, b).[22] Some Ionian had made or deliberately purchased a vase to dedicate at Karnak because the Dionysiac procession shown on it so closely matched the local Egyptian festival.[23] And then there are those remarkable Ionian painters of panel or wall, one of whom went to Egypt and painted the wooden panel found recently at Sakkara

Figs. 4a, b. Fragments of a vase of East Greek type from Egypt. Basel, Herbert A. Cahn collection, 1175. Photos courtesy Herbert A. Cahn.

(fig. 5), while his companions went west to establish the workshop of the Caeretan hydriae in Etruria.[24]

Further knowledge of Egypt in Athens is demonstrated by the appearance of blacks on the vases. On two of Exekias' vases a black attendant of the Ethiopian king Memnon at Troy is called Amasis and Amasos (figs. 6, 7).[25] Carl Robert had thought that in the first case the name referred to the warrior, in whom he saw the Egyptian king,[26] but its second occurrence makes clear who is intended. Exekias might have been led to use it simply through knowledge of the Egyptian king, but these are the only followers of Memnon to be graced with names. Moreover, the potters' quarter was a small place, and when Exekias wrote, at least twice, this name beside a black, it is surely impossible that a foreign king was so much on his mind that it excluded his rival across the street. The foreign name alone might have been enough to suggest its use in this case, or was Amasis rather dusky in appearance? Was this, perhaps, why he acquired the name in the first place? We have to admit that, so far as we can observe the exchanges between the two, the Amasis Painter comes off better with his brilliant and scurrilous parody of an Exekian eye-cup (*Amasis Painter* 221–222, no. 61), while Exekias merely calls him names, or rather attaches his name to a barbarian image.

There is more to observe on the Exekias vase: two inscriptions, placed symmetrically over the heads of the blacks, in straight lines set obliquely in the manner familiar from other works by Exekias. The writing appears to be his, though he was not a wholly consistent scribe. The inscription at the right is the *Amasis* (fig. 8a), which we have seen to refer to the black. The one at the left reads *aoiesn* (fig. 8b). It cannot be nonsense, because Exekias does not write nonsense—how could he? It looks a bit like *epoiesen*, but Exekias never leaves floating *epoiesen*s without a subject, as some do. If the subject is meant to be the other inscrip-

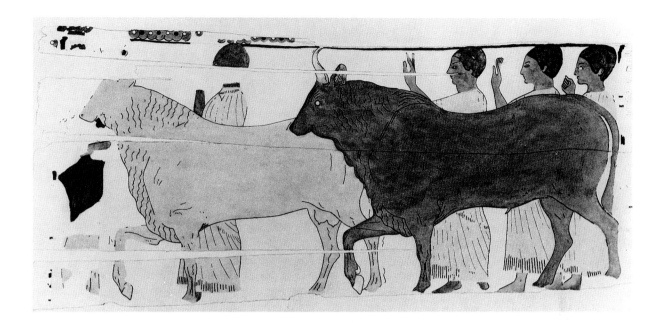

Fig. 5. Painted wooden plaque from Sakkara, Egypt. Painting by Helen Ward (from G.T. Martin, *The Tomb of Hetepka* [London 1979] pl. 1).

tion, *Amasis*, written to its right and apparently to be read after it, it would be oddly inverted and amount to a forgery of Amasis' signature—not a totally unfamiliar phenomenon in the Athenian potters' quarter in later years, but not looked for here and in this form, and at any rate we have found a use for the *Amasis* inscription, designating the black. If it is meant for a name, for the other black, which is what its position suggests, it makes no sense as any Greek name, or Egyptian name, or hellenized Egyptian name. It certainly does seem to be an attempt at *epoiesen*, but Exekias does not make attempts at inscriptions. Is it deliberately a barbarized version, almost phonetic? It is almost impossible to believe this, but there must be some explanation for it. Enhancing the idea that it, too, is "getting at" Amasis the non-Athenian is the presence in it of an Ionic eta,[27] otherwise virtually unknown in Athens at this date, and certainly unknown otherwise in Exekias' script. He could have chosen a less sensitive place in which to be epigraphically obscure, but I am left with the feeling that, whatever the explanation may be, it could prove to be not unrelated to our subject.

We shall never have a clear answer to all these puzzles about Amasis and his name, but it would be wrong simply to dismiss them as not puzzles at all. There is enough still to stimulate thought and speculation and none of it, or little of it, is idle. It has become a commonplace by now that each generation writes its own version of ancient history, influenced, sometimes consciously, by the temper of the times. In Greek art history the same has happened with the Amasis story, with the Egyptian/Ionian element stressed in days of Panionism, abandoned as the reaction set in. The role of Ionia is becoming better recognized again, so perhaps it is time for the pendulum to swing back, and all the time there is the chance of new evidence emerging to complicate the issue, or even perhaps one day to resolve it. The current orthodoxy, if it is to be judged

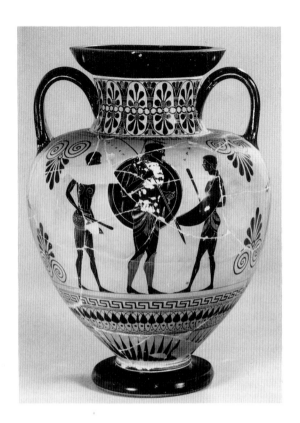

Fig. 6. Neck-amphora by Exekias. Side B: Memnon with two attendants. London, British Museum, B 209.

Fig. 7. Drawing of a panel-amphora by Exekias. Side A: Menelaos attacking Amasos. Philadelphia, University Museum, MS 3442 (from *Museum Journal* 6 [1915] 91).

from the publication *Amasis Painter,* betrays strong elements of a sort of Panatticism, and I suppose one of the characteristics of life today is a resurgence of almost isolationist nationalism. The archaeological equivalent is the highly fashionable rejection of all diffusionist theories and a fondness for finding models to explain new developments in terms of local changes, needs, and challenges. In ten years' time some new study of Athenian painters or potters may find it less embarrassing to suggest that there were in the Athenian potters' quarter foreign ideas and attitudes that profoundly influenced the course of Athenian art; what part Amasis might play in such a study we can barely guess.

ASHMOLEAN MUSEUM OF ART AND ARCHAEOLOGY
OXFORD

NOTES

1. *Museum étrusque de Lucien Bonaparte, Prince de Canino.* Fouilles de 1828 à 1829 (Viterbo 1829) 179–182, pl. 42. See also Lord Dudley Stuart's report on these finds in *Archaeologia* 23 (1831) 255–257. The vase is Munich 2044; *ABV* 146,21; *Paralipomena* 60; *Beazley Addenda* 18.

2. E. Masson in M.-L. Vollenweider, *Catalogue raisonné des sceaux, cylindres, intailles, et camées,* vol. 3 of Musée d'Art et d'Histoire de Genève (1983) 215, no. 155. *Atti e memorie della società Magna Grecia* 15–17 (1974–1976) 58–64, pls. 22–23.

3. "De origine pictorum vasorum," *Göttingische gelehrte Anzeigen,* 1831, 133–135.

4. *JHS* 78 (1958) 1–3.

5. Ibid. 2 n. 5. Cf. J. Boardman, *The Greeks Overseas*, 2nd ed. (London 1980) 116, fig. 135.

6. Athens, National Museum 3851. G.M.A. Richter, *Kouroi* (London 1970) no. 136, figs. 395–398, 400–401. E. Mastrokostas, *Archaiologika Analekta ex Athenon* 7 (1974) 215–228, for the base.

7. J.B. Salmon, *Wealthy Corinth* (Oxford 1984) 225–230.

8. J. Boardman, *Athenian Red Figure Vases: The Archaic Period* (London 1975) 9–10.

9. Black-figure kyathos, Rome, Museo Nazionale Etrusco di Villa Giulia; F. Canciani and G. Neumann, *AK* 21 (1978) 17–22.

10. Malibu 76.AE.48. *Amasis Painter* 229, Appendix 1.

11. Berlin F 1685 and London B 148. H. Bloesch in *ABV* 109, nos. 24, 29; H. Mommsen, *Der Affecter* (Mainz 1975) 43 n. 213 (for London B 148). M.A. Tiverios, Ο ΛΥΔΟΣ ΚΑΙ ΤΟ ΕΡΓΟ ΤΟΥ (Athens 1976) 56, 61.

12. Boardman (supra, note 4) 2.

13. Athens, Agora Museum P 12628. *Amasis Painter* 43, fig. 34.

14. D.A. Jackson, *East Greek Influence on Attic Vases* (London 1976) especially 30–32.

15. Boardman (supra, note 4) 2; cited in *Amasis Painter* 38. It is encouraging that Joan Mertens, in her fine paper published in this volume (pp. 168–183), also argues for identity.

16. J.D. Beazley, *Attic Black-figure, A Sketch* (London 1928) 21.

Figs. 8a, b. Details of the inscriptions on neck-amphora, fig. 6.

17. *Development* 57.

18. *Amasis Painter* 230–231 for the signatures.

19. *Imagery* chapter 3 for a description of the phenomenon of the "stock figures" in Dionysiac scenes, in the work of the Heidelberg and Amasis painters.

20. M.A. Littauer, *AJA* 72 (1968) 150–152.

21. J. Boardman, *The Greeks Overseas,* 2nd ed. (London 1980) 114 and references.

22. Ibid. 139, fig. 164.

23. Ibid. 137–138, figs. 162–163. Oxford 1924.264.

24. J.M. Hemelrijk, *Caeretan Hydriae* (Mainz 1984) 201–202; *Cambridge Ancient History,* plates to vol. 3 (Cambridge 1984) 224–225, no. 299.

25. London B 209; *ABV* 144,8; *Paralipomena* 60; *Beazley Addenda* 17. Philadelphia MS 3442; *ABV* 145,14; *Paralipomena* 60; *Beazley Addenda* 17; *Amasis Painter* 31, fig. 19.

26. C. Robert, *Archäologische Hermeneutik* (Berlin 1919) 81.

27. Not an aspirate H, if the inscription is an attempt at *epoiesen*.

Mary B. Moore

The Amasis Painter and Exekias: Approaches to Narrative

Among all of the black-figure vase-painters known to us, Exekias and the Amasis Painter are unanimously acknowledged to be the best, superior not only as draftsmen but also as illustrators of mythological subjects and themes from daily life. Of the two, the Amasis Painter has a longer period of productivity, and he has left us a larger number of vases (over 130) than Exekias, whose working years may be charted for a scant two decades and whose known output does not quite total forty pieces. Still, for about twenty years, the two were contemporaries in the potter's quarter of ancient Athens, and they surely knew one another. My purpose here is to try to establish something about the personality of each one through the subjects he paints and the manner in which he paints them. We shall probably never know for certain whether it was the potter, the painter, or perhaps even the client who decided what subject was to be painted on a specific vase, but in the case of Exekias and the Amasis Painter, I do not think it too rash to believe they selected their own themes and for some of them invented new compositions.

On the splendid neck-amphora in the Cabinet des Médailles,[1] the Amasis Painter depicts Athena and Poseidon standing before one another. Though the exact subject the painter had in mind is not entirely clear, one thinks immediately of the contest between the two over who would be the patron deity of Athens, and the scene here might depict the moment before the start of the contest. The quiet, dignified calm of each deity is remarkably similar to the figure scene on a neck-amphora in London[2] by Exekias. There Oinopion stands before his father, Dionysos, a quiet rendering of the wine god and his son that is far removed from the spirited, often drunken revel associated with Dionysos and his reti-

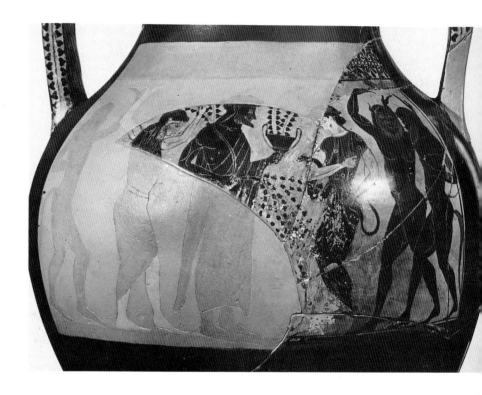

Fig. 1. Amphora by Exekias. Side B, panel: Dionysos and satyrs. Budapest, Szépmüvészeti Múzeum, 50.189.

nue of unruly satyrs and frenzied maenads—popular subjects with so many of Exekias' contemporaries, including the Amasis Painter.

On the other side of the neck-amphora in the Cabinet des Médailles, a majestic Dionysos greets two maenads who dance up to him, arms around each other. Their spontaneity stands in sharp contrast to the reserved calm of Dionysos. On an amphora once in Berlin,[3] the two maenads have been joined by two satyrs and by two more maenads, and the revel is well under way. The source of all the gaiety is, of course, wine. On one side of the Amasis Painter's amphora in Würzburg,[4] satyrs are busily at work making wine for a future occasion, one like that shown on the other side, where even Dionysos takes part by sampling the new wine instead of standing coolly aloof as he does in the two previous scenes. The satyr who fills the god's kantharos from his bulging wineskin looks out at us as if inviting us to join the fun. The vintagers go about their various tasks. One satyr dumps ripe grapes into the basket for a portly, well-fed-looking satyr to tread in rhythm to the music played on the *aulos* by one of their companions. Note the casual way he grasps the vine to steady himself. On the right a satyr picks more grapes and on the left another pours the juice into a *pithos*, where it will remain until it has fermented and is ready to drink. Bibulous times to come are assured. In these scenes everyone enjoys the occasion; the spirit is light-hearted, playful, and gay.

Only once does Exekias paint Dionysos with his unruly satyrs and maenads, on his amphora in Budapest (fig. 1),[5] and here he seems almost a bit embarrassed by their shenanigans. To be sure, the pair of

MOORE

Fig. 2. Cup by Exekias. Tondo: Dionysos sailing. Munich, Staatliche Antikensammlungen und Glyptothek, 2044. Photo C.H. Krüger-Moessner.

satyrs on the right remind us of some we have just seen, but the world of the Dionysiac thiasos, with its uninhibited behavior—much loved by other artists—does not seem to attract Exekias. He has, however, left us a representation of Dionysos that is unique. On the inside of the famous cup in Munich (fig. 2),[6] Dionysos sails over the sea in solitary splendor, a theme that does not seem to have good visual parallels, though its subject—the kidnapping of the god by pirates—is well known from the *Homeric Hymn to Dionysos*. (I am reluctant to dismiss entirely the association of this scene with the hymn as Professor Albert Henrichs has.) I quote from the translation by Charles Boer:[7] "Suddenly a vine sprang up on each side, to the very top of the sail. And grapes all over clung to it, and a dark ivy coiled the mast, it blossomed with flowers and yielded pleasing fruit." The pirates were terrified when they saw it. "They all jumped into the sea, they jumped into the divine sea. They became dolphins."

This cup surely would not have been intended for daily use but only for special occasions, such as the Anthesteria, the festival of Dionysos, when his image was driven to his sanctuary in Athens in a wheeled ship. But even this association cannot be proven beyond doubt.

Let us turn now to some of the Greek heroes. Of all such figures depicted in Greek art of the sixth century, Herakles is the undisputed favorite, *the* hero par excellence, the one hero who attained immortality and joined the gods on Mount Olympos. But before that, Herakles had a good many adventures, and illustrating these sparked the imagination of many painters in the Kerameikos. It may perhaps strike us as odd, then,

that neither the Amasis Painter nor Exekias seems particularly interested in Herakles. Each depicts Herakles choking the Nemean lion, a beast invulnerable to weapons whose pelt Herakles had to display to Eurystheus: the Amasis Painter's version is on a chous in the Louvre,[8] Exekias' on a neck-amphora in Berlin.[9] On each vase, the hero overpowers the lion in a standing position, a familiar arrangement that has a long history, and in each scene the hero and beast are flanked by Iolaos and Athena: the strength of man and beast are ruggedly tested, the outcome not yet decided.

In addition to his scene of Herakles and the lion, the Amasis Painter has left us a splendid example of the hero trying to steal Apollo's tripod at Delphi: one of his two neck-amphorae in Boston[10] depicts the fierce struggle between Apollo and Herakles, in which it was clear from the start that no hero, not even one destined for immortality, is a match for an Olympian god. (The tripod was soon restored to its rightful owner.) Twice the Amasis Painter depicted the fight between Herakles and Kyknos, the aggressive son of Ares. From the sixth-century poets we learn that Kyknos attacked and robbed worshipers bringing gifts to Apollo at Delphi and that, at Apollo's urging, Herakles fought and killed the brigand. One example, on the pyxis at Aegina with the names inscribed, is not in the Amasis Painter exhibition (it is in Appendix 4 of the catalogue, where it is published for the first time);[11] the other is on an amphora in the Louvre.[12] In both, Athena and Ares flank the duel. In these representations the struggle is intense; in the better-preserved one, Herakles may seem a little bit more aggressive than his opponent.

As far as we know, Exekias did not paint either of these two scenes, but perhaps we may compare another labor of Herakles that is fraught with danger, for it shows how Exekias will often play down the moment of most intense action in favor of one that alludes to it.

On one side of an amphora in Orvieto,[13] Herakles appears in the presence of Olympian deities with a very large but subdued Cerberus. Quite a bit of this vase is missing, but one recognizes easily the body of the dog with it shaggy locks of hair along its back and its tail ending in a snake's head, as well as most of Herakles, Hermes, and probably Athena. Capturing Cerberus, the fierce two-headed dog that guarded the gateway to the underworld, bringing him to King Eurystheus, and then returning the beast unharmed was one of the last labors Herakles had to complete in servitude to this king. The sedate appearance of everyone here, including the dog, which often does not look very threatening, stands in sharp contrast to the manner in which the Amasis Painter presented the tripod and Kyknos adventures.

Herakles' reward for successful completion of the twelve labors was admission to Olympos. On the obverse of this amphora by Exekias, the hero has taken his place among the Olympians, seated next to Zeus in the middle of the composition. Herakles has changed from his usual lion skin to apparel more appropriate to the occasion: a long chiton with embroidered or woven designs and a striped cloak over his shoulder—but he still has his club. Clearly, he is the center of attention.

When the Amasis Painter takes up this subject, on two amphorae

in Berlin with very similar compositions,[14] he shows a procession. On the vase in the Amasis Painter exhibition,[15] we see Hermes, Athena, Herakles, and an unidentified youth come up to Zeus. Like Exekias' version, the moment shown is quiet and dignified, yet the formality of it is diminished slightly by the dogs, who do not really belong here. Exekias also depicts an earlier moment in the Introduction of Herakles into Olympos,[16] which shows a chariot driven by Athena, Herakles' protectress during many of his arduous labors. This is the version that becomes the customary manner of illustrating this episode of the hero's life in the late sixth century.

Herakles was the favorite hero of the Greeks, but others were also important, particularly the heroes who fought at Troy, not only on the Greek side but on the Trojan one as well. There was great admiration for these heroes, and poems were composed about this great war for the nobility who wanted to hear about the glorious past, about supermen of a bygone golden age. Strong historical threads give these poems a peculiar concreteness and a certain plausibility. They describe a complete and vital world remote enough to be romantic and intriguing, yet sufficiently detailed to be sympathetic and alive. The heroes who fought at Troy often came to tragic ends, and they frequently exhibited human failings, but they were never feeble or weak, not even in the most dangerous and threatening circumstances. And they often provided models of courage, bravery, and intelligence—high goals toward which humbler men might aspire.

When we examine representations of scenes from the Trojan cycle, we shall begin to see where Exekias' true interests lie and where his personality best expresses itself. But the Amasis Painter, while not especially interested in Troy, has left us two memorable Trojan scenes, which we shall look at first.

Greatest of all the Greek heroes at Troy was Achilles, whose cry to battle instilled fear and dread in the heart of every Trojan. Early in life, Achilles learned he had two choices: to remain at home and live out an ordinary life to old age, or to fight at Troy and die young and gloriously for the Greek cause. Without hesitating, he chose the latter. On one of his neck-amphorae in Boston,[17] the Amasis Painter shows the young Achilles receiving armor from his mother in the presence of Phoinix. On the surface, this is a quiet moment, but one that alludes to fierce battles to come.

One of the acknowledged masterpieces of all Greek vase-painting is a splendid cup in the collection of Norbert Schimmel.[18] The two sides are linked thematically: on the one, the stable of Poseidon; on the other, the sea god himself with heroes. The subject, a unique one, comes from book 13 of the *Iliad*: Poseidon's grooms harness his team, and he comes down to the Trojan plain to encourage the Greeks and give them heart during a dark moment in the war when they find themselves driven back to their ships. These horses are well-bred, elegant animals, frisky and eager to be off. The identity of the diminutive figures on the backs of two of them is not yet assured; perhaps they are demons who instill spirit and vigor into the beasts. On the other side of the cup, Poseidon moves

between two heroes who ought to be Ajax, the son of Telamon, and Ajax, the son of Oileus, accompanied by archers and other heroes.

Speaking of Telamonian Ajax, Exekias seems to have a special sympathy for this hero, for he invents new scenes for him or reinterprets old ones. And he stresses the friendship between Ajax and Achilles.

Between battles and skirmishes in the Trojan War, there was probably a good bit of time. Part of this time could, of course, be spent repairing armor, tending to various daily needs, or playing games, such as the board game combining skill with chance on Exekias' famous amphora in the Vatican.[19] Ajax and Achilles concentrate intently on their game. Even without the inscriptions that tell the throw of the dice, subtle details such as the relative heights of the heroes' heads, the slightly different positions of their feet, and their hands gripping spears, one loosely, the other tightly, mark Ajax as the loser and depict him as the tenser of the two. This theme becomes very popular in the late sixth century, which may well be due to Exekias. On an example by the Lysippides Painter, who was probably a pupil of Exekias',[20] the influence is clear.

When Achilles was slain by Paris, a great fight arose over his body. While the Greeks kept the Trojans at bay, Ajax shouldered the corpse and carried it safely back to the Greek camp. This subject is one of the oldest depicted in Greek mythological illustrations. Examples that predate those by Exekias, such as the one on the back of the handle of the François Vase by Kleitias,[21] really minimize the difficulty of Ajax's task. Ajax moves to the right, or perhaps rises, rather easily in spite of his burden. There is no evidence of strain or of concern for the Trojan enemy around. Exekias, however, gives new meaning to the subject: on his neck-amphora in Munich,[22] Ajax moves to the left, slowly and steadily, straining beneath the great weight of his dead friend (fig. 3). Achilles still wears the splendid armor crafted by Hephaistos that will become the object of the bitter quarrel between Ajax and Odysseus over who deserves more to inherit it. In Archaic Greek art, the movement to left usually signals someone who will ultimately lose, and it may be that by showing Ajax moving to the left, Exekias is alluding to the dark future of the hero. Inclusion of the armor not only forecasts a future event—the quarrel over the arms of Achilles and their award to Odysseus, which is the decision that leads to Ajax's suicide—but it also has the immediate effect of increasing the burden that Ajax must carry from the battlefield. Rescuing the body of Achilles from Trojan capture and defilement was Ajax's noblest deed, the one for which he was best remembered, his last and highest service to his loyal friend. Exekias' version plays up the danger of Ajax's feat and his unfailing bravery as Achilles' friend as well as his commitment to him.

This neck-amphora also illustrates an important characteristic of Exekias' approach to narrative, namely that he reduces the scene to its essentials by eliminating extra figures, preferring to concentrate on just those absolutely necessary for his story. He thus lets the viewer supply the others in his imagination—in this case, the Greeks keeping the Trojans at bay while Ajax carries Achilles to the Greek camp.

In addition to his version of Ajax carrying the body of Achilles, Exekias also painted a very poignant scene of Ajax leaning over the body

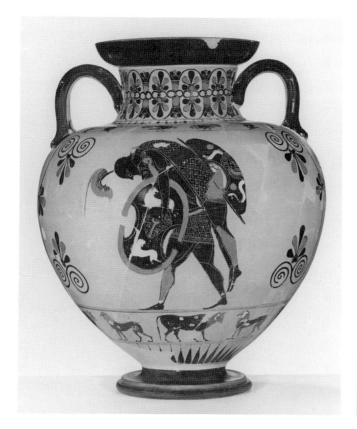

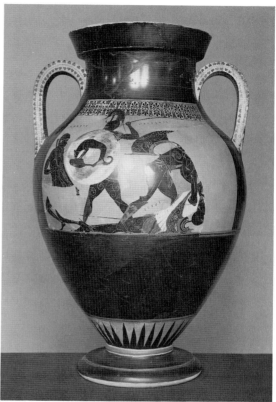

of Achilles, which is stretched out on the ground extending almost across the entire length of the panel. It is on one of his amphorae in Philadelphia (fig. 4).[23] Here Ajax grasps Achilles firmly by the left wrist and upper right arm, lifting the heavy torso a bit off the ground. The dead hero's head hangs downward, and the crest of his helmet trails on the ground. His name is inscribed above his thigh, and presumbly Ajax's name appeared in the upper right of the panel, which is now missing.

No doubt the Boulogne amphora best demonstrates Exekias' power to paint scenes of mythological narrative which combine restraint and strong expression.[24] The obverse of this vase depicts the suicide of Ajax, a theme that appeared a few times before Exekias painted his version. Exekias, however, offers an entirely new approach to the theme, one that departs not only from that of his predecessors, who showed the completed deed, but also from Archaic Greek narrative in general. He shows the isolated preparation for the suicide: Ajax pats down the soil as he probably muses over the destructive act he is about to commit and reflects how guest-friendship prompted Hektor to give him the sword after a long duel, which was stopped only when it became clear that neither hero was the better man that day.

On Exekias' vase, a wispy tree provides a touch of landscape, balanced by the splendid armor on the right. The hero's nudity makes him appear vulnerable, alone and isolated, shunned by gods and men

Fig. 3. Neck-amphora by Exekias. Side A: Ajax carrying the body of Achilles. Munich, Staatliche Antikensammlungen und Glyptothek, 1470. Photo C.H. Krüger-Moessner.

Fig. 4. Amphora by Exekias. Side A: Ajax lifting the body of Achilles. Philadelphia, University Museum, MS 3442.

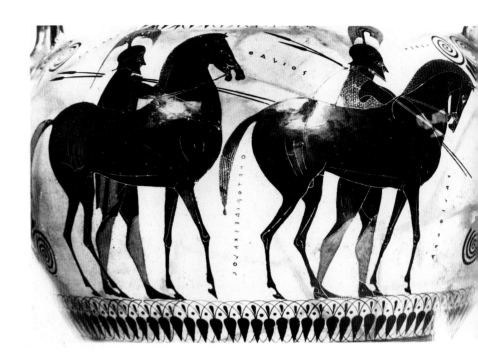

Fig. 5. Neck-amphora by Exekias. Side B, panel: Demophon and Akamas leading their horses. Berlin, Staatliche Museen, 1720.

alike. His furrowed brow attests to his sorrow and shame as well as to his concentration on the destructive act he is about to commit. Exekias' version of this Trojan episode is unique, but in many ways it foreshadows the memorable passage in the play by Sophokles first performed about a hundred years later. Here, too, Ajax fixes the sword in place and pats down the earth, as he muses over how he acquired the sword through guest-friendship with Hektor. I quote from the translation by Charles Moore:[25]

> He's firm in the ground, my slayer. And his cut (if I have time for even this reflection) should now be deadliest. For, first, the sword was Hektor's gift, a token of guest-friendship, and he of all guest friends, my bitterest foe. Here, too, it stands lodged in this hostile ground of Troy, its edge made new with iron-devouring stone. And, last, I've propped it so, with careful handling, to help me soon and kindly to my death.

It is difficult to believe that both Exekias and Sophokles were not particularly sensitive to this heroic episode, and perhaps they were even inspired by the same earlier, literary source. In any case it was scenes like those we have just seen that prompted Sir John Beazley to write nearly fifty years ago: "There was something in Exekias of Ajax: so that he could admire the hero slow, and strong, and at heart delicate."[26]

We may now turn to other scenes by our artists. In Archaic Greek art, the horse is the most important theme next to man. Both Exekias and the Amasis Painter have given us memorable examples of this beast. We have already seen them in the stable of Poseidon as rendered by the Amasis Painter and in the Introduction of Herakles into Olympos by

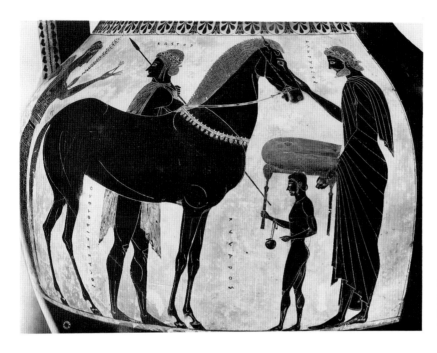

Fig. 6. Amphora by Exekias. Side B, panel: Kastor with his horse, Polydeukes, and Tyndareos and Leda. Rome, Musei Vaticani, 344.

Exekias. The Munich amphora by the Amasis Painter depicts a cavalcade at full gallop;[27] we can almost hear the clatter of the horses' hoofs as their riders give them free rein. With their finely chiseled heads, muscular necks, and clean-boned legs supported by strong hoofs, these spirited horses are a match for the well-bred steeds by Exekias. We see them, for instance, on his neck-amphora in Berlin that depicts Demophon and Akamas,[28] the sons of Theseus, leading their horses, a subject so far unparalleled both visually and in literature (fig. 5). These elegant beasts are fitting mounts for the sons of a hero. No less suitable is the splendid horse on one side of the Vatican amphora (fig. 6),[29] a picture so aptly described by Beazley as "not so much a scene from everyday life, to which the artist has added heroic names, as a scene from heroic life when at its simple everyday level."[30] Subtle touches that enliven the interaction between the figures are Leda offering Kastor a flower or Tyndareos stroking the muzzle of the horse that puts its ears back just a little in slight annoyance at this gesture. Few black-figure painters have matched the quality of this scene for its understanding of the tender feelings between family members that do not need to be expressed verbally.

Twice the Amasis Painter depicts an unusual horse theme: a youth training or trying to control two rearing horses. One appears on the aryballos in the Metropolitan Museum of Art,[31] the other on an amphora in Leningrad not in the Amasis Painter exhibition.[32] Each reminds us how nimble and quick-witted anyone who works around horses must be. The same goes for the groom about to be kicked by a rearing chariot horse on one side of Exekias' neck-amphora in Boston (fig. 7),[33] or the fallen chariot horse on an amphora, also by Exekias, in a Swiss private collection.[34] Here the charioteer must quickly cut loose the fallen horse

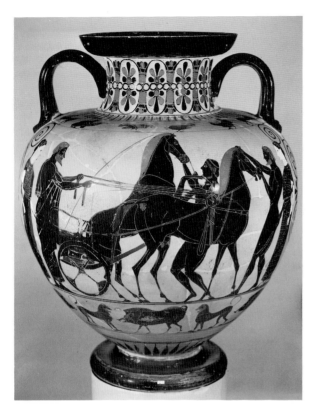

Fig. 7. Neck-amphora by Exekias. Side A: harnessing a chariot team. Boston, Museum of Fine Arts, 89.273.

Fig. 8. Amphora fragment by Exekias. Side B, panel: archer grazing his horse. Philadelphia, University Museum, 4873.

so that the team may right itself and avoid disaster. The subject on this vase may illustrate a scene from book 16 of the *Iliad:* the Death of Pedasos, the one mortal horse in Achilles' team who was killed on the same day that witnessed Sarpedon's death by Patroklos' spear and Patroklos' death at the hands of Hektor. The heroic temper of this scene and the bold drawing of the horses—not only the one that has fallen on its side but also the frenzied three who try to scramble away—recall well the passage in which Homer describes this moment. Another unusual representation, also by Exekias, painted on the fragmentary amphora in Philadelphia (fig. 8),[35] shows a man in Oriental garb grazing his horse— a quiet moment between man and beast that takes place in the cool of the evening after a long day. These vases show that both the Amasis Painter and Exekias knew and liked horses, though I think that Exekias' feelings for them were deeper and a little more special.

We may turn now to some scenes by each painter that depict events from daily life or that thus far have not been identified as illustrations of specific myths.

For the most part, Exekias does not seem interested in painting scenes that may not be precisely interpreted or, to put it another way, in painting scenes that are difficult *for us* to interpret. One appears on his neck-amphora in the Metropolitan Museum of Art that shows the departure of a man and woman in a chariot (fig. 9).[36] The youth with the kithara is surely Apollo (the kithara is Apollo's instrument), and the pair

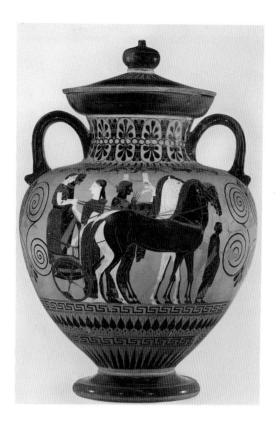

in the chariot are very likely bride and groom. Peleus and Thetis or Herakles and Hebe come to mind, but without more to go on, we cannot be absolutely certain exactly what theme Exekias had in mind. The same may be said for an amphora in the Louvre that has a certain heroic quality, but whose exact subject still awaits identification.[37] Two well-armed warriors confront two others who are mounted and a third who is on foot. One mount has stumbled, and his rider is concerned only with helping his horse regain its footing, while his two companions, on the missing part of the vase, were probably fully engaged with the enemy.

Exekias has not given us very many scenes that reflect events in Greek daily life. In addition to the wrestlers on his prize Panathenaic amphora in Karlsruhe and the victorious charioteer on the Brauron pyxis,[38] the best-known scenes of daily life in his work appear on the fragmentary funerary plaques in Berlin and Athens.[39] Here Exekias has demonstrated in a restrained manner the grief and pain of the mourners: the woman tearing at her hair and the man with his head raised, their lips slightly parted, wailing at their loss; then the one who looks straight out at us.[40] Exekias has attempted to render some degree of emotion on the faces of these Athenians but without distorting them, which would lessen the degree of their human-ness. For reasons unknown to us, distortion of facial features of gods, heroes, and mortals was apparently unacceptable to either Archaic or Classical Greek artists.

We turn now to the Amasis Painter and his depictions of unidenti-

Fig. 9. Neck-amphora by Exekias. Side A: man and woman in a chariot. New York, Metropolitan Museum of Art, 17.230.14, Rogers Fund, 1917.

fied subjects and themes of daily life. We have already seen the horsemen on his Munich amphora.[41] The departing warriors on one side of his other neck-amphora in Boston and on the amphora once in Berlin (where we saw Dionysos and his retinue on one side) cannot be identified with certainty.[42] The depiction on each is surely intended to represent a scene from heroic mythology, for the warrior is equipped with a Boeotian shield, a type known only from representations. It may have existed in the Bronze Age, but we cannot be sure. By the sixth century B.C., the Boeotian shield was associated with heroes, especially Achilles and Ajax. While it is tempting to identify the warriors on these two vases with either of these heroes, without more to go on it is perhaps best to leave the question open, as Beazley did.

Also difficult to link with specific persons is the figural scene on an amphora in New York,[43] on which a warrior puts on a greave in the presence of a woman and youths; equally difficult is an olpe in Würzburg,[44] on which a woman, a man, and a youth greet a warrior who returns with his dog. The absence of attributes or of inscriptions naming the figures in these and the two previous scenes prevents us from interpreting the subjects more precisely at this time.

The two scenes on an amphora in Copenhagen are tantalizing.[45] On the front of the vase we see a man facing two youths with their dog, followed by Poseidon and a warrior. Beazley suggested that the youths might be the Dioskouroi, Kastor and Polydeukes, standing before Zeus, and indeed the two youths resemble the inscribed representation of them in the homecoming scene on Exekias' amphora in the Vatican that we saw a little while ago. On the other side of this vase the only identifiable figure is Athena, recognizable by her shield, spear, and helmet. Is she perhaps greeting Herakles after his successful completion of the twelve labors? We would dearly like to know what the Amasis Painter had in mind when he decorated this vase.

We may look rather quickly at a few vases depicting daily life before coming to the last two vases by the Amasis Painter I shall discuss—the exquisite pair of lekythoi in New York.

On the neck of an amphora in Basel,[46] two wrestlers take each other on, flanked by judges or by trainers—perhaps the latter, for this would better explain the encouraging gesture of each. The two wrestlers seem about evenly matched, and it is unclear who will win. A lovely olpe in the British Museum[47] shows the return of a successful hunter with his dog. The Amasis Painter clearly likes dogs; we have seen quite a few. An olpe in the Metropolitan Museum of Art depicts an amorous encounter between a man and a woman.[48] She offers her potential lover a flower as two youths look on, each holding a branch of ivy. A boisterous scene occurs on an olpe in Oxford where a revel is in full swing to music played on the *aulos* by a woman.[49]

We come now to the two lekythoi by the Amasis Painter that are acknowledged masterpieces in all of Greek vase-painting. In the first,[50] we have a wedding scene, the fullest known pictorial account of an Attic wedding. We see the house of the bridegroom, a well-made building with walls of carefully worked stone blocks, fronted by a porch sup-

ported by wooden Doric columns painted white. The doors of the house are wide open, and we glimpse a woman with a torch, indicating that the ceremony is taking place after dark. She is the mother of the groom. Next comes the wedding party in a cart drawn by two donkeys: the bride and groom and the best man, as well as two women and a man on foot. After them we see a mule cart with four guests accompanied by two women and a man on foot.

The second lekythos of this pair depicts women engaged in the various stages of wool working.[51] First the balls of wool are taken from the basket in which they were gathered to be weighed. One woman holds the scale while another puts balls of wool in the pan and yet another looks on. Then follow two women spinning the wool into yarn and two who fold the finished cloth and place it on a stool. Next come two more spinners and, finally, two women working at an upright loom on which there is already a bit of woven cloth rolled up. This is a particularly realistic rendering: one woman pushes the weft thread through the threads of the warp while another separates the warp with a heddle. The tension of the warp threads is kept constant by the loom weights suspended from their ends. For good measure, a shuttle is wedged between the threads of the warp.

We may now try to sum up how each of these artists approaches narrative. Unlike many of the other painters, Exekias seldom uses stock motifs or standard compositions, yet when he does—for instance, in the scene of Herakles choking the Nemean lion—the result is superb. But Exekias really prefers to reinterpret well-known scenes—Ajax carrying Achilles is a good example—or to invent new and even unique ones, such as Dionysos in his boat. Exekias often reduces his compositions to just those figures who are absolutely essential to the myth, letting viewers supply the others in their imaginations if they are so inclined. Exekias is a serious painter who, in spite of the limitations of the black-figure technique, is capable of rendering mood or psychological states of mind, and he prefers scenes that display tension in strong but subtle and often silent ways. Occasionally, he depicts the moment just before the climactic action, the one most pregnant with meaning—Ajax preparing for his suicide is a good example. Simplicity of composition or greatly restrained and tempered action characterize the work of Exekias. In his narrative there is nothing in excess, no filler figures, no casual gestures. In these respects, he shows more kinship with artists of the high Classical period than with his contemporaries of the sixth century, and one may even go so far as to say that in his very personal way, Exekias comes as close to the Classical moment as an Archaic artist can.

The Amasis Painter presents a very different personality from that of Exekias. To begin with, there can be no doubt that he has a good sense of humor; the vintage scene on the Würzburg amphora and other Dionysiac scenes we saw earlier are firm testimony to that, as are a good many other vases in the Amasis Painter exhibition. Occasionally, however, he too concentrates on just the essential elements of a subject, such as Athena and Poseidon on the vase we saw first. More often he prefers to fill out his illustrations with lively participants or quiet spectators. He

also has a certain preference for symmetrical compositions. Unlike Exekias, the Amasis Painter may repeat subjects, such as Herakles and Kyknos or warriors arming, but these are never dull. They are always fresh and lively.

Both of these painters are keen observers, and for the most part they are rather conservative artists. Crisp, precise incision defines their figures and often embellishes their garments, creating a rich, tapestrylike effect. Exekias and the Amasis Painter take the black-figure technique just about as far as it can go. The technique can be different, but it cannot be improved. And maybe it is not going too far to hope that in the near future, new vases by these painters will come to light that will increase our understanding of the artists, perhaps bringing us one step closer to the Kerameikos of sixth-century Athens.

HUNTER COLLEGE
NEW YORK

NOTES

1. Paris, Cabinet des Médailles 222, *ABV* 152,25; *Paralipomena* 63,25; *Amasis Painter* no. 23.

2. London B 210, *ABV* 144,7; *Paralipomena* 60,7.

3. Berlin 3210, *ABV* 151,21.

4. Würzburg 265, *ABV* 151,22; *Paralipomena* 63,22; *Amasis Painter* no. 19.

5. Budapest 50.189, *Paralipomena* 61.

6. Munich 2044, *ABV* 146,21; *Paralipomena* 60,21.

7. *The Homeric Hymns* (Chicago 1970) 15–17.

8. Paris, Louvre F 37, *ABV* 153,41; *Amasis Painter* no. 34.

9. Berlin 1720, *ABV* 143,1; *Paralipomena* 59,1.

10. Boston 01.8027, *ABV* 152,27; *Paralipomena* 63,27; *Amasis Painter* no. 25.

11. *Amasis Painter* 236–238.

12. Paris, Louvre F 36, *ABV* 150,6; *Paralipomena* 63,6; *Amasis Painter* no. 5.

13. Orvieto, Faina 78, *ABV* 144,9; *Paralipomena* 60,9.

14. Berlin F 1688, *ABV* 150,9; *Paralipomena* 63,9; *Amasis Painter* no. 9. Berlin 1689, *ABV* 151,10; *Paralipomena* 63,10.

15. Supra, note 14.

16. Orvieto, Faina 187, *ABV* 145,11; *Paralipomena* 60,11.

17. Supra, note 10.

18. Kings Point, New York, *Paralipomena* 67; *Amasis Painter* no. 60.

19. Vatican 344, *ABV* 145,13; *Paralipomena* 60,13.

20. London B 211, *ABV* 256,14; *Paralipomena* 113,14.

21. Florence 4209, *ABV* 76,1; *Paralipomena* 29,1; M. Cristofani, *Vaso François*, Bollettino d'Arte, Serie Speciale 11 (Rome 1980) figs. 148–149.

22. Munich 1470, *ABV* 144,6.

23. Philadelphia 3442, *ABV* 145,14.

24. Boulogne 558, *ABV* 145,18; *Paralipomena* 60,18.

25. *Sophocles II: Ajax; The Women of Trachis; Electra; Philoctetes* (New York 1971) 41.

26. J.D. Beazley, *Attic Black-figure: A Sketch* (London 1928) 20—21.

27. Munich 8763, *Paralipomena* 65; *Amasis Painter* no. 4.

28. *Supra*, note 9.

29. *Supra*, note 19.

30. *Development*, rev. ed. 61.

31. New York 62.11.11, *Paralipomena* 66—67; *Amasis Painter* no. 52.

32. Leningrad 161, *ABV* 151,15; *Paralipomena* 63,15.

33. Boston 89.273, *ABV* 144,4; *Paralipomena* 59,4.

34. Zurich, ex-Roš, *ABV* 147,5; *Paralipomena* 61,5; H. Bloesch, "Heilsame Wäsche," in I. Scheibler and H. Wrede, eds., *Wandlungen: Studien zur antiken und neueren Kunst* (Waldsassen-Bayern 1975) 84—89.

35. Philadelphia 4873, *ABV* 145,16; *Paralipomena* 60,16.

36. New York 17.230.14, *ABV* 144,3; *Paralipomena* 59,3.

37. Paris, Louvre F 206, *ABV* 145,12; *Paralipomena* 60,12.

38. Karlsruhe 65.45, *Paralipomena* 61,8 bis. Brauron, *Paralipomena* 61.

39. Berlin 1811—1826, *ABV* 146,22; *Paralipomena* 60,22. Athens, National Archaeological Museum 2414—2417, *ABV* 146,23; *Paralipomena* 60,23.

40. Berlin 1811 and 1818 (supra, note 39).

41. *Supra*, note 27.

42. Boston 01.8026, *ABV* 152,26; *Paralipomena* 63,26; *Amasis Painter* no. 24. Berlin 3210 (supra, note 3).

43. New York 06.1021.69, *ABV* 150,2; *Amasis Painter* no. 1.

44. Würzburg L 332, *ABV* 152,30; *Amasis Painter* no. 28.

45. Copenhagen, Nationalmuseet 14347, *Paralipomena* 65; *Amasis Painter* no. 13.

46. Basel, Antikenmuseum und Sammlung Ludwig BS 497, *Paralipomena* 66; *Amasis Painter* no. 21.

47. London B 52, *ABV* 153,31; *Amasis Painter* no. 26.

48. New York 59.11.17, *Paralipomena* 66; *Amasis Painter* no. 30.

49. Oxford 1965.122, *ABV* 154,45; *Paralipomena* 64,45.

50. New York 56.11.1, *Paralipomena* 66; *Amasis Painter* no. 47.

51. New York 31.11.10, *ABV* 154,57; *Amasis Painter* no. 48.

Joan R. Mertens

THE AMASIS PAINTER: ARTIST AND TRADITION

For F.B. Tweed
on June 7, 1986

The occasion of the Amasis Painter exhibition has presented an exceptional opportunity to try to define a few features characteristic of the artistic personality of the Amasis Painter.[1] Technique is a particularly fruitful point of departure, for as one considers how an artist renders the forms on a vase, one necessarily also takes up what is rendered as well as such other points as the manner of composition, shapes, and scale. In the case of the Amasis Painter, the investigation proves particularly worthwhile because one not only enjoys the works of a consummate draftsman but also comes to see an individual of extraordinary sensitivity and understanding.

There are over 130 surviving black-figure vases by the Amasis Painter, produced during a career that began about 560 B.C. and ended about 515 B.C. Though his style evolved over this period of almost half a century, the precision and clarity with which he uses his medium remains consistent and conspicuous throughout. Let us begin with the rendering of his figures, for example, on an early amphora in the Metropolitan Museum of Art.[2] The warrior putting on his greaves and the accompanying youths show an essential minimum of incised detail—for the line of the thigh, kneecaps, ankles, genitals, hair, eyes. No fussiness; perfect sureness. The same applies to the two robed figures. Their garments have a red stripe down the center, dot rosettes to either side, and an ornamental border at the neckline and the bottom. The effect may seem a little stiff, but, on the other hand, everything is immediately legible. To some degree, the impact of the forms is simply inherent in black-figure, in the placement of dark shapes against a light background. I would suggest, however, that the Amasis Painter used the technique with very deliberate purpose.

Corroboration of this point can be found in the Amasis Painter's

treatment of ornament. In the palmette-lotus festoon above the picture, each unit is meticulously spaced within the field, and extraordinary care has been taken with the tendrils, especially those developing from the palmettes. The intervals are as important as the forms. If we turn to the Metropolitan Museum's other amphora of type B,[3] assigned by Bothmer to the painter's middle period, we see that the upright lotus buds and the connecting arcs, once again, could not be sharper or clearer.

The two amphorae—which I suppose I chose out of local pride but could have substituted with many another vase—indicate that the painstaking rendering of individual forms—anatomy, garments, ornament—also applies to the way in which the Amasis Painter renders his scenes. In the Metropolitan Museum's late olpe[4] of about 520 B.C., as on the amphorae, the arrangement is roughly symmetrical and, worthy of particular note, the figures are well spaced out. They interact without losing their separateness. Moreover, what each figure holds is, to the extent possible, set against the light background for maximum visibility—the ivy branches of the youths to either side, the myrtle and flower of the woman. The only exception is the staff on which the man is leaning, which obviously had to overlap his body, but only as much as necessary, for the lower part of the staff is well clear of his leg.

Although painters of other black-figure vases show the qualities that we have been discussing, I consider them particularly significant in the case of the Amasis Painter because they inform his work from beginning to end. Furthermore, the painter's predilection for preserving the discreteness of parts, whether in figure-work or ornament, contrasts with a concurrent tendency in black-figure to create ever fuller and more complex compositions, to introduce as many overlapping planes as possible without sacrificing the intelligibility of the individual forms. The highest achievement of this kind is undoubtedly the Parthenon frieze, but if we remain with pottery of the sixth century, we can go back to the François Vase,[5] where the marriage procession of Peleus and Thetis shows as many as eight overlapping figures, and the battle of the pygmies and cranes displays a general imbroglio of combatants and casualties. During the third quarter of the century we may find in the gigantomachy on an unattributed column-krater in the Metropolitan Museum[6] (fig. 1) or in a chariot scene by the Swing Painter, also in the Metropolitan Museum,[7] the kinds of subjects to which many of the Amasis Painter's contemporaries were addressing themselves. Exekias, it is worth noting, was among them; although he has left us memorable representations of the "sparse" type,[8] his early production includes very dense compositions that have no parallels at any stage of the Amasis Painter's career as we know it.[9]

Within the Amasis Painter's oeuvre, there is a group of vases that deserves special attention for the expressiveness the artist achieved through the handling of his medium in conjunction with composition. I should like to dwell on these vases at some length. The centerpiece of the group is the neck-amphora in the Cabinet des Médailles,[10] which unfortunately did not travel westward with the rest of the exhibition. On the obverse, Athena and Poseidon appear in a representation that is remark-

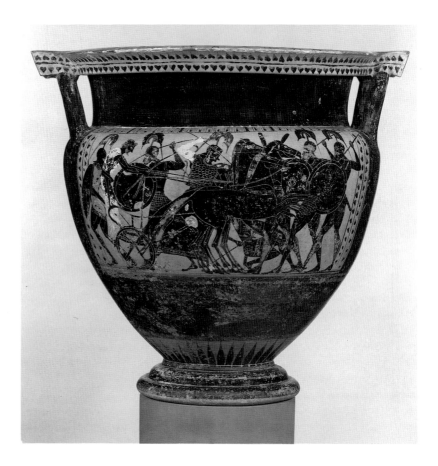

Fig. 1. Column-krater. Side A: gigan-tomachy. New York, Metropolitan Museum of Art, 24.97.95, Fletcher Fund, 1924.

able not only for its stateliness but also for the absence of any reference to the most famous circumstance that brought them together, their contest for overlordship of Athens. The overwhelming effect of the depiction of the contest on the west pediment of the Parthenon somewhat obscures the fact that Athena and Poseidon often joined forces, as in their support of the Greeks at Troy, which Homer reports.[11] The two deities also shared the Erechtheum and, indeed, their contest seems to have established them as benefactors of Athens as much as rivals.

While numerous black-figure vases depict Athena and Poseidon together at gatherings[12]—at Athena's birth from the head of Zeus, at other assemblies of the gods, in the gigantomachy—only the Amasis Painter has left us several depictions in black-figure that focus on the two gods. In addition to the Cabinet des Médailles neck-amphora, there is the neck-amphora in Boston,[13] also with a two-figure composition. On the chous in Florence[14] and the fragmentary olpe in Oxford,[15] the principals in the center are flanked by Hermes and a man on the former vase and by three figures on the latter. I think it is fair to say that the Amasis Painter had a special liking for Athena and Poseidon juxtaposed, but whether the predilection was personal or prompted by some external cause, we cannot know. In the controversy over whether the artist was of Attic or Egyptian origin, this factor can be used either way.[16] Regardless of where

he came from, however, the manner in which he renders the two gods exemplifies black-figure work at its finest.

The reverse of the Cabinet des Médailles vase is equally masterful. Dionysos, at the left, strongly resembles his uncle Poseidon but is identified by an inscription as well as by his ivy wreath and kantharos. The maenads are dressed in the most beautiful black-figure peploi and pelts. If we look at their faces and necks, arms and feet, however, we see that these flesh parts are drawn in outline with no added white, in glaze lines applied directly to the surface of the pot.

The use of glaze outline for rendering the flesh of women occurs on five other vases by the Amasis Painter, preserved either complete or in fragments. While we shall return to each of them, here is a quick summary of all the pieces: in addition to the neck-amphora in Paris, there was the special amphora of type A once in Berlin but lost during World War II;[17] there are the fragments of a panel-amphora, possibly of type A, recently acquired by the Metropolitan Museum;[18] the amphora type B in Basel, Käppeli 420;[19] and the fragments on Samos[20] and in Kavalla.[21] According to Bothmer,[22] all six works are close in time within the artist's middle period.

The preserved evidence suggests that the figures for whom the Amasis Painter preferred to use outline are maenads. The one exception of which I am aware is the woman in the scene of a warrior's departure on the obverse of Berlin inv. 3210.[23] While we shall revert to the question of why the artist might have chosen this technique for these particular figures, right now I would only point out that the reverse of this vase in Berlin also has one of the six depictions of outline maenads. Furthermore, it is pertinent to note that satyrs and maenads fill the subordinate zone above the Berlin departure scene.

The subordinate scene on the obverse of the Berlin amphora prompts two further observations. First of all, it is interesting that of the six vases with outline maenads, four for sure show a subsidiary zone of figures, rather than the conventional ornament, above the principal scene. Three are panel-amphorae: the ones in New York, on Samos, and formerly in Berlin. The fourth is the Cabinet des Médailles neck-amphora: in accommodation to the exigencies of the shape, its subsidiary frieze of hoplite combats is disposed around the gently sloping surface of the shoulder. Of the two remaining vases, the amphora in Basel has a palmette-lotus festoon; the fragmentary amphora in Kavalla does not include anything of the zone above the figures, but it may well have been a floral band.

The second observation prompted by the Berlin amphora is that the satyrs, maenads, and athletes in the little friezes are executed in standard black-figure, while the ladies in the panels below are in outline. Of particular interest in this connection are the fragments on Samos, where the subject is Dionysiac both above and below. Above, the maenads appear in standard black-figure; below, they appear in outline. The same combination with a comparable subject occurs on the group of fragments that were recently acquired by the Metropolitan Museum of Art.

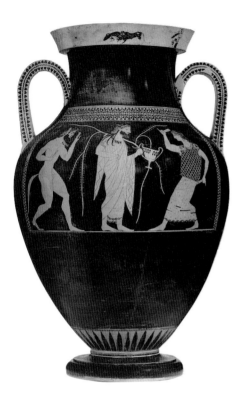

Fig. 2. Amphora by Andokides and the Andokides Painter. Side B: Dionysos between a satyr and a maenad. New York, Metropolitan Museum of Art, 63.11.6, Purchase, Joseph Pulitzer Bequest, 1963.

Fig. 3. Cup fragments attributed to the AMA Group. Florence, Museo Archeologico, 1 B 6. Photo courtesy Beth Cohen.

If, as I should like to suggest, the Amasis Painter had full command of the standard black-figure technique and, at the same time, was introducing new ways of employing his medium, what further conclusions may be drawn concerning his place in the Kerameikos during the second half of the sixth century?

First of all, allowing for a margin of chronological error, the vases with outline-figures by the Amasis Painter seem to anticipate by five to ten years the earliest appearance of the red-figure technique, which is commonly associated with the Andokides Painter.[24] Semni Karouzou and John Boardman have seen the Amasis Painter's outline work as "presaging the red-figure style," to use Mrs. Karouzou's words.[25] I would go a little further and suggest that, of the major black-figure artists active during the third quarter of the sixth century, the Amasis Painter is the one who comes closest to the threshold of red-figure. His use of outline is the most obvious indication. I would also point to the incised depiction of a satyr assaulting a maenad on the column-krater, which is as incomplete as it is prominent on the Samos fragments. The Amasis Painter was neither the first nor the only artist to employ outline or incision. His application of both to one vase, however, and his repeated use of outline suggest to me that he was searching for the technical facility that red-figure ultimately provided.

The combination of techniques on the Samos fragments, as well as on the fragments in New York, has one further noteworthy aspect

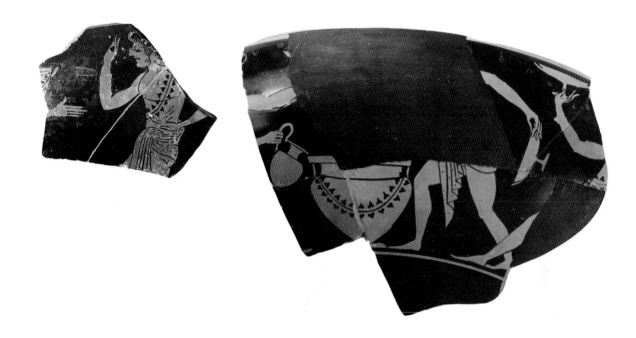

insofar as it may be considered an anticipation of the so-called bilingual vases.[26] The juxtaposition of a subject executed above in standard black-figure, below in outline, differs little, in principle, from the juxtaposition of a subject executed in black-figure on one side, red-figure on the other (fig. 2).[27] The Amasis Painter, therefore, may well have been demonstrating what he could do—and what could be done—just as the Andokides and Lysippides painters did a decade or so later.

One would very much like to know whether the Amasis Painter ever tried his hand at red-figure. A little evidence exists, but it allows of no firm conclusions. Beazley associated two very incomplete, very early red-figure cups in Florence with each other, calling them the AMA Group.[28] Pertinent to them are one, perhaps two, cup fragments belonging to Herbert Cahn.[29] The Group takes its name from one of the Florence pieces, which preserves a little of a red-figure satyr in the tondo, as well as the letters "AMA" and "E" (fig. 3); Beazley proposed that they might be restored to read *Amasis epoiesen*.[30] The Cahn fragments depict red-figure komasts (figs. 4a, b). The smaller, and more important, piece allows us to read]MASIS (fig. 4a). The larger one preserves part of a kalos inscription and]SEΓOIE[SEN] (fig. 4b); while its pertinence to the smaller piece, proposed by Bothmer, seems probable, it is not certain. The third cup, in Florence, is bilingual, showing a black-figure satyr with kithara on the inside (fig. 5c); a mask of Dionysos between eyes and palmettes (fig. 5a) and a red-figure satyr (fig. 5b) appear on the outside.[31] The ends

Fig. 4a. Cup fragment. Komasts. Basel, Herbert A. Cahn collection, 696. Photo courtesy Herbert A. Cahn.

Fig. 4b. Cup fragment. Komasts at a column-krater. Basel, Herbert A. Cahn collection, 695. Photo courtesy Herbert A. Cahn.

5a

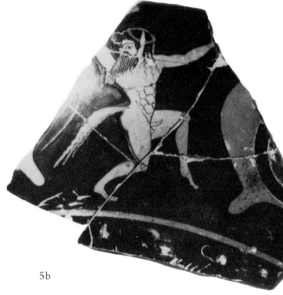

5b

5c

Fig. 5a. Cup attributed to the AMA Group, fig. 5a. Side A: mask of Dionysos. Photo courtesy Beth Cohen.

Fig. 5b. Cup attributed to the AMA Group, fig. 5a. Side B: satyr. Photo courtesy Beth Cohen.

Fig. 5c. Cup attributed to the AMA Group. Interior: satyr. Florence, Museo Archeologico, A B 1. Photo courtesy Beth Cohen.

of Dionysos' beard, like the inscription on the other Florence cup, are rendered in the special clay preparation that Psiax, for instance, favored for details like the shafts of spears.[32]

Dr. Cahn has attributed his fragments quite plausibly to Skythes, who is most familiar as a painter of early red-figure cups.[33] Skythes, however, also decorated three bilingual cups where the exterior rather than the interior is in black-figure, and the ground is coral-red.[34] Moreover, there is an artist by the same name who signs as painter on two contemporary black-figure plaques from the Akropolis.[35] Addressing the question whether the black-figure Skythes was identical with his red-figure and bilingual namesake, Beazley wrote in *ARV*[2], "doubtful if the Skythes whose signature appears on two black-figure plaques is ours; or even if the two plaques are by the same hand."[36] While Beazley's doubt remains entirely justified today, I think one can say that the painter of the plaque, Akropolis 2586, was definitely versed in red-figure.

The Florence red-figure cup of the AMA Group is too poorly published to allow comment about the little that remains. The Florence bilingual cup, however, is better preserved, and I think it is worth considering the possibility that it was decorated by Skythes.[37] In any case, following Beazley and Beth Cohen,[38] I accept interior and exterior as being by the same hand. While connections may be found among the three AMA Group pieces in their decoration, their relationship to Amasis—potter or painter—is a different matter. In *ABV* Beazley said about the red-figure AMA cup in Florence that "the style of drawing has no connection with the Amasis Painter";[39] in *ARV*[2] he made no comment. The Amasis vases and the AMA cups are surely painted by different hands, but it is not impossible for Amasis to have been the potter.

The lekythos in Malibu points to Amasis' collaboration with the Taleides Painter.[40] As Bothmer explains in the exhibition catalogue,[41] there are now three signatures that identify Amasis as father of Kleophrades. Thus Amasis evidently did work with other painters, and he could well have worked with a red-figure one.[42]

Any discussion of the Amasis Painter's relation to red-figure also requires consideration of his late black-figure cups, notably the examples in the Vatican,[43] Oxford,[44] and Florence.[45] In the Amasis exhibition catalogue, Bothmer makes clear that these cups postdate the introduction of red-figure and depend upon red-figure eye-cups.[46] The interesting question that remains, however, is whether these works were the Amasis Painter's response to the new technique or whether, concurrently with them, he produced red-figure vases that have not survived or have not been recognized so far.

While it is useless to speculate about what we do not have, the late cups allow a few additional remarks. In my opinion, they represent the Amasis Painter's use of line developed a stage beyond the panel- and neck-amphorae with maenads that constituted our point of departure. The eyes and handle-ornament are the most important parts of the decoration, their clear, wiry curves swinging generously and easily, in evident contrast to the constrained black-figure personages. The painter leaves the entire exterior of these cups in reserve to gain the freest possible field upon which to draw, perhaps also to achieve some of the brightness of red-figure works, for a vase with light figures strikes us as being brighter than one in which the major forms are black. The character of the ornament, with its fanning palmettes and spiky lotuses on tendrils punctuated with short crossbars, is highly unusual for the painter as well; as Bothmer has pointed out, it is best paralleled on the late neck-amphora in Boston with Herakles and Apollo disputing the Delphic tripod.[47] Outside the Amasis Painter's oeuvre, the detail occurs—in Attic art—on the black-figure mastoi by Psiax, for example.[48] Finally, I should like to point out that, for innovations in the use of his medium, the Amasis Painter seems to have favored panel-amphorae and cups—two shapes in the forefront of creative development from about 540 on; one has only to think of Exekias and of Andokides, painter and potter.

One can fairly conclude, I believe, that the Amasis Painter's late cups represent a response to red-figure. With the evidence available at present, one could also say that the cups represent as far as he went in meeting the challenge of the new medium. The germ of this development, however, lay in his pots with outline maenads, and to them I wish to return. While the ramifications of the purely technical points draw us ever farther afield, a central question that should be addressed is why the Amasis Painter chose to apply the outline technique to the figures he did.

The area of intention is extremely treacherous, so I merely submit some thoughts for consideration. The outline women preserved to us are, on the one hand, maenads, and on the other, the woman of the Berlin amphora who grasps a spear in one hand and, on her left arm, carries the shield that the warrior facing her is in the process of taking. One certainly is inclined to identify the protagonists as Thetis and Achilles. But

whether the identification is correct or not, the particularly elaborate shield and seemingly specific situation suggest a mythological, or heroic, story. There is nothing that characterizes the protagonists as gods. I would therefore suggest further that the woman in this scene is neither an ordinary mortal nor an Olympian deity. The maenads, who represent the other outline women, belong to the same category. Together with the satyrs they have a function, which is to serve as attendants of Dionysos, but otherwise they are ageless and timeless. They, like the shield bearer, were beings whom no one had really seen or studied, so that in depicting them, the Amasis Painter could allow his creative imagination some latitude. He was not bound to render what everyone could observe, and he did not have to be totally "orthodox" in using standard black-figure.

What he developed was an idiom that allowed him to depict and characterize these invisible presences while, at the same time, maintaining the clarity and precision of his presentation. The point can be illustrated by the different kinds of composition in which the painter uses the outline women. On the reverse of the amphora in Basel the five figures are well spaced out, so that the purpose of the outline seems primarily to distinguish the female figures from the male and what I would call the timeless maenads from the Olympian god Dionysos and the evidently mortal youths. On the neck-amphora in the Cabinet des Médailles we see the two maenads presented as a pair before Dionysos and, to some degree, in contrast to him. On the reverse of the amphora in Berlin a satyr and maenad appear as a couple in front of and behind Dionysos. The maenad appears once on the far side of the satyr, once on the near side. These maenads are nude, while a clothed maenad appears at the far left and right of the scene. Compositionally, the artist has created a nice alternation of outline and black-glaze figures, female and male. In the case of the couples, the difference in technique maintains the distinctness of each figure. In addition to the purely visual aspect, however, the use of outline emphasizes the distinctness of the maenads as a species, the uninhibitedness that is so much an aspect of the followers of Dionysos and that the Amasis Painter conveys with the lightest touch. The fragments on Samos preserve two couples, the right one advancing to right, the left one embracing. The maenad in the subsidiary zone above presents a noteworthy contrast; she is executed in standard black-figure and is just one in a row of Dionysiac revelers.

The conclusion that I wish to draw from the vases we have reviewed is that the Amasis Painter's capacities for observation, imagination, and representation were on a consistently high level and very much interconnected. The early vases that were mentioned at the outset—for instance, the amphorae type B in New York with warriors making ready—illustrate the iconographical and technical tradition that the Amasis Painter received as a professional inheritance. In the course of time, as his experience and proficiency grew, he sought forms of expression that were appropriate to new dimensions of subject, and this, I believe, is shown by the pots with outline maenads. I use the word "appropriate" quite deliberately, because the development is not strictly a chronological one. When we look at the outline maenads, we read them

differently from the black-figure ones; they have a transparency that is absent in black-figure. The available evidence suggests to me that such timeless figures lent themselves particularly well to the kind of experiment the Amasis Painter was making. It might have been inappropriate to depict a god in any but the canonical way, and it may have seemed inaccurate to do so with a mortal. But maenads and women of the heroic past occupied a different category, one for which the Amasis Painter seems to have been seeking a means of expression.

This point is also directly pertinent to certain aspects of the Amasis Painter's subject matter. If one tabulates the subjects depicted by him under the rubrics of gods, heroes, and mortals, his preferences are quite clear. Among themes related to the gods and, indeed, of all the themes in his oeuvre, Dionysos and his followers occur by far the most frequently. Other deities who recur are Artemis and, as we have seen, Poseidon and Athena. From the realm of heroic mythology, Herakles is most often represented, while Helen appears several times, rather unexpectedly. Among images drawn from daily life, the painter clearly favored gatherings of men and women, whether conversing or as part of a komos.

To these, obvious, observations about the Amasis Painter's iconography, two more, of some importance, should be added. The first, made by Bothmer as the latest in a long line of scholars, is that the subjects of the Amasis Painter are often difficult to identify.[49] As we saw previously with the amphora in Berlin, the absence of inscriptions makes it impossible to be sure whether we are looking at Achilles and Thetis, another specifically identifiable pair, or an—albeit elaborate—arming of a mortal, something of an unknown soldier.

The second observation is that the Amasis Painter shows a consistent inclination to blur the lines between the realms of mortals and of immortals or, if you prefer, to combine the two. For example, a recurrent figure in his oeuvre is a winged youth who, most often, appears in the company of figures who seem to be mortal. Such a being appears on the aryballos in the Metropolitan Museum's collection[50] and on the amphora, Louvre F 26.[51] One has the impression of a benevolent presence who has materialized from another world. I would compare the angels and archangels of Christian iconography—the archangel Raphael, for instance, who accompanies Tobias carrying the fish that will cure his father's blindness.

As another instance of the Amasis Painter's melding of realities, I would cite a detail in the stables of Poseidon depicted on one side of the cup belonging to Norbert Schimmel.[52] Numerous scholars have wondered about the identities of the two little figures—one nude, one an archer—who are positioned on the backs of the two horses on the left. Equally worthy of attention is the architrave, with every second metope inhabited by an animal, mythical creature, or human. In the second metope from the right, the inhabitant—a monkey—is slipping out of his square, which indicates to me that all of the others could do likewise. With such a miniscule detail, the Amasis Painter demonstrates to us that what we see is only a small part of what there is to be known. Indeed,

these examples of the winged youths and the animate architrave bring us back to the outline maenads, because in every case, the Amasis Painter—for our benefit—gives form to things that we would otherwise not be aware of through our five senses.

Many details that now puzzle us would, of course, have been perfectly obvious to the painter's contemporaries. First of all, they were familiar with the material. Equally important, they were much more accustomed than we are to using their imaginations to explain all sorts of things and accepting the existence of imagined things. One need only think of the many Greek personifications and etiological myths. Though I could only substantiate it to a limited extent, it is my feeling that the scenes with winged youths, for example, represent situations in which they make something happen in a way that would not have been possible if the other figures had been left to their own devices. This vagueness may be unsatisfactory to the point of being exasperating, but a picture like the one on Louvre F 26 simply gives us very few clues.

On the one hand, therefore, the Amasis Painter is a master of precision and clarity. On the other, a picture like the one on Louvre F 26 makes us conscious of the great distance in time and difference in approach between the world in which it was made and ours. We are back to the question of intention. Yet we may perhaps be guided toward one of many possible answers through the Amasis Painter's manner of composition. I should like to characterize his preferred treatment of a subject as by "affinity group." He likes to bring together the cast, as it were, of a situation: a warrior arming for battle among the people who assist with his equipment or who watch; Dionysos with a vase for wine among men; men and women; or whatever the case may be. He wants to show every member of the cast as distinctly as possible, often making this a priority over involving them in some kind of action. In this connection, it is wonderfully appropriate that Sir John Beazley dubbed the mantled observers at the sides of so many Amasean compositions "Rosincrantz and Guildenstern,"[53] for the substance in these "affinity group" scenes clearly lies in the dialogue and soliloquies.

When the Amasis Painter chooses to depict movement, there are instances where he freezes the poses lest there be any risk of our missing something. On the amphora in Munich,[54] the galloping horses on the reverse almost take our breath away. Their delicate hind legs supporting the substantial bodies, the line of their bellies forming a continuous horizontal, the perfect choreography of their positions are features that in no way detract from the indication of rapid forward motion, but that take the thunder out of it. Similarly, on the neck-amphora in Basel[55] the artist has made one of the wrestling scenes almost bilaterally symmetrical; we therefore get the clearest possible picture of the situation without any of the disorder that would have been a part of it in real life.

Finally, there are, of course, scenes in which the Amasis Painter allows his figures to move freely and to make all the noise they want. The vases with satyrs and maenads are good examples. To those we considered earlier we should add the amphora in Würzburg.[56] Again, on the lower frieze of the aryballos in New York, the lions felling a bull and

the lions felling a ram do so with a ferocity that might well make the youths to either side exclaim.

Whatever the tenor or pace of the representation may be, the Amasis Painter conveys its constituents to us with rare directness. A contributing factor that has not been mentioned so far and to which, in conclusion, we may turn briefly, is that of the shapes on which he worked and, specifically, their scale. The range of shapes that one can associate with a given artist is, of course, very much an accident of survival. Any generalization one may make is necessarily provisional, for new finds can radically change the state of our knowledge. The shape that is best represented in the Amasis Painter's oeuvre is the amphora type B, although among the other large pot shapes there are also amphorae of type A and neck-amphorae of various varieties. Among the smaller shapes, he seems to have favored oinochoai and lekythoi, drinking cups, and other kinds of deep cups or bowls. In addition, there are also the shapes of which only a single example by him is preserved, such as the aryballos in New York and the alabastron[57] and the standlet[58] in Athens.

Surveying the shapes that the Amasis Painter decorated and the dimensions of his largest vases—the amphorae and neck-amphorae—one becomes aware of a predisposition for reduced dimensions. Among the amphorae of type B in the Amasis exhibition, Louvre F 25 illustrates a diminutive piece, measuring 18.2 cm in height,[59] while Munich 8763 is one of the larger examples, at 41.2 cm.[60] The preferred size seems to fall between about 30 and 35 cm. These are his large pots on which, significantly, the field to be decorated has been reduced to a panel. Among his neck-amphorae, it is noteworthy that up to now we have so few of the standard type, that is: without panels, only ornament under the handles, which leaves the artist considerable space, vertically as well as horizontally, over which to extend his composition. Three complete and particularly significant examples of this shape decorated by the Amasis Painter appear in the exhibition catalogue: the one from the Cabinet des Médailles[61] and the two from Boston.[62] Of the latter, the neck-amphora showing Herakles and Apollo contending for the Delphic tripod is one of the exceptional cases in which the figures are closely knit and their action is so vigorous that one feels the Amasis Painter has used up just about all of the available space.

Thus the Amasis Painter's large vases are moderate in size. Through the use of panels and subsidiary zones, his figures and ornament are scaled down so as to be properly proportioned in every case to the whole vase and, evidently, congenial to the painter. The Amasis Painter's small vases are recognized as masterpieces of what is often called a "miniature" style. The consistent tendency to favor small rather than large size seems to me as important a characteristic of his artistic personality as his clarity, precision, and capacity to use his medium according to the nature of the subject matter. To describe him as a miniaturist is to deliver an art historical verdict. To realize that the dimensions and weight of nearly all of his vases made them easy to handle, empty or full, brings them—and us—into the everyday world of which they were a part. His vases fit the hand so well that their original users must have been as

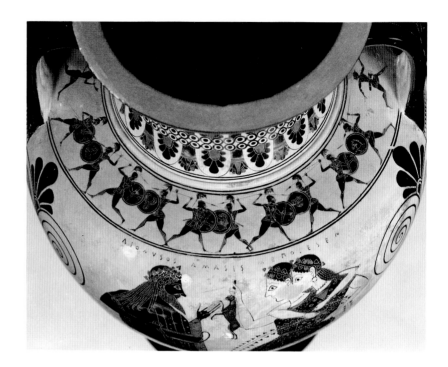

Fig. 6. Neck-amphora by Amasis and the Amasis Painter. Side B: detail showing Dionysos and maenads below inscriptions. Paris, Bibliothèque Nationale, Cabinet des Médailles, 222. Photo courtesy Metropolitan Museum of Art.

inclined as we are to turn, scrutinize, and enjoy them. Trivial and mundane though it may seem, the matter of size in combination with the perfect legibility of his figures and ornament contributes significantly to the accessibility of his work.

We have certainly not exhausted the possible lines of approach to the oeuvre of the Amasis Painter. Nonetheless, our brief and selective consideration of technique, subject matter, and scale may suffice to indicate that he treated his vases with as much attention to each part as to the whole, so that the result is an extraordinary harmony among all component elements. A corollary to this premise, in my opinion, is that the Amasis Painter and his potter must have been one. While this artist may well have collaborated with other painters, the consistent "wholeness" of the Amasis Painter vases makes it very difficult for me to attribute their creation to more than one person. To the technical, stylistic, and conceptual or expressive considerations that point to this conclusion another can be added.

If one looks at the inscriptions on side B of the Cabinet des Médailles neck-amphora (fig. 6), the flow of glaze in the words *Dionysos* and *Amasis epoiesen* is the same as in the outline arms and faces of the maenads immediately below.[63] If one pays attention to the placement of the potter's signatures on the signed vases, one notes their prominence and their tendency to follow the lines of the composition. Thus, on the Louvre[64] and Würzburg[65] olpai, as on side A of the neck-amphora, Boston 01.8026,[66] the lines of writing are as straight as the adjacent spears. On side B of Boston 01.8026, the operative object is the right-hand hoplite's Boeotian shield. On the neck-amphora Boston 01.8027[67] the inscription twists around the similarly restless group of figures.

Everyone in this audience is well aware that there is much we do not know about the meaning of the word *epoiesen*. More is known about the painters' role, thanks especially to Sir John Beazley's lifelong study. And yet, when one comes down to the individual artist and the considerations surrounding specific artistic details, one can only observe and hypothesize. The opinion expressed here that the Amasis Painter and the potter Amasis are identical is open to question and discussion; the evidence available at present remains insufficient for the matter to be resolved conclusively. With the benefit of the Amasis exhibition and catalogue, however, it seems to me that Amasis has characterized himself tellingly in the Vatican eye-cup.[68] Through the placement of his signature above the eyes and above the brows, he may be saying something about his ability to give form to what he sees.

<div align="right">

THE METROPOLITAN MUSEUM OF ART
NEW YORK

</div>

NOTES

1. I should like to thank Marion True and John Walsh for the opportunity of participating in the Getty Museum's symposium devoted to the Amasis Painter. Herbert Cahn has generously allowed me to publish two cup fragments in his collection. I feel particularly indebted to Dietrich von Bothmer for being able to better my acquaintance with the Amasis Painter.

2. *Amasis Painter* no. 1, side B.

3. *Amasis Painter* no. 7.

4. *Amasis Painter* no. 30.

5. Florence 4209, *ABV* 76,1.

6. New York 24.97.95, G.M.A. Richter in *Bulletin of the Metropolitan Museum of Art* 20 (December 1925) 299, fig. 8.

7. New York 17.230.8, *ABV* 307,55; *CVA* 3, pls. 26, 27; most recently E. Böhr, "Weitere Werke des Schaukelmalers," in *Praestant Interna: Festschrift für Ulrich Hausmann* (Tübingen 1982) 213 n. 7.

8. E.g., Berlin 1720, *ABV* 143,1; London B 210, *ABV* 144,7; Vatican 344, *ABV* 145,13; or the pyxis from Myrrhinous, *Paralipomena* 61.

9. E.g., Orvieto, Faina 78, *ABV* 144,9; Orvieto, Faina 77, *ABV* 144,10; Orvieto, Faina 187, *ABV* 145,11; or Munich 1470, *ABV* 144,6.

10. *Amasis Painter* no. 23.

11. *Il.* 1.400; 15.213; 20.33–34; esp. 21.284–297.

12. See *LIMC* 2, 956, B.1, B.2a, B.2d.

13. *Amasis Painter* no. 24.

14. *Amasis Painter* 131, fig. 79.

15. *Amasis Painter* no. 29.

16. Arguments reviewed in *Amasis Painter* 37–38.

17. *Amasis Painter* 49, figs. 45 a, b.

18. *Amasis Painter* no. 18 bis.

19. *Amasis Painter* 47, figs. 40 a, b.

20. *Amasis Painter* 109, fig. 67; more complete in S. Karouzou, *The Amasis Painter* (Oxford 1956) pl. 30,2–3.

21. *Amasis Painter* 116, fig. 70.

22. *Amasis Painter* 128.

23. The importance of this vase for the development of figural representation in Attic vase-painting was emphasized by B. Schweitzer, "Die Entwicklung der Bildform in der attischen Kunst von 540 bis 490," *JdI* 44 (1929) esp. 112–114.

24. Bothmer (*Amasis Painter* 239) dates the Amasis Painter's middle period between 550 and 530 B.C. and places the New York fragments, for example, toward the middle of that period (*Amasis Painter* 112). The conventional date of circa 530 B.C. for the introduction of red-figure is lowered by Beth Cohen, for example, to circa 525 B.C.: *Attic Bilingual Vases and Their Painters* (New York 1978) 118.

25. Karouzou (supra, note 20) 15; J. Boardman, "The Amasis Painter," *JHS* 78 (1958) 2; also idem, *Athenian Red Figure Vases* (London 1975) 14; *ABFV* 55.

26. Most fully treated by Cohen (supra, note 24).

27. The juxtaposition of two techniques on the same side of a vase, with the more progressive technique below, the less progressive one above, is a special facet of bilingual vases. Of particular interest in this context are works such as the amphora, New York 63.11.6, *ARV*² 3,2 bis, 1617; and *Paralipomena* 320 by the Andokides Painter; Nicosthenic neck-amphorae, Vienna 3722, *ARV*² 11,3; and Rome, Villa Giulia 50560, *ARV*² 11,4; or the hydria, Munich 2418, *ARV*² 12,7. A subordinate black-figure zone can also occur below the main scene in a bilingual vase, e.g., Athens, Akropolis 726, *ARV*² 5,5.

28. *ARV*² 160, above.

29. Herbert Cahn collection 695, 696.

30. *ARV*² 160. See also *ABFV* 54.

31. *ARV*² 160.

32. H.R.W. Smith, *New Aspects of the Menon Painter* (Berkeley 1929) 2; J. Mertens, "Some New Vases by Psiax," *AK* 22.1 (1979) 31–32; Cohen (supra, note 24) 272–274.

33. *ARV*² 82–85.

34. Paris, Louvre F 129, *ARV*² 84,20; Palermo V 651, *ARV*² 85,21; Basel, ex Hoek. Cf. B. Cohen, "Observations on Coral-red," *Marsyas* 15 (1970–1971) 9–10.

35. Athens, Akropolis 2557 and 2586, *ABV* 352,1–2 above.

36. *ARV*² 82.

37. On the inside and on side B, the long line in the thigh and a mark for the kneecap beneath it recur on the Herakles of Louvre F 129, *ARV*² 84,20, and in a different form also on Akropolis 249, *ARV*² 83,7. The kithara-playing satyr on the inside finds a good red-figure counterpart on a cup in a Centre Island, New York, private collection. Their bloated, rubbery bodies, the double line on the buttock, the awkward contour of the near shoulder as well as of the right arm, and the articulation of the instrument correspond well in both pieces. The exercise in anatomy on the abdomen of the red-figure satyr in Florence may be compared with the inside of Toronto 923.12.11, *ARV*² 83,8; inside and side A of Louvre G 12, *ARV*² 84,17; or Herakles on Louvre F 129, *ARV*² 84,20.

38. Cohen (supra, note 24) 274.

39. *ABV* 158.

40. *Amasis Painter* 229. Bloesch has also attributed two vases by Lydos to the potter Amasis, Berlin 1685, *ABV* 109,24, and London B 148, *ABV* 109,29; Bothmer disagrees (see *Paralipomena* 44,29).

41. *Amasis Painter* 230–231.

42. The Amasis Painter's familiarity with the achievements of the Pioneer Group (*Amasis Painter* 52–53) suggests further that his awareness of contemporary artistic developments was far from casual.

43. *Amasis Painter* no. 62.

44. *Amasis Painter* no. 63.

45. *Amasis Painter* 224, figs. 114a, b.

46. *Amasis Painter* 223–224.

47. *Amasis Painter* 228.

48. Mertens (supra, note 32) pl. 10.

49. *Amasis Painter* 44–45.

50. *Amasis Painter* no. 52.

51. *Amasis Painter* no. 11.

52. *Amasis Painter* no. 60.

53. J.D. Beazley, "Amasea," *JHS* 51 (1931) 259.

54. *Amasis Painter* no. 4.

55. *Amasis Painter* no. 21, esp. side B.

56. *Amasis Painter* no. 19.

57. *Amasis Painter* 43, fig. 34.

58. *Amasis Painter* 152, fig. 92.

59. *Amasis Painter* no. 12.

60. *Amasis Painter* no. 4.

61. *Amasis Painter* no. 23.

62. *Amasis Painter* nos. 24 and 25.

63. Best visible on the object itself but perceptible in P.E. Arias and M. Hirmer, *A History of One Thousand Years of Greek Vase Painting*, translated and revised by B. Shefton (New York 1962) color pl. XV.

64. *Amasis Painter* no. 27.

65. *Amasis Painter* no. 28.

66. *Amasis Painter* no. 24.

67. *Amasis Painter* no. 25.

68. *Amasis Painter* no. 62.

Dietrich von Bothmer

Greek Vase-Painting:
Two Hundred Years of Connoisseurship

The two centuries of connoisseurship to be surveyed here span the period from the death of Johann Joachim Winckelmann in 1768 to 1968, the year that Sir John Beazley, disabled by a stroke, ceased writing. Greek and Etruscan painted vases had been known even before Winckelmann, and a concise account of the early history was put together by Otto Jahn in his introduction to the catalogue of the Munich vases published in 1854 and reviewed by Eduard Gerhard in *Archäologische Zeitung*.[1] Robert Cook's chapter 15 in *Greek Painted Pottery*[2] owes much to Jahn, and we, in turn, are much beholden to Cook for bringing Jahn's history up to date. Cook's careful, detailed observations, made highly readable by his somewhat sharp tongue that spares few of his predecessors and contemporaries, supply us with a wealth of information and important dates, and some might well think that Cook's research has rendered any further presentation of the subject unnecessary. Yet it may perhaps be appropriate on the occasion of this symposium to refresh our memory by focusing our searchlights on those dates and scholars that represent landmarks and watersheds.

At the outset it should be made clear that no accurate count exists of the number of painted vases known today, though we can trace their steady increase since the eighteenth century. In Winckelmann's day most of the vases dug up until then came from excavations in Italy, chiefly Etruria and the south. They were by and large in private collections in Italy, and even those which the heirs of Giuseppe Valetta had sold to Cardinal Gualtieri, and which later (in 1744) were installed by Cardinal Quirini in a special room in the Vatican, were not freely shown to visitors. Some vases had already crossed the Alps—those of the Comte de Caylus, now in the Cabinet des Médailles in Paris, and two in Vienna, acquired by Charles VI, the father of Maria Theresa. Even earlier, others

had reached the Elector of Brandenburg, but were traded to the Elector of Saxony for a regiment of dragoons shortly after 1701. Though few had actually seen these collections, several vases had been published. Beginning with *Romanum Museum* of 1690 by M.-A. de La Chausse;[3] the *Museum Etruscum* by A.F. Gori (1737–1743);[4] *L'Antiquité Expliquée* by B. de Montfaucon (1719–1724);[5] and *Recueil d'Antiquités égyptiennes, étrusques, grecques et romaines* by Caylus (from 1752 on),[6] engravings of vases were regularly included in handbooks on antiquity, and when Filippo Buonarotti in 1722 started to publish Thomas Dempster's *De Etruria Regali*,[7] a hundred years after the Scottish papist's sojourn as professor of law in Padua, he seized the opportunity to append to Dempster's work engravings of more than two dozen vases, including the famous Arezzo krater by Euphronios, even though Dempster did not talk about vases in his Etruscan encyclopaedia, save for a few quotes from Latin authors.

To those early pre-Winckelmann scholars, vases found on Italian soil constituted welcome evidence of the glorious artistic past of ancient Italy, with special emphasis placed on Etruria, and an Etruscan origin was assumed even for vases found in Campania. This is perhaps not so unreasonable as it might strike us today, for little was known of the export of Greek vases to Italy, and the discovery and publication of a Panathenaic prize amphora found in 1701 in Benghazi, with the name of Hegesias, archon in 324/323 B.C., was ignored until D. Raoul-Rochette reminded Gerhard of it in 1834.[8] Many of the vases found in Italy were also inscribed, but it took some time before the inscriptions were read. The breakthrough came in 1754, when A.S. Mazochius published four inscribed vases[9]—a cup by the Penthesilea Painter (now in Boston); a neck-amphora by the Dresden Painter (now in Stockholm); a bell-krater (now in Toronto); and a Nolan amphora (now lost).

The very year Mazochius spoke up for a Greek origin of these inscribed red-figure vases, Raphael Mengs, a Bohemian-born painter of Danish descent, settled in Rome, where he met Johann Joachim Winckelmann a year later. The two became great friends, and it may well have been Mengs who introduced Winckelmann to the beauty of Greek vases. As a painter Mengs was drawn to them, and in 1759 he acquired three hundred vases in Naples of which several appeared in Winckelmann's *Monumenti antichi inediti*, published in Rome in 1767. That Winckelmann in his preference for Greek art wished to think of painted vases as Greek is not surprising, but his arguments are those of a scholar. Recalling an inscribed cup he had seen in the Museo Mastrilli in Naples in the spring of 1758 (now in Boston), he criticized Caylus, in what today would be called a book review, for having fallen into the common error of claiming all painted terracotta vases to be Etruscan—"ha sposato un errore commune ed è di pigliare tutti vasi di terracotta e dipinti per Etruschi"—as he wrote his friend Giovanni Lodovico Bianconi in Bologna on July 22, 1758.[10] Caylus had taken the inscriptions on a skyphos (now in the Cabinet des Médailles) to be Etruscan; but Winckelmann saw that they were Greek and compared the Caylus inscriptions to the ones he had seen on the cup now in Boston and, like the skyphos published by Caylus, by the Penthesilea Painter. Not trusting

the accuracy of the letter forms in Caylus' publication, Winckelmann wrote Bianconi that he planned to ask his friend Wille in Paris, the "graveur du roi," for a facsimile. The two inscriptions, on the skyphos in Paris and on the cup in Boston, are indeed misspelled: "the familiar words [ho pais kalos]" are, as Beazley noted, "wilfully one would say— garbled: this is common in the school of the Penthesilea Painter and in his own works."[11] We can hardly blame Winckelmann for misinterpreting them. For the Boston cup, he took the misspelled "ho pais" to be Hoposdas, as if it were a kalos name, but at least he saw that the letters were Greek, not Etruscan, and that the meaning was laudatory, connecting it with the Greek practice of publicly praising handsome boys, as known to him from a passage in Pausanias.[12]

When Winckelmann arrived in Rome at the age of thirty-seven, his ambition, nourished for so long, to look at ancient art was fulfilled beyond all expectation. Three years later, in 1758, he had already seen more than five hundred vases in Rome and Naples. His studies of ancient art culminated in the pioneering *Geschichte der Kunst des Alterthums*, which appeared, after many preliminary drafts, in Dresden in 1764. By that time he had not yet made the acquaintance of Sir William Hamilton, but the British minister in Naples had taken note of Winckelmann and encouraged him in 1766 to have his *Geschichte der Kunst des Alterthums* translated into English and published in London, in an edition of three hundred copies to be priced at four guineas. Hamilton's arrière-pensée was to enlist Winckelmann as the cataloguer of his vase publication, for which the plates were being engraved in the late 60s. Winckelmann was at first reluctant to undertake this task, for, as he explained in a letter to Baron Stosch on January 24, 1767, if he agreed to such a labor, he would not escape torture for all eternity and would have to give up all thoughts of traveling freely.[13]

Hamilton had arrived as British minister in Naples in 1764, and with the ample means at his disposal he acquired in three years the four hundred-odd vases that were sold to the British Museum in 1772 for £8,400. He had commissioned the somewhat shady adventurer Pierre F. Huguet (who called himself chevalier d'Hancarville or baron de Han) to bring out the plates in four volumes at a cost to Hamilton of £20,000.[14] In those days before photography and editorial boards, publications were begun with the plates, while the text was written and printed later. The first plates of the Hamilton collection reached Winckelmann in Porto d'Anzio on April 2, 1767, and Winckelmann was duly impressed, noting that "a work of this kind has never before been published."[15] Winckelmann returned to Naples in mid-September for two months. Well received by Hamilton, and full of admiration for his collection, Winckelmann, as late as February 1768—a scant four months before his death in Trieste—wrote to one of his friends that the explanatory text to the plates was reserved for him.[16]

It is not altogether idle to speculate about what would have happened to the study of vase-painting had Winckelmann lived long enough and found the time to describe Hamilton's vases. His keen eye and his highly developed historical sense would have allowed him to attribute the

vases to periods, and he might well have read the Meidias signature on the London hydria, a vase he incidentally praised as the "aller-vortrefflichste mit der schönsten und reizendsten Zeichnung der Welt,"[17] long before Gerhard in 1839 discovered the inscription. His passion for beauty might well have raised the collecting instincts from the anti-quarian level to that of art, and his strong plea for calling the painted vases Greek, rather than Etruscan, might even have dissuaded Josiah Wedgwood from naming the pottery factory he founded in 1769 "Etruria."

The splendid publication of Hamilton's first collection inspired others, notably Giovanni Battista Passeri, who set the pattern for richly illustrated books on "masterpieces." No longer a mere catalogue of an individual collection, Passeri's *Picturae Etruscorum in Vasculis*[18] published on three hundred plates vases from forty collections known to him, but, as the title reveals, he adhered to the Etruscomania of the previous cen-tury. Sir William Hamilton next brought out, between 1791 and 1795, another sumptuous catalogue of a second collection he had formed, again rather rapidly, shortly after Goethe's visit to Naples in 1787.[19] The plates of this opus were entrusted to Wilhelm Tischbein, then director of the Naples Academy of Painting, with the text written by Italinski and Fon-tanini. Today very few of us are tempted to consult the descriptions, and the same may be said for the "explications," as they were then called, printed in the other vase books of the period. On the other hand, the circulation of these folios or quartos was considerable and did much to awaken an interest in painted vases. On these vases, especially the more pleasing red-figure ones, were to be found men and women, children, animals, and monsters, as well as the pantheon of deities; scenes from the heroic past of a mythological age and of the human race in all its as-pects—at war and at home, in the palaestra or in the women's quarters of their houses, at religious festivals or at banquets. All are depicted with a wealth of detail extending even to furniture, to the tools of different trades, and to details of architecture not readily available from the sculp-tural remains known in the eighteenth century. Conversely, the willing-ness of a Sir William Hamilton to pay good money for these clay vessels spurred on a frenzied activity on the part of landowners and peasants to find more of these highly salable items in the ground, and needless to say there were no restrictions imposed on this activity, carried on in broad daylight, other than those of property rights. It is sometimes overlooked by the purists that without this exploitation of the treasures awaiting the lucky finder, today there would be neither the truly impressive body of preserved and recovered ceramic remains nor, for that matter, employ-ment for so many archaeologists.

Obviously the advance in knowledge went hand in hand with the increased numbers of vases that became known, and by the time intrepid travelers visited Greece, even before the war of independence, the experi-ence of Italy was applied to Greece and at once broadened the scope of connoisseurship, which was still in its infancy well into the nineteenth century. In 1805, when Dodwell acquired in Corinth the Corinthian pyxis that bears his name, or when Burgon excavated in Athens in 1813,

genuine scholars could see the close connection between the vases known from Italian sites and those found in Greece.

In the meantime the Etruscan-Greek controversy continued unabated. While some of the more ardent adherents to the Etruscan party, misled by forged Etruscan histories going back to the Italian Renaissance, combined Tuscan patriotism with their antiquarian Etruscophilia, saner voices were heard in Southern Italy and in Sicily. As early as 1749 the Florentine A.F. Gori, learned author of the *Museum Etruscum,* could no longer contradict the Sicilians Blasi, and later Pancrazi,[20] who claimed that most of the vases found in Sicily were Greek. The discovery of a black-figure amphora in Agrigento in or about 1800 gave the Greek faction another argument. This vase, today in New York,[21] was signed by Taleides as potter, and since the signature of Meidias on the Hamilton hydria by then already exhibited in London had not yet been spotted, Taleides became to the learned world the first Greek potter known by name, and L.A. Lanzi, in 1806, used this vase effectively in a treatise entitled *De' vasi antichi volgarmente chiamati etruschi.*[22]

Vase scholarship had by then been taken over by the French and the British. Aubin-Louis Millin (1759–1818) brought out in Paris between 1808 and 1810 his two folio volumes *Peintures de vases antiques vulgairement appelés étrusques.* The publisher was Dubois Maisonneuve; his draftsman was Clener, a pupil of Tischbein who had collaborated with him in the drawings and engravings for the second Hamilton publication, which served Millin as model. These vases, about 120, were for the most part in Paris or in private collections now dispersed. The engravings are rather unreliable, and Beazley remarks on the particularly villainous drawing of a lost vase that he thought might be by the Phiale Painter.[23]

James Millingen's volume, by contrast, entitled *Peintures antiques et inédites de vases grecs tirées de diverses collections avec explications par J.-V. Millingen,* printed in Rome in 1813, drew high praise from such reviewers as Jean de Witte: "on a pu dire sans exagération que les planches de ce recueil sont les premières reproductions fidèles que l'on ait données d'après des peintures céramiques."[24] Millingen, born of Dutch parents in London in 1774 and fifteen years younger than Millin, lived mostly in Paris, Florence, and Rome. Salomon Reinach, who republished in a reduced format the plates of both works with an abridged description based on the texts of Millin and Millingen, praises Millingen's sobriety:

> Le texte marque la première réaction sérieuse contre l'abus des interprétations à tous prix et du recours arbitraire aux explications mystiques, là même où une interprétation réaliste pouvait convenir. C'est l'oeuvre d'un Anglais à l'esprit pratique et dont l'érudition était contenue par le bon sens.[25]

Millin had made no attempt to classify the vases he published by style or period, but Millingen followed Winckelmann's broad divisions. His first period runs from 700 to 450 B.C.; the second, that of Pheidias and Polygnotos, ends in Sicily and Southern Italy with the second Punic war; his third epoch lasts until the civil wars in Italy. He also knew his classical authors and was the first to cite the passage in Strabo from which

Humfry Payne more than a hundred years later took his title "Nec-rocorinthia."[26] Even more relevant is his complaint of the fraudulent restorations perpetrated by the clever restorers of Naples, and he advises owners of vases to rub the surface with alcohol to remove the repainting. His plates, drawn by Michel Steurnal in Naples and engraved by Giangiacomo in Rome, are the first on which missing and restored portions are indicated. Robert Cook, who does not bestow praise freely, has called Millingen "the sanest of the broader students of vase-painting."[27]

Meanwhile, in Germany, C.A. Boettiger's *Griechische Vasengemälde* appeared in three volumes between 1797 and 1800.[28] He is responsible for the trend to interpret vase-paintings symbolically and mystically, especially in terms of the bacchanalia. Millin invented the *génie des mystères*, and James Christie, whose olpe by the Amasis Painter (now in New York) is in the exhibition that prompted this symposium, wrote in 1806 a learned treatise, *Disquisitions upon the Painted Greek Vases and their probable connection with the Shows of the Eleusinian and other Mysteries.*[29] These rather misguided attempts to overinterpret Greek vases were accepted by Georg Friedrich Creuzer, whose *Symbolik und Mythologie der alten Völker, besonders der Griechen*[30] provoked Goethe to say, "Die Masse der Worte nimmt zu, man sieht zuletzt von den Sachen garnichts mehr," a criticism that today might be extended to other authors as well.

Boettiger's book was based exclusively on the Hamilton vases; Millingen owned many of the vases in his book himself, while others were the property of the queen of Naples or, with an anagram for Napoli, Countess Lipona, as she became known after the fall of her husband, Joachim Murat. Millingen also republished vases known from Passeri that he saw in the Vatican, some vases then belonging to Durand, as well as other private collections. The collection of Sir John Coghill, the subject of Millingen's next publication,[31] was formed in Naples. Coghill's vases were sold after his death at Christie's in two auctions (June 18–19, 1819, and June 29, 1820). Up to then not many vases had been sold at public auction. I know of only four earlier auctions: the Cawdor sale of 1800, the Edwards and Cripps sales of 1815, and that of Choiseul-Gouffier in 1818; but private sales, of course, were as common then as they are now.

The second Hamilton collection had been offered to Friedrich Wilhelm III of Prussia, but after the shipwreck of the *Colossus,* which resulted in the loss of one third of the twenty-four packing cases, the remainder was bought in 1801 by Thomas Hope. The center of the art market for vases was still Naples, but many more vases began to come to light in Sicily, an island that had fiercely resisted the Etruscomania of central and northern Italy. Scholarship in Sicily was of the highest order, and Raffaello Politi of Agrigento deserves to be mentioned here. Between 1826 and 1841 he published a score of brief but highly readable pamphlets devoted to single vases or small groups of vases. His writings are not well known, but Beazley, who admired Politi, collected them, and today the scholarship of Politi can best be appreciated in the library of the Ashmolean.

The next date to remember, a veritable watershed, is 1829. History loves coincidences, and one of the most fortunate ones for the study of

vase-painting was the foundation on April 21, 1829, in Rome, of the Instituto di Corrispondenza Archeologica, a few months after excavations in Vulci had brought to light several thousand Greek vases. If I link the two events, it is because the true founder of the institute was Eduard Gerhard, who ever since his arrival in Rome in 1820 at the age of twenty-five had worked very hard to bring this about. He persuaded Crown Prince Friedrich Wilhelm of Prussia, the later (1842) King Friedrich Wilhelm IV of Prussia, to assume the patronage of the institute. The list of *associati,* i.e., the supporting members or benefactors, reads like the roster of an exclusive club—a Russian grand duchess, four German princes, the British minister to the court of Tuscany, the Dutch and Austrian ambassadors to the Holy See, the Prussian ministers to the courts of Florence and Naples, and the Russian minister plenipotentiary to the court in Naples. The *associati*, more than fifty in number, also included academicians, painters, Italian nobility and clergy, British and German noblemen, an Italian lawyer, and a sprinkling of lovers of antiquity residing in Italy. The first president of the institute was the Duc de Blacas, French ambassador in Naples. The members proper were divided into three classes—honorary, full, and corresponding. Among the twelve honorary members we meet the Duke of Buckingham; the Principe di Canino; the French, Portuguese, and Russian ambassadors to the Holy See; the Marquess of Northampton; Michelino Santangelo (whose vases are now in the Naples museum); and two Prussian privy councillors. The other two classes are composed of artists, scholars, museum directors, and more diplomats. Through its publications—the *Monumenti inediti,* the *Annali,* and the *Bulletino*—scholars, students, collectors, and artists at last had an opportunity to keep in touch, learn of new discoveries, address the meetings, and publish the results of their research. There was much to discuss, and the reports were printed with commendable dispatch. The languages employed were Italian and French, and what the Germans lacked in Italian literary skills was more than compensated for by the wealth of factual information that was presented month after month in the *Annali* and the *Bulletino.*

Lucien Bonaparte, papal Principe di Canino, was one of the honorary members of the institute, elected no doubt because of the extraordinary quality and number of vases that were dug up on his property in Vulci. Gerhard went to Vulci in March and June of 1829, lived in the tents erected on the site, and admired the speed and skill of the restorers who put together overnight what had been mere fragments the day before. Gerhard repeated his excursions to Vulci in May of 1830 and 1831, and his *Rapporto Volcente,* published as the first fascicule of *Annali* in 1831,[32] not only gives a full account of the discoveries but establishes a system of classification. His report, moreover, does not limit itself to the vases that were the property of Lucien Bonaparte, but also includes those found a little earlier by Wilhelm Dorow in the same territory that had gone to Berlin; the vases excavated by Secondiano Campanari and Melchiade Fossati on the property of the brothers Candelori at Camposcala; as well as the collection of the Feoli family formed with the finds from Campomorto. Gerhard tabulated that more than 3,400 vases had come

to light in Vulci within one year, and it is to his credit that he was not discouraged by this avalanche. Far from limiting his researches to the pottery found at Vulci, he recognized the similarity between the Vulci vases and those already found in Athens, Aegina, Sicily, and Nola and saw the differences between them and the products of Apulia, Lucania, and Campania. Gerhard's classification, to which he gave such fancy names as Egyptianizing, Tyrrhenian, and Nolan, based partly on the subject matter, the quality of style, and the perfection of the glaze, has long since been dropped by scholars, but confronted with the sudden onslaught of thousands of ancient vases, these preliminary criteria helped him and others to sort out and divide the different groups.

It is easy for us today to smile at these primitive efforts, but it must be remembered that the pre-Vulci finds had not been sufficient to attempt a valid system. There had also been a dearth of inscriptions, and in this respect alone the finds from Vulci were most revealing. In addition to mere names identifying figures painted on vases, the *Rapporto Volcente* gives us almost all the potters and painters known from signatures. Gerhard wisely also included in his repertory those found elsewhere, especially in Tarquinia, and we thus meet for the first time, in the order in which they appear in Gerhard: Hermogenes, Nikosthenes, Tlempolemos, Tleson son of Nearchos, Archikles, Phintias, Hypsis, Euthymides, Epiktetos, Euxitheos, Pamphaios, Andokides, Tychios, Amasis, Kleophrades, Hischylos, Brygos, Kachrylion, Chelis, Deiniades, Euphronios, Exekias, Hieron, Sosias, Epitimos, Douris, Onesimos, Pheidippos, Sakonides, Python, and Oltos, whereas up to then the only artist known by name had been Taleides.

Gerhard did not limit himself to the highlights, as it were; he also listed those signatures on which we only have the verb, just as in tabulating the names of figures he included satyrs, maenads, horses, and the identifying *bomos* for an altar on a Tyrrhenian neck-amphora now in Munich. He covered the inscriptions on Panathenaic vases, except for those with archon names, since they had not yet been found in Etruria; he cited the exhortations on Little-Master cups; and he explained the famous *hos oudepote Euphronios* inscription as sarcasm, applied not—as Amati supposed—to the slight tipsiness of the reveler next to whom the phrase appears, but to the artistic quality of the vase.[33] The different kalos and kale names are recorded as completely as possible and tag-kaloi are recognized. Absolute dates for the dating of vases such as the Persian sack of the Athenian Akropolis or the reburial on Rheneia had in the absence of ceramic finds in those locations not yet been applied to archaeology, and Gerhard's chronology was therefore off: he claimed that the Vulci vases were not earlier than 480 B.C. and not later than 280. His dates were influenced by those of Roman history for the towns of Etruria, but what still evokes our admiration is the great passion and the colossal industry of a man who, undeterred by recurrent eye trouble, professional jealousies, and poverty, recognized the importance of vases, laid the groundwork to a systematic study, and encouraged publications. His own motto, the first of the twelve Latin theses that he appended to his *Rapporto Volcente,* was "Monumentorum qui unum vidit, nullum vidit;

qui millia vidit, unum vidit," and his own prophetic view of what he had accomplished he found expressed in Tacitus' quote from the closing sentence of a speech by the emperor Claudius to the senate (A.D. 48): "Inveterascet hoc quoque, et quod hodie exemplis tuemur, inter exempla erit"—"This likewise becomes established, and what today we uphold with precedents will rank among precedents."

Gerhard had received a thorough training in classical philology at the gymnasiums of Halle and Breslau and at the University of Breslau. In 1813 he went to Berlin and fell under the influence of Boekh, who lectured on Greek antiquities. He got his Ph.D., the first given by the newly founded Friedrich-Wilhelms University in Berlin, with a dissertation on Apollonios Rhodios and a thesis on the *digamma,* and after a stint as a school teacher, he began his many travels, which took him in the years to come all over Germany, Switzerland, Austria, Italy, France, Denmark, Belgium, and England. Not long after the foundation of the Roman Institute, he obtained, in March 1833, his first salaried position at the Berlin museum with the express charge to travel in the interest of scholarship—a commission almost hand-tailored to Gerhard's personal preferences. His organizing experience gained in Rome helped him throughout his career in Berlin, as a member of the academy, professor at the university, and museum curator, to keep himself involved in more than one gigantic undertaking. His *Auserlesene Vasenbilder*[34] reproduced an intelligent choice of important vases in lithographs. Smaller in size than the contemporary *Elite des Monuments Céramographiques,*[35] it had the advantages of more accurate drawings and a more sober text. The years in Rome had also taught Gerhard the value of tracings and drawings. He collected them in much the same way that Beazley a hundred years later built up his collection of photographs and tracings, which today is the pride of the so-called Beazley Archive at Oxford.

In Italy, meanwhile, patriots like Francesco Inghirami and Giuseppe Micali continued to use vases found in Italy to reinforce their arguments about the Etruscan supremacy. More significant, surely, was the first fully illustrated catalogue of the *Museum Etruscum Gregorianum* of the Vatican, issued in 1842.[36] Private collectors kept alive the tradition of Sir William Hamilton, Sir John Coghill, and Count Lamberg in making their holdings available to a larger public. The *Musée* of the Duc de Blacas,[37] the antiquities of Comte Pourtalès-Gorgier,[38] and the vases of the Duc de Luynes[39]—the "last gentleman of Europe" as he was called— all were published between 1829 and 1840 in sumptuous catalogues, of which the first two were written by Theodor Panofka, Gerhard's friend from his student days in Breslau, who had settled in Paris. This period also witnessed the rise of detailed sale catalogues, chiefly those written in Paris by the Belgian Jean de Witte (Lenormant's collaborator on the *Elite Céramographique*) and J.J. Dubois, a curator of the Louvre.

The Principe di Canino died on June 29, 1840, but even before his death hundreds of his vases had been sold. Not long after the two initial publications of his collection—the *Museum Etrusque*[40] and the *Catalogo di Scelte Antichità Etrusche*[41]—his son-in-law Dudley, Lord Stuart, translated the Italian text of the latter and saw to it that it was printed in volume 23

of *Archaeologia* in 1831.[42] The public sales of the Canino collection began in March 1834,[43] a modest prelude of only 117 minor vases which was followed in 1837[44] by the more important sale of 196 vases described by Jean de Witte, of which the British Museum bought 55. The best Canino vases, 117 in all, were offered in London in 1838 for £4000, but found no buyers until Canino's widow took them to Frankfort in 1841. Gerhard arrived there in August, but was powerless to buy much for Berlin, since his director delayed his arrival and could not come to a decision. Thus Berlin got only twenty-two vases, but Friedrich Thiersch, who came from Munich a month later armed with the full powers of King Ludwig I of Bavaria, acquired fifty-one, and among them were easily the best Canino had to offer: the Exekias cup, the Euphronios cup, the Andokides bilingual amphora, most of the amphorae by Euthymides, and cups by Makron and the Brygos Painter. Added to King Ludwig's Candelori purchases of 1836, the South Italian vases of the wife of Murat, and the vases found in Sicily sold by Panitteri, the Canino purchase in one fell swoop gave the Munich collection a position of preeminence that has never been shaken. Not that the public was allowed to appreciate these treasures: Gustav Kramer, who in 1837 had come out strongly and convincingly with his opinion that the bulk of the Greek vases found in Italy and Sicily were Attic, complained that the Panitteri vases were still inaccessible. In Leo von Klenze's novel display the vases were exhibited, mostly without vitrines, in first three, later four galleries of the Alte Pinakothek (figs. 1, 2). They were grouped on open shelves along the walls or openly set out on tables, in the middle of the rooms. Visitors had to apply in person for a special admission ticket, which could be handed out only by the director or his two curators. When the French scholar D. Raoul-Rochette sent a draftsman to Munich in the cold winter of 1843 to draw some of the vases, they could not be moved to a somewhat warmer adjacent room: King Ludwig refused this request by declaring, "if at present the gallery is too cold let him wait until it gets warm enough."

By 1854, when Otto Jahn, with the aid of his nephew Adolf Michaelis, published the catalogue of the Munich vases, a fifth room in the Alte Pinakothek had been added, and the number of vases had grown to 1,367. Jahn, a professor in Leipzig, did all his descriptions in the two months of September and October 1853 in front of the vases, revised his descriptions in Leipzig, and saw the catalogue printed the following year.[45] Jahn had been inspired by the *Catalogue of the Greek and Etruscan Vases in the British Museum*, of which the first volume, written by S. Birch and C.T. Newton, had come out in 1851.[46] The English catalogue in turn followed the model established by Jean de Witte in his sale catalogue of the Durand collection of 1836[47] in illustrating the vase shapes in plates at the end, each small drawing equipped with a running number. Durand recognized 104 different shapes; the British Museum catalogue differentiated 203; Jahn gave 86. Designating any given shape by a number and small drawing had become a necessity since in the wake of the Vulci discoveries an incredibly heated debate had arisen as to the proper nomenclature. The Italian system was based on the usage of the Neapolitan

Fig. 1. View of the Munich vase galleries, circa 1880/1890 (from R. Wünsche, *Ein griechischer Traum: Leo von Klenze, der Archäologe* [Munich 1985] 74, fig. 53). Photo courtesy Stadtarchiv München.

art dealers; the cataloguers of the two Canino publications of 1829 divided all vases merely into cups and pots; Theodor Panofka jumped into the fray with his ambitious *Recherches sur les véritables noms des vases grecs et sur leur différents usages d'après les auteurs et les monuments anciens*,[48] which provoked Jean-Antoine Letronne to counter with his *Observations philologiques et archéologiques sur les noms des vases grecs à l'occasion de l'ouvrage de M. Th. Panofka*.[49] Gerhard in his *Rapporto Volcente*[50] had already introduced many of the names still in use today—amphora, Nolan amphora, pelike, skyphos, olpe, lekythos, aryballos, kylix, lekane, stamnos, hydria, krater, etc. His nomenclature was further refined five years later in a long defense of his friend Panofka.[51] This, in turn, prompted a reply by Letronne, and even now, 150 years later, our usage is a hodgepodge of merely conventional and authentic ancient names.

The British Museum catalogue of 1851 was the first to give the different graffiti, forty-four in all, on two separate plates in facsimile, and introduced letters or initials for the collectors from whom the vases had been acquired, two innovations that were adopted by Jahn. What Jahn, however, given the arrangement of the vases in Munich, could not do, since he had no official standing in the Alte Pinakothek, was to rearrange the vases systematically according to period, style, and fabric before proceeding with his entries. The existing fortuitous order had to be respected, and the result was a descriptive inventory by location rather than a catalogue, and this shortcoming Jahn indicated by calling his book not

Fig. 2. View of the Munich vase galleries, circa 1910 (from R. Wünsche, *Ein griechischer Traum: Leo von Klenze, der Archäologe* [Munich 1985] 75, fig. 54). Photo courtesy Stadtarchiv München.

a *Katalog* but a *Beschreibung*. Its precursor, the British Museum volume 1, had been more ambitious. The authors established broad categories: "Early Italian Ware," "Black Italian Ware," "Miscellaneous varnished ware mostly of the early period," "Italian vases of archaic Greek style," "Vases of Finest Greek Style," and finally "Black vases of the best period of fictile art." All told, some 1,300 vases and fragments were catalogued, and within the sections similar vases, like the Panathenaic prize amphorae or the red-figure cups, were kept together. Though this volume describes the finest Attic black-figure and Attic red-figure in the British Museum, the word "Attic" occurs nowhere in the text, and the Burgon amphora, for instance, though fully noted as having been found in Athens, is classed with the other "Italian vases of archaic Greek style."

By the middle of the nineteenth century, painted vases from Greece had become widely known, and Otto Magnus, Baron Stackelberg's *Die Gräber der Hellenen*[52] had served as a warning to those who based their vase scholarship exclusively on the ceramic finds from Italy. Ever since the Greek liberation, an increasing number of European scholars and travelers went to Greece, whose first government from the very beginning sponsored conservation of ancient ruins and encouraged excavations. One of these early explorers was Ludwig Ross, who as First Conservator of Antiquities in Athens worked on the Akropolis and in 1835 and 1836 discovered red-figured sherds in the so-called Persian debris. This find should have helped to revise the chronology of Greek

vase-painting, but his discovery was not written up until 1852[53] and thus received as little attention as the much earlier note on the Panathenaic prize amphora with the archon name for 324/323 communicated by Lucas in 1702.[54] Jahn, as is to be expected, made due allowances for the few known fixed dates and adjusted Gerhard's brackets, but no consensus was reached in his day, and Heinrich von Brunn, misled by epigraphical considerations, stipulated that all vase-painters were archaizing and worked in the Hellenistic and Roman periods. Lest we condemn Brunn's nineteenth-century heresy too rashly, let us remember that playing with established chronology has been a temptation even some of our own learned contemporaries have not been able to resist.

After the middle of the century, vase-scholarship advanced on all fronts, and we now encounter the great names who still deserve to be remembered after more than a hundred years and whose works can still be consulted with profit. Excavations had been elevated from ill-disguised pillage of ancient sites and necropoleis to a science, and the net had been cast wider to include Asia Minor, Rhodes, Samos, Cyprus, and the Nile delta. The exploration of Cerveteri and the resulting collection of the Marchese Campana may be termed the last of the old-fashioned endeavors. Though almost as many important vases were found at Cerveteri as were included among the 1828/1829 finds at Vulci, the haste of assembling an impressive private museum coupled with the incompetence, if not fraudulence, of the restorers—the Penelli brothers—represent a regrettable taint from which the Campana vases in Leningrad, Brussels, and above all the Louvre have not yet recovered.

The Italian sites had already provided collectors and scholars with such non-Attic Greek fabrics as Corinthian, Laconian, and some East Greek vases. Excavations by Edouard Biliotti and Auguste Salzmann on Rhodes in 1859 put East Greek vases in a more rational context. Corinthian, already localized since 1805 in the Greek city of Corinth thanks to Dodwell's purchase there of the pyxis now in Munich, posed no problems, but Chalcidian did not get its name until Adolf Kirchhoff in 1863 identified the alphabet of its inscriptions.[55] Laconian passed through a Cyrenaean phase prompted by the Arkesilas cup in the Cabinet des Médailles, a phase that lasted from 1880 (Otto Puchstein[56]) until J.P. Droop's excavations at Sparta (first published by him in 1909).[57]

The new excavations on Rhodes and the resulting augmentation of East Greek vases gave rise to a Panionism which, like a disease, had to run its course; this slant left its mark on the early studies of the Amasis Painter and affected even Beazley, who as late as 1914 called the Würzburg satyr amphora "Ionic."[58] Flinders Petrie's excavations at Naukratis and Tell Defenneh occurred at the same time as the systematic excavations of the Akropolis in Athens. The year 1885, when Beazley was born, also saw the publication of Adolf Furtwängler's catalogue of the Berlin vases in two volumes.[59] The Berlin collection was much bigger than that of Munich and, at that time, even bigger than the holdings of the British Museum. When its first catalogue was published by Konrad Levezow in 1834,[60] a year before he died, it already comprised more than fifteen hundred entries, another thousand, mostly undecorated or minor

vases having been excluded by the author and over the years given to universities or sold as duplicates. Levezow's catalogue soon became outdated thanks to the many purchases negotiated by Gerhard. Supplements published by Gerhard could not keep pace with the new accessions and stopped when Gerhard in 1855 became director of the sculpture galleries and was succeeded as curator of vases by Panofka.

Furtwängler's catalogue, like Jahn's modestly entitled *Beschreibung*, accomplished two major innovations. The vases were numbered according to a system of rigid but scholarly classification, in which all 4,221 vases were divided by fabric, period, and shape; the second, more daring attempt was to group vases within each section by style, or at least stylistic affinity. In many cases Furtwängler ventured to make what today would be called an attribution. Robert Cook has gone to the trouble of calculating that only a third of Furtwängler's attributions are right,[61] but there are many more hidden attributions, such as when Furtwängler numbered in sequence several vases that Beazley recognized later as being by the same painter. Nor should it be forgotten that the exercise in making attributions was a relatively novel one a hundred years ago: Jean de Witte, one of the founding members of the Roman Institute, had, in 1836, said of the Aithra calyx-krater in the British Museum: "It deserves to be compared for the style of the paintings with the great vase representing Croesus"[62] (now in the Louvre); Friedrich Hauser, who published the Croesus amphora with Reichhold's new drawings in 1908,[63] instinctively and independently grouped together the same two vases, whose painter, Myson, was identified a few years later by Beazley. In any event, Furtwängler's Berlin catalogue brings us to the threshold of what might be styled the century of attributions.

Many of the prerequisites for such a specialization had already been tackled satisfactorily: the different fabrics had been sorted out, the fanciful overinterpretation of the subject matter had been discarded, the chronology had been tightened and corrected, and even the shapes, thanks to Theodor Lau[64] and A. Genick,[65] had been studied in proper profile drawings. Many gaps, of course, still remained, but now that the foundation had been established, the tidying up could be done with relative ease. With attention also directed toward style, a real need arose to illustrate vases faithfully.

Though drawings and engravings had improved since the days of Buonarotti (1723–1726), D'Hancarville (1766–1767), Passeri (1767–1775), and Tischbein (1791–1795), the greater fidelity of Millingen's and Gerhard's vase publications was still somewhat inadequate, and photography, though already employed as an aid for lithographic reproductions by Adrien de Longpérier in 1868,[66] was not yet accepted as the answer. Accurate drawings had been made for a long time, but their reproduction, be it by engravings or lithographs, left much to be desired, since the original tracings had to be redrawn and were printed on a reduced scale. Paul Hartwig's *Die griechischen Meisterschalen der Blüthezeit des strengen rothfigurigen Stiles*,[67] a pioneering work of extraordinary artistic perception, reproduced in its plates the drawings he had commissioned and collected one to one, and in his preface Hartwig observed that

the relative scale for the individual drawings on vases was an important criterion for the recognition of the individual painters. Hartwig did not always insist on the chromatic reproductions of added colors and the finer shades of dilute glaze, since to him the ductus of the drawn line, whether solid or thinned, was the handwriting of the artist. As is to be expected, many of these pre-Beazley attributions clustered around the known signatures, and obviously the difference between *egrapsen* and *epoiesen*, though duly noted, was not carried to the logical conclusion that only "egrapsen" should mean "painted." Furtwängler's review of Hartwig's folio[68] straightened this out. He also put the beginning of Attic red-figure back to the Andokides Painter, and not to Epiktetos as Wilhelm Klein, misled by the many bilingual cups, had proposed.[69]

The time had now come for Furtwängler to put to use what he had preached for so long: in 1900 he launched, with Karl Reichhold as draftsman and with the financial support of the Bavarian Academy of Sciences, the first fascicle of ten plates in folio size of *Griechische Vasenmalerei*, accompanied by a quarto-sized text in which Furtwängler described each vase not in terms of a standard museum catalogue, but with the delight of an informed connoisseur. The series was planned with six fascicules of ten plates in each volume, with the entire range of figured vases represented in each installment. This explains an arrangement that might strike students who now consult the bound volumes of the text and plates as haphazard. When Furtwängler died in Athens in 1907, he had finished the first volume of sixty plates, which was completed and bound in 1904, written the text for plates 61–100, and selected the vases for the remaining planned plates 101–120. Friedrich Hauser, Furtwängler's junior by six years, now stepped in and continued the work in 1908, furnishing the text for the fifth and sixth fascicules of the second volume, which was completed in 1909. Of the third volume, the first two fascicules, comprising twenty plates, were published in 1910 and 1912.

Friedrich Hauser, born the same year as Paul Hartwig, survived Furtwängler by only ten years; two years after Hauser's death, in 1919, Karl Reichhold died, as did Hartwig, but fortunately the vases for the remaining forty plates had already been drawn. Now the task of concluding the great enterprise fell to Furtwängler's pupil Ernst Buschor (1886–1961), who with the help of Carl Watzinger (1877–1948) and Robert Zahn (1870–1945) succeeded between 1921 and 1932 in finishing the work in the tradition of its originator. Though the conclusion of the third volume was delayed by the deaths of Hauser and Reichhold, and by the catastrophic conditions in Germany after World War I, the master plan was adhered to, and it is somewhat unfair to characterize the publication as R.M. Cook did when he wrote that it "flourished before the First World War and lingered on until 1932."[70]

The optimism of the nineteenth century had created the climate for such ambitious long-range projects as the *Corpora* of Latin and Greek Inscriptions, Attic Grave Reliefs, Roman Sarcophagi, Etruscan Mirrors, Ancient Coins, the *Denkmäler griechischer und römischer Skulptur*, the *Einzelaufnahmen*, the types of terracottas, and much else. No wonder, therefore, that in 1919 Edmond Pottier conceived the plan for a *Corpus*

Vasorum Antiquorum. Two years younger than Furtwängler, Pottier joined the Louvre in 1884. In 1886 the vases were detached from the Département des Antiquités Grecques et Romaines and put with the Département des Antiquités Orientales in which Pottier served as *conservateur adjoint* under Léon Heuzey. In 1896 the first volume of Pottier's *Catalogue des Vases Antiques de Terre Cuite* came out in Paris, followed the next year by the quarto-sized *Album*, which on fifty-one plates illustrated a choice of over three hundred vases exhibited in galleries A–E of the Louvre. His master plan comprised several innovations, of which the most important was the use of photographic reproduction, supplemented on occasion by drawings. Pottier had also succeeded in completely revamping the installation. The more than 6,600 vases had been divided before Pottier between the "old collections," exhibited in four galleries of the second floor facing north over the *cour carré*, and the Campana collection in the adjacent galleries facing south, called the Musée Napoléon III. Pottier in his rearrangement got ten vase galleries, which he lettered "A" through "H" and "K" through "M" ("I" and "J" were reserved for glass, wall-paintings, and small marbles). The numbers in his catalogue were preceded by the letters of the lettered galleries, and visitors looking, for example, for the Euphronios krater G 103 could, in Pottier's day, ask any guard where Gallery G was and find in its proper numerical sequence G 103, the Antaios krater signed by Euphronios. Of Pottier's catalogue only three installments of the smaller text volumes appeared, ending with G 450, and the publication of the *Album* did not keep pace with the text, for the last volume of text appeared in 1906, while the last installment of plates was not issued until 1922. By a curious system of overlap and duplication, the original, unillustrated text gives neither measurements nor bibliography: these were reserved for the *Album*. Conversely, the text issued in a format that was intended to be slipped by a visitor into his pocket had grown quite bulky with volumes 2 and 3, since it contained long introductions and essays on style and the like. Galleries H, K, L, and M, for which catalogues never appeared, exhibited relief vases and plastic vases (H), South Italian pottery (K), Greek vases found in Greece (L), and Greek vases from Asia Minor, the Crimea, Libya, and Egypt (M). The arrangement of the vases planned and executed by Pottier has, of course, been changed many times, and, needless to say, some galleries have been lost to other departments, so that today, a hundred years after Pottier began his reorganization, the prefixed letters have become rather meaningless, except as a reference to the classes published in his catalogue. The reviewers of Pottier have not been very kind to him, but the 160 plates of his albums were pioneering for their time. If Pottier did not continue his catalogue and albums, it may well be that the *Corpus Vasorum*, to which he devoted the last fifteen years of his life, were intended by him to replace the earlier scheme.

Today, sixty-six years after the proposal for a *Corpus Vasorum Antiquorum* was unanimously approved by the Union Académique Internationale[71] and half a century after the death of Pottier, our view of the *CVA* is no longer dimmed by the dismal appearance of the first fascicules. Pottier's extraordinarily detailed outline of his new project runs

to nineteen typewritten pages and even calculates the cost of each fascicule down to the last centime. Born and trained in the nineteenth century and impressed by the vision and labor that had gone into other *Corpora*, Pottier felt that vases, the most numerous class of antiquities, deserved equally ambitious and comprehensive treatment. At the same time he foresaw that the completion of the *Corpus Vasorum* would require several generations, and as a museum curator he realized that the fascicules of the *Corpus* should be based on the contents of individual museums, prepared by the curators, rather than arranged by style, period, or subject matter. The uniform format of the individual fascicules was modeled after the volumes of Naukratis and Tell Defenneh, published by the Egypt Exploration Society.[72] Pottier also had the good sense to consider vases in museums as more important for the *Corpus* than private collections, and he emphasized the priority of painted vases over Roman relief ware.

Since the editing was left to the discretion of national committees that acted under the auspices of their respective academies, not every author slavishly followed the model Pottier had established with the first French issue. Some fascicules were clearly better than others, and some countries introduced deviations from the norm which soon caught on. The overly detailed and not entirely logical system of rubrics with many subdivisions, already formulated in 1919 by Pottier, was often misunderstood or modified to suit the scholarship of the author. While Pottier had stipulated that the text should be brief—not more than six lines on each vase, or only three or four for the vast majority—nobody complained when learned authors used the text as a launching pad for informed digressions. There was, of course, some initial opposition to the *CVA*: in America, the Museum of Fine Arts in Boston and the Metropolitan Museum of Art had other plans for the publication of their vases and withheld participation for quite some time. Germany did not oppose the *Corpus*, but was excluded from the Union Académique Internationale until the late 1930s and thus did not participate in the *CVA* until 1938. Germany's late arrival on the scene, on the other hand, spared her the growing pains of adolescence, and Greifenhagen's Bonn red-figure[73] was praised by Beazley: "The first German fascicule of the Corpus is a model: good photographs well reproduced, good text, the get-up good."[74]

Today, with 236 fascicules from 24 countries filling our bookshelves, the Soviet Union, incredibly rich in vases, is the only nation whose absence is sorely felt, especially when we remember that Michael Rostovtzeff represented his country at the crucial meeting of the Union Académique Internationale in Brussels on May 26, 1920.

Beazley, whose authority and knowledge in the field of Greek vases had already been established and demonstrated by the time Pottier inaugurated the *CVA*, was, of course, not immediately taken by the new project as envisaged by the creator, and in his early reviews of the fascicules he did not hesitate to draw attention to its shortcomings. In 1927, however, he himself published a fascicule—the first of the Ashmolean Museum—devoted to Attic red-figure, and scholars could see at once that in the hands of an intelligent author, the new enterprise could put its best

foot forward and become respectable. Four years later this Ashmolean fascicule was followed by a second one, for which Beazley enlisted Humfry Payne and Miss E.R. Price as authors of the sections devoted to the "Hellenic Cretan," "Corinthian and Italo-Corinthian," and "East Greek" vases. Though Beazley never wrote another *CVA* fascicule, he watched over the *Corpus* with patient criticism in his reviews, of which he wrote seventy in all, and he also made his views on the *Corpus* known in a communication to the colloquy convoked by Dugas in Lyons in 1956, a note that was printed as an *Annexe* in the *Compte rendu*.[75]

In the thirty-five years that had elapsed between the publication of the first *CVA* fascicule and the first international symposium of vase specialists from twelve countries in Lyons, not only had Beazley emerged as the greatest expert on vases but the subject itself had become recognized as more than just an inconveniently large class of *Kleinkunst*. What had been in the nineteenth century the prey of diverse and divergent scholarly stabs at a complex and confusing mass of minor monuments had been turned into a proper discipline, well ordered and sorted out, in which no aspect had been neglected, even if it had not yet been exhausted. This rise in esteem was in no small measure due to Beazley himself and to his passionate pursuit of the artistic personalities responsible for the countless products. Though unsurpassed in his clear recognition and analysis of individual styles, even those of minor masters, his research and publications touched on much else besides—the epigraphy of vases, the interpretation of their subject matter, the potting, the technique, and the internal chronology.

His example served as an inspiration and challenge to his friends, colleagues, pupils, and followers—museum curators, university professors, excavators, students, collectors, and lovers of antiquity alike—and even those who question his judgment or are intimidated by the construction of his dominating edifice would be foolhardy to attack his bedrock foundations.

This very Getty symposium and colloquium, and the exhibition in Los Angeles that occasioned it, would not have been possible or even thought of fifty years ago. For the opportunity to gather here, to listen and to talk, we ultimately have to thank Beazley, not merely for the timing of his birth—whose precise centenary was commemorated on September 13 of last year at the opening of the exhibition in New York with an exactitude he had taught us to appreciate and respect—but above all for the incredible labors he put into his chosen field and for the liberality with which he shared his findings on so many levels.

The chronological limits of this paper put Beazley at the end—the grand finale, we might say—though for many members of this session he may be the beginning of a new era. I do not believe that Beazley himself would ever have considered his word to be the last, for he never stopped acquiring new knowledge or refining and perfecting his method. Once again I wish to place the emphasis on this delicate process called "learning." What sets his accomplishment apart from that of his predecessors and coevals is his recognition of the scope of the task he had set for himself, the application of a unique talent to its pursuit, and the en-

durance or tenacity of his discipline. Where others might have contented themselves with basking in the glory of brilliant flashes, and then turning their talents to something else, he kindled the flame and saw to it that it stayed lit. The reconstruction of hundreds of vase-painters, which in its complexity baffles the beginner, turns through his skilled approach into a strong fabric of which some stray threads may perhaps have to be re-woven without danger of unraveling the texture. It should always be remembered that Beazley's upbringing and historic training kept him from belittling the achievements of earlier generations, which prepared the ground that by his labors yielded such a rich and rewarding harvest to be enjoyed by all of us for a long time to come.

THE METROPOLITAN MUSEUM OF ART
NEW YORK

NOTES

In addition to the works cited in the footnotes, the reader may wish to consult Otto Jahn's biography of Eduard Gerhard, printed in 1868 as the preface for E. Gerhard, *Gesammelte akademische Abhandlungen und kleine Schriften*, vol. 2 (Berlin 1868) I–CXXIV. For the history of the growth of the Munich vase collection under King Ludwig I, R. Wünsche's account in *Ein griechischer Traum: Leo von Klenze, der Archäologe* (Munich, Staatliche Antikensammlungen und Glyptothek 1985) 67–77 is indispensable. I am, moreover, much beholden to Raimund Wünsche for sending me the two photographs of the vase galleries in the Alte Pinakothek (illustrated by him on pages 74–75, figures 53 and 54) and for permission to have them reproduced in this article.

1. O. Jahn, *Beschreibung der Vasensammlung König Ludwigs in der Pinakothek zu München* (Munich 1854) IX–CCXLVI; E. Gerhard in *Archäologische Zeitung* 13 (Berlin 1855) cols. 100–110 and 113–119; *AA* 82–83 (October–November 1855) cols. 87–94; ibid. 84 AB (December 1855) cols. 110–115.

2. R.M. Cook, *Greek Painted Pottery*, 1st ed. (London 1960) 288–330; 2nd ed. (London 1972) 287–327.

3. M.-A. de La Chausse, *Romanum Museum* (Rome 1690).

4. A.F. Gori, *Museum Etruscum* (Florence 1737–1743).

5. B. de Montfaucon, *L'Antiquité expliquée* (Paris 1719–1724).

6. A.C.P. de Caylus, *Recueil d'Antiquités égyptiennes, étrusques, grecques et romaines* (Paris 1752–1767).

7. T. Dempster, *De Etruria regali* (Florence 1722–1724).

8. D. Raoul-Rochette in *Annali dell'Instituto di Corrispondenza archeologica* 6 (Paris 1834) 287–288 n. 2.

9. A.S. Mazochius, *In regii herculanensis musaei tabulas heracleenses commentarii* (Naples 1754–1758).

10. For Winckelmann's letters (*Briefe*), see the edition published in Berlin 1952–1957 in four volumes prepared by Walther Rehm and annotated by Hans Diepolder.

11. L.D. Caskey and J.D. Beazley, *Attic Vase Paintings in the Museum of Fine Arts, Boston*, part 2 (London and Boston 1954) 64.

12. "Pausania riporta che si usava di notare il nome d'un bello ragazzo tale sul mura nelle loro stanze" (Winckelmann, *Briefe*, vol. 1, 395); Pausanias must be a slip for Suidas who under καλοί (editio Bekker [Berlin 1854] 561) quotes Aristophanes, *Acharnians* 144, and comments on it; Winckelmann's paraphrase, wrongly credited to Pausanias, is a partial translation of Suidas' commentary on the line by Aristophanes.

13. Winckelmann, (supra, note 12) vol. 2, 230.

14. Ibid. 242.

15. Ibid. 246.

16. Ibid. 366.

17. Ibid. 343.

18. Rome 1767–1775.

19. W. Tischbein, *Collection of Engravings from Ancient Vases mostly of Pure Greek Workmanship*, vols. 1–4 (Naples 1791–1795).

20. Cf. Cook (supra, note 2) 290.

21. New York 47.11.5, *ABV* 174,1; *Paralipomena* 72.

22. Florence 1806.

23. *ARV²* 1024,2.

24. J. de Witte, *Etudes sur les vases peints* (Paris 1865) 20.

25. S. Reinach, *Peintures de vases antiques* (Paris 1891) XII.

26. H. Payne, *Necrocorinthia* (Oxford 1931).

27. Cook (supra, note 2) 295.

28. Weimar and Magdeburg 1797–1800.

29. London 1825.

30. Darmstadt and Leipzig 1810–1812; 2nd ed. Leipzig 1820–1823; 3rd ed. Leipzig 1837–1844.

31. *Peintures antiques de vases grecs de la collection de Sir John Coghill, Bart.* (Rome 1817).

32. *Annali dell'Instituto di Corrispondenza Archeologica* 3 (1831) 5–218.

33. For a revival of Amati's interpretation, cf. A. Linfert in *Rivista di Archeologia* 1 (Rome 1977) 20, based on G. Neumann's new reading of ΕΛΕΟV, favored by S.P. Morris in her review of *The Amasis Painter and His World* in *AJA* 90 (1986) 360. Neither Linfert nor Morris seems to have noticed that Gerolamo Amati was the first to associate the statement by Euthymides with the inebriation of the reveler ("Sui vasi etruschi" in *Giornale arcadico di scienze, lettere ed arti* 45 [Rome 1830] 24ff.), a view E. Gerhard corrected in *Annali dell'Instituto di Corrispondenza Archeologica* 3 (1831) 185 n. 751.

34. Berlin 1840–1858.

35. C. Lenormant and J. de Witte, *Elite des monuments céramographiques* (Paris 1837–1861).

36. Rome 1842. Printed in two different editions: for a convenient concordance, cf. A. Klügmann in *Archäologische Zeitung* 37 (Berlin 1879) 34–36.

37. T. Panofka, *Musée Blacas* (Paris 1829).

38. *Antiquités du Cabinet du Comte Pourtalès-Gorgier* (Paris 1834).

39. Honoré d'Albert, Duc de Luynes, *Description de quelques vases peints* (Paris 1840).

40. Viterbo 1829 (the actual printing was finished on March 26, 1830).

41. Viterbo 1829 (printed by the brothers Monarchi).

42. London 1831, 130–276.

43. Paris, March 17–20, 1834.

44. Paris, May 8 and following, 1837.

45. See supra, note 1.

46. London 1851.

47. Paris, April 25 to May 27, 1836. *Vente du Cabinet de feu M. Le Chevalier E. Durand* (Paris 1836).

48. Paris 1829.

49. Paris 1833.

50. Supra, note 33, 24ff.

51. *Annali dell'Instituto di Corrispondenza Archeologica* 8 (1836) 147ff.

52. Berlin 1837.

53. In *Allgemeine Monatsschrift für Literatur* (Halle 1852) 349–365.

54. See supra, note 8.

55. A. Kirchhoff, *Studien zur Geschichte des griechischen Alphabets*, 1st ed. (Berlin 1867), based on a paper first read at the Berlin Academy on March 19, 1863.

56. *Archäologische Zeitung* 38 (Berlin 1880) 185–186.

57. J.P. Droop in *BSA* 15 (1909).

58. *JHS* 34 (1914) 190 n. 10.

59. A. Furtwängler, *Beschreibung der Vasensammlung im Antiquarium* (Berlin 1885).

60. K. Levezow, *Verzeichnis der antiken Denkmäler im Antiquarium des kgl. Museums zu Berlin. 1. Abteilung. Galerie der Vasen* (Berlin 1834).

61. See supra, note 2, 325.

62. Supra, note 47, 152.

63. A. Furtwängler and K. Reichhold, *Griechische Vasenmalerei*, vol. 2 (Munich 1900–1932) 281.

64. T. Lau, H. Brunn, and P.F. Krell, *Die griechischen Vasen, ihre Formen und Dekorationssystem* (Leipzig 1877).

65. A. Genick and A. Furtwängler, *Griechische Keramik* (Berlin 1883).

66. A. de Longpérier, *Musée Napoléon III* (Paris 1868–1874).

67. Stuttgart 1894.

68. A. Furtwängler in *Berliner Philologische Wochenschrift,* January 20, 1894, cols. 105–114; January 27, 1894, cols. 141–147.

69. *Euphronios. Eine Studie zur Geschichte der griechischen Malerei*, 2nd ed. (Vienna 1886) 14ff.

70. See supra, note 2, 325.

71. *Compte Rendu de la première session annuelle du Comité, 26–29 mai, 1920* 5–6.

72. Published in London, 1886–1888.

73. *CVA* Bonn, Akademisches Kunstmuseum, fasc. 1 (Munich 1938).

74. *JHS* 49 (London 1939) 150.

75. *Colloques Internationaux du Centre National de la Recherche Scientifique "Corpus Vasorum Antiquorum,"* Lyon 3–5 juillet 1956, 23–30.

Index